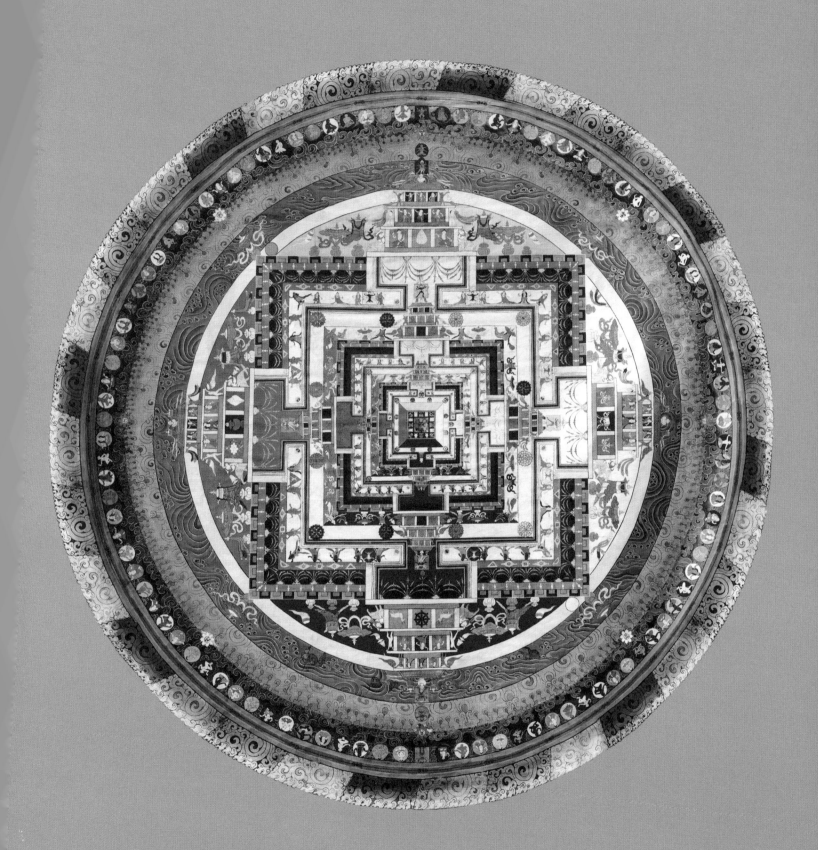

The Kālachakra Mandala

The *Treasury of the Buddhist Sciences* series is copublished by the American Institute of Buddhist Studies and Wisdom Publications in association with the Columbia University Center for Buddhist Studies and Tibet House US.

The American Institute of Buddhist Studies (AIBS) established the *Treasury of the Buddhist Sciences* series to provide authoritative translations, studies, and editions of the texts of the Tibetan Tengyur (*bstan 'gyur*) and its associated literature. The Tibetan Tengyur is a vast collection of over 4,000 classical Indian Buddhist scientific treatises (*śāstra*) written in Sanskrit by over 700 authors from the first millennium CE, now preserved mainly in systematic 7th–12th century Tibetan translation. Its topics span all of India's "outer" arts and sciences, including linguistics, medicine, astronomy, socio-political theory, ethics, art, and so on, as well as all of her "inner" arts and sciences such as philosophy, psychology ("mind science"), meditation, and yoga.

THE DALAI LAMA

Message

THE FOREMOST SCHOLARS of the holy land of India were based for many centuries at Nālandā Monastic University. Their deep and vast study and practice explored the creative potential of the human mind with the aim of eliminating suffering and making life truly joyful and worthwhile. They composed numerous excellent and meaningful texts. I regularly recollect the kindness of these immaculate scholars and aspire to follow them with unflinching faith. At the present time, when there is great emphasis on scientific and technological progress, it is extremely important that those of us who follow the Buddha should rely on a sound understanding of his teaching, for which the great works of the renowned Nālandā scholars provide an indispensable basis.

In their outward conduct the great scholars of Nālandā observed ethical discipline that followed the Pāli tradition, in their internal practice they emphasized the awakening mind of *bodhichitta*, enlightened altruism, and in secret they practised tantra. The Buddhist culture that flourished in Tibet can rightly be seen to derive from the pure tradition of Nālandā, which comprises the most complete presentation of the Buddhist teachings. As for me personally, I consider myself a practitioner of the Nālandā tradition of wisdom. Masters of Nālandā such as Nāgārjuna, Āryadeva, Āryāsaṅga, Dharmakīrti, Candrakīrti, and Śāntideva wrote the sūtras that we Tibetan Buddhists study and practice. They are all my gurus. When I read their books and reflect upon their names, I feel a connection with them.

The works of these Nālandā masters are presently preserved in the collection of their writings that in Tibetan translation we call the Tengyur (*bstan 'gyur*). It took teams of Indian masters and great Tibetan translators over four centuries to accomplish the historic task of translating them into Tibetan. Most of these books were later lost in their Sanskrit originals, and relatively few were translated into Chinese. Therefore, the Tengyur is truly one of Tibet's most precious treasures, a mine of understanding that we have preserved in Tibet for the benefit of the whole world.

Keeping all this in mind I am very happy to encourage a long-term project of the American Institute of Buddhist Studies, originally established by the late Venerable Mongolian Geshe Wangyal and now at the Columbia University Center for Buddhist Studies, and Tibet House US, to translate the Tengyur into English and other modern languages, and to publish the many works in a collection called The Treasury of the Buddhist Sciences. When I recently visited Columbia University, I joked that it would take those currently working at the Institute at least three

"reincarnations" to complete the task; it surely will require the intelligent and creative efforts of generations of translators from every tradition of Tibetan Buddhism, in the spirit of the scholars of Nālandā, although we may hope that using computers may help complete the work more quickly. As it grows, the Treasury series will serve as an invaluable reference library of the Buddhist Sciences and Arts. This collection of literature has been of immeasurable benefit to us Tibetans over the centuries, so we are very happy to share it with all the people of the world. As someone who has been personally inspired by the works it contains, I firmly believe that the methods for cultivating wisdom and compassion originally developed in India and described in these books preserved in Tibetan translation will be of great benefit to many scholars, philosophers, and scientists, as well as ordinary people.

I wish the American Institute of Buddhist Studies at the Columbia Center for Buddhist Studies and Tibet House US every success and pray that this ambitious and far-reaching project to create The Treasury of the Buddhist Sciences will be accomplished according to plan. I also request others, who may be interested, to extend whatever assistance they can, financial or otherwise, to help ensure the success of this historic project.

May 15, 2007

THE KĀLACHAKRA MANDALA

MANDALA

The Jonang Tradition

By
Edward Henning

TREASURY OF THE BUDDHIST SCIENCES SERIES
STUDIES AND REFERENCE WORKS

COPUBLISHED BY
THE AMERICAN INSTITUTE OF BUDDHIST STUDIES AND WISDOM PUBLICATIONS
IN ASSOCIATION WITH THE COLUMBIA UNIVERSITY CENTER
FOR BUDDHIST STUDIES AND TIBET HOUSE US

Treasury of the Buddhist Sciences series
Studies and Reference Works
A refereed series published by:

American Institute of Buddhist Studies
Columbia University
80 Claremont Avenue, Room 303
New York, NY 10027
www.aibs.columbia.edu

Wisdom Publications
132 Perry Street
New York, NY 10014
www.wisdomexperience.org

In association with Columbia University's Center for Buddhist Studies
and Tibet House US.
Distributed by Wisdom Publications.

Chapter 6 reprinted from *As Long as Space Endures*, edited by Edward A. Arnold, © 2009. Reprinted by arrangement with Shambhala Publications, Inc., Boulder, CO. www.shambhala.com.

Library of Congress Cataloging-in-Publication Data
Names: Henning, Edward, 1949–2016 author.
Title: The Kālachakra Mandala: the Jonang tradition / by Edward Henning.
Description: New York: The American Institute of Buddhist Studies and
 Wisdom Publications, 2023. | Series: Treasury of the Buddhist sciences |
 Includes bibliographical references and index.
Identifiers: LCCN 2023031656 (print) | LCCN 2023031657 (ebook) |
 ISBN 9781949163261 (hardcover) | ISBN 9781949163339 (ebook)
Subjects: LCSH: Kālacakra (Tantric rite)—China—Tibet Autonomous
 Region. | Mandala (Buddhism)—China—Tibet Autonomous Region. |
 Jo-nang-pa (Sect)—Rituals.
Classification: LCC BQ7699.K34 H46 2023 (print) |
 LCC BQ7699.K34 (ebook) | DDC 294.3/437—dc23/eng/20230802
LC record available at https://lccn.loc.gov/2023031656
LC ebook record available at https://lccn.loc.gov/2023031657

ISBN 978-1-949163-26-1 (hardcover) ebook ISBN 978-1-949163-33-9
27 26 25 24 23 1 2 3 4 5

Cover and interior design by Gopa & Ted2, Inc.
Set in Diacritical Garamond Pro 11.6 / 16.

Printed on acid-free paper and meets the guidelines for permanence and durability of the Production Guidelines for Book Longevity of the Council on Library Resources.

Printed in Canada.

Contents

Copublisher's Preface .ix

Author's Preface and Acknowledgments . xiii

Typographical Conventions and Abbreviations . xvii

 1. Entering the Mandala . 3

 2. The Drawing of the Mandala . 27

 3. The Mandala in Three Dimensions . 85

 4. The Deities of the Mandala . 117

 5. Symbolism: The Purity of the Mandala . 161

 6. The Six Yogas: The Six Yogas of the
 Kālachakra Perfection Process . 205

Appendix: Mandala Measurements . 221

Glossary . 223

Bibliography . 231

Indexes

 Canonical Authors Cited . 235

 Canonical Texts Cited . 237

 General Index . 239

Copublisher's Preface

WE ARE DELIGHTED to publish Edward Henning's masterful presentation of the Kālachakra mandala, especially as deeply understood, devotedly revered, and assiduously practiced and performed by the venerable Jonang order of Tibetan Buddhism. The Jonangpas were among the earliest schools that hugely appreciated the mysteries of the Kālachakra vision of life beyond death, and not only because of the great eleventh-century Indian psychonaut adept and scholar Somanātha, who brought its sciences and arts from India to Tibet; Kunpang Thukje Tsondru (1243–1313), who deeply practiced and carefully coordinated seventeen different traditions of Kālachakra teachings; Dolpopa Sherab Gyaltsen (1292–1361), a wild and great yogi adept lama who achieved miraculous spiritual experiences and mystical enlightenments; and Tāranātha (1575–1634), another great adept and polymath scholar, who made a special effort to center their research, experiential attainment, and education systems around the world of the Kālachakra. Nowadays, even H.H. the Great Fourteenth Dalai Lama, Lobsang Tenzin Gyatso (b. 1935), widely known as the greatest exponent and worldwide teacher of the Kālachakra yogas, invited the senior Jonangpa masters to transmit to him some of their most rare and profound instructions. Such is the tradition of the masters under whom Edward Henning has been one of the most important long-term Western researchers, a practitioner and independent scholar transmitting to us in these volumes what he has learned.

The Kālachakra Tantra is one of the most compre- hensive technologies of the unexcelled yoga tantra class, placed by some authorities in the mother tantra category, by others in the nondual category. Its mandala (sacred universe) represents a most vivid artistic representation of the uninterrupted, continuous presence of the Buddha's awareness and beneficent activity in the world, long after his humanoid embodiment as Shakyamuni passed away more than two and a half millennia ago. It quite magnificently represents the mahayana (Universal) vehicle discovery that the realm of nirvana, free from suffering, is not somewhere outside of the life-cycle realm of suffering but is ultimately findable through enlightenment as indivisible from this world, as experienced by anyone who eliminates the self-centered, materialistic misperception of its nonduality. The main and subsidiary embodiments such an enlightened being manifests are entirely constituted by the elements and divisions of time itself, demonstrating that a such an inconceivable being can expand his/her/its presence in time in all of past, future, and present "everywhen," yet effectively engage with beings who perceive themselves as trapped in specific instants within a linear flow, exiled from the past and not admitted to the future and not really aware of whenever is the present.

Given the omnipresence of such a by-us-imagined-as-possible enlightened being, its divine embodiment can be thought of as simultaneously manifesting also as his/her/its residence and environment and retinue. Its Kālachakra mandala is the ideal space—abode and company—into which suffering beings can be invited to feel immersed in the buddha presence. Therein they

can be enabled gradually, critically, and aesthetically to revise their misperceptions of the seemingly inescapable reality of the danger and pain of life, awaken to a basic trust of life's goodness, and carefully open to the perception of its beauty. The mandala is thus a sanctuary, a forum for the deep discovery of freedom, and a school for learning how to wield the joy of its taste compassionately and responsibly to share that freedom with infinite others.

In this volume, Mr. Henning follows upon his numerous essays and his systematic intellectual and experiential explorations of Buddhism in general and the Jonang Kālachakra traditions in particular. It is a companion of his first volume in our series, *Kālachakra and the Tibetan Calendar* (AIBS-CBS-THUS, 2007), wherein he tackled the notoriously difficult subject of the mathematics, astronomical calculations, and calendar construction of *The Light Kālachakra Tantra*. It must be acknowledged and remembered that it was the Indian "inner scientific" tradition that discovered the empowering use of the zero (*shūnya*) in mathematics, perhaps as a practical corollary of their enlightenment discovery of the empty or void nature of ultimate reality that mandates the absolute relativity of the living relatedness of everything in the world, enabling the digital

representation of things in the inconceivable tapestry of our interconnected lives which universal compassion can deploy to ameliorate the condition of countless sensitive beings.

I first met Edward Henning at SOAS at University of London, where I was giving a talk myself on something, I don't clearly remember what, and I was delighted by his erudition and sincerity when he answered very well a question from the audience. Whatever it was, I didn't know the answer, nor did the other professors or grad students present. Afterward, we enjoyed a supper together, and I began to realize the depth and breadth of his researches, his realizations, and his dedication to the Indo-Tibetan Buddhist tantric sciences and arts that are so rarely appreciated and understood for the extraordinary humanistic and scientific achievements that they are. His work is part of the huge work of a small group of modern scholars—philological, philosophical, rigorously analytical, and experientially empirical and scientific—rediscovering a profound and detailed knowledge of the human psyche and human body and the planetary environment. This rediscovery and systematic presentation is as necessary for human survival and flourishing today as it has ever been. It is a high priority asset that is aiding the marvelous efforts of con-

temporary materialist scientists who find themselves blocked from finding the key insights needed to prove to intelligent people the critical urgency of changing the trajectories of current self-destructive technologies of our clearly terminal lifestyle of industrialized consumerism and militarism.

This work that Edward Henning labored relentlessly to complete as he was passing beyond his body's ability to keep him going is an utterly marvelous presentation of the amazing mandala—purifying and sustaining enlightening environment—of the Kālachakra, "Wheel of Time." Sadly, his body let him go before we finished all the p's and q's, so our editors had to complete the work without being able to consult with him about every step involved in the polishing of the material. However, we have ourselves learned so much from what he so lucidly presents on these important topics that we are pleased to present it mostly as he left it to us, for the benefit of the many others who are also trying to scale the Himalayan heights of the amazing psychonaut traditions of the Wheel of Time.

We are confident that Edward, wherever he may be by now, will be very pleased with the result (even forgiving us for not preserving the British spelling in a few cases!), and may he be inspired in his rebirth in another enlightenment-supporting family to eventually produce further volumes for new generations. For the moment, we thank him for having taught us so much with these two wonderful volumes and the many informative essays on his website, and we congratulate him beyond his bardo for this wonderful work on the Kālachakra.

May there be blessings and good fortune for all sentient beings!

Robert A. F. Thurman

Editor-in-Chief,
Treasury of the Buddhist Sciences

Jey Tsong Khapa Professor Emeritus,
Columbia University
Director, Columbia Center for Buddhist Studies

President, American Institute for Buddhist Studies
President, Tibet House US

Ganden Dechen Ling, Woodstock, New York
June 14, 2022

Tibetan Saga Dawa Fourth Month,
Enlightenment Full Moon
Sovereign Year 2149, Water Tiger Year

Author's Preface and Acknowledgments

M Y INTEREST IN Kālachakra started in 1974, and a couple of years later, my teacher, Tenga Rinpoche of Benchen Monastery, introduced me to the practices used by our tradition of Tibetan Buddhism, the Karma Kagyu. Interestingly, these were just about all written by a lama from the Jonang tradition, Tāranātha. I later discovered that the Karma Kagyu had its own tradition of Kālachakra practices, but that these had fallen into disuse. Earlier that same year, I had attended a course on the basic philosophies of the Karma Kagyu tradition, given by Thrangu Rinpoche, and it was then that I first came across the name Tāranātha, at that time in relation to the concept of extrinsic emptiness (*gzhan stong*).

I spent most of that year of 1976 in India and Nepal, and during that time I was unable to find any texts by Tāranātha other than the couple of Kālachakra practice texts that I copied out by hand. On returning to the UK and the British Library, I found that, apart from a handful, the works of Tāranātha were indeed difficult to find. However, a few years later I came across a seventeen-volume set of his collected works in a library in Germany; this included the instruction texts on the Kālachakra practices that I needed, and much, much more besides. I spent many hours over a hot photocopy machine.

During the following years, Tāranātha easily became my favourite writer on Buddhism, until one day in the late 1990s, Guenther Grönbold, of the Bayerische Staatsbibliothek in Munich, gave me a copy of a paper by Matthew Kapstein, entitled "From Kun-mkhyen Dol-po-pa to 'Ba'-mda' Dge-legs: Three Jo-nang-pa Masters on the Interpretation of the Prajñāpāramitā" (Mkdoleg).

I knew Matthew, as he had interpreted for Thrangu Rinpoche during the 1976 course and had helped me obtain some useful Tibetan texts. I much appreciated his comments early in this paper regarding Tāranātha: "he should be regarded as one of the greatest contributors to the study of tantrism and yoga, in any time, place or methodological tradition. . . ." I could not have put it better myself.

And then a few pages later came a surprise that changed the course of my Kālachakra studies: Banda Gelek, a lama of whom I had never heard before (I subsequently learned that none of my Karma Kagyu teachers had heard of him, either). Matthew had obtained a copy of his collected works from Dzamthang in Eastern Tibet (now part of Sichuan) and usefully reproduced in his paper a list of the contents. Among them was a significant number of texts on Kālachakra, many of them of very considerable length. Matthew was at the time living in Chicago, and luckily I soon needed to go there on business: more time followed spent over a hot photocopy machine.

In the second chapter of this book, I describe the most significant feature of Banda Gelek's work as his "pedantic attention to detail." It goes further than this. He seems basically to have written down most, if not all, of the oral instructions he received on any particular subject, and done so in great detail. He also mostly avoids any discussion of different views on any particular subject. Tāranātha, for example, will often

introduce a point and then discuss the views of various previous teachers before finally stating his own particular approach. I would not try and pretend to know if his understanding of tantra is any different than that of Tāranātha, but if I simply want to get straight to the Jonang view on any point, Banda Gelek stands out as the main source.

There is no single Tibetan text that fully describes all the aspects of the Kālachakra mandala and its meaning, and so this book draws on a large number of texts—the main ones, of course, being by Tāranātha and Banda Gelek. Much of this work, particularly after the first chapter, consists of translations from the Tibetan, sometimes very literal, at others very loose, often combining comments from more than one author.

My original intention was to describe several types of Kālachakra mandala as found in three of the main traditions of Tibetan Buddhism: the Jonang, (the earlier) Karma Kagyu, and the Gelug. I eventually found that this was becoming too complex and likely to be confusing to readers. (It was getting confusing to me, so I could hardly expect it to be an easy read for others!) I decided instead to concentrate on the Jonang tradition and only mention the main differences with the others. Also, I would not cover the other mandalas, such as those of the 100 yoginīs and of Mahāsaṁvara Kālachakra. I decided to put much of this extra material on my website, www.kalacakra.org.

There are two reasons for concentrating on the Jonang mandala rather than one from one of the other two main traditions: it is the one I am personally involved with, and the wealth of information available in the Jonang tradition on the mandala more than outweighs all others combined.

There is also one aspect of the mandala that is brought out particularly well in the Jonang tradition, which is also relevant to other types of tantric practice: this is the development of the mandala within a major meditation practice and the benefits of this. Many texts describe how the process of imagining the mandala and populating it with deities purifies the cycle of existence, but there is normally scant detail available. This process applies to all the main tantric cycles but is particularly

well developed in the Kālachakra cycle and, of course, most extensively described by Banda Gelek. I have included this subject in this book because I feel it is essential to a proper understanding of the meaning of the mandala.

In the second chapter I describe the 2D drawing of the mandala; this can be considered as essentially a floor plan of the full 3D structure, which is the subject of chapter three. The meditative process of the creation of the mandala, which in Kālachakra can easily take well over an hour, can be thought of as the fourth dimension of the mandala, a process of creation that takes place in time; the mandala, when in actual use in a meditation practice, is not a static entity. This is described in the fifth chapter. In the sixth chapter I briefly outline the distinctive Jonangpa approach to the six yogas of the perfection stage.

I worked for many years as a computer journalist, and in an editorial meeting in about 1987, the remark was made that "We need somebody to learn CAD so that we can cover that area of software." I had started studying texts on the drawing and structure of mandalas a few years before (and had been building one from balsa wood), and it took a few seconds for me to realize the benefits of volunteering for this work. The first software of this type that I tested was AutoCAD from Autodesk, and within just a couple of years that company produced the first proper 3D rendering and animation software for a PC, 3D Studio. I was introduced to this very early and was on the beta program before final release in 1990. This DOS program (yes, really!) was much later replaced by 3D Studio MAX (later, 3ds Max) running on Windows. Over the years, I used many other programs from different vendors, but these from Autodesk were the ones used for most of the illustrations in the second and third chapters.

Those chapters deal with a great number of measurements, and the two main units used are called minor units and door units. I use for these the symbols "mu" and "DU," and treat these as if they were standard SI units (Système International d'unités). So, no plurals with the symbols and there is always a space between a number and the symbol: "4 mu" instead of "4mus."

It is all very well being able to produce 2D and 3D illustrations on a PC, but I am no artist and cannot draw deities, either on a PC or on paper. To accompany the descriptions of the deities in the fourth chapter, I therefore photographed Kālachakra mandala deities in three locations for illustrations: the Kagyu Bokar Monastery in Darjeeling district, India, and Tsangwa and Jayul Jonang monasteries in Dzamthang, Sichuan. I am very grateful to the lamas and monks that allowed and helped me with this photography.

I was at first surprised to find discrepancies between the paintings and descriptions in texts. However, I have come to accept that it is unlikely that artists will read in detail the instruction texts in which the full descriptions are to be found. For example, reading the main practice texts—the most likely sources for an artist— the retinue goddesses in the speech and body palaces will be given as being in the lalita posture. But as there are several versions of this posture, the artist will likely paint the one most familiar to him, rather than searching out the small details hidden away in a large specialist text. Gathering images for a full and accurate collection has to be a future project.

This is not an art book, in the sense that I have not been concerned with having the most accurate reproduction of a painting; I have therefore adjusted many images, as my main purpose is to represent the Kālachakra deities as accurately and clearly as possible. By way of example, the image that required the most work is the beautiful mandala from Jayul Monastery in Dzamthang. This is about 200 years old and is now rarely unrolled as it is showing signs of wear and the monks quite rightly feel that it receives a little more damage each time it is displayed. Unfortunately, there is no suitable place to hang it for proper photography— we hung it from a window, and my images were captured handheld with the sun in a bad position and the wind blowing! Many thanks are due to Ricky Swaczy for help in adjusting my original photograph.

On images, I am also grateful to the Victoria and Albert Museum in London for allowing me to include a photo of my personal favourite painting of Kālachakra (at the beginning of the fourth chapter).

Regarding the terminology in this book, where a Sanskrit equivalent to a Tibetan term is available in the literature, I give the Tibetan term first, in italics and in Wylie transcription and then the Sanskrit. Tibetan proper names are also given in phonetic form for the benefit of people not familiar with the language.

A couple of words of caution regarding mandala terminology. The meaning of some terms can be a little different when used with other mandalas. This is not a major problem—a parapet in Kālachakra does not suddenly become a balcony in some other mandala (despite what some translators would have us believe)—but at least care needs to be taken, particularly with more minor terms, such as the Tibetan equivalents for joist and rafter. More problematic in the translation of mandala architectural terminology is the fact that so many English architectural terms have evolved from the Greek and may not therefore be appropriate in a Tibetan/Indian context.

However, one major difference in Kālachakra concerns the torans that sit above the porches of the palaces. Their design and the terminology associated with their components is quite different to torans in other tantras.

Many people have helped with the production of this work, but the most important has certainly been my own teacher, Tenga Rinpoche. Not only did he introduce me to Kālachakra, but as an accomplished artist himself, he also introduced me to both the 2D and 3D construction of mandalas. His help continued through nearly four decades, until not long before he passed away in 2012.

Among westerners, the greatest help came from the late Gene Smith, founder and head of the Tibetan Buddhist Resource Center, until his death late in 2010. As well as republishing in electronic format a vast number of Tibetan texts, including every Tibetan source for this book but one, he always kept his eye open for new materials on my favourite subjects. A typical experience was an envelope dropping unexpectedly through my letterbox in London including a photocopy of a very rare text on the 3D Kālachakra mandala that Gene had received just a few days before.

I hope this book is of benefit to a range of people, including those interested in the art, but also those engaged in Kālachakra meditation practice.

I am especially grateful to Dr. Robert Thurman, Dr. Thomas Yarnall, William Meyers, and the AIBS for accepting this second work of mine into their series. There is no other group that has done more to publish translations of Kālachakra materials, and as with my last work on the Tibetan calendar, I feel that the AIBS is the natural home for this book.

In particular, Dr. Yarnall has paid close attention to the editing, design, and layout of this book, which is somewhat complex due to the number of calculations, tables, and graphics that it contains. Any errors that may remain are of course entirely my own.

Edward Henning
May 2016

Typographical Conventions and Abbreviations

Sanskrit and Tibetan transliterations

WE HAVE STRIVED generally to present Tibetan and Sanskrit names and terms in a phonetic form to facilitate pronunciation. For most classical Sanskrit terms this has meant that—while we generally have kept conventional diacritics for vowels—we have added an *h* to convey certain sounds that the general reader will mispronounce without it (thus *ś*, *ṣ*, and *c* are rendered as *sh*, *ṣh*, and *ch* respectively).

In addition, in the context of the Kālachakra literature presented herein, two Vedic Sanskrit letters (*ḥpa* and *ḥka*) are also attested, which are pronounced *fa* and *xa*, respectively.

In more technical contexts (notes, bibliographies, appendixes, and so on) we use full standard diacritical conventions for classical Sanskrit, and Wylie transliterations for Tibetan.

For Sanskrit terms that have entered the English lexicon (such as "mandala," "nirvana"), we use no diacritical marks.

The reader will notice that clusters of Sanskrit letters or characters (e.g., CCHJJHÑA) appear in a few instances in conjunction with the names of certain deities. In these instances, we render the clusters with conventional diacritics but apply our own phonetic form to the deity names.

British spellings

While we have Americanized most of the author's original British spellings, in deference to the author's preferences we have maintained British spellings for a few select words, including, for example, "practise" and "memorise."

Abbreviations

The author used multiple abbreviations (e.g., Bglha9, Bg6yspyi, 6ykrab) to refer to Tibetan texts. While we were able to identify many of these and cite their full references in the bibliography below, we were unable to identify several abbreviations (e.g., Kagcho, Dpkthig, Takhist) as we were not able to consult the author during the final editing process.

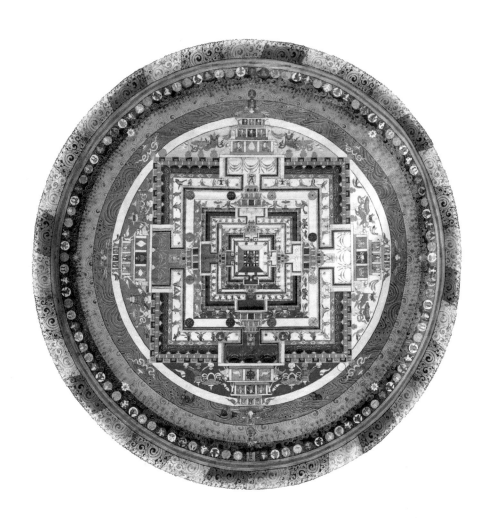

The Kālachakra Mandala

1. Entering the Mandala

IF YOU LOOK UP the word "mandala" in a Sanskrit dictionary you will find meanings such as: circular, round, a disk, a circle, a wheel, a group, and so forth. The word also has more technical uses, and in a Buddhist ritual context, mandala is used mostly to represent two closely related but different things.

In the Tibetan language a distinction is made between these two by, for the first use, leaving the word "mandala" in its original Sanskrit and transcribing it into Tibetan characters, and for the second, translating the word into Tibetan. As yet there is no consensus as to how, if at all, we should represent either of these two uses of this word in English.

The first type of mandala is a representation of the Buddhist view of the world system, or universe. This consists of a central mountain, known as Mt. Meru, surrounded by four major continents, rings of lesser mountains, continents and oceans, and much else.

Most people new to Tibetan Buddhism encounter this type of mandala first. In a widely used type of preliminary meditation practice, the practitioner imagines offering the whole world and its contents to an assembly of buddhas, lamas, and so forth, imagined in the form of this mandala. This is often called in English an "offering mandala," and it is encountered in many situations in Tibetan Buddhism, not just these preliminary practices.

The second main use of the term "mandala," translated into Tibetan as kyil-khor (*dkyil 'khor*), is more widely known. In this use the mandala is a representation of a divine palace (*gzhal yas khang, vimāna*), in which at least one deity, and sometimes several hundred, is imagined as dwelling. Two words that are often used in this context are support (*rten*) and supported (*brten pa*). The latter refers to the deities that are housed in the mandala, and the support refers to the palace that houses them. This pair of words also often describes the support of the outer physical world and the supported animate world that lives in it.

The most common representation of a palace mandala is a two-dimensional drawing or painting, usually of a square structure within circular boundaries. However, the divine palace is really a three-dimensional object, and the two-dimensional representation is effectively a floor plan of the three-dimensional palace.

As it happens, in a full textual description of a divine palace mandala, the mandala as world system is also often included, because the divine palace mandala is often said to sit on top of the central Mt. Meru, within a world-system mandala.

The most widely known representation of the divine palace mandala is usually referred to as a powder mandala (*rdul tshon gyi dkyil 'khor, rajomaṇḍala*); these are often also referred to as sand mandalas, but fine sand, although commonly used, is just one suitable powder. For a very large mandala, large grains can be used, such as rice. During large rituals, particularly empowerments (initiations), a large mandala is drawn on a flat surface using colored powders. This becomes the focus of the main ritual and is destroyed after several days at the end of the ritual.

These powder mandalas have attracted much attention in the West—they are after all visually attractive and complex, true works of art—and many have been created outside of a ritual context in such places as

museums and art galleries. Drawn or painted mandalas are also commonly used for small rituals performed in monasteries or in private individual practice. In such instances the mandala again usually becomes the focus of the ritual concerned. In both cases, the procedure for creating the mandala starts by laying out a grid of lines (*thig rtsa*) for the dimensions, and then drawing the components of the mandala with the help of this grid. After this quite complex drawing has been completed, the colors are applied, either in the form of powder or paint.

The most commonly cited Buddhist definition of a mandala comes from a tantra called the *Vairochanābhisambodhi*. For example, the early Gelug writer Drakpa Gyaltsen refers to this as the basis of his definition in his text on Sarvavid Vairochana meditation: "Mandala means leading to the essence; as it says in the *Vairochanābhisambodhi*: 'maṇḍa is essence, la is leading.'"

Drakpa Gyaltsen continues by describing the nature of the mandala as being a manifestation or projection of the awareness of enlightenment, and that this has two aspects, the inner mandala and the outer. The inner mandala is that nondual awareness of enlightenment that itself has no form, color, and so forth. The outer mandala has form and structure and is described for the benefit of unenlightened beings as a means to attain enlightened awareness. This outer mandala which has the structure of a divine palace is not enlightened awareness itself, but it is used as a means to help realize that awareness. It embodies or grasps the essence of that enlightenment and both symbolizes that final goal and is also used as a tool on the path to enlightenment.

The divine palace is not considered real in any sense and neither are the deities that are imagined within it. There is no concept of a creator god in Buddhism, and the deities that are described are not considered to exist in this world or any other in any literal sense, even though the mythology that accompanies many of them is very rich and full of wonderful stories. That mythology helps practitioners to develop a proper feel for the spiritual reality that the deity and its divine palace represent.

To paraphrase Drakpa Gyaltsen, the images and mythologies of the outer mandala are not real but are described as means to help achieve the realization of the inner mandala, the awareness of enlightenment, that is real. These images are part of the vocabulary that is used in ritual and meditation to communicate with and about that spiritual reality. Perhaps we could say that they are a metaphorical reality representing the state of enlightenment.

Within vajra vehicle Buddhism there are many different divine palace mandalas described, but the purpose of this book is to describe the Kālachakra (*dus kyi 'khor lo*) mandala and its meaning. By this I mainly refer to the divine palace of Kālachakra, but as this is always imagined as sitting on top of Mt. Meru, this also therefore implies the world-system mandala as defined within the Kālachakra system.

The source material for the meditation and ritual practices of the vajra vehicle, or tantric Buddhism, is a set of Indian texts known as tantras. Associated with any particular tantra will be commentaries explaining its meaning and the practices it describes. There will also be texts to be used in those practices and rituals, together with material covering the many other topics possibly discussed in the basic tantra.

These works were originally written in Sanskrit, although most of the Sanskrit originals have now been lost. Over a period of several hundred years, Tibetan, Indian, and Nepali scholars translated a large amount of this material into Tibetan. There are two large collections of the original material that was translated into Tibetan—not just concerning the tantras, but all aspects of Buddhism.

The original tantras themselves are said to be the word of the Buddha himself, and these are included with all other such works, sutras, and so forth, in a set of texts of about 100 volumes, depending on the edition, known as the Kangyur (*bka' gyur*). The commentaries, ritual manuals, and all other materials associated with the tantras are included in a section of the other large collection of translations, the Tengyur (*bstan 'gyur*).

The two most important source texts for the Kālachakra system are the *Kālachakra Tantra* (more properly called the *Laghutantra*, or *Abbreviated Tantra*), and the commentary to this, the *Vimalaprabhā*.

Origins of the Kālachakra literature

It is said that the Buddha was requested to teach the Kālachakra by the king from the land of Shambhala, Suchandra. According to the famous historian Tāranātha: "On the full moon of the month Chaitra in the year following his enlightenment, at the great stūpa of Dhānyakaṭaka, the Buddha emanated the mandala called The Glorious Lunar Mansions. In front of an audience of countless buddhas, bodhisattvas, vīras, ḍākinīs, the twelve great gods, gods, nāgas, yakshas, spirits, and fortunate people gathered from the 960 million villages north of the river Shītā, he was requested by the emanation of Vajrapāṇi, the king Suchandra, to teach the tantra." (Takhist)

It is said that Suchandra then returned to his kingdom of Shambhala and wrote down in textual form the original tantra as taught by the Buddha, the 12,000-line Kālachakra root tantra (*mūlatantra*). As a commentary to this he also composed the explanatory tantra in 60,000 lines. If either of these texts ever existed, they do not survive today, although many quotations attributed to the root tantra do survive, particularly in the *Stainless Light* (*Vimalaprabhā*). Suchandra is also said to have constructed out of precious materials a three-dimensional Kālachakra mandala palace, 400 cubits in size.

A later king of Shambhala, Yashas, is said to have written the abbreviated version of the tantra summarizing the meaning of the root tantra, known as the *Kālachakra Laghutantra* (KalT). This is the one that survives today, both in the original Sanskrit and in several Tibetan translations.

The next king of Shambhala is said to have been Puṇḍarīka, an emanation of the bodhisattva Avalokiteshvara. Following the structure of the root tantra, he composed a commentary to the *Kālachakra Laghutantra*, known as the *Vimalaprabhā*. Fortunately, this also survives in both Sanskrit (Vimala) and Tibetan (Kaldri).

The history of the Kālachakra tradition now moves from the realm of myth and legend into history, but much is still unclear. There are many variations available on similar stories depending on which author one references. The following description of the Indian Kāla-

chakra history up until the time of the visits to Tibet of Somanātha is adapted from the work (Kzabhis) of the Sakya writer Amye Zhab (*a mye zhabs*, aka: *ngag dbang kun dga' bsod nams*).

The one known as Kālachakrapāda the Elder (*dus zhabs pa chen po*) was born in Varendra (a region of northern Bengal) in eastern India. His father was a Brahmin yogin who practised Black Yamāri (*gshin rje gshed nag po*), and his mother was an awareness ḍākinī. They performed a ritual from the *Kṛṣṇayamāri Tantra* to ensure the birth of a noble son. The father dreamed of the noble Mañjushrī entering his wife's belly, and the child was later born together with auspicious signs.

Due to the blessing of noble Mañjushrī, the child had a bright mind with clear faculties and took ordination when he was young. He studied many subjects, and understanding them all with ease, he became a paṇḍita and was known as Chilupa. He heard of Kālachakra from one Paṇḍita Ācharya, but was not satisfied, and through the awakening of his previous prayers he developed a powerful wish to go to Shambhala.

As his personal deity, Tārā would grant the realization of anything he wished, she prophesied that for the benefit of beings he would gather from Shambhala many tantras and bodhisattva commentaries. Those commentaries are known as the "bodhisattva trilogy" (*sems 'grel skor gsum*). Each said to have been written by great bodhisattvas, one is the *Vimalaprabhā* commentary on Kālachakra and the other two deal with the Chakrasaṁvara and Hevajra tantras, but explained from a Kālachakra point of view.

He traveled north, but as there was physical danger due to a desolate area that would need four months to cross, he journeyed together with some traders by boat across an ocean. The traders went to an island of jewels, and he traveled on north. He climbed a mountain on an island in the ocean and there met a white man, who was an emanation of the Kalkī king of Shambhala. Some say this was the king Shrīpāla, and others say it was Puṇḍarīka.

The king asked him where he was going and for what

reason. He replied that he had traveled from eastern India and was on his way to Shambhala to meet the Kalkī and request teachings on Kālachakra. The king told him that he would not be able to make such a journey, but that if he could understand such things here, would he not listen?

Chilupa then understood that the man was an emanation of the Kalkī and prostrated to him and circumambulated him many times. After offering a mandala, he requested that the king accept him as a student. The king told him, "I have come here in order to teach you Kālachakra for the benefit of beings in India, so listen."

He then manifested the complete Dharmadhātu mandala and gave him empowerment. The full name of the mandala is the *Dharmadhātuvāgīshvaramandala* (*chos dbyings gsung gi dbang phyug gi dkyil 'khor*), a name of the normal triple Kālachakra mandala. He then gave Chilupa instruction in the very fast path of the profound six-limbed yoga.

Chilupa meditated for seven days at the foot of the mountain by the side of the ocean and attained realization. He magically flew through the air to the sandalwood grove in Shambhala, and there, at the Kālachakra mandala house, he bowed to the feet of the Kalkī in person, who gave him the complete empowerment, explained to him the instructions on the tantra and commentary, and gave him texts of the bodhisattva teachings, including the *Laghutantra*, the *Kālachakra Tantrottara* (*rgyud phyi ma*), the *Vimalaprabhā*, the root tantra, the *Sekoddesha* (*dbang mdor bstan*), "a synopsis of our and others' views," the *Triyogahṛdayavyākaraṇa* (*rnal 'byor gsum gyi snying po gsal ba*), the *Paramārthasevā* (*don dam bsnyen pa*), the *Piṇḍārtha* commentary on Chakrasaṁvara (*bde mchog bstod 'grel*), and Vajragarbha's commentary on Hevajra (*rdo rje snying 'grel*).

He then traveled to Puṣhpagiri (*me tog khyim*) in eastern India, and after journeying to Magadha, Chilupa became known as Kālachakrapāda the Elder. He spread the teachings of the bodhisattva cycle widely through east and west India.

Kālachakrapāda the Elder had many students, among whom were three known as Kālachakrapāda the Younger: Avadhūtipa, Shrībhadrabodhi, and Nālandāpa; also Nāropa, Sādhuputra, Ratnakaragupta, Mokshākaragupta, Vinayākaramati, Siṁhadhvaya, and Anantajaya.

Regarding the one known as Kālachakrapāda the Younger, Avadhūtipa: in India a monk with a dull mind performed a practice of the goddess Kurukullā in order to increase his intelligence. The goddess appeared to him in a dream and taught him what to do. He should make a coral image of Kurukullā and then find in a charnel ground the corpse of a woman with all her faculties. He should insert the image in the mouth of the corpse and, placing it facedown, sit in meditation on its back for seven days, until achieving success.

In accordance with this prophecy, after seven days had passed the corpse looked up and asked, "What kind of intelligence do you want?" He had wanted to be able to memorize anything that he saw, but when it came to it, because of his dull mind, he said that he wanted to be able to remember everything that he wrote, and this came to be.

As he lived from alms, he became known as "paṇḍita āchārya." Later, in Madhyadesha, he became known as Vāgishvarakīrti, and he lived at the Khasarpaṇa temple.

He touched the feet of Kālachakrapāda the Elder and asked him how many tantras he knew, but it is said that he could not even remember the names of those given in the answer. He was then given the empowerment and instructions of Kālachakra, and as a result of his practice he achieved realization and became known as Avadhūtipa, also as Kālachakrapāda (the Younger).

He authored such works as the *Padmanināmapañjika* (*dka' grel padma can*) and the sādhana of the Glorious Lunar Mansions (*dpal ldan rgyu skar dkyil 'khor gyi cho ga*).

His main students were the younger Kālachakrapāda Upāsakabodhi and his son, Nālandāpa. He also spread the teachings of Kālachakra in southern India.

Regarding Nālandāpa, he was the intelligent son of Upāsakabodhi, named Bodhibhadra. Having become an unequaled great paṇḍita, in order to learn Kālachakra from Kālachakrapāda the Elder in Magadha, he thought he should make a golden offering mandala for

this teaching. It was said that in Tibet gold could be dug from the ground, and so he went to Tibet in search.

He traveled to Chirong in Mangyul (*mang yul skyid grong*), and obtained his gold there from a head craftsman who became his patron. Later, when traveling on the road to Dingri, he met a paṇḍita riding on a donkey. When he asked him why he was doing this, the paṇḍita replied that as Tibetans were poor they had to act in this way, and this saddened him (the implication being that anybody of substance would be riding a horse).

Nālandāpa returned to India and presented the gold to Kālachakrapāda the Elder, who was greatly pleased. Together with Nāropa he received the full empowerment and instructions on the tantra and commentary. Having practised, in one moment he achieved the ten signs and the eight qualities, and the mandala of his body was filled with bliss. Right there he achieved realization.

His father and his aunt also heard the teachings, but from Avadhūtipa. It is said therefore that there were certain discrepancies between the explanations of the father and son. He considered that the Kālachakra would spread widely if it were taught in Magadha.

At a time when the king of Magadha was the "One with the Wooden Seat," [that is, Rāmapāla (1072–1126, approx.)], and Sendhapas were in charge of the vihāra of Uddaṇḍapura, he traveled to glorious Nālandā and placed over the door of the vihāra the "Letters of Ten Powers" (the well-known monogram of Kālachakra). Underneath this he wrote:

"Those who do not understand the *Paramādibuddha* do not understand Kālachakra; those who do not understand Kālachakra do not understand the *Nāmasaṃgīti*; those who do not understand the *Nāmasaṃgīti* do not understand the awareness body of Vajradhara; those who do not understand the awareness body of Vajradhara do not understand the mantrayāna; those who do not understand the mantrayāna are those in cyclic existence, and are not on the path of the victorious Vajradhara. This being so, all pure teachers should rely on the *Paramādibuddha*, and take with them all pure students intent on liberation."

About 500 paṇḍitas were living there, and not liking

this, they argued with Nālandāpa. However, he convinced them of the profound and vast nature of these teachings, and they all gave up their own positions, bowed to him, and became his students.

Well known among these who became experts were: Abhayākaragupta, Buddhakīrti, Abhiyukta, Mañjukīrti, the Kashmiri Somanātha, Paṇḍita Parvata, Achalagarbha, Dānashrī, Puṇya the Great, the Kashmiri Gambhira, Shāntagupta, Guṇarakṣhita, and others.

Also, many kṣhatriyas, vaiṣhyas, and traders developed great confidence in these teachings, copied texts, and developed a strong inclination to these teachings, spreading them widely.

As he stayed at Nālandā, he was known as Lord Nālandāpa. He also built there a Kālachakra temple. His qualities became equal to those of Kālachakrapāda the Elder, and throughout the whole of east and west India he was known as Kālachakrapāda the Younger.

The Kashmiri paṇḍita Somanātha was born the son of a Kashmiri brahmin, and he was able to memorise sixteen verses at one time, remembering one with each breath. Up until the age of twelve he learned all the Vedas from his father, but his mother was a Buddhist, and she sent him to study the Dharma from an excellent great Kashmiri paṇḍita called Brāhmaṇapāda, also known as Sūryaketu.

This paṇḍita had a daughter who found Somanātha very attractive and told him that in order to request teachings the two of them should behave as a couple. He acted accordingly and heard many teachings, and he and the other main students, Sonasahi, Lakṣhminkara, Jñānashrī, and Chandra Rahula, all became paṇḍitas expert in the five subjects. In particular, Somanātha became expert in the "Noble cycle of Guhyasamāja" (the tradition of Guhyasamāja meditation that comes from the "noble" Nāgārjuna) and Mādhyamika.

At that time, paṇḍita Vinayākaramati (earlier mentioned as a student of Kālachakrapāda the Elder) sent as a present to one Bhadrapāda (Brāhmaṇapāda) copies of the *Sekoddesha* (a section of the *Kālachakra Mūlatantra* dealing with empowerment) and the *Sekaprakriya* (an extract from the third and fifth chapters of the *Kālachakra Laghutantra*, also about empowerment). He

placed these on his head and prayed, and his students asked what they were and if he would give them to them. He said, "These are from a particular profound tantra which I have not received, and so I am unable to explain these to you."

He gave the texts to the students, and Somanātha, having looked at them, developed great respect for them.

He broke off his studies and headed to Magadha to investigate these teachings. He met the father and son Kālachakrapāda the Younger, and heard the entire cycle of the bodhisattva teachings (the bodhisattva trilogy), took empowerment and instructions on the tantra and commentaries, and so forth. He also listened to the Abhidharma.

Having mastered all these instructions, he achieved the pacification of the winds and saw all objective phenomena as only the play of awareness. He could not be overpowered by thieves, had the ability to withhold bodhichitta without release, and was greatly blessed. He became known as truly (an embodiment of) Mañjushrī.

He then traveled to Kashmir, debated with the Kashmiri Ratnavajra, and won by refuting his Chittamātra view. Ratnavajra told him that lest his students should come to lose confidence in him, Somanātha should go somewhere else.

As it happened, at that time the Kalkī Puṇḍarīka came to him and told him, "You should go to Tibet and spread widely the teachings of definitive meaning," and on the basis of this prophecy, Somanātha went to Tibet.

Kālachakra in Tibet

Somanātha traveled to Tibet three times, became expert in the language, and either translated certain texts himself into Tibetan or worked with other translators helping them produce Tibetan versions of important Kālachakra materials. Among these the most notable, and in the long term the most influential, was Dro Sherab Drak (*'bro shes rab grags*), born at the beginning of the eleventh century.

Generally considered to be equally important and influential in the early translation of Kālachakra material was the translator Ra Chorab (*rwa chos rab*), born a little later than Dro, in the middle of the eleventh century. He journeyed to Nepal and worked with the Newari paṇḍita Samantashrī, who lived in Patan. Samantashrī is said to have learned Kālachakra from Abhayākaragupta and Mañjukīrti. Both of these are given in the above list as contemporaries of Somanātha at Nālandā.

The traditions in Tibet that come down to us from these two great translators, known respectively as the Dro and Ra traditions, give somewhat different versions of the origin of the Kālachakra teachings before Kālachakrapāda the Elder, but in these stories we read the names of most of the important Indian figures in the transmission of Kālachakra. Later in this book I shall be quoting from the works of some of these Indian mas-

ters, particularly Puṇḍarīka, Kālachakrapāda the Elder, Abhayākaragupta, Sādhuputra, and Somanātha.

However, there were many others involved, such as Anupamarakṣhita and Vibhūtichandra, particularly in association with the perfection process meditations of Kālachakra, the six yogas, and their teachings passed along different routes.

Although Dro Sherab Drak and Ra Chorab are considered the most important early translators of Kālachakra, many others were also involved, and *The Blue Annals* (BlueAn) gives a list of twenty such translators of just the *Kālachakra Tantra* alone and adds at the end of the list "and others."

It is also not the case that any one tradition in Tibet adopted just one of the early Indian traditions passing through just one translator. Instead, it was usual that multiple lineages combined together to form the systems that survive today in the Tibetan traditions.

For example, in a quote often cited from *The Blue Annals*, Zhonnu Pal (*'gos lo tsā ba gzhon nu dpal*) writes of two contemporary (fourteenth-century) great Tibetan masters of Kālachakra, Buton Rinchen Drup (*bu ston rin chen grub*) and Dolpopa Sherab Gyaltsen (*dol po pa shes rab rgyal mtshan*). In Roerich's translation we read: "Bu(ston) and Dol-(pa-pa) were the two great expounders of the Kālachakra in the Land of the

Snows. These two first obtained it from the spiritual descendants of Rwalo-(tsā-ba), but later they studied it according to the tradition of 'Bro lo-tsā-ba."

Buton had considerable influence on the later development of the Gelug and Sakya traditions of Kālachakra, and Dolpopa on the development of the Jonang, but there were many other influences and much cross-fertilisation between the different traditions.

In the current work I shall be describing the Kāla-chakra mandala from the point of view of the Jonang tradition. A main reason for this is simply that the Jonang were, and still are, the foremost practitioners of Kālachakra in Tibet, with the Gelug a close second. However, I will also be pointing out the main differences in the mandalas as described in the Karma Kagyu and Gelug traditions.

In the main vajra vehicle meditation practices the focus of attention is on one particular yidam (*yi dam*), or meditation deity. In the so-called creation process meditations, the practitioner imagines becoming that particular deity within its mandala palace, surrounded perhaps by a large retinue of other deities. The different Tibetan traditions preserve meditation practices that focus on many different yidams—in fact, some collections contain practices for several hundred different deities—but all these traditions specialize in just a handful.

The Sakya have Hevajra (*dgyes pa'i rdo rje*) as their main yidam; the Kagyu traditions focus on Chakrasaṁvara ('*khor lo sdom pa*) and Vajrayoginī (*rdo rje rnal 'byor ma*); the Gelug tradition practice mainly Guhyasamāja (*gsang ba 'dus pa*) and Vajrabhairava (*rdo rje 'jigs byed*); and the Jonang specialize in Kālachakra.

Most notably including the present Dalai Lama, Tenzin Gyatso, there were many Gelug teachers and writers who specialized personally in Kālachakra, as well as teachers from other traditions, but the primary position of the Kālachakra within the Jonang means that there survives today more detailed material describing the practices of Kālachakra, including the mandala, in Jonang texts than in works from any other tradition. Unfortunately, there is not so much surviving Jonang material on the theory of Kālachakra, although Jonang annotated commentaries on *Vimalaprabhā*, one possi-

bly attributable to Dolpopa and, most notably, another by Jonang Chokle Namgyal (*phyogs las rnam rgyal*), have recently been found and republished. In one of these works, many of the comments that come from the *Vimalaprabhā* follow the revised Jonang translation, commissioned and annotated by Dolpopa. There are several points where the Jonang translation improves upon the clarity of the earlier versions. There are also substantial works on the theory of the Kālachakra six yogas, by both Tāranātha and Banda Gelek.

The situation with regard to the Karma Kagyu school is rather odd. That tradition's Kālachakra practices originally came from the translator Tsami (*tsa mi lo tsā ba*), and passed through the siddha Ogyenpa (*o rgyan pa*), and then to the third Karmapa, Rangjung Dorje (*rang byung rdo rje*). From him it was passed down the Karma Kagyu lineage. However, the use of the practice texts of this tradition, the most notable being written by the eighth Karmapa, Mikyö Dorje (*mi bskyod rdo rje*), has largely ceased, and the practices of the Jonang tradition written by Tāranātha are now mainly used. But still the mandala is drawn according to the original Karma Kagyu methods (to which I will refer as the Tsami tradition), even though there are some clear, although minor, contradictions between the descriptions given in the mandala drawing texts and the practice texts. These differences have sometimes caused puzzlement to modern Karma Kagyu mandala artists, unaware of the full history of their tradition.

In this book I shall therefore describe the Kālachakra mandala mainly from the point of view of Jonang writings, particularly those of Tāranātha (1575–1634) and Banda Gelek ('*ba' mda' thub bstan dge legs rgya mtsho*, 1844–1904). For the Gelug tradition my main sources are Tsongkhapa's student Khedrubje (*mkhas grub rje*, 1385–1438) and the third Detri Rinpoche, Jamyang Thubten Nyima ('*jam dbyangs thub bstan nyi ma*, 1779–1862). My main sources for the Karma Kagyu tradition are Mikyö Dorje (1507–1554) and the fourteenth Karmapa Thekchog Dorje (1798–1868) (*theg mchog rdo rje*).

There are differences between the mandalas as described by the Jonang, Gelug, and Karma Kagyu traditions, and I shall point out only the most important of these; it could be confusing to go into too many minor

details. The differences are relatively small, and by describing them from the point of view of these traditions, this almost certainly covers the variations within the mandala as described by all the Tibetan traditions.

Most of these differences, but not all of them, can be traced back to variations between the original Indian writers. As the Tibetans studied all the original Indian material, they clearly had to make choices when writing their own practices. Most tried to base those choices, or at least justify them, by reference to the *Vimalaprabhā*, the great Indian commentary on the *Kālachakra Tantra*, but the *Vimalaprabhā* does not describe the mandala and meditation practices in as much detail as one would perhaps hope. And, as we shall see, there are

some variations in the descriptions as given within the *Vimalaprabhā* itself, and of course differences between the various translations, original and revised, of the *Vimalaprabhā* into Tibetan. There are also some difference between the mandala descriptions given in the *Vimalaprabhā* and some of the original Indian mandala rituals that have been preserved in Tibetan.

The present writer is not free from preferences in this respect, and my choices are influenced by the *Vimalaprabhā*, which in my opinion should be the primary reference work for the Kālachakra. Unfortunately, we cannot now judge why there were some minor differences in the Indian traditions, as those early Indian writers did not leave us explanations for them.

Structure of the meditation practices

Before discussing the mandala in detail in the following chapters, as it is the focus of meditation practices in the Kālachakra system, some overview of that system would be helpful. As with most vajra vehicle meditation practices, the most common format is that of the sādhana (*sgrub thabs*). Vajra vehicle practice has two main components: the creation process (*bskyed rim, utpattikrama*) and perfection process (*rdzogs rim, utpannakrama*). A sādhana is a ritual text for performing the creation process of a deity such as Kālachakra.

A typical sādhana for Kālachakra consists of certain preliminary sections. After the standard Buddhist preliminaries such as refuge and so forth, the most important of these is the protective sphere, which itself consists of two parts, the protection of the individual performing the practice and the protection of the site where it is performed.

There then follows the development of the two accumulations, of virtuous actions and wisdom, the latter culminating in the contemplated dissolution of the individual performing the practice and all the physical worlds into emptiness. From this point on starts the creation process proper.

The creation process is divided into four sections, properly known as the fourfold yoga (*yan lag bzhi'i rnal 'byor*). In order, these are known as: the Mastery of the

Mandala (*dkyil 'khor rgyal mchog, maṇḍalarājāgrī*), the Mastery of Activity (*las rgyal mchog, karmarājāgrī*), Drop Yoga (*thig le'i rnal 'byor, binduyoga*), and Subtle Yoga (*phra mo'i rnal 'byor, sūkṣmayoga*). In the longer versions of the practice the first two are very extensive.

1. Mastery of the Mandala. First of all, the mandala palace is imagined. Out of emptiness arises the world-system mandala—the elemental disks, Mt. Meru, and so forth. This dissolves into the form of the monogram of Kālachakra, the so-called "ten-powered" (*rnam bcu dbang ldan, daśākārovaśī*), which itself then transforms back again into the world-system mandala.

Next, on top of Mt. Meru, inside a vajra tent, is imagined the mandala palace. In the center of this is a lotus, moon, sun, and Rāhu, on which the practitioner appears in the form of Kālachakra. That process of Kālachakra forming out of emptiness takes place in five steps, known as the five true awakenings (*mngon par byang chub pa, abhibodhi*). Banda Gelek explains the meaning of this phrase in terms of the development of awareness: a particular aspect of the meditation removes obstacles to the development of an aspect of awareness, which is then realized, or achieved.

Next, resulting from the union of Kālachakra and his consort, Vishvamātā, the various groups of deities in the mandala are born from the womb of the consort,

each taking their place in the palace. Once all the deities have been created, there is a short section known as the Empowerment of Compassion (*snying rje'i dbang bskur*, *karuṇābhiṣeka*); in this, all beings are invited into the palace and transformed into the purified forms (deities) of their aggregates (*skandhas*), elements (*dhatus*), and so forth.

The main deities then dissolve into light, and this section ends with Kālachakra and his consort existing as a sphere of light above the lotus seat.

As this section of the practice sees the formation of the mandala together with the initial radiation of its deities, it is known as the Mastery of the Mandala. It is associated with the purification of the channels and is also known as the path of the body vajra.

2. Mastery of Activity. Goddesses arise spontaneously and request Kālachakra to arise again. In response, the central couple are reformed, and the retinue deities are once again born from the womb of the consort.

Next, the wrathful form of Kālachakra, Vajravega (*rdo rje shugs*), radiates out and attracts the awareness beings of the Kālachakra mandala. These are then dissolved into the originally imagined forms (the commitment beings), the two groups becoming indistinguishable.

There then follow several sections which could generally be grouped under the heading of empowerment. The first is the placement of six syllables at the six places of the deities (crown, forehead, throat, heart, navel, and genital area). There is then the empowerment proper of the three vajras, those of body, speech, and mind. Next, the deities are "sealed" at the six places, then further syllables are placed at five places (excluding the genital area) and then four places (excluding the crown), and finally one, the vajra jewel (penis).

This completes the Mastery of Activity section. This purifies the impure action-winds that create all the various conceptual activities of the mind, the activities of talking, and various physical activities; it also goes beyond the Mastery of the Mandala with the activities of attracting the awareness beings, the empowerment, and so forth. For this reason this section is called the Mastery of Activity. It is associated with the puri-

fication of the winds and is also known as the path of speech vajra.

3. Drop Yoga. These last two sections are quite short and relatively simple, although this does not suggest any lesser importance. Banda Gelek states that when proficiency has been obtained in the two Masteries, much more time and attention should be paid to these. In the Drop Yoga, bodhichitta (the subtle aspect of gross semen) flows all the way down the central channel generating bliss. Bodhichitta is here referred to as "drop," which is the focus of attention in this section. It is also known as the path of mind vajra.

4. Subtle Yoga. In ordinary human activity, semen is ejaculated, and the focus of attention is on the bliss that this creates. In the Subtle Yoga, the bodhichitta instead returns up the central channel, generating even greater melting bliss, and as it passes each of the six centers, it causes the radiation of subtle forms of the six classes of deities of the mandala. This is also known as the path of awareness vajra.

Once these four processes that make up the creation process are complete, it is usual that the practitioner will then recite the mantra of the deity many times while cultivating a clear image of being the deity, identifying with that deity.

The typical practice will often end at this point after a torma offering and some other ritual conclusions, but a more elaborate ritual of offering (*mchod pa'i cho ga*, *pūjāvidhi*) can be performed, to another mandala of Kālachakra, imagined in front. On a shrine in front of the practitioner will be a physical mandala of Kālachakra. This could be something very small, such as a painting, or it could be a large powder mandala for a major ritual involving many people. Either way, the principle is the same, and this mandala in front is contemplated as dissolving into emptiness, and then the imagined form of the mandala palace is created, together with Kālachakra and all the retinue deities inside and around it.

The process of creation of this front mandala is essentially the same as that used for the creation of the individual as Kālachakra; in fact, the liturgies used are usually the same, apart from a few words changed for

the different context. In the main practice, the practitioner and the world they are in were imagined as transformed into Kālachakra together with the retinue inside a mandala palace. Similarly, for the offering ritual, the physical mandala image in front of the practitioner will be imagined also as transforming into Kālachakra and the retinue inside another palace, in the sky in front; the two Kālachakras facing each other, with the eastern side of one mandala facing the eastern side of the other. (I should point out that in most practices, at this point the self-creation is much simplified, as the focus of attention is on the mandala in front.)

Next, extensive offerings and praises are made to these deities in front. Just as the mandala in the sky is a transformation of a physical mandala on the shrine, so real physical offerings are arranged on the shrine, dissolved into emptiness, and then recreated as vast and fantastic imagined offerings to be presented to the deities. These offerings take many forms and need not be elaborated on here. The ritual concludes with both the front- and self-generated deities dissolving back into emptiness, followed by various dedications of the virtue of the practice and verses of good fortune.

This has been a very brief description in order to place the use of the mandala image in context. Physical mandalas are only used in rituals in which a front-creation is going to be required. All such rituals require in addition a sādhana, or self-creation practice, but if no front-creation is performed, and only a sādhana, then a physical mandala is not required. However, the form of the mandala that is imagined for the sādhana is, with one exception, identical to that used for the front-creation. Many further details of the creation process will be described in later chapters.

The most extensive Kālachakra sādhanas use the full triple mandala of Kālachakra. This is sometimes known as the mandala of body, speech, and mind because the palace consists of three component palaces stacked one on top of the other: the body palace at the bottom with the smaller speech palace on top and the still smaller mind palace on top of that. Twenty-four-armed Kālachakra is in the middle of the mind palace, with a total of 634 other retinue deities arranged throughout the three palaces and beyond. It is this triple mandala that is the subject of this book, and the one intended here by any simple references to "the Kālachakra mandala."

Kālachakra symbolism

Drakpa Gyaltsen was quoted earlier as describing the nature of mandala as being a manifestation of enlightened awareness, and that the outer form of this—the mandala with form and color—is described for the benefit of unenlightened beings as a means to attain that enlightened awareness. I wrote that images such as that of a mandala were "part of the vocabulary that is used in communicating through ritual and meditation with and about that spiritual reality."

That vocabulary is very extensive, and the mandala is just one component. A practitioner will be presented with a large amount of information concerning any particular practice. For example, many deities, most notably the protectors, have considerable myths and stories associated with them—by myths I am referring to descriptions of the lives of the deities, their exploits

and powers, and by stories to details of notable practitioners of the particular deity and their meditation experiences and powers.

Also, the deities themselves and their mandala palaces have rich symbolism and meaning, as do other elements in the practice, such as offerings presented and other objects and substances used, hand gestures known as mudras, music, and other ritual elements, mantras recited, and so on; there will often also be complex dynamic images contemplated in the meditation, such as radiation of light, revolving of mantra garlands, and so on. All of this, learned and repeatedly recited and contemplated, creates dispositions in the mind of the practitioner; when the practice is performed, these pure dispositions (*dag pa'i bag chags*) give rise to a developing mental state in the practitioner that eventually should

lead to the realization of that enlightened awareness that is the goal of the practice.[1]

So the mandala is a tool used in meditation practices; it represents the totality of enlightened awareness, which itself has no form, and hence it is said to symbolize that awareness. The different components of the palace and the different arms, weapons, and so forth of the deities symbolize different aspects or features of that enlightened awareness, that final state of perfection.

However, the concept of symbolism does not fully do justice to the intentions here. A word that is much used in this context is purity (*rnam par dag pa, viśuddhi*), and there is often a section in creation process meditations where one contemplates the purity of the imagined forms, which is called the contemplation of purity (*dag pa dran pa*). This usually takes the form of verses in which the attributes of the deity and the mandala are mentioned together with their symbolism. (Much more on this in the fifth chapter.)

The components in a mandala or the attributes of the same deity symbolize two types of things: qualities of enlightenment, such as compassion, pure awareness, and so forth, and aspects of human experience that have been purified. Buddhism describes three states: ground, path, and goal. The ground is the state in which we find ourselves, the world and its beings in the impure state. The goal is the enlightened state when all impurities and obscurations have been removed, and the path is the set of methods used to achieve that goal.

Regarding the symbolism, for example, a lotus held by a deity commonly represents enlightened compassion. From one point of view, it is not a normal lotus but a pure lotus, the manifestation of compassion, and the appearance of that compassion to an enlightened mind. Of course, compassion can manifest, or be represented, by many other forms, as it is with different deities and in different mandalas. Also, the contemplation of the lotus is a method used in the meditation as a means to develop compassion. In this way, the lotus represents

a purified aspect of the ground (perhaps desire, which when purified will manifest as compassion), the path (a method used on the path), and an aspect of the goal when purified.

I find it useful to refer to the kind of symbolism just described as the static symbolism of a deity or mandala palace in order to distinguish it from the symbolism of the various stages of the creation process, to which I refer as dynamic symbolism. These words are not translations from the Tibetan, and such a distinction is not made in that language, but these words are useful as there are these two different uses of the concept of symbolism or purity.

There are three components to the dynamic symbolism in a full description: purification, perfection, and development.

Purity (*dag pa*) refers to the purification of the whole process in cyclic existence, from death, the intermediate state, conception, and gestation in the womb through birth and growing up to be a sexually mature adult. The various stages of the creation process are contemplated as purifying the different steps in that whole process, from death through rebirth to sexual maturity.

If the experience of cyclic existence is purified and one achieves the state of enlightenment, then the result of that purification is the various aspects of the goal, and so each step of the creation process is contemplated as producing in the practitioner some aspect of the goal, of the enlightened state. This is called perfection (*rdzogs pa*).

Third, the creation process is a system of meditation that prepares the practitioner for perfection process meditation, such as the six yogas in the Kālachakra system. Therefore many, but not all, steps in the creation process are contemplated as preparing, or developing (*smin pa*), in the practitioner certain qualities needed for the correct practice of the perfection process.

Typically, an instruction text might include something along these lines at some point in the creation

1. Critical to understanding the mechanics of this and any other unexcelled yoga practice is the relationship between the basis, unenlightened existence, and the result, enlightened existence, whose extensive correlations form the detailed structure, the symbolism, of this book. Specifically, the purification process explained in the fifth chapter brings about the extraordinary or divine reality—the purity—that transforms, as it were, "natural" human development into supernormal buddha actuality. This is discussed here briefly and elaborated fully in that chapter.

process: *Identify with this, contemplating that the process of birth in samsara has been purified and that I have obtained the ability in the goal-state to produce emanations to benefit other beings.* That is not a direct quote, but the sense should be clear. Many other instances will also include the need to imagine that some quality relevant to perfection process has been achieved. Banda Gelek (Bgdubum) expresses this in the following way:

"Regarding the purification, perfection, and development of the generation process, those which are to be purified are birth, death, and the intermediate state of cyclic existence; the ultimate results that are obtained by means of the generation process are those which are to be perfected, and the particular aspects of the perfection process are those which are to be perfected, and the particular aspects of the perfection process are those which are to be developed. The creation process purifies birth, death, and the intermediate state, perfects or

obtains the ultimate results, and develops aspects of the perfection process."

All of this can be considered a purification process: the experiences in cyclic existence are to be purified, the perfection of the aspects of the goal are the results of that purification, and also the development of qualities needed for the perfection process is also a result of purification of aspects of the mind. There is rather more here than we normally understand by the word "symbolism."

In this way, there is nothing real or absolute concerning these deities and the mandalas. Just as there are countless words in different languages that can indicate a table, so there can be many different forms and images that represent aspects of enlightenment, such as compassion. And of course, there are. This is why there are so many different forms of deities and mandalas in Buddhism—all equally valid, all representing true enlightenment, but in different styles and with different emphasis.

Basics of Kālachakra symbolism

In its introduction to Kālachakra symbolism, the *Vimalaprabhā* first describes "the five letters of great emptiness" (*stong pa chen po yi ge lnga, pañcākṣaramahāśūnya*) and "the six letters of empty potential" (*thig le stong pa yi ge drug, binduśūnyaṣaḍakṣara*). The first of these are five vowels, A, I, Ṛ, U, and Ḷ, and the second are the six consonant groups, KA, CA, ṬA, TA, PA, and SA.

These six groups comprise the usual way in the Kālachakra system of categorizing the consonants of the Sanskrit alphabet:

hard	hard aspirate	soft	soft aspirate	nasal	hard spirant
KA	KHA	GA	GHA	ṄA	ḤKA
CA	CHA	JA	JHA	ÑA	ŚA
ṬA	ṬHA	ḌA	ḌHA	Ṇ	ṢA
TA	THA	DA	DHA	NA	SA
PA	PHA	BA	BHA	MA	ḤPA

Table 1

These two groupings, of the five letters of great emptiness and the six letters of empty potential, are associated with the different components of human experience, and these fall into six groups of six. These are the most important aspects of Kālachakra symbolism, and their purified forms are symbolized by the deities in the mind mandala palace. They feature also in the purification process of the main initiation ritual of Kālachakra, known as the Seven Empowerments Raising the Child.

First are the six aggregates (*phung po*): form (*rūpa, gzugs*), sensation (*vedanā, tshor ba*), recognition (*samjñā, 'du shes*), reaction (*samskāra, 'du byed*), consciousness (*vijñāna, rnam shes*), and awareness (*jñāna, ye shes*). The second group comprises the six elements (*khams*): earth, fire, water, wind, space, and awareness. In other tantras one normally only finds sets of five aggregates and five elements, the inclusion of awareness being peculiar to the Kālachakra tradition.

The next two groupings comprise the six organs of sense (*dbang po*) and their objects (*yul*): body, eyes,

tongue, nose, ears, and intellect; textures, forms, tastes, odors, sounds, and concepts.

Finally, we have the six action organs (*las kyi dbang po*): the organ of speech, legs, hands, rectum, urethra, and genital organ; and their activities (*las kyi dbang po'i yul*): speech, motion, grasping, defecation, urination, and orgasm.

The *Vimalaprabhā* associates these in either five or six categories in order to describe the five letters of great emptiness and the six letters of empty potential. The text starts by taking two categories together—the two that are combined from the set of six to make five categories:

"The aggregates of awareness and consciousness, the elements of awareness and space, intellect and ears, sounds and reality, urethra and genitals (lit. supreme organ and vagina) and urination and orgasm: all these free from obscuration, of same taste, and combined together, are called empty; they are not intangible as they are perceived by the yogi. The jinas call this indestructible (*gzhom du med pa, anāhata*), and the symbolic emblem for this indestructible, in the center of South, North, East, and West, is inexpressible and is merely a picture of a curved knife, the first letter of great emptiness."

The point here is that the character "A" is itself in the center and has a shape like that of a curved knife. This is introducing the first of two fundamental concepts in the symbolism of the creation process, the most basic concepts of the mandala—the four directions, plus the center. The main deities in the mandala are colored according to their positions within the palace, whether they are in the East, South, West, or North, or centrally placed, either above the center or below. Some of the deities are literally placed above or below the center of the mandala palace; others associated with the above and below directions are of the appropriate colors, but in among the various other deities in the palaces.

The floors of the palaces and the deities in the eastern direction are black, in the South red, in the West yellow, and in the North white. The deities that are above the center are green and those below blue. In the simple arrangement being described here, this first sym-

bolic emblem, the curved knife, is in the center, and it includes both the elements of space and awareness. When these are considered separate, awareness (blue) is below the center and space (green) above.

The text continues with the next category, in the South: "The aggregate of sensation, the element of fire . . ." and so on; this is the character "ṛ" in the shape of two drops. It is easiest to list these categories in table 1 above, each category being one of the columns, the two columns on the right being taken together.

In the table on page 17 (table 3), each of the 36 is given together with the character associated with it in the *Vimalaprabhā* discussion of the five letters of great emptiness. These characters are all either vowels or are derived from vowels.

Next is the discussion of the six letters of empty potential. The same components are given, except in six groups rather than five. The *Vimalaprabhā* lists these in a similar manner: "The consciousness aggregate, the space element, ears, reality, genitals, and orgasm: all these, free from obscuration, are emptiness possessing the totality of possibilities; above the central indestructible, its symbolic emblem with the nature of the ka-group is the letter KA, the inexpressible consonant, the first empty potential."

This group, including the space element, is given as above the central emblem. The latter group associated with the awareness element is given as below the center. The others are in the same directions as before, but beyond—east of East, south of South, and so on. The descriptions of the others follow in the same manner, this time associated with groups of consonants rather than vowels. These groups of consonants are called the ka-group, ca-group, and so forth, and are given in the *Vimalaprabhā* in the following way:

KA	KHA	GA	GHA	ṄA	
CA	CHA	JA	JHA	ÑA	
ṬA	ṬHA	ḌA	ḌHA	ṆA	
PA	PHA	BA	BHA	MA	
TA	THA	DA	DHA	NA	
SA	ḤPA	ṢA	ŚA	ḤKA	
HA	YA	RA	VA	LA	KṢA

There are seven groups where we need six, and the last represents syllables that have to be added to the six groups above, in the order as given. Associating these with the aggregate groups and writing them fully, the list becomes:

Consciousness	KA KHA GA GHA ṄA HA
Reaction	CA CHA JA JHA ÑA YA
Sensation	ṬA ṬHA ḌA ḌHA ṆA RA
Recognition	PA PHA BA BHA MA VA
Form	TA THA DA DHA NA LA
Awareness	SA ḤPA ṢA ŚA ḤKA KṢA

Table 2

Presumably, within these groups, the order of association is as before, with consciousness associated with KA, space with KHA, ears with GA, etc., but I have not found this explicitly stated in the literature.

So far, each of these groupings has been identified with a particular symbolic emblem and a direction. Also, the five emptinesses have been described as indestructible, and the six letters of empty potential as inexpressible. There is much more.

These two groups are associated with the two well-known symbolic characters, "E" and "VAṀ." First, combining the five letters of great emptiness together, the character "VAṀ" has the nature of the five emptinesses; this is Vajrasattva, great bliss, the vajra. The essence of these five, free from obscuration and of one taste, taken together is indestructible, and so is likened to a vajra.

Next, the six letters of empty potential are the character "E," the dharmodaya, the form of emptiness of the totality of possibilities. Here, the six groups free from obscuration are referred to as the emptiness having the form of all possibilities. In his great commentary on the *Kālachakra Tantra* (MiKal), Mipham explains that this does not refer to an emptiness which is empty of all possibilities, but to that nature which itself has no (is empty of) inherent existence, but possesses the totality

of possibilities, the incessant manifestation of all possible appearances.

These two groupings have now been associated with the typical pairings of opposites, familiar from other tantras, but expressed in Kālachakra terms: "VAṀ" and "E." These are, respectively, male and female, bliss and emptiness, the vajra and the reality source (*dharmodaya*) (or lotus).

These six letters are described as the *dharmodaya*, represented as two interlocked equilateral triangles, which is the holder of the indestructible vajra, the character "E," being the receptacle or support for the vajra, the character "VAṀ." I have not found this mentioned in any of the literature, but it is worth pointing out that a vajra, symbol for the five emptinesses, usually has five tines, and the dharmodaya, symbol of the six letters, as it consists of two triangles, contains six straight lines and six vertices.

The five emptinesses are also called semen and moon; the six letters of empty potential are ovum and sun. The dharmodaya can be replaced by a lotus, and we then have that semen and moon are the character "VAṀ," or vajra; and ovum and sun are the character "E," or lotus. The identity of the vajra and lotus is Vajrasattva.

The list of pairings is expanding: "VAṀ" and "E," respectively—male and female, bliss and emptiness, vajra and dharmodaya, semen and ovum, moon and sun, knowledge and objects of knowledge, method and wisdom.

Regarding Vajrasattva as the identity of the vajra and lotus, Mipham explains that vajra is also called ultimate bliss, knowledge, semen, and also moon and body; sattva is the form of the understanding of the totality of possibilities (the form of emptiness), object of knowledge, ovum (the red aspect), sun, and speech. These, body and speech, infused with mind, base consciousness, the awareness of reality together with life-wind, taken as one-taste, originally of pure nature, free from obscuration; these combined together as one-taste are ultimate reality, the very nature of secret mantra, and it is through their power that beings are benefited.

West	South	North	East	Above	Below
Ploughshare	Two Drops	One Drop	Club	Curved Knife	Curved Knife
Form	Sensation	Recognition	Reaction	Consciousness	Awareness
Ḷ	Ṛ	U	I	A	AṀ
Earth	Fire	Water	Wind	Space	Awareness
Ḹ	Ṝ	Ū	Ī	Ā	AḤ
Body	Eyes	Tongue	Nose	Ears	Intellect
AL	AR	O	E	A	AṀ
Odor	Tastes	Forms	Textures	Concepts	Sounds
ĀL	ĀR	AU	AI	Ā	ĀḤ
Rectum	Urethra	Hands	Legs	Speech	Genitals
LA	RA	VA	YA	HA	HAṀ
Speech	Motion	Grasping	Defecation	Orgasm	Urination
LĀ	RĀ	VĀ	YĀ	HĀ	HAḤ

Table 3

These two components, semen and ovum, also called the white and red elements, are the two main drop-potentials that create our bodies. It is considered in the Kālachakra system that at the moment of conception, the consciousness that is to be reborn unites with the combined white and red elements; once this occurs, life-wind automatically arises to create the living fetus. In this discussion of semen and ovum, this is being described from the point of view of the purified form, and this is imagined in the sādhanas as the process that gives rise to the formation of the deity Kālachakra.

So we have here the second of the two fundamental concepts in creation process meditation, the creation of the form of the deity. The contemplation of this process, imagining the semen and ovum in the form of moon and sun disks and consciousness and life-wind in the form of characters, is intended to purify the process of conception.

Mipham continues by telling us that this ultimate nature is embodied in Kālachakra, and the description given is of the combination of body, speech, mind, and awareness, which is the reason for the four faces of Kāla-chakra: awareness is the yellow face in the West; consciousness is the black face in the East; moon and body are the white face in the North; and sun and speech are the red face in the South.

The descriptions in both the *Vimalaprabhā* and Mip-ham's commentary now start to elaborate in greater detail. If the next three paragraphs seem rather dense—they are a loose translation from the *Vimalaprabhā*—this is because the scene is being set for the symbolism of the full mandala of Kālachakra.

Considering the six elements, they can be classified into two groups: three of them mainly arise from semen and three mainly from ovum. The three that mainly arise from semen are water, wind, and space (called taste

in the *Vimalaprabhā* at this point), and the three that mainly arise from ovum are earth, fire, and awareness (great taste).

The three elements that mainly arise each from moon and sun create the body, speech, and mind of one born from a womb. From the lunar elements arise the body, speech, and mind of method; from the solar elements the body, speech, and mind of wisdom. Body is the union of earth and water, speech the union of fire and wind, and mind the union of space and awareness.

These elements give rise also to the six classes of the six senses, and so forth. In the mind mandala palace, these give rise in their purified forms to the buddhas, their consorts, and others. There also arise the classes of body, speech, and mind, and together with the class of identity (*ngo bo nyid*) the four connate classes; this also creates the three bodies and the four bodies, also the three states and the four states, also the classes of the five elements, and together with the awareness element, the six classes. Similarly, for those born from a womb, the classes of the five aggregates, combined with the aggregate of awareness, create the six classes.

The two fundamental points (static and dynamic) concerning the creation process symbolism have been described, the directions in space of the mandala and the formation of the deity. These descriptions are now giving a sense of how the full elaborate mandala together with its hundreds of deities evolve from this. This is not a formation that happens in one go; it is a process that has many steps and purifies, or symbolizes, the processes of growing up from conception through birth and learning and finally to sexual maturity. This is why the empowerment that introduces practitioners to the practice of the creation process is called the Seven Empowerments Raising the Child.

The texts continue, telling us that for a girl up to age twelve when menstruation starts, and for a boy up to age sixteen when semen is ejaculated, they are understood as being of the three (body, speech, and mind) and five (aggregate) classes. But from the time of the development of the element of awareness until the time of death, they both are of the four and six classes.

The *Vimalaprabhā* next starts describing some of the groups of deities in the mandala and their association with these different classes, a subject that we will leave until later. Mipham concludes his discussion of this section by repeating that the five emptinesses and the six letters of empty potential have been explained as the characters "E" and "VAṂ": through the symbolism of the emblem "EVAṂ," one comes to realize that which is symbolized, the ultimate "EVAṂ," the union of method and wisdom. The nonduality of method and wisdom has no classification; this is Kālachakra, Vajrasattva, the ādibuddha; from this one class arise the three classes, the five, a hundred, and a multiplicity of classes. In other words this is describing, from the point of view of the ground, the world and the beings in it in all their complexity, and from the point of view of the path and goal, the full elaborate mandala of palace and deities, both in terms of the final structure and in terms of the process of its creation.

These two groupings of five or six classes, each consisting of six components, are symbolized by their respective vowels and consonants. These can all be subdivided and combined together further, and we shall encounter such subdivisions later in the mandala itself, with the seed characters of the deities, which are clearly derived from the two lists of the five emptinesses and the six letters of empty potential.

Mandala overview

Before moving on to the details of the mandala in the following chapters, it is worth giving a short overview. The structure consists of four stories, each one half the size of the one below it. The largest, the body palace, sits on the vajra ground that is the base for the palace. Inside of this, and in height equal to the wall structure of the body palace, is a foundation for the next storey, the speech palace. From the outside it looks as though the speech palace sits in the middle of the roof of the body palace, but in fact the roof surrounds the speech foundation, and this sits on the floor of the body palace.

Similarly, inside the speech palace is a foundation for

the next storey, the mind palace. All these three palaces are constructed of walls, each with four doorways, with a toran (*rta babs, toraṇā*) over each porch. These torans are easily seen in a drawn two-dimensional mandala, laid flat away from the porches. On the floor of each palace, between the walls and the foundation for the one above, are podiums on which sit the lotuses for the main deities of that palace. Also, around the base of the outside of the walls of each one are plinths on which are other deities.

The fourth storey is constructed differently. Known as the Circle of Great Bliss, it sits on its foundation which is in the middle of the mind palace. Instead of walls, it is constructed from two square sets of pillars; it also has no doorways, torans, or plinths. The pillars support the final roof structure. In the center is a raised platform for the central lotus for the Kālachakra couple and the eight shaktis. This is raised, but as it is quite low and does not protrude through the top of the Circle of Great Bliss, it cannot really be considered as a fifth storey—however, for symbolic reasons it is often described as such. So, we have four stories, each half the width of the one below, looking from the outside as if they are sitting one on top of the other, but in fact supported by internal foundations.

In the drawn mandala, these stories are rendered each one inside the other, the body palace structure being the largest on the outside. The lines for the walls of the three main palaces, the positions of the pillars in the Circle of Great Bliss, the positions of the plinths and podiums and the position of the central main lotus are all in exactly equivalent positions in the drawn mandala as in the three-dimensional structure, the drawn mandala therefore being an accurate floor plan.

There are several groups of deities in the mandala. On the receptacle of the main central lotus stands Kālachakra in union with his consort Vishvamātā (*sna tshogs yum*). On the eight petals of their lotus are eight female goddesses, the eight shaktis. In the corners around the central lotus are four emblems: a conch, jewel, semantron, and tree. On the tathāgata-extension, in the space between the inner and outer pillars of the Circle of Great Bliss, are the buddhas and their consorts. Between these is a group of vases, not deities in form but

of a similar nature, considered to be in essence consorts of the eight shaktis. On the mind palace podium, surrounding the base of the foundation for the Circle of Great Bliss, are a group of (bodhi)sattvas and their consorts, the *chittās*. In the doorways of the mind palace are wrathful deities, and finally, on the plinth outside the wall are offering goddesses.

Two groups of deities are associated with the speech palace. On the inner podium are the eight yoginīs, each together with a consort and a retinue of eight similar yoginīs, for a total of sixty-four retinue yoginīs. On the plinth around the outside of the base of the wall is a group of thirty-six goddesses known as *icchās*.

On the podium inside the body palace is a group of twelve deities, each with a female consort and a retinue of twenty-eight goddesses. Three-hundred-sixty in total, these are the deities of the three-hundred-sixty lunar days of the year. In the doorways of the body palace are protective deities riding chariots (plus another two above and below the palace). Also on the plinth around the outside of the body palace is another group of thirty-six goddesses known as *pratīcchās*.

Between the pillars of the toran of the body palace is a group of eight nāgas (plus one above and one below), and in the charnel grounds above the border between the disks of wind and fire are their consorts, goddesses known as "prachaṇḍā," seated on wheels. Around or between the charnel grounds, usually depicted along the border between the fire and wind perimeters, or just in the wind perimeter, are numerous other perimeter beings, the numbers and forms of which are not specified in the original literature, although a couple of Tibetan traditions have developed lists of these and include them in mandalas.

Some of the groups just given have members which are above and below the center of the palaces. And there is also an indeterminate number of minor deities, some of which are named, above the disk of wind. This completes our brief overview of the Kālachakra triple mandala, but with this mandala, of course, the devil is truly in the detail.

Structure of the empowerment

The main part of the empowerment, which introduces the student to the creation process meditation, is known as the Seven Empowerments Raising the Child (*byis pa 'jug pa'i dbang bdun*). These seven are known as:

1. **Water empowerment** (*chu'i dbang, toyābhiṣeka*)
2. **Crown empowerment** (*cod pan gyi dbang, mukuṭābhiṣeka*)
3. **Silk Scarf empowerment** (*dar dpyangs kyi dbang, paṭṭābhiṣeka*)
4. **Vajra and Bell empowerment** (*rdo rje dril bu'i dbang, vajraghaṇṭābhiṣeka*)
5. **Vajra Conduct empowerment** (*rdo rje brtul zhugs kyi dbang, vajravratābhiṣeka*)
6. **Name empowerment** (*ming gi dbang, nāmābhiṣeka*)
7. **Permission empowerment** (*rjes su gnang ba'i dbang, anujñābhiṣeka*)

The first two of these seven purify the body and enable the realization of body vajra. The second pair purifies the speech, enabling the realization of speech vajra. The third pair purifies the mind, enabling the realization of mind vajra. The final empowerment purifies obscurations of awareness, enabling the realization of awareness vajra.

As far as the association with the raising of a child is concerned, this is nicely explained by Drukpa Pema Karpo (*'brug pa padma dkar po*):

1. **Water:** Just as a child is washed by its mother as soon as it is born, so there is the water empowerment of the five "mothers," the consorts of the five buddhas.
2. **Crown:** Just as a barber cuts the hair of the child, so there is the crown empowerment of the five buddhas.
3. **Silk Scarf:** Just as the child's ears are pierced, so there is the silken scarf empowerment of the ten shaktis (these are the eight goddesses surrounding Kālachakra, plus two others considered to be aspects of his own consort, Vishvamātā).
4. **Vajra and Bell:** Just as the child develops the ability of speech and starts to talk, so there is the vajra and bell

empowerment of the chief deity couple, Kālachakra and Vishvamātā.
5. **Conduct:** Just as the child experiences the objects of the five senses, so there is the conduct empowerment of the bodhisattvas and chittās.
6. **Name:** Just as the child is given a name, so there is the name empowerment of the male and female wrathfuls.
7. **Permission:** Just as the child is introduced to reading and so on by its father, so there is the permission empowerment of Vajrasattva.

For these reasons, these empowerments are called the Seven Empowerments Raising the Child. These seven introduce one to the vajra vehicle, the contemplation of the mandala, and recitation of the mantra.

A key factor within the empowerment is that the student is introduced to some major elements of the symbolism of the mandala, specifically of some of the main deities within the mandala. All these deities are in a part of the mandala known as the mind palace (Vajrasattva and his consort are not represented in the mandala but are considered inherent in the Kālachakra couple).

Water	five buddha consorts	five elements (wind, water, etc.)
Crown	five buddhas	five aggregates (form, sensation, etc.)
Silk Scarf	ten shaktis	ten winds
Vajra & Bell	Kālachakra & Vishvamātā	right & left channels
Conduct	twelve bodhisattvas & consorts	six senses & their objects
Name	ten male and female wrathfuls	the ten organs & activities
Permission	Vajrasattva & consort	the element & aggregate of awareness

Table 4

There are many other deities in the mandala, in the speech and body palaces and beyond, but these are all

considered emanations of the main deities in the mind palace; their symbolism is therefore effectively included in the empowerment.

In the order in which they are introduced in the empowerment, these groups of deities represent the purified form of the following aspects of experience:

The first six empowerments are taken in pairs, as they were described above. However, there are many steps before the seven empowerments themselves begin, and only a few of these need be described here. The focus of the activity at the beginning is on the request for the empowerments (including a mandala offering to request the empowerment as a whole) and the commitments that the students make in response to the empowerment. Water from a conch shell is drunk by the students as a sign of making these commitments. The strength of the commitment is indicated by the idea that, if the vows are broken, then the water will turn to poison, but if they are preserved, then it will become nectar. This is repeated many times during the following empowerments, basically at all the key points.

Another important factor in the preliminary part of the ritual is that the students are introduced to the mandala. Indicating the fact that, due to obscurations, the minds of the students are unable to perceive the pure mandala, they all wear red ribbons across the forehead as symbolic blindfolds. These are later removed when the mandala is revealed to the students.

The main seven empowerments start with the students imagining that they are transformed into the form of the white body vajra, the buddha Amitābha, and are guided by the vajra held in the right hand of the teacher to the ground outside the northern door of the mandala palace, facing the palace. They then offer a mandala to request the first two empowerments, Water and Crown.

Water empowerment. All of the empowerment deities, the buddhas, their consorts, the bodhisattvas, and so forth, together with their ḍākinī retinues, are imagined as being attracted into the sky by the chief deity of the mandala. Vases of water are then empowered as the essence of the five consorts of the buddhas. Water

Space	Vajradhātvīshvarī
Wind	Tārā
Fire	Pāṇḍarā
Water	Māmakī
Earth	Lochanā

Table 5

from these vases is given to the students, and five parts of their bodies are anointed with this water: the head, two shoulders, and two hips. The students imagine that their five elements are purified into the five consorts of the buddhas found in Table 5.

Crown empowerment. For this empowerment, different colored head-ornaments are empowered as the essence of the five buddhas. As with many other empowerment materials (*dbang rdzas*), either actual head-ornaments may be used, or more likely, small pictures, called tsakali, of head-ornaments are used instead. These are then touched on the five places of the students' bodies, and the students imagine the crown being fixed to their head. The students imagine that their five aggregates are purified into the five buddhas listed in Table 6:

Consciousness	Akṣhobhya
Reaction	Amoghasiddhi
Sensations	Ratnasambhava
Recognition	Amitābha
Form	Vairochana

Table 6

The students imagine at the conclusion of these first two empowerments that they have properly realized the nature of body vajra, free from defilements. The students are then transformed into the red speech vajra, the buddha Ratnasambhava, and are guided by the vajra held in the right hand of the teacher to the ground

outside the southern door of the mandala palace, facing the palace. They then offer a mandala to request the next two empowerments, Silk Scarf and Vajra and Bell.

Silk Scarf empowerment. Different colored silk scarves, or tsakali of scarves, are empowered as the essence of the ten shaktis. These are similarly touched on the five places of the students and imagined as bound to the head. The students imagine that their ten main winds are purified into the ten shaktis listed in Table 7.

Samāna (*mnyam gnas*)	Kṛṣhṇadīptā
Nāga (*klu*)	Pītadīptā
Vyāna (*khyab byed*)	Shvetadīptā
Udāna (*gyen rgyu*)	Raktadīptā
Kūrma (*rus sbal*)	Dhūmā
Dhanañjaya (*nor las rgyal*)	Pradīpā
Devadatta (*lhas byin*)	Khadyotā
Kṛkara (*rtsangs pa*)	Marīchī
Prāṇa (*srog 'dzin*)	Paramakalā
Apāna (*thur sel*)	Bindurūpiṇī

Table 7

Vajra and Bell empowerment. A vajra and bell (in this case a tsakali representation is often not used) are empowered respectively as Kālachakra and his consort Vishvamātā. The vajra and bell are touched on the heads of the students and then placed into their hands. The students imagine that their left and right, lalanā and rasanā, channels are purified into Kālachakra and Vishvamātā:

Lalanā = Kālachakra
Rasanā = Vishvamātā

The students imagine at the conclusion of these two empowerments that they have properly realized the nature of speech vajra, free from defilements. The students are then transformed into black mind vajra, the

buddha Amoghasiddhi, and are guided by the vajra held in the right hand of the teacher to the ground outside the eastern door of the mandala palace, facing the palace. They then offer a mandala to request the next two empowerments, Conduct and Name.

Conduct empowerment. Different colored flower petals are empowered as the essence of the six bodhisattvas and their consorts. These are then touched on the sense organs of the students, although in normal practice they are touched on the head and then possibly offered to the hands. The students imagine that their sense organs and their objects are purified into the six bodhisattvas and their six consorts as listed in Table 8.

Ears	Vajrapāṇi
Concepts	Dharmadhātuvajrā
Nose	Khagarbha
Tangibles	Sparshavajrā
Eyes	Kṣhitigarbha
Tastes	Rasavajrā
Tongue	Lokeshvara
Forms	Rūpavajrā
Body	Nīvaraṇavishkambhin
Smells	Gandhavajrā
Heart, mind organ	Samantabhadra
Sounds	Shabdavajrā

Table 8

Name empowerment. Different colored bracelets or garlands of flowers are empowered as the essence of the ten male and female wrathfuls. These are touched on the limbs of the students. The students are also at this point given a name and instructed to remember it! The students imagine that their action organs and their activities are purified into the five wrathfuls and their five consorts outlined in Table 9.

Urinary and sexual organs	Uṣhṇīṣhachakrin
Emission of urine and semen	Raudrākṣhī
Organ of speech	Vighnāntaka
Speech	Ativīryā
Hands	Prajñāntaka
Grasping	Jambhakī
Legs	Padmāntaka
Walking	Mānakī
Rectum	Yamāntaka
Defecation	Stambhakī

Table 9

The students imagine at the conclusion of these two empowerments that they have properly realized the nature of mind vajra, free from defilements. The students are then transformed into yellow awareness vajra, the buddha Vairochana, and are guided by the vajra held in the right hand of the teacher to the ground outside the western door of the mandala palace, facing the palace. They then offer a mandala to request the final empowerment, Permission.

Permission empowerment. Hand emblems such as a wheel are empowered as the essence of Vajrasattva and his consort. The wheel represents the Dharma, and this is offered to the hands of the students who promise to teach the Dharma, "to turn the wheel of the Dharma," for the benefit of all beings. Other hand emblems can also be involved here for the others of the main five classes: lotus, jewel, sword, and vajra. The students imagine that their awareness aggregate and element are purified into Vajrasattva and his consort:

> Awareness aggregate = Vajrasattva
> Awareness element = Prajñāpāramitā

The students imagine that having received the Permission empowerment they have properly realized the nature of the awareness vajra, free from defilements.

In this way, the students are introduced to the main deities of the mandala and the factors in the students' experience that contemplating them will purify. That purification process of the mandala is the subject of the last chapter.

Other Kālachakra mandalas

Before moving on to describe the details of the mandala in the coming chapters, I should explain something of the other mandalas associated with the Kālachakra cycle. The most important of these is certainly the mind mandala.

The mind mandala practice is the one most commonly used in a meditation retreat situation, and as the mind mandala contains all the basic symbolic elements of the triple mandala, it is also considered a suitable alternative as a basis for giving empowerment. In fact, the focus of attention in an empowerment is on the deities in the mind palace. As a result, representations of this mandala are relatively common in museums and art books.

The mind mandala is simple to explain—all the components of this mandala are the same as their equivalents in the main triple mandala, and the method of

drawing is simply a subset of that for the triple mandala (apart from a small difference regarding the wrathful door protectors). For the mind mandala, the speech and body palaces are not drawn, and the mind palace and all its contents are increased in size by a factor of four, making it the same relative size as the body palace in the triple mandala. There are no wheels for prachaṇḍās, no nāgas on the plinths, no chariots among the perimeters and no perimeter beings, but the main six perimeters are drawn and the charnel grounds are included in their usual place. The deities of the mind palace are all included: the main couple, the eight shaktis, four emblems, four buddhas and consorts, six sattvas and cittas, wrathfuls in the doorways, and twelve offering goddesses.

Mandala of 100 yoginīs

Unlike the triple and mind mandalas, depictions of the mandala of the 100 types of yoginī (*rigs brgya'i rnal 'byor ma*) are quite rare. The mandala is used as the basis for offerings to the 100 types of yoginī; this is an optional part of the offering ritual (Kagcho) by Tāranātha that is usually associated with the nine-deity mandala practice, although it can be combined with any sādhana. This practice combines the principles of two original Indian texts: one is an offering to the sixty-four yoginīs of the speech mandala and the other is the feast offering (*tshogs kyi 'khor lo, gaṇacakra*) for Kālachakra, involving thirty-six yoginīs. These thirty-six are associated with a group of thirty-six goddesses in the triple mandala from which the icchās and pratīcchās are said to emanate.

The mandala of 100 yoginīs is a two-storey palace, and, describing it from the 2D point of view, it is similar to the mind and speech palaces of the normal Kālachakra mandala. The outer (lower) palace is effectively identical to the normal speech palace and the inner (upper) palace is equivalent to the normal mind palace, but with a different internal structure. They are simply referred to as the outer and inner palaces.

The goddesses in the outer palace are exactly the same as those in the speech palace of the main mandala, including the central goddess on each lotus and her male consort. These total eighty deities, so what does this do to the total number of deities in this mandala? This is a mandala of yoginīs, and so the male deities are not counted. Also, the eight central goddesses also appear on the speech wheel of the inner palace, and are not counted twice; the total is still 100 types of yoginī.

Anybody familiar with the main Chakrasaṃvara mandalas will recognise the structure of the inner palace. They are identical, and they are clearly related. One of the main source texts for the offering to the thirty-six yoginīs is in fact the Chakrasaṃvara commentary, the *Lakṣābhidhanāt uddhṛta laghutantra piṇḍārthavivar-* aṇa (*mngon par brjod pa 'bum pa las phyung ba nyung ngu'i rgyud kyi bsdus pa'i don rnam par bshad pa*). This is by the bodhisattva Vajrapāṇi and one of the so-called bodhisattva trilogy mentioned earlier. The commentary lists the thirty-six goddesses and identifies each with one of a group that it calls the thirty-six messengers of caste (*rigs kyi pho nya mo*). The list is not exactly the same as that of the thirty-six yoginīs in the inner 100 yoginī palace, but it is very close. Where there are differences, the yoginīs are almost certainly equivalents.

The inner palace consists of three wheels—of body, speech, and mind—stacked one on top of the other, each one smaller than the one below it and sitting on its hub. On the hub of the topmost wheel is an eight-petaled lotus, with a central goddess and four around her. The wheels each have eight spokes, each of which supports a goddess, and the space around the lowest wheel—the corners of the palace and the doorways, often also described as the wheel of space or as the charnel grounds—also contains eight goddesses. This give the total of thirty-six goddesses, or thirty-seven including the central goddess, but she is not counted as she is inherent in all the others.

The group of thirty-six starts off in the meditation practice as a group of yoginīs not mentioned before, each with the name of a professional caste, such as beer-seller, meat-seller, tailoress, and so forth. This list is remarkably similar to the lists of thirty-six castes in medieval Bengal; one of a few indicators suggesting a Bengali origin for, or influence on, the Kālachakra system.

After they have been generated, these goddesses then transform, each via an emblem, into the group from which the icchās in the main mandala are considered to be emanations: four buddha consorts, six bodhisattva consorts, four mind palace wrathful consorts, the eight chief goddesses of the speech palace, the six wrathfuls and consorts on chariots, and the eight prachaṇḍās.

Mandala of Mahāsaṁvara Kālachakra

Finally, there is the unusual circular mandala palace of wrathful Mahāsaṁvara Kālachakra (*dus 'khor sdom chen*). This deity is very similar to Kālachakra, although he is wrathful in form and has two extra arms as well as some other attributes, such as an elephant skin held over his back. He is very similar in form to the protective aspect of Kālachakra, Vajravega (*rdo rje shugs*). Vajravega has no consort and is chief of the sixty protectors of the Kālachakra system. Mahāsaṁvara does have a consort and is a yidam in his own right.

The mandala is a striking image, being one of the very few that is circular. The palace is one storey, with circular walls enclosing a space containing six stacked wheels and a final central lotus on top. The palace has eight doorways and eight torans, and also sixteen charnel grounds around.

The central couple is surrounded on their sixteen-petaled lotus by eight goddesses, similar to those on the Kālachakra main lotus in the normal mandala, except they are simpler in form, each with only two hands. On the other petals are skulls of nectar, clearly equivalent to the vases in the Kālachakra mind palace. On each of the spokes of each of the six wheels are pairs of deities, a total of ninety-six vīras and ḍākinīs. There are also further goddesses associated with the sixteen charnel grounds in the doorways and on the plinths around the outside of the walls, all on wrathful wheels.

Those just mentioned are the main deities of the mandala. There are also further attendant deities: also on the plinths between each doorway are eight nāgas, together with their prachaṇḍā consorts, and eight offering goddesses; the position of the other four offering goddesses is not specified in the mandala description, but it is most likely that they are placed in the torans in the cardinal directions, as is the case with the main Kālachakra mandala. As with Kālachakra, an unspecified number of perimeter beings should be represented in the wind perimeter.

Both of these two mandalas, of the 100 types of yoginī and of Mahāsaṁvara Kālachakra, are worthy of more than this short mention and could easily have justified a whole chapter each in a book of this kind, should time have permitted.

2. The Drawing of the Mandala

THE MOST EXHAUSTIVE description that I have come across in Tibetan materials of the drawing of the main Kālachakra mandala is by the Jonang writer Banda Gelek. One of his most important texts on mandalas, *The Illuminating Sun-rays* (Bggthig), explains the general mandala drawing methods of Tāranātha. In the section on Kālachakra he describes the drawing of the Kālachakra mandala from four different points of view, four different methods. The main differences between these lie in the number and length of construction lines (*skam thig*) that need to be drawn, but there is no difference between the lay-out of the finished mandala drawings.

After a general introduction to the structure and dimensions of the mandala, his first method takes the description given in the *Kālachakra Tantra*, in which a uniform grid of construction lines is used to measure out the mandala. Second, he takes the main description given in the *Vimalaprabhā*. This is said to be based on the original *Kālachakra Mūlatantra* and uses fewer construction lines, removing the need to draw many which are not used and would simply have to be erased.

His third method follows the description given by Abhayākaragupta in the *Vajrāvalī*. This also follows the method of the *Mūlatantra*, but further reduces the need for erasure by only describing final lines (*rlon thig*), although in practice it is not possible to remove completely the need for construction lines. This is the general method that has mainly been followed by later Tibetans, although some details of the *Vajrāvalī* description are controversial, being contradictory to the *Vimalaprabhā*, and therefore not accepted by many.

His fourth description follows the method of Dol-popa (Dpkthig). This adds several details, including some which are peculiar to the Jonang tradition.

Finally, in a text compiled and partly written by Tsok-nyi Gyatso, *The Melody of the Queen of Spring* (Mtk-mand), in a section written by Banda Gelek himself, he gives an annotated commentary to the description of the mandala drawing given by Tāranātha (Kayega), itself based on an earlier work of Dolpopa (Dpyega). This is Banda Gelek's most extensive description of the drawing of the mandala, containing many details not found in *The Illuminating Sun-rays*. This section has its own name, *The White Crystal Mirror* (Bgcrmir), and was presumably first written as a standalone text. However, it is not now found in current editions of the collected works of Banda Gelek and is preserved in the work of Tsoknyi Gyatso.

The pedantic attention to detail of Banda Gelek is extraordinary and invaluable for the work of translating these materials into another language. For a full under-standing of the mandala it is not necessary to translate the five methods in full. However, it is worth looking at the differences between them, in particular the histor-ically important descriptions given in the original tan-tric literature.

I shall therefore follow Banda Gelek by giving first a general description of the dimensions and overall structure of the mandala. This will be followed by a description of the different methods of laying out these dimensions on a surface. Finally, I shall give the full description of the mandala, based mainly on *The White Crystal Mirror*, but adding any interesting or useful

comments from other sources. I shall also point out the most important differences with other traditions, including that of the *Vajrāvalī*, a text that is important in all Tibetan traditions but particularly influential in the Gelug. In describing those points, unless otherwise stated, my main sources for the Gelug tradition are Khedrubje (Kdkthig) and Sherab Gyatso (Acvrjed);

both of them comment on the *Vajrāvalī* tradition. In the Tsami tradition the main source is the fourteenth Karmapa, Thekchog Dorje (Ttgyam), and for the Vajrāvalī tradition, the two root texts by Abhayākaragupta, the *Vajrāvalī* and *Niṣpannayogāvalī*. Another useful Indian source is the mandala ritual text (*maṇḍala vidhi*) (Spmancho) by Sādhuputra.

Units

Units of measurement are required in order to describe the dimensions of both two- and three-dimensional mandalas. There are three basic types of these, of which the first two are units that are used in the real world, and both are described and used in the original Kālachakra literature.

The first of these is the yojana (*dpag tshad*), which is sometimes translated into English as "league." This is defined in verse 13 of the first chapter of the *Kālachakra Tantra*. After building up from a number of minor units of measurement (see Newman, 486), it is described that eight barleycorns (*nas, yava*) are equal to one finger(-width, *sor, aṅgula*); 24 fingers make up one cubit (*khru, hasta*); four cubits are one bow (*gzhu, dhanu*); two thousand bows are one earshot (*rgyang grags, krośa*); and finally, four earshots make up one yojana.

If one assumes approximately eighteen inches as the length of a cubit—generally considered to be the length of the forearm measured from the elbow to the tip of outstretched middle finger—a yojana consisting of 32,000 cubits works out to about nine miles. This is approximately double the length of a yojana as described in the *Abhidharmakosha*.

In the original description of the world-system mandala in the first chapter of the *Vimalaprabhā* and in the description of the mandala palace on top of Mt. Meru in the creation process that is set out in the third chapter, all the dimensions are given in yojanas. The width of the body palace, measured from the inside surface of one wall to the inside surface of the opposite wall, is given as 400,000 yojanas.

As Tāranātha points out (Kasain), these sizes are not

to be taken literally, but are given in order to describe the relative proportions of the different parts of the palace.

The second type of real-world unit that is used consists of the finger-width and the cubit. These two are often used together. For example, the *Vimalaprabhā* states that the king Suchandra, who is said to have received the original *Kālachakra Mūlatantra* from the Buddha, erected in a sandalwood grove in Shambhala a large building in the form of a Kālachakra mandala palace. The body palace of this is said to have had a width of 400 cubits (about 600 feet).

When a powder mandala is laid out in preparation for an empowerment, the main units of measurement used are the cubit and the half-finger (*sor phyed, aṅgulārdha*). The width of the body palace is described as four cubits, or 192 half-fingers.

In other early texts describing the drawing of the mandala it is usually these two units that are used, and in later Tibetan texts the description of the overall size of the mandala is normally given in terms of cubits. However, in these later texts the third and abstract set of units are mainly used.

There are four of these units: door units (*sgo tshad, dvāramāna*), major units (*cha chen, mahābhaga*), minor units (*cha chung, mātrā*), and fractional units (*cha phran*). Unfortunately, there is not complete agreement with regard to their definitions or consistency in the ways they are used. The door unit is simple to define: it is the width of a doorway in the palace, and as there are three palaces, there are three sizes of door unit.

The next term is the "major unit," and this is simply equal to a door unit, although it is not used as often in a Kālachakra context.

In all mandala systems other than Kālachakra, there are smaller units described which are equal in size to one-quarter of a door unit or major unit. These are either called minor units or fractional units. These two terms are almost identical in meaning, and I use the term "fractional unit" to translate *cha phran* because a child in a Tibetan school studying arithmetic will, when learning fractions, be learning about *cha phran*.

In Kālachakra, one minor unit is defined differently, being equal to one half-finger—the same as one-sixth of a mind-DU. In general this is how a minor unit is defined, although sometimes the term "minor unit" is used to describe one-sixth of a speech-DU or of a body-DU. In fact, Buton (Bukthig) states that the minor unit is one-sixth of any door unit, and his contemporary Dolpopa (Dpkthig) states that in terms of the bodhisattva trilogy, the same is true, even though he does not use it exclusively in this way.

The term "fractional unit" is also used in describing Kālachakra mandalas, but it does not always mean the same as a minor unit. Banda Gelek gives two different definitions for this term. In one section of a Jonang compilation text regarding various mandalas (Mtkmand) he states that a fractional unit is equal to one-fourth of a door unit (of any particular palace door). However, in his text (Bgslos) describing the three-dimensional structure of the Kālachakra mandala palace, he states that a fractional unit is equal to one-sixth of any partic-

ular door unit and that one-fourth of a door unit is a different measurement.

Although Banda Gelek does sometimes use the term "fractional unit" to mean a quarter of a door unit, he usually prefers simply to use quarter-door for such a measure (and sometimes the term *rkang pa*, *pāda*, which in normal use is loosely equivalent to the "foot" as a unit of measurement). This unit of a quarter-door is useful because it is equivalent to the minor unit in other mandalas.

There is far from complete consistency in the way different Tibetan writers use these units, and even the same writer may use them differently. According to Banda Gelek, "to take one-sixth of a speech or body door unit as a minor unit is very mistaken" (Mtkmand). However, many do, and although it is generally the case that six mu equal one mind-DU, a minor unit is sometimes referred to as one-sixth of a speech-DU or one-sixth of a body-DU.

Banda Gelek's second definition of a fractional unit as a sixth of a DU seems to cover most uses of these terms, but there is clearly plenty of scope here for ambiguity. I shall therefore in this work not use fractional units, but keep to door units and minor units, with minor units defined as one-sixth of a mind-DU and only of a mind-DU. However, as we shall see, one-quarter of a door unit is a useful measure to apply, and in keeping with writers such as Banda Gelek I shall also make use of this.

General dimensions

Traditionally, the size of the mandala that is to be drawn for a particular ritual, most notably an empowerment, is determined by the size of the teacher, or vajra master (*rdo rje slob dpon*, *vajrācārya*), who is to lead the ritual. The width of the vajra master's thumb is taken as the basic unit of measurement, which is a finger. As mentioned before, this is further subdivided into eight barleycorns and 24 fingers make one cubit. A cubit is the length of the forearm, from the elbow to the tips of the outstretched fingers—about 18 inches, on average.

For the main Kālachakra mandala, the size of the mandala is traditionally said to be four cubits. This size is not the overall size but the inner width of the body palace, from the inside of one wall to the inside of the opposite wall.

Several basic lines are drawn at the start of the construction, in particular two central lines (*tshangs thig*, *brahmasūtra*), one running East-West (from the point of view of the mandala, not geographically) and one running North-South. There are also diagonal lines (*zur thig*, *koṇasūtra*) that run through the center from Northeast to Southwest and from Southeast

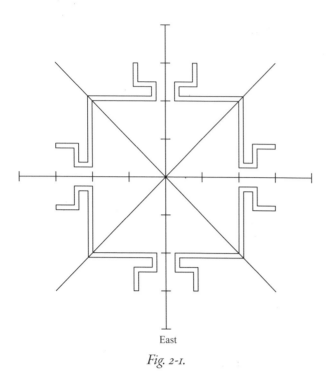

East

Fig. 2-1.

to Northwest. These are drawn using cords (*thig skud, sūtra*) dipped in chalk which are held taut over the surface and then flicked. This leaves a chalk line immediately under the cord. The cords should have a thickness of one barleycorn.

Eight such basic lines are needed, and these are usually called the eight great lines (*thig chen brgyad*). There are two ways that these are described.

The first method seems to be more common in the context of Kālachakra mandalas, and in this the central and diagonal lines are considered to be pairs, on either side of the central point. For example, the line running East-West is considered to consist of one central line from the East to the center and another from the center to the West. Four central lines and four diagonal lines make the total of eight.

The next method, used more in the descriptions of the building of stūpas, counts two crossing central lines, one vertical (East-West) and one horizontal (North-South), two diagonal lines also passing through the center, and four side lines (*logs thig*) that form a square around the whole surface. In mandala drawing, these side lines on the edge of the drawing are usually not needed.

However, using this second convention, Banda Gelek explains that with the size of the mandala consid-

ered to be four cubits, the size of each of the central lines and of the cords used to draw them are all eight cubits. In figure 2-1, the walls of the body mandala are shown, together with the central and diagonal lines. The central lines have cubits marked along them.

These units of cubits, barleycorns and finger-widths are used to describe the dimensions of the mandala in the original Indian literature, and are still used to determine the overall size. However, some of the units described above, such as the door unit, are more commonly used for describing the dimensions of the mandala.

Each cubit in the original description is equivalent to two door units of the body mandala. As the three mandala palaces of body, speech, and mind are of different sizes, it is important to distinguish between the different units used. The door unit is simply the width of the doorway in a palace, and I will represent door units (DU) of the body palace as body-DU, those of the speech palace as speech-DU, and those of the mind palace as mind-DU. A body-DU is twice the size of a speech-DU and four times the size of a mind-DU.

Using this measurement, the internal width of any palace is equal to eight door units of that particular palace. This is the same in most mandalas and not peculiar to Kālachakra. However, as mentioned above, the definition of the minor unit is unique to Kālachakra. In most mandalas, a minor unit (mu) is one-quarter of a major unit or door unit. In Kālachakra, 1 mu is equal to one-sixth of a mind-DU, and therefore equal to one half of a finger.

Another way of describing that the internal width of the body palace is 8 body-DU is to say that the distance from one baseline of the palace to the opposite baseline is 8 body-DU. The baseline (*rtsa thig, mūlasūtra*) is the inner line of the wall of any of the palaces. The space enclosed by the baselines, clearly the interior of the palace, is called in the *Vimalaprabhā* the wheel or circle (*'khor lo, cakra*) of the palace.

The outlines of the walls of the three palaces are shown in figure 2-2, with the mind palace in the center. Body-DU are marked along the central lines, and the two central lines are 16 body-DU in total length. In the

2D mandala, the triple palace is surrounded by several perimeters (*khor yug, valaya*), and in the diagram the circles represent the inner edge of the innermost perimeter of earth and the outer edge of the final perimeter, the garland of light.

Notice that the central lines form exact diameters of the inner edge of the earth perimeter. This circle is actually the outer edge of the offering ground (*mchod pa'i sa gzhi, pūjābhūmi*), on which the mandala palace stands. In the full 3D image of the mandala, the whole structure sits on top of Mt. Meru. On the top of the mountain is a lotus together with disks of the moon, sun, and Rāhu. Over these, and in diameter the same as the top of Mt. Meru, is the disk of the offering ground with the palace sitting on it.

If viewed from directly overhead, Mt. Meru would be hidden and around the outer edge of the offering ground would be seen the outer part of the great disk of the element of earth, far below the palace. In the 3D image it is not correct to call these elemental disks perimeters, but they are called this in the context of the 2D mandala because their representations surround the palace.

This is why the central lines are the length that they are, as they represent the full extent of the actual structure of the palace and the ground on which it sits. In practice, of course, they are usually drawn longer, reaching to the outer edge of the perimeters.

The diagonal lines are drawn a little longer than the central lines. In the diagram I have followed Banda Gelek and made them 17 body-DU in diameter. This is because the two-dimensional representation of the tops of the walls of the body palace extend beyond the offering ground by half a body-DU at each corner, reaching to the outer edge of the earth perimeter. The diagonal lines are needed for drawing the wall structure, and

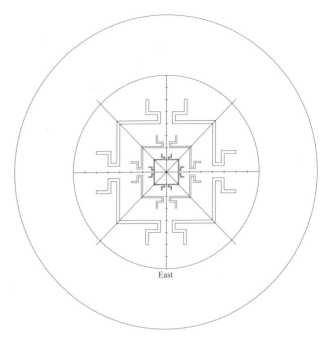

East

Fig. 2-2.

therefore have to reach to that outer edge of the earth perimeter.

To recap the main dimensions, as there are 24 (6 × 2 × 2) mu in each body-DU, the internal width of the mind palace, baseline to opposite baseline, is 48 (2 × 24) mu; the width of the speech palace is 96 (4 × 24) mu, and the width of the body palace is 192 (8 × 24) mu. The length of the central lines, which is also the diameter of the offering ground, is 384 (16 × 24) mu; the distance from the tip of the toran of the body palace to the tip of the opposite toran (these are not shown in the diagram) is 432 (18 × 24) mu; and the diameter of the outer edge of the garland of light is 624 (26 × 24) mu.

This final measurement is the overall size of the whole mandala drawing and equal to 13 cubits. If the size of the mandala as given in the original tantra is taken literally, this will give an overall diameter of an ideal mandala at just less than 20 feet (just under 6 meters).

The description from the tantra

The original description of the drawing of the Kālachakra mandala is contained in verses 36 to 41 of the third chapter of the *Kālachakra Tantra*. The following verses continue with further details of the mandala, including the colors, symbolism, and so forth.

My interpretation of these six verses is that the first

verse sets out the basic plan and methodology, and the following verses fill in the details. To judge by the analysis of Banda Gelek, he considers this first verse to represent the basic method of the *Laghutantra* and the following verses to represent the slightly different method of the *Mūlatantra*. In commenting on these verses, after having covered verse 36, the *Vimalaprabhā* indeed quotes the *Mūlatantra* before continuing with the details as given in the following verses.

Although I do not accept his interpretation, there are some interesting points brought out in Banda Gelek's analysis and methods, and so I shall cover these in brief.

Verse 36 reads: "Arrange taste (6) and ninety lines in each direction from the central lines; Called half-fingers, jewel (8) and age (4) lines form the heart mandala in the center; Beyond the heart, the rest that are arranged reach to the doorway of the great mandala; Beyond the mandala display the walls, torans, and so forth, the pointed and the moving."

In literature of this kind numbers are often represented by symbolic names, and I have given the relevant numbers here in brackets after the names that represent them. Numbers are also written with least significant figure first, and so "taste and ninety" means ninety-six.

This verse is describing a grid system of four sets of ninety-six lines, half a finger or a minor unit apart, cov-

ering the whole internal area of the body palace. My interpretation of this is not that all of these lines need literally to be drawn, but that they are understood as a means of measuring out the mandala, rather like a coordinate system.

The 96 mu from the central line would reach exactly to the baseline of the body palace, and so arranging ninety-six lines "in each direction from the central lines" would create a grid covering the whole inside of the body palace. The verse continues by stating that the middle forty-eight of these lines form the space for the internal area of the mind palace (heart mandala). The internal width of the mind palace was given above as 48 mu.

Beyond the mind palace, the speech palace has an internal width of 96 mu, and the lines of the whole grid system that is 192 mu across "reach to the doorway of the great mandala," meaning that the grid of lines reaches to the baseline of the body palace, the doorway being in the middle of the baseline.

"Beyond the mandala," in other words, beyond this internal space of the body mandala described by this grid of lines, lie the walls of the body palace, the plinths, and so forth, also the torans over the porches, and the perimeters of the disks of fire (pointed), wind (the moving), and so forth.

Banda Gelek actually describes two slightly different

Fig. 2-3.

Fig. 2-4.

methods for laying out the grid of lines based on this verse of the tantra. I shall briefly describe the first of these as it includes a traditional method for drawing the eight great lines, the basics of which apply to most mandala drawings. His method extends that of the tantra, with the grid covering the whole area of the central lines rather than just the internal space of the body mandala.

One needs first to determine the space available for drawing the mandala and understand that the overall width is going to be 26 body-DU. The middle 16 of these will be used to form the grid.

First, draw the East-West central line, and having found its center, describe from that center a circle of radius 8 body-DU. From where that circle meets the central line, draw intersecting arcs of larger radius. Where these arcs cross (literally called "at the head and tail of the fish"), draw the second central line, running North-South. These steps are illustrated in figure 2-3.

Then, where the two central lines meet the original circle, draw further intersecting arcs using the previous radius of 8 body-DU. Connect these together in order to form both the two diagonal lines and the four side lines, forming a square. These steps are illustrated in figures 2-4 and 2-5.

The description of the drawing of these first lines is nearly always accompanied by the ritual procedure that is given in the commentary to these verses in the *Vimal-aprabhā*. Mipham's (MiKal) description of this procedure reads:

"The teacher sits on the ground for the mandala, in the West, facing East. He holds the cord in his left hand and has his left foot in the half posture with the right placed on the ground. The student, the one with the action vajra, sits in the East, facing West, holding the cord in his right hand and with his right foot in the half posture and the left placed on the ground. Having measured out the square base for the mandala, they place the first central line.

"Then, as before, but with the teacher in the South facing the North and with the action vajra facing South, they place the second central line.

"They then place the two diagonal lines, between the Northwest and Southeast, and between the Southwest and Northeast."

Having described the drawing of the eight main lines, Banda Gelek next states that the spaces on either side of the central lines should be successively divided into two. This is usually done by drawing further short diagonal lines, first by connecting the ends of the central lines together. At the points where these cross the original diagonal lines, further lines are drawn parallel to the central lines. The first stage of this process is illustrated in figure 2-6.

Fig. 2-5.

Fig. 2-6.

Then, further diagonal lines are drawn to bisect the spaces again. This next step in the process is shown partially in figure 2-7 and completed in figure 2-8. Banda Gelek says that this process should be continued until there is a grid of squares with 32 squares on either side of the central line—this means sixty-four squares in each direction, a total of 4,096. Each of these squares is in width one mind-DU, and he says that each of these is then divided into six parts, each of which measures 1 mu, a total of 192 mu from the center to the outside edge of the grid of squares.

For obvious reasons, this is not illustrated here in a diagram, and the sheer impracticality of this is one reason that I consider this mention of a grid of lines in the tantra to be a theoretical point, rather than a practical one.

However, after having given his second and slightly more complex description of this, Banda Gelek goes on to describe the layout of the mandala using this grid as a reference. With such a grid of lines, numbering them in terms of distance in mu from the central lines, the description that Banda Gelek gives effectively uses coordinate geometry to describe the mandala.

For example, in order to draw the inner line of the wall and the porch of the mind palace, he states: "Con-

nect the 24th, the baseline, from the diagonal to the point on the third from the central line…connect from the 3rd from the central line and 24th up to the 30th, then to the side as far as the 9th, then up to reach the 36th" (Bggthig).

The way he describes this is best illustrated by considering the northern side of the western wall of the mandala—the upper right in the normal way of displaying a mandala. This is illustrated in figure 2-9, and the relevant construction lines have been numbered (even numbers only). If we use coordinate geometry to paraphrase Banda Gelek's description, then the x-axis is the North-South central line and the y-axis is the East-West central line. The y-axis is shown in the diagram as the leftmost, and slightly longer, vertical line. He uses the concept of moving up and to the side, just as one would expect in a diagram oriented in this fashion.

In coordinate geometry a point is described by two numbers, the x-coordinate and the y-coordinate, given in that order. In terms of this diagram, the x-coordinate is the horizontal distance in mu from the East-West central line, and the y-coordinate is the vertical distance from the North-South central line. So, in figure 2-9, the heavy lines show the construction that this quote from Banda Gelek describes. The lower left corner of this is 3

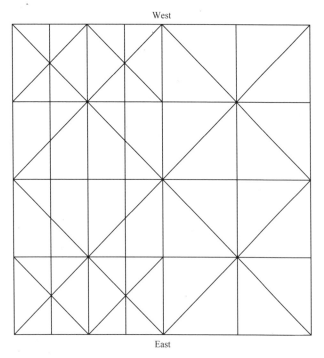

West

East

Fig. 2-7.

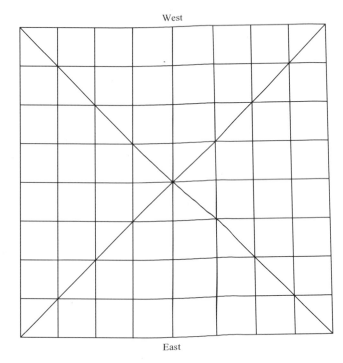

West

East

Fig. 2-8.

Fig. 2-9.

mu to the right of the East-West central line, and 24 mu up from the North-South central line (not shown). It is therefore represented as the point 3,24.

So, using coordinate geometry, Banda Gelek's description becomes: "Connect the point 24, 24 on the diagonal along the baseline to 3,24 . . . then up to 3,30, across to 9,30, and up again to 9,36." In later descrip-

tions he also describes vertical lines (*gyen thig*) and horizontal lines (*'phred thig*) in just the way one would expect in relation to a diagram such as in figure 2-9. Given the symmetrical nature of mandalas, this is a precise and very useful convention to employ, and where relevant I shall describe points on the mandala in this way throughout this work.

The description from the *Mūlatantra*

In the second of his four main descriptions of the drawing of the mandala, Banda Gelek gives his interpretation of the method given in the *Vimalaprabhā* and said to be derived from the *Kālachakra Mūlatantra*. After the explanation of verse 36, the *Vimalaprabhā* introduces the detailed description of the drawing of the mandala with a short quotation from the *Mūlatantra*, a quote that is also cited by Banda Gelek. This states:

"On a level square base, having created 16 units, mark out (the baseline of) the body mandala and again create 16 units for the speech mandala. Then again, mark

out the speech mandala and create sixteen units for the mind mandala. Thus revealing three fortnights yields the three qualities of the mandala. Then draw the three mandalas, with lines at two, ocean (4), and so forth, units."

The word "fortnight" seems out of place here, and I have followed the *Vimalaprabhā* annotations of Buton (Bubangre, 43a). Fortnight is a translation of the Sanskrit *pakṣa* (*phyogs*), meaning half a lunar month of fifteen lunar days, bounded by sixteen lunar phases, from new moon to full moon. The 16-square grid symbolises

the sixteen joys and these sixteen phases, and so the term "fortnight" is a poetic expression for a grid of 16 × 16 squares. There are three of these, one for each mandala palace.

Figure 2-10 represents the first step in the *Mūlatantra* description. The walls of the body palace are shown in this diagram for clarity. The outer four squares in each direction contain the walls of the body palace, and if one lays these aside, what remains covers the space of the interior of the body palace, consisting of a set of 8 × 8 squares. These are then divided into halves, to produce a new grid of 16 × 16 squares to provide the outline of the speech palace. This is illustrated in figure 2-11, and the speech palace walls are shown within this structure in figure 2-12.

Finally, the 8 × 8 squares of the grid in the interior of the speech palace are themselves subdivided into halves to produce the inner grid of 16 × 16 squares for the outline of the mind palace. This final stage is illustrated, together with the mind palace walls, in figure 2-13.

The squares in this final innermost grid are all 1 mind-DU across, and the original squares in the first grid of 16 × 16 are all 1 body-DU across. The width of the overall grid is therefore the same as the length of the central lines, and this initial grid of 16 × 16 squares is commonly used to start the process of laying out many

mandalas, not just that of Kālachakra. The process would start with constructing the central and diagonal lines and then bisecting the vertical and horizontal space to produce the grid of 16 × 16 squares. The diagonal lines have not been shown in these diagrams.

The last line of the quote from the *Vimalaprabhā* states: ". . . with lines at two, ocean (4), and so forth units." Having defined the overall structure of a mandala with the main lines and reference grid, it is usual to describe the details from the center outward, and this comment refers to the first two construction lines. The first of these is 2 mu from the central lines, and the next is 4 mu further (6 mu from the central lines). These determine respectively the diameter of the receptacle of Kālachakra's central lotus and the external diameter of that lotus.

At least as far as the central lotus is concerned, no construction lines need to be placed at distances of one, three, four, or five units from the central lines. Banda Gelek takes this idea and describes a rather complex procedure for drawing only those construction lines that need to be used for drawing components of the mandala.

These construction lines are numbered from the central line as before, but in this description they do not have a fixed distance between them. He then goes

Fig. 2-10.

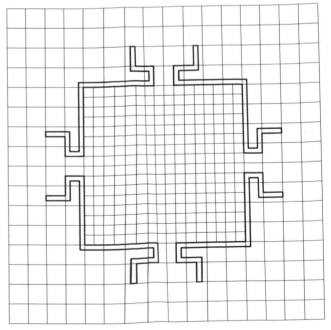

Fig. 2-11.

through the entire description of the mandala again, but this time using these construction lines to determine the position of the final lines that need to be drawn. In this method no construction lines are drawn that are not used, and so this method avoids the use of construction lines that would only be erased.

The descriptions from Abhayākaragupta and Dolpopa

In the *Vajrāvalī*, Abhayākaragupta describes the overall dimensions of the mandala followed by the need to construct the central and diagonal lines. He then starts from the center, describing the sizes and forms of the various components of the mandala. He describes no detailed grid of construction lines, and for this reason Banda Gelek states that his method avoids the use of such lines. In practice, of course, some construction lines are needed, but the use of these is left up to the individual artist.

The description of the mandala from Dolpopa follows a very similar method to that in the *Vajrāvalī*, although with some further, particularly practical, details. Even so, Banda Gelek goes through the entire description of the mandala for each of these systems, concluding with the description of the colors and other details of the mandala. There is no need to give further details of these methods here as essentially the same method is followed, with many further details and refinements, in Banda Gelek's annotated description of the mandala drawing, *The White Crystal Mirror*, based on the work by Tāranātha.

The description from Tāranātha

The long description of the mandala drawing in *The White Crystal Mirror* (Mtkmand) only deals with the dimensions of the mandala; the colors and details are described elsewhere. The text starts with a general introduction to the overall dimensions.

The basics of this introduction are a confirmation of the units used, in terms of door and fractional units relative to a particular mandala palace, and minor units being one-sixth of a mind-DU.

For each of the three palaces, the distance from the outside line of the wall structure, the parapet line (*mda' thig, kramaśīrṣasūtra*), to the center of the mandala is six

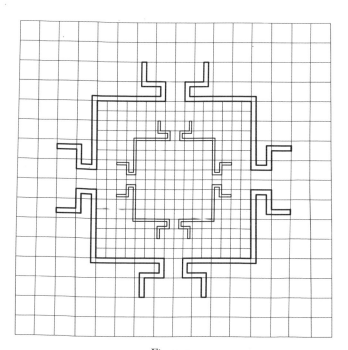

Fig. 2-12.

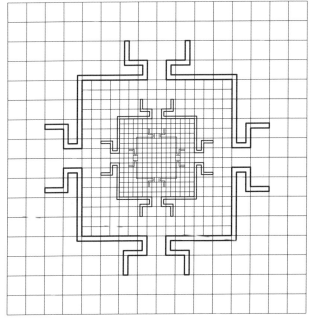

Fig. 2-13.

respective door units, and the distance from the baseline (the inner edge of the walls) to the center is four respective door units. The distance from the outside edge of the Circle of Great Bliss to the center is 2 mind-DU, exactly half the internal width of the mind palace.

The detailed description starts with measuring out the space on which the mandala is to be drawn, and after the center of this space has been determined, the main lines are drawn, the basic structure marked out, and then the detailed dimensions are described from the center outward.

The overall diameter of the mandala, from the outside eastern edge of the garland of light to its outside western edge, is 26 body-DU. Once the central and diagonal lines have been drawn, the distance along one of these, from the outside edge to the center, should be divided into 13 equal parts. Each of these is 1 body-DU in size, two of them being one cubit.

First, a circle is drawn from the center of radius 8 body-DU. This is used to determine the length needed for the central lines. It also serves as the outer edge of the offering ground, which is the same as the inner edge of the perimeter of earth. Next, a circle is drawn from the center of radius 8½ body-DU. This determines the length needed for the diagonal

lines and will also serve as the outer edge of the earth perimeter.

These steps are shown in figure 2-14. In that diagram one of the central lines is shown reaching to the outer perimeter and has units of body-DU marked along it. Two of these have been numbered for clarity.

The next steps determine five sets of lines for the mandala: the baselines of the three palaces, the external line of the Circle of Great Bliss, and the outer line for the site of the chief deity, which is also the inner line of the inner beams of the Circle of Great Bliss. First, the ends of the central lines are connected together and the points where these intersect with the diagonal lines are connected to form a square. This square consists of the four baselines of the body palace.

This process is then repeated by connecting the four points where these baselines intersect with the central lines. This again produces intersections with the diagonal lines, and these are connected up to form the baselines of the speech palace. This is then repeated twice more, for the baselines of the mind palace and the external lines of the Circle of Great Bliss.

Each of these steps is bisecting a distance along the central line. The central line is 8 body-DU from the center, the body baseline is 4 body-DU, the speech

Fig. 2-14.

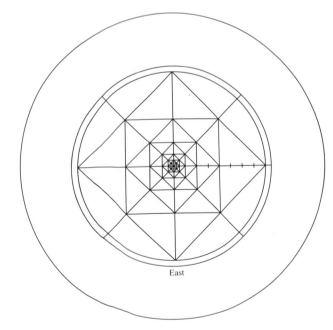

Fig. 2-15.

baseline 2 body-DU, the mind baseline 1 body-DU, and the external line of the Circle of Great Bliss half of a body-DU from the center. The result of this procedure is shown in figure 2-15.

The next steps determine the positions of the parapet lines for the palaces. The ones for the inner palaces are found by bisection, as the mind parapet lines lie exactly halfway between the baselines of the mind and speech palaces, and the speech parapet lines lie exactly halfway between the baselines of the speech and body palace. The parapet lines for the body palace are drawn by connecting the ends of the diagonal lines together—the points where the diagonal lines meet the second circle. The result of this procedure is shown in figure 2-16 (with previous construction lines removed).

Of course, an alternative method would be to create the body parapet lines first and then bisect as before to find the positions of the other two sets of parapet lines. Incidentally, there is a small inaccuracy in determining the positions of the parapet lines from the ends of the diagonal lines, but as the value of this error is about 1/100th body-DU, it is irrelevant. (By Pythagoras's theorem: $8.5^2 \div 2 = 6.01^2$.)

Further construction lines are now drawn for the wall structures in the spaces between the base and parapet lines of each of the three palaces. This space is first divided into two. These two halves are each then divided into quarters, although not all three lines between those quarters are drawn. This type of procedure and its style of description are very common in mandala drawing. For the inner of the two halves, Banda Gelek states that the "middle is discarded and the two outer lines are drawn." The outer half "is halved and the outer of those halved."

This means that having halved the space between the base and parapet lines, the innermost of these two halves has the first and third lines of the three that would divide it into four drawn, and the outer half has the second and third of those lines drawn. These construction lines are shown in figure 2-17 for the body palace. In the body palace, the baseline is at position 96 mu from the center and the parapet line 144 mu. These new construction lines are at positions 102, 114, 120, 132, and 138 mu, making the six spaces now formed between the base and parapet respectively 6, 12, 6, 12, 6, and 6 minor units in width. These six spaces are for the walls (*ra ba, prākāra*), plinth (*stegs bu, vedika*), jeweled frieze (*rin chen snam bu, ratnapaṭṭika*), garlands (*do shal do shal phyed pa, hārārdha hāra*), pipes (*shar bu, bakulī*), and parapet (*mda' yab, kramaśīrṣa*). The positions and sizes for the equivalent structures in the speech and

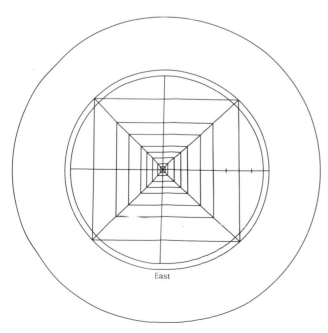
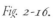

Fig. 2-16.

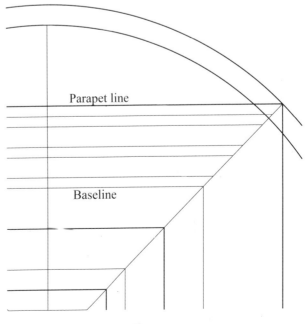

Fig. 2-17.

body palaces are respectively one-half and one-fourth of those for the body palace.

One point worth noting here is the difference between the terms "construction" and "final" lines. It is clear that the diagonal lines drawn in order to bisect the space when determining the positions of the baselines are construction lines as they are simply used to find points from which to draw new lines, and they can then be erased. However, these new lines drawn in the space between the base and parapet will be used in the final drawing, but as parts of them will be erased, for this reason they are also called construction lines. For the same reason the baselines also are considered construction lines, but as no part of the parapet lines are ever erased, they are properly called final lines. Banda Gelek repeatedly makes these distinctions clear during his description as these two line types can be drawn using different materials.

Banda Gelek then states that further construction lines need to be drawn bisecting the inner space between the wall structure of each mandala palace and the structure inside it. These are spaces for the colored ground (*tshon sa, rangabhūmi*) and deity podium (*lha snam, devatāpaṭṭikā*) for each palace, although these construction lines define neither of these. They are drawn at this stage for later use.

Starting from the outside, the first of these spaces is between the baseline of the body palace and the parapet line of the speech palace. When divided into two, the width of each of those halves is half a body-DU. The next two spaces are both the same size. These are between the baseline of the speech palace and the parapet line of the mind palace, and between the baseline of the mind palace and the outer line of the Circle of Great Bliss.

The next procedure draws the final lines for the sixteen pillars and the inner and outer beams of the Circle of Great Bliss. All of these lie between the innermost two final lines that have already been drawn; the outer of these is the outer line for the Circle of Great Bliss, and the inner one is the outer line for the site of the chief deity, which is also the inner line of the inner beams of the Circle of Great Bliss.

The distance between these two lines is 6 mu. As Banda Gelek expresses it, this space is divided into six, and only the two outer lines are drawn (the inner three being discarded). This means that lines are drawn to form new squares, one minor unit beyond the inner of the two original lines and one minor unit inside the outer of those two lines. The structure now consists of four squares, at distances from the center of the mandala of 6, 7, 11, and 12 mu. These form the spaces for the inner beams, for the tathāgata-extension (*de gshegs 'phar ma, tathāgatapuṭa*, also, sugata-extension), and for the outer beams, all of the beams being 1 mu in width.

The next lines drawn are for the pillars. There are four pillars in each of the four directions. The outermost lines of each set of four pillars are easily drawn by extending the outer lines for the inner beams until they reach the outer beams. Then, further lines are drawn parallel to these extensions, 1 mu closer to the central lines, running between the two sets of beams. The final four pillars are formed by drawing lines between the pairs of beams, 2 and 3 mu right and left of the central lines. All the pillars formed in this way are 4 mu in length and 1 mu in width. This structure is shown in figure 2-18.

Unlike many writers, Banda Gelek does not continue describing further details of the mandala from the central lotus and then working outward. Instead, he describes features according to type, and all the deities' lotuses are described together later. The next step in his description concerns the colored ground and deity podium for the mind palace.

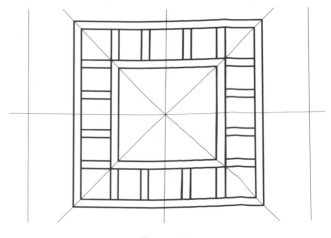

Fig. 2-18.

These are in the space between the external line for the Circle of Great Bliss (12 mu from the center) and the baseline of the mind palace (24 mu). This space has already been bisected by a construction line. The outer of these two halves is described as being "the fourth mind-DU" from the center. In other words, the inner lines of that space, the bisecting construction lines, are all 3 mind-DU from the central lines, and the outer lines, the baselines of the mind palace, are 4 mind-DU from the central lines. If one imagines squares marking out successive distances from the center in increments of 1 mind-DU, the fourth such area produced is the one described here, between 18 and 24 mu from the center. Terminology like this is often used to describe positions in the mandala.

As before, this space is divided into six (it is also 6 mu wide), the middle lines are discarded, and the two outer lines only are drawn. These lines are final lines, as no part of them needs later to be erased. These two new lines are shown in figure 2-19, together with the bisecting construction line, which can then be erased. These lines produce three spaces between the outer line of the Circle of Great Bliss and the baseline of the mind palace. These are for, from the inside, the colored ground,

7 mu in width, the deity podium, 4 mu in width, and, the narrow gap (*spang chung*), 1 mu in width. The next steps describe the doorway and wall structure for the mind palace. Following the convention of describing the western side of the palace, with West at the top, a set of vertical construction lines needs first to be drawn. These lines will be used not only to draw the doorway and porch structure (*sgo khang, dvārakoṣṭhaka*) but also the toran above the porch. The limits right and left of the central line of the toran are 12 mu from the central line. This is 2 mind-DU from the central line, the same distance as the outer edge of the Circle of Great Bliss.

These two major units are then subdivided. The innermost is divided into two, and the outer half that results is again divided into two. The outermost mind-DU is divided into four equal parts. Apart from those nearest the central line, all these construction lines (seven either side of the central line) are 1½ mu apart. This first step is shown in figure 2-20. In that diagram the construction lines are shown extended up beyond the mind parapet line for the later drawing of the toran.

The description then moves on to the final lines for the wall structure, and here it will be useful to use coordinate geometry to describe the points that need to be

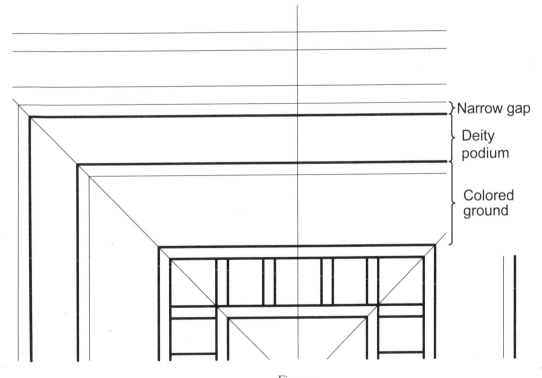

Fig. 2-19.

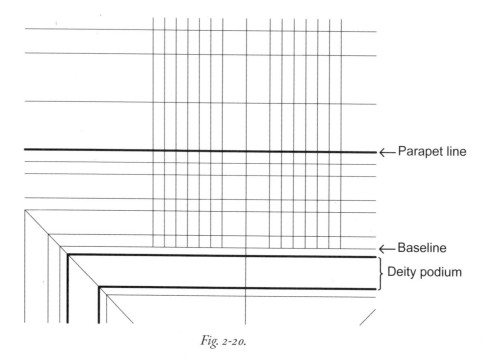

Fig. 2-20.

connected. The point where the baseline intersects the diagonal line (24,24) is connected along the baseline to the vertical construction line nearest to the central line (3,24), then up to 3,30, along to 9,30, and finally up again to the parapet line (9,36). This is the description we had earlier and forms the inner line of the walls.

The outer line of the walls starts 1½ mu farther up at the point 25½,25½. This line follows the horizontal construction line immediately above the baseline, connecting to the point 4½,25½, then 4½,28½, then 10½,28½, and finally to 10½,36.

The outer line of the plinth connects along the next horizontal construction line from the point 28½,28½ to 10½,28½. The outer edge of the toran pillar connects along the seventh vertical construction line, from the point 12,28½ to 12,36. Finally, the outer lines for the jeweled frieze, garlands, and pipes are drawn by joining along the final three horizontal construction lines, from the diagonal line to the seventh vertical construction line. The result of this procedure is shown in figure 2-21.

This description has been for the northern, or right-hand, part of the western wall structure, and so a mirror image of this procedure needs to be performed on the southern side, and then the whole repeated in the other three directions. The parapet line has already been drawn as a final line, connecting from one diagonal line to the opposite. It crosses right over the open front of the porch, because at that position it represents the lower line of the bottom beams of the toran. This will be drawn later. It is worth noting that one does not connect any of the points that have been used that lie on the diagonal lines.

In the middle of the wall structure this procedure creates the outline of the walls of the porch. This consists of three sections, which are shown named in figure 2-21. The porch projection (*sgo khyud, niryūha*) consists of two walls that form a passageway in the middle of which is the actual door itself, which is not represented in a 2D mandala. The porch extensions (*sgo 'gram, kapola*) and the porch sides (*sgo logs, pakṣaka*) widen the structure to form, in a full 3D palace, the covered porch.

Some, but not all, writers in the Gelug tradition reverse the names of these last two components, and this is presumably due to a passage in the third chapter of the *Vimalaprabhā* which names them in the order: projection, side, and extension. This is unusual, and in other places in the *Vimalaprabhā* and in reference to other mandalas, the names are as shown in figure 2-21.

The description next moves to the area between the parapet line of the mind palace and the baseline of the speech palace. In width, this is actually exactly the same as the equivalent space inside the mind palace,

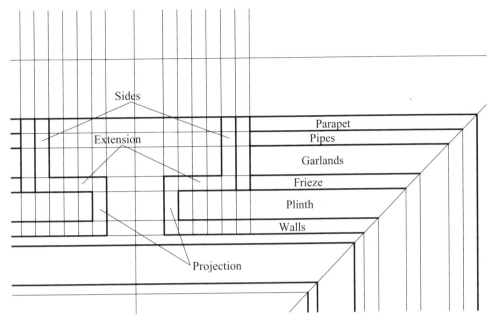

Sides

Extension

Parapet

Pipes

Garlands

Frieze

Plinth

Walls

Projection

Fig. 2-21.

12 mu, and it is divided up in the same way. The space has already been bisected by a construction line, and as before the outer of these two halves is divided into six, the middle lines are discarded, and the two outer lines only are drawn. These form the colored ground, the deity podium, and the narrow gap, all with the same widths as in the mind palace.

Banda Gelek calls these lines final lines, but this is not strictly true for the inner line of the podium, a small section of which will need to be erased when the mind toran is later drawn.

One might expect the space for the colored ground and podium of the speech palace to be double the width of that inside the mind palace. The reason that this is not the case is that although the width of the Circle of Great Bliss is half the internal width of the mind palace, it does not have the structures of the porch, plinth, frieze, torans, and so forth. The free space that would otherwise be taken by these creates a proportionately larger space for the colored ground and podium inside the mind palace. This applies equally to both 3D and 2D mandalas.

Regarding the wall structure and the doorways of the speech palace, Banda Gelek starts the description by stating that the width of the doorway is equal to the diameter of the chief deity's lotus. There are many

comparisons like this throughout his work and the descriptions of other writers, making the job easier of measuring out the mandala without the need to draw many long construction lines. I need not give any more of these comparisons in this description. Suffice it to say that the width of the speech doorway is twice that of the mind doorway, at 12 mu.

In fact, all the dimensions of the speech walls and porch, the construction lines needed, and all the coordinates are exactly double those of the mind palace.

Regarding the body palace, the dimensions for the podium are different from the mind and speech palaces. The width available for these, between the speech parapet line and the body baseline, is 24 mu. This space has already been bisected by a construction line, and for each of these two halves, a new line is drawn one minor unit inside the outer edge. These form the inner and outer lines of the deity podium, giving the colored ground a width of 11 mu, the podium a width of 12 mu, and the narrow gap a width of 1 minor unit.

Again, Banda Gelek calls these final lines, and this time I disagree with both of these, as small sections of each will need to be erased when the speech torans are drawn.

As before, the description of the doorway and wall structure of the body palace is trivial, all the dimensions

Fig. 2-22.

and coordinates being double those of the speech palace. In a similar way, the description of the torans that now follows applies equally to all three palaces, those of the speech palace having double the dimensions of those of the mind palace, and those of the body palace double those of speech.

Some of the vertical construction lines for the mind palace toran have already been drawn, and these should be extended for a distance of 3 mind-DU above the mind parapet line. The vertical construction lines that were used for the doorway and wall structure were separated by multiples of 1½ mu, and those that fall on half minor unit positions are not needed for the toran. Of those that have already been drawn, only those that are integral numbers of minor units from the central line are needed. In fact, all the positions for 2 mind-DU right and left of the central line that are a single mu apart need vertical construction lines drawn—a total of twenty-four, plus the central line.

I shall use the mind toran as the example here, but one point needs to be made for the body torans: that the equivalent 3 body-DU reach beyond the ends of the central lines, and so these also need to be extended.

The toran structure now needs horizontal construction lines. The lowest of the three door unit sections has the lower third drawn, and that itself is then halved.

In other words, horizontal lines are drawn 1 and 2 mu above the parapet line. The middle section is divided into four, the middle of which is discarded and the two outer lines are drawn. Of the two outer quarters that result, each has its own inner third drawn. This means that lines are drawn ½, 1½, 4½, and 5 mu from the bottom of this middle section; these lines are at distances of 6½, 7½, 10½, and 11 mu from the parapet line.

Finally, the upper section is divided into three and the middle third has its lowest quarter drawn. These lines are 2, 2½, and 4 mu from the bottom of this upper section, respectively 14, 14½, and 16 mu from the parapet line. These construction lines are shown in figure 2-22. For clarity, the horizontal construction lines marking the three mind-DU sections have been slightly lengthened, and the wall structure of the speech palace has been removed, as have the lines for the deity podium.

The final lines of the toran are normally described by giving the horizontal lines needed and then the vertical lines that connect these together. Numbering the horizontal construction lines upward from the first above the parapet line, the first line is drawn from 12 mu either side of the central line—connecting the point 12,37 with its opposite point the other side of the central line (-12,37).

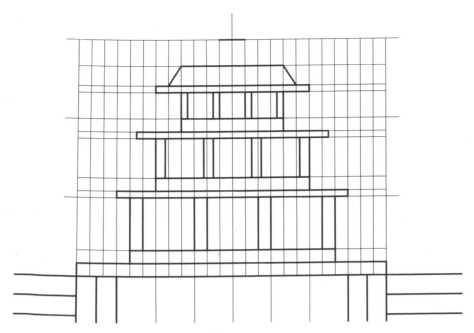

Fig. 2-23.

The second line connects points 8 mu from the central line, and the third and fourth connect points 9 mu from the central line. The fifth line connects points 6 mu from the central line, and the sixth and seventh lines connect points 7½ mu right and left. The eighth line connects points 4 mu from the central line, the ninth and tenth 6 mu, the eleventh 4 mu. Finally, the top horizontal line, the twelfth, extends between the first vertical construction lines right and left of the central line.

These horizontal lines form the spaces for the beams, guardrails, and pillars of the lower stage (*brtseg ma, pura*) of the toran, then the same for the middle and upper stages, and on top the beam, Chinese roof and vase (*bum pa, kalaśa*)—a total of twelve components.

The toran pillars now need to be drawn. For the three stages these are between the second and third, the fifth and sixth, and the eighth and ninth horizontal lines. In each section there are four pillars, and the outer line of the outer pillars in each stage are flush with the ends of the lines of the guardrails below.

For the first stage, in the space between the second and third horizontal lines, vertical lines are drawn, right and left of the central line, 2, 3, 7, and 8 mu from the central line. The outermost of these lines are extended down to reach the first horizontal line, thereby forming the edge of the guardrail.

The space available for the pillars in the upper stages is smaller, and so the pillars themselves are also closer together and narrower. For the middle stage, in the space between the fifth and sixth horizontal lines, vertical lines are drawn 1½, 2¼, 5¼, and 6 mu from the central line. As before, the outermost of these is extended downward.

For the upper stage, in the space between the eighth and ninth horizontal lines, vertical lines are drawn 1, 1½, 3½, and 4 mu from the central line, extending the last of these down, as before.

The remaining horizontal lines are connected from their ends down to the lines below. These are the first, fourth, seventh, and tenth horizontal lines. The ends of the eleventh horizontal lines are connected down to meet the tenth horizontal line at a distance of 5 mu from the central line to form the line of the Chinese curved roof. Finally, the top horizontal line, which is 2 mu in length, forms the upper line of the vase which is to be drawn on top of the toran. These final lines for the toran are shown in figure 2-23.

Banda Gelek's description now moves on to the perimeters surrounding the mandala. The first two of these have already been drawn as construction lines. They are considered construction lines because parts of them need to be erased as they are overlaid by parts of

the body toran, and the inner one also by corners of the body wall structure.

The inner of these two is a circle through the very end of the central line, a position that is now described as the point of intersection of the central line with the upper line of the guardrail in the upper stage of the body torans. This is the inner line of the perimeter of earth. The next circles for the perimeters measure out from this first one, in body-DU: ½, 1, 1, 1, ½, and 1. The first and last of those have already been drawn. This gives a total of seven circles bounding six perimeters; from the inside these are: earth, water, fire, wind, space, and garland of light.

The space perimeter is now divided into three equal parts. The width of that perimeter is 12 minor units, and so these extra circles are in steps of 4 mu. This forms three narrow bands, the inner and outer of which are the perimeter of space, and the middle is for the vajra garland (*rdo rje 'phreng ba, vajrāvalī*). The circles for these perimeters are shown in figure 2-24.

Another method for the vajra garland, said by Banda Gelek (Bggthig) to be found in Dolpopa's annotated tantra commentary, divides the width of the space perimeter into four, and combining the middle two quarters together, uses these for the vajra garland. This gives a potentially useful additional space for drawing the shapes of the vajras (6 mu rather than 4). This method actually originates in the *Vajrāvalī*, dividing the space perimeter into bands of 3, 6, and 3 mu width.

If drawn, the eight charnel grounds are placed in the cardinal and intermediate directions in the outer half of the perimeter of fire and the inner half of the perimeter of wind. This is the normal way, although some say that the charnel grounds are not in the perimeter of fire but take up the whole width of the perimeter of wind.

The usual names of the charnel grounds (there are many minor variations) are as in Table 10. These names are different from those found in the Chakrasaṃvara tradition, but apart from one other point, their descriptions are the same.

That one difference lies in the fact that when the charnel grounds are positioned in the normal manner overlapping the fire and wind perimeters, the usual pro-

East	Shūlabheda (*rtse mos 'bigs pa*)
Southeast	Ucchiṣṭabhaktra (*lhag ma za ba*)
South	Shavadhana (*ro bsregs pa*)
Southwest	Ghorayuddha (*drag po'i g.yul*)
West	Pūtigandha (*rnag gi dri*)
Northwest	Sarpadaṣhṭa (*sbrul gyis zos pa*)
North	Saklinna (*rul ba dang bcas pa*)
Northeast	Bālamṛtya (*byis pa shi ba*)

Table 10

tectors of the directions (*phyogs skyong, dikpāla*) and protectors of the land (*zhing skyong, kṣetrapāla*) are not drawn. Instead of them are the female prachaṇḍā on their wrathful wheels. However, Tāranātha states that if the charnel grounds are drawn fully inside the perimeter of wind, then the wheels for the prachaṇḍā goddesses are on the very inner edge of the wind perimeter, and the direction and land protectors can be drawn in the outer half of the wind perimeter. However, this is rarely, if ever, done.

Also some state that the wrathful wheels themselves replace the charnel grounds. There are examples of just the wheels being drawn, particularly when the perimeters are drawn narrower than normal, but Tāranātha insists that as the charnel grounds feature in the meditations, so they should be drawn in a mandala, and he backs this up by stating that mandalas observed in India and Nepal generally included fully featured charnel grounds.

In addition to the deities just mentioned, each charnel ground contains, usually drawn against a black background: a mountain, a stūpa, a mahāsiddha, a river, a nāga, a cloud, a tree, and a fire. Not all of these are individually named and described, and in some lists of those that are there are many variations. The following combines the description given by Banda Gelek in *The Illuminating Sun-rays* (Bggthig) together with information from the Chakrasaṃvara cycle given by Tāranātha on the Kṛṣhṇapāda tradition (Tndemnag) and by Tsongkhapa (Tsluido) on the Lūipa tradition. The source for

the trees is the *Saṁvarodaya Tantra*, and the thesis on this text by Shiníchi Tsuda is particularly useful as it includes an edited edition of the Sanskrit original. In the Tibetan texts, the tree names are not translated but given as transliterated Sanskrit.

The eight mountains:

East	Mt. Meru (*ri rab*) composed of the four jewels	four-colored
Southeast	Gandhamādana (*spos ngad ldang ba*)	yellow
South	Malaya mountain(s)	yellow
Southwest	Himavat (*gangs ri*)	white
West	Kailash	white
Northwest	Shrīparvata (*dpal gyi ri*)	blue
North	Mandara	green
Northeast	Mahendra (*dbang chen ri*)	black

Table 11

The stūpas on (or on top of) each mountain:

East	Vajra	white
Southeast	Body vajra	red
South	Black vajra	black
Southwest	Jewel vajra	black
West	Vajra creation	white
Northwest	Dharma vajra	green
North	Composite vajra	yellow
Northeast	Mind vajra	white

Table 12

Alternatively, all the stūpas are white.[2]

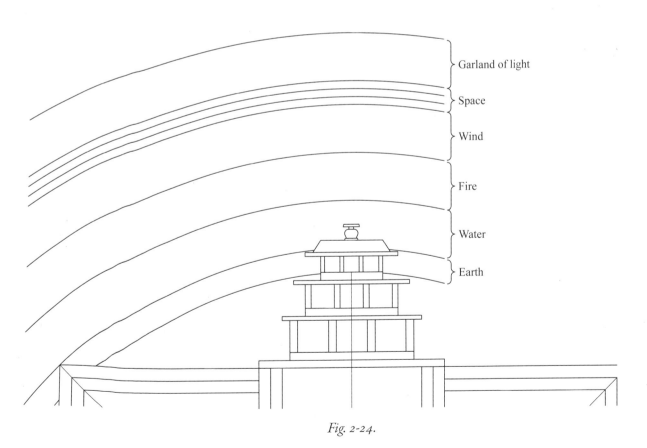

Fig. 2-24.

(Labels on figure, top to bottom: Garland of light, Space, Wind, Fire, Water, Earth)

2. The Tib. term *mchod rten* (Skt. *stūpa*) for these are, respectively, *rdo rje'i mchod rten, sku yi rdo rje'i mchod rten, rdo rje nag po'i mchod rten, rin chen rdo rje'i mchod rten, rdo rje chags pa'i mchod rten, chos kyi rdo rje'i mchod rten, rdo rje 'dus byas mchod rten,* and *thugs kyi rdo rje'i mchod rten.*

The mahāsiddhas in caves in the sides of the mountains

East	Indrabhuti, like a king, with his queen
Southeast	Ḍombhīheruka, riding a tiger
South	Saraha, holding a bow and arrow
Southwest	Vajra Ghaṇṭapa, flying with his consort
West	Kukkuripa, together with dogs
Northwest	Nāgārjuna, as a monk
North	Lūipa, eating fish guts
Northeast	Padmavajra

Table 13

Banda Gelek states that six of these who are with consorts should be drawn in heruka form—but which six? The most likely *not* to have a consort are Nāgārjuna and Padmavajra. The Gelug tradition typically does not identify those residing in charnel grounds. Tsongkhapa states that they should be drawn in contemplation, naked, head shaven, wearing the five (bone) ornaments, the head adorned with skulls, holding a ḍamaru, a skull, and a khaṭvāṅga.

The rivers and nāgas

The rivers are not named, but each has in it a nāga, identified below, half of whose body protrudes out of the water.[3]

East	Yellow Vāsuki (*nor rgyas*)
Southeast	Blue Hulunṭa/Huluhulu
South	White Padma
Southwest	Green Kulika (*rigs ldan*)
West	Black Kārkoṭaka
Northwest	Yellow Shaṅkhapāla
North	Red Takṣhaka (*'jog po*)
Northeast	White Mahāpadma (*padma chen po*)

Table 14

For all of them, the upper half of the body is human-like, with two hands held palms together, holding jewels; they have snake hoods and the lower body is a tail. Tsongkhapa adds that they are marked with:

Vāsuki	blue poppy on hood
Ananta	lotus on head
Padma	many drops on head
Kulika	crescent moon on hood
Kārkoṭa	triple design on neck
Shaṅkhapāla	drop/s(*bindu*) on hood
Takṣhaka	knot of eternity
Mahāpadma	trident on hood

Table 15

3. Tsongkhapa gives these alternatives: Vāsuki is white in color, multicolored Ananta (*mtha' yas*) occupies the Southeast, Kulika is green in color; and Kārkoṭaka blue.

The clouds

In the sky are the eight clouds. Their names, of which there are many variations, are descriptive:

East	Yellow Noisy (*sgrog byed*)
Southeast	Red Covering (*'geb par byed*)
South	Blue Reversing (*ldog byed*)
Southwest	Blue Raining (*char 'bebs*)
West	Red Terrifying (*'jigs byed*)
Northwest	Green Fierce (*gtum po*)
North	Yellow Semicircular (*'khor phyed*)
Northeast	White Dense (*'thug po*)

Table 16

The upper part of each can be drawn in the form of a nāga, the lower part like swirling masses of clouds, all with rain, lightning bolts, and (when imagined in the meditation) resounding with the sound of thunder.

The trees

This is a difficult list, as there are many variations in names as well as corrupt Sanskrit in the Tibetan texts, and it has not been possible to identify all of them here:

East	shirīṣha, siris tree, Acacia sirissa
Southeast	karañjaka, Indian beech, Pongamia glabra
South	cūta, Mango tree, Mangifera indica
Southwest	(latā)parkaṭī, wavy-leaved fig, Ficus infectoria
West	kaṅkelli, Ashoka tree, Saraca indica
Northwest	pārthiva
North	ashvattha, fig tree, Ficus religiosa
Northeast	vaṭa, nyagrodha, banyan tree, Ficus benghalensis

Table 17

The tree in the Northwest is one I have not been able to identify. The Sanskrit name simply means "earth" or "land." When the charnel grounds are drawn fully and placed in the perimeter of wind, at the base of each tree is a direction-protector, and in the middle of each a land-protector. These are not normally drawn in a Kālachakra context, but for the sake of completeness, they are given here.

The direction-protectors

East	White Indra (*brgya byin*), riding an elephant, holding a vajra
Southeast	Red Agni (*me lha*), riding a goat, holding a counting māla
South	Blue Yama (*gshin rje*), riding a buffalo, holding a club
Southwest	Black Rakṣhasa (*srin po*), riding a zombie, wielding a sword (or a curved knife and skull)
West	White Varuṇa (*chu lha*), riding a makara, holding a snake-bond
Northwest	Blue-green Vāyu (*rlung lha*), riding a deer, carrying a flag
North	Yellow Yakṣha (*gnod sbyin*, or Kubera), riding a horse, holding a club
Northeast	White Īṣha (*dbang ldan*), riding an elephant, holding a trident

Table 18

They are all at the base of their respective tree; they are adorned with ornaments and are each attended on the left by their similar consorts. They can all be four-armed, but are mainly imagined as two-armed. Rakṣhasa is wrathful; the others are all peaceful in form. The word for bond (*zhags pa*, *pāśa*), as held by Varuṇa, is usually translated as noose, but this is quite wrong. A noose has a running, or slip, knot. These bonds have no such thing, and usually are just shown as having half-vajras at either end of a cord, or, in this case, just a snake as the bond. Fetter would also be a suitable translation.

Tsongkhapa states that they all have one face and four hands, the first pair of which have the palms placed together; the other left hands hold skulls, embracing their consorts. He gives some other differences, also with the implements held in the right hands:

East	Yellow Indra
Southeast	Agni, a counting mālā and vase
Southwest	Black Rakshasa, naked, crown of human skulls
West	White Varuṇa, seven snake hoods over his head
Northwest	Grey Vāyu
North	Yakṣha, riding a human, holding a jewel-spitting mongoose

Table 19

The land-protectors

Tsongkhapa states that the upper half of the body of each of these land-protectors protrudes out from the branches of the trees. There are two main traditions for their forms, the first of which has each one having the head of the mount for the respective direction-protector. So, for example, the land-protector in the East is simply called elephant-headed, in the Southeast goat-headed, etc. They all hold in their right hands curved knives and in the left skulls of blood.

The other tradition takes their forms from eight door-protector goddesses in the Chakrasaṁvara mandala. Those in the intermediate directions have human forms; for the one in the Southeast the right side of the body is blue, the left yellow; in the Southwest the right yellow and the left red; in the Northwest right red and left green; and in the Northeast the right green and left blue.

East	Light blue Kākāsyā (*khwa gdong ma*), raven-headed
Southeast	Blue-yellow Yamadāḍhī (*gshin rje brtan ma*)
South	Light yellow Shūkarāsyā (*phag gdong ma*), Sow-headed
Southwest	Yellow-red Yamadūtī (*gshin rje pho nya ma*)
West	Light red Shvānāsyā (*khyi gdong ma*), dog-headed
Northwest	Red-green Yamadaṇshtrī (*gshin rje mche ba ma*)
North	Light green Ulūkāsyā (*'ug gdong ma*), owl-headed
Northeast	Green-blue Yamamathnī (*gshin rje 'joms ma*)

Table 20

According to Tāranātha, they are each extremely wrathful, wearing a tiger-skin skirt, with one face and two hands, holding in the right a curved knife and in the left a skull of blood.

The eight fires do not have any particular names or descriptions. Apart from these groups of eight, the charnel grounds contain innumerable siddhas, yogins, and yoginīs, also corpses in various states of burning and dismemberment, skeletons, zombies, yakṣhas, and rākṣhasas, vultures, lion- and tiger-faced beings, wolves, snakes, and other wild animals.

Banda Gelek now describes all the various seats for the deities, starting with that for Kālachakra in the center.

The distance from the center to the inner line of the inner beam (a distance of 6 mu) is divided into three equal parts. The inner of these positions is used to draw a circle, and another is drawn at the edge just touching the inner beam. This means that circles are drawn with radii of 2 and 6 mu. The inner of these forms the receptacle of the lotus, and the space between them is the area for the eight petals of the lotus.

Further arcs are now drawn, with their centers on the eight great lines between the two circles. Their radius is not explicitly given, but a suitable method seems to be to center them approximately 4 mu from the center of

the mandala and for each to have a radius of 2 mu. The points of intersection of adjacent arcs are connected with their opposite points, but without drawing across the receptacle. Once the inner parts of these arcs are removed, this produces the outline of the lotus's eight petals. A similar method is used to draw the petals for the many other lotuses in the mandala. This inner lotus is shown in figure 2-25.

This central lotus is surrounded by the tathāgata-extension, bordered by two sets of beams arranged in squares. This extension holds eight lotuses supporting deities, and eight supporting vases. In the 3D mandala, naturally the pillars stand upright, but in the 2D version only one set of the supporting pillars is shown and these stretch between the inner and outer beams. This forms a set of sixteen cells, in which lotuses for the deities and the vases are to be drawn.

The four cells in the cardinal directions and the four in the intermediate directions, the corners, are all square, 4 mu across. These have circles drawn in them of a radius of 2 mu so that these circles just touch the lines of the beams and the pillars that form each cell. The other eight cells, their positions would usually be described as right and left of each of the four cardinal directions, have circles drawn in them of radius 1½ mu. They are centered in their respective cells, so that they just touch the lines of the pillars that form their cells, but there are gaps of ½ minor unit between these circles and the lines of the beams.

In order to form lotuses, these circles are now divided into three equal parts across a diameter. A circle is drawn through these dividing points and this forms the receptacle. The radius of this circle is therefore one-third the radius of the main circle. The outer section of each circle is for the eight petals of the lotus, and these are formed in the same way as with the central lotus of the chief deity. Part of the tathāgata-extension is shown with some of these lotuses in figure 2-26.

Drawing the lotuses for the vases is not described in this way in the Gelug or Tsami traditions. Instead, the lotuses are expected to be drawn side on, as seats for the vases.

Next, there are twelve lotuses on the deity podium of the mind palace. These are exactly the same size and style (eight-petaled) as those in the 4-mu cells of the tathāgata-extension. There are two lotuses in each of the four directions, right and left of the respective doorways, and there are four in the intermediate directions. The lotuses in the intermediate directions are centered on the diagonal lines, a little less than 21 mu from the central lines; this means that there is a little space around each lotus rather than them being right up against the edge of the podium.

Banda Gelek states that the distance between these points is divided into three equal parts, and at the division points the other lotuses are drawn. In *The Illuminating Sun-rays* (Bggthig) he instead states that these other lotuses are centered 6½ mu right and left of the central lines. The difference is very small (½ mu), and given the second method, the center of the lotus to the right of the western door has coordinates 6½,21.

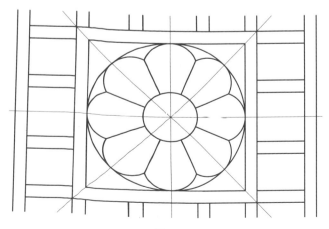

Fig. 2-25.

Fig. 2-26.

The last lotuses in the mind palace are placed in the doorways of the palace. They are the same size and form as the previous lotuses and are placed exactly in the middle of the porch projections. This means they are centered on the central lines, 27 mu from the center of the mandala. Three of these sixteen lotuses of the mind palace are shown in figure 2-27, depicting as usual the northern part of the western side of the palace (the section to the right of the western door; in all such descriptions, right and left are from the point of view of the center.)

The next lotuses described are for the deities of the speech palace. There are eight lotuses on the deity podium, four in the cardinal and four in the intermediate directions. The podium in the speech palace is the same width (4 mu) as that in the mind palace, and so those lotuses in the intermediate directions are drawn exactly as those in the mind palace. They are drawn so that there is a little space around each one and they are not right up against the edge of the podium.

The lotuses in the cardinal directions present a problem in the 2D mandala because the mind torans are drawn right over their position. In fact, their position, right in the middle of each side of the podium, coincides with the central cell of the middle stage of the toran. However, the toran cell is smaller than the size needed for the lotus, and instead of making the lotus smaller, it is drawn full size, overlapping or cutting into the two pillars either side, the beam above and the guardrail below. This is illustrated in figure 2-28.

The description now moves on to the more complex lotuses in the body palace. Instead of eight petals, each of these has twenty-eight. There are twelve of these lotuses, positioned in a similar manner to those on the mind podium: two in each cardinal direction, right and left of the doorways, and one in each intermediate direction.

These are drawn first as circles of a radius of 6 mu. As with the mind and speech palaces, those in the intermediate directions are drawn so that there is a little space around them and they are not touching the lines of the podium. Again, in order to draw those in the cardinal directions Banda Gelek states that the space between these corners should be divided into three equal parts, and yet in *The Illuminating Sun-rays* (Bggthig) he gives the position of the centers of these circles as $27\frac{2}{3}$ mu right and left of the central lines. Again, there is a small difference, and this latter figure actually divides the inner line of the podium into three equal parts. Using this figure, the coordinates of the center of the lotus right of the western gate is $27\frac{2}{3},89$.

Each lotus has four sections: the inner receptacle, a group of four petals, a group of eight petals, and finally a group of 16 petals. Three inner circles need to be drawn to create these sections. This is done by dividing a diameter into seven equal parts and drawing circles through the resulting points. This means that the radius of the inner circle, forming the receptacle, is $\frac{6}{7}$ minor units, the next circle is $2\frac{4}{7}$ mu, and of the third $4\frac{2}{7}$ mu.

There is no description given in the text for the man-

Fig. 2-27.

Fig. 2-28.

Fig. 2-29.

Fig. 2-30.

ner of drawing the petals, but the method given for the inner chief deity lotus can easily be adapted for this purpose. It is important to note that in each ring of petals, one must be facing inward. For those at the corners of the palace, this simply means that in each ring one petal must lie exactly over the diagonal line. The chief deity on the receptacle of each lotus is facing Kālachakra, and one petal in each ring needs to be in line.

With the other lotuses, the same applies, but they are not turned through small angles in order literally to face Kālachakra, or the center of the mandala. Instead, they are drawn so that the lotus's central deity and the petals line up parallel to the relevant central line. A similar logic applies to all other lotuses in the mandala. As examples of these, the lotus right of the western door is shown in figure 2-29, and that in the Northwest is shown in figure 2-30. In that diagram the diagonal line is still shown. The part of it crossing the podium and lotus would of course need to be erased.

Banda Gelek next describes the chariots for the six wrathfuls (door-protectors). These are in the middle of the porch projections of the four doorways of the body palace and above the tips of the eastern and western torans. Each of them requires a square half a body-DU (12 mu) in width.

Construction circles are drawn for each of these. In the four directions there is one in the middle of each of the porch projections, centered on the central lines at a point 114 mu from the center of the mandala. There are two further circles in the eastern and western direc-

tions, centered on points 6 mu along the central lines from the tops of the vases. These circles all have a radius of 8½ minor units.

In each of these circles draw the eight main lines (central and diagonal), and then connect up the points of intersection of the diagonals and the circle to form a square of final lines. These squares have a width of half a body-DU (12 mu). Strictly speaking, a square of diagonal 17 units has a width of 12.02 units. The construction for the square in the western doorway is shown in figure 2-31. The upper and lower chariots fill the spaces between the top of the vases in the East and West and the outer edge of the water perimeter.

These chariots are pictured as drawn by various groups of seven animals and carry the male and female

Fig. 2-31.

Fig. 2-32.

wrathfuls, with the males being the chief deities. However, the chariots are those of the female deities, and as they face in the opposite direction to the males, the draft animals also face in the same direction, those in the doorways therefore facing outward. However, this is not always practicable, and they are often drawn sideways. Also, in the East and West directions, circles are needed just beyond the upper and lower wrathful chariots for the element seats for the upper and lower nāgas. These two are therefore in the outer half of the perimeter of water, and the two element seats are in the inner half of the fire perimeter. I have seen the nāga seats drawn as squares, and as a possible source for this, in his description of the mandala drawing, Tsoknyi Gyatso (Mtkmand) states that immediately beyond the upper and lower wrathful chariots, further chariots should be drawn. This certainly seems to be a mistake, as these nāga seats are of the space and awareness elements and are always described as circular.

Next, in the charnel grounds are needed in each of the eight cardinal and intermediate directions eight-spoked weapon wheels (*mtshon cha'i 'khor lo*), half a body-DU in diameter. Construction lines need to be drawn extending the central and diagonal lines out to the wind perimeter, and where these lines intersect with the outer line of the fire perimeter (the inner wind line), circles are drawn.

These wheels are for the prachaṇḍās, female deities in union with male consorts. Although there are ten prachaṇḍās, only eight wheels are required, as those for above and below require chariots instead. These are drawn in the East (above) and West directions, and they are drawn in the same way as the chariots for the wrathfuls already described. These chariots are drawn just beyond the eastern and western wrathful wheels in the outer half of the wind perimeter. They have no draft animals.

For each of the weapon wheels, draw a circle 6 mu in radius. As before, construct in each of these the eight main lines, and then connect up adjacent points of intersection of the central lines with the circle and also adjacent points of intersection of the diagonal lines. This forms two intersecting squares, the outer lines of which are used to form the points of the wheels. In figure 2-32 these lines are shown straight, and this is how they are often drawn, but the word actually used by Banda Gelek is curved line (*gcus thig*). Most similar wrathful, or weapon, wheels are in fact drawn with the edges as slightly convex curved lines.

A further refinement described by Banda Gelek consists in drawing arcs of suitable sizes centered on the points of intersection of these lines between the spokes of the wheels, thereby forming indents (*nyag mtshams*) between each of the spokes. The partially finished wheel in figure 2-32 shows one of these completed.

Regarding these wheels, the Gelug tradition uses dharmachakras rather than wrathful wheels, even though they are described in the *Vajrāvalī*, presumably the main source, as charnel ground wheels (*dur khrod kyi 'khor lo, śmaśānacakra*). Elsewhere in the *Vajrāvalī*, Abhayākaragupta mentions Dharmachakras, and as these are given a different name, they are presumably intended to be different.

Next, in the porch alcoves (*sgo phug*) just outside the porch projections, on top of the plinths, are seats of the four elements for the nāgas. There are two of these in each direction, with shapes associated with their respective elements: in the East two circles (wind), in the South two triangles (fire) with a vertex pointing outward, in the West two squares (earth), and in the

North two semicircles (water), with their straight edges inward.

Banda Gelek states that the sizes of these are not explicitly given in the tradition, but they should be drawn similar in size to the previous chariots. He is uncharacteristically ambiguous at this point and says that the eastern circles should be drawn with a radius of one body-minor unit. This term, the use of which he generally criticises, can be interpreted as either 4 mu units or 6, depending on whether it is considered to be either one-quarter of a body-DU or one-sixth.

I am assuming the latter definition due to his comment about the earlier chariots and the fact that in *The Illuminating Sun-rays* (Bggthig) he gives their radius as 6 mu. In that text he also gives an exact position: 108 mu from the central lines and 36 mu right and left of the central lines. In other words, the coordinates of the center of the circle right of the eastern doorway are: -36,-108. (The negative values mean for the x-coordinate 36 mu left of the East-West central line, and for the y-coordinate 108 mu below the North-South central line. Additionally, in his description of Dolpopa's method of drawing the mandala, he states that the nāga seats are in line with the centers of the toran pillars, that is, 45 mu right and left of the central lines.

For the triangles in the South, Banda Gelek states that one first draws construction circles of the same size (6 mu radius) and, that having divided the circumference into three equal parts, these points are connected to form equilateral triangles, with one vertex pointing outward.

The squares in the West are drawn 12 mu in width, and Banda Gelek describes them as being like a section of the plinth. This is because they completely obscure the plinth next to the toran pillars.

Colors and designs

Texts describing the drawing of mandalas usually first give the general dimensions and construction of the mandala and then follow this with the colors and designs that are needed once the basic geometry has been produced. Being a particularly detailed work on the man-

Fig. 2-33.

Finally, the semicircles in the North are drawn with a radius of 6 mu, and approximately one-fifth of the circumference is not drawn, but the ends are connected with a straight line. Clearly, this is not exactly a semicircle, although the same word is used in Tibetan (*zla gam*) for both semicircles and this shape. The semicircle left of the northern doorway is shown in figure 2-33. Its center is at 108,36.

In Gelug mandalas one usually sees the northern and eastern positions reversed: with the semicircular disk in the East and circular in the North. This is how it is described by Sherab Gyatso, even though he follows the *Vajrāvalī*, which has circles in the East. Tāranātha mentions this variation and states that it is perfectly acceptable, as the normal (non-Kālachakra) associations are in fact semicircle for wind (black, East) and circle for water (white, North).

At this point, Banda Gelek states that all the remaining parts of construction lines should be erased, as the basic mandala is now finished (figure 2-34 on next page).

dala construction, *The White Crystal Mirror* is unusual in this respect and does not describe the colors, and so the following description of these details is drawn from two other sources: *The Illuminating Sun-rays* by Banda Gelek and extensive descriptions by Tsoknyi Gyatso in

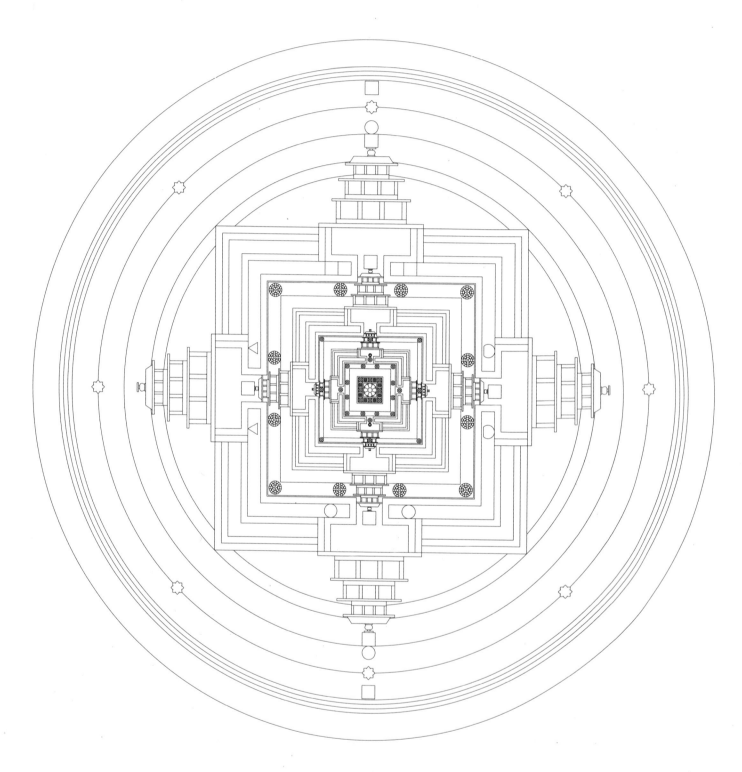

Fig. 2-34. Line structure for the full mandala.

The Melody of the Queen of Spring (Mtkmand), much of which is based again on Banda Gelek.

The most prominent colors in the maṇḍala are those associated with the four directions: East black, South red, West yellow, and North white. These are the same colors as the respective faces of Kālachakra.

The whole structure of the mandala palace sits on a colored ground that bears these four colors, the divisions between them lying along the diagonal lines. For this reason, although many of the diagonal lines need to be erased, those parts where the colored ground is exposed between other components of the mandala are not removed.

The ground in the very center, between the chief deity lotus and the inner beams of the Circle of Great Bliss is colored blue, but beyond this all exposed parts of the colored ground are given the colors of the directions. These parts are the backgrounds within the cells of the tathāgata-extension, the colored ground inside the deity podium in each palace, the narrow gaps, the inside of all doorways and porches, and the offering ground beyond the walls of the body palace up to the inner edge of the perimeter of earth.

The walls of the palaces are more complicated than have previously been described. Those of the mind palace consist of three parallel walls, from the inside colored black, red, and white (in the Gelug tradition, following the *Vajrāvalī*, this order is reversed), and those of the speech and body palaces consist of five walls, from the inside colored green, black, red, white, and yellow.

These walls have small gaps between them—this is not specifically described, but it would make sense for these gaps to be given the colors of the directions, the colors of the ground on which the walls stand.

For the mind palace walls, the space of the total width of the walls (1½ mu) is divided into eight equal parts. Each wall is given a width of two of these units (⅜ mu) and each gap a width of one unit (³⁄₁₆ mu). This is illustrated in figure 2-35.

A similar process is followed for the fivefold walls of the speech and body palaces. The space for the walls is divided into fourteen equal parts, and again two of

Fig. 2-35.

these units is taken as the width of each wall and one unit for the gaps between them. The description in the *Vajrāvalī* has the total width of the mind palace walls being divided into nine parts, and those of the speech and body walls into fifteen. This seems simply to be a different grammar for describing the same division.

For the mind palace this is a fine detail to draw. If the mandala is drawn full size, approximately 20 feet across, the width of each of these gaps becomes just less than ¹⁄₁₀th inch, or just under two millimeters. Most powder mandalas are drawn perhaps a third or a half of this size.

The lotus of the chief deity is colored green and the ground around it blue. The inner beams of the Circle of Great Bliss are blue and the outer beams green. Vajra garlands are drawn on these beams running their entire length. The sixteen pillars drawn between the beams are all black, but with emblems drawn on them. The four in the East have garlands of black swords (with their tips facing outward), those in the South have red "one-eyed" jewels, in the West yellow wheels, and in the North white lotuses.

For all three palaces, the deity podium and plinth are white, and the jeweled frieze is red. The background of the garlands, pipes, and parapets are either blue or black. The details of the garlands themselves and the pipes and parapets are all white.

Regarding the garlands, small pillars are drawn that are yellow in color, and at the top of these are makara (*chu srin*) faces from which hang white garlands between the pillars, with white drops hanging straight

Fig. 2-36.

down. The ends of these are decorated with bells, mirrors, banners, and chowries.

The pipes are drawn like a line of little white bottles, hanging upside down from the parapet, and the merlons of the parapet are drawn in the shape of half lotus petals. In a section of *The Melody of the Queen of Spring*, Lozang Chophel Gyatso writes that the parapet is divided into ten merlons (right and left, each side) shaped like half lotus petals and drawn with white outlines. If the drawing is not too small, each one has an inner and outer petal. These are colored as follows: when the outer petal is blue, the inner is red, and vice versa; when the outer is green, the inner is orange, and vice versa.

Of the torans, all the pillars (those supporting the torans themselves and those in the three stages), the four beams, the three guardrails, and the vase top are all golden yellow. Tsoknyi Gyatso suggests light yellow for the guardrails. Regarding the backgrounds for the cells of the torans: for the lower cells, the middle is green and right and left red; for the middle cells, the middle is red and right and left green; for the upper cells the middle is blue and right and left red. Alternatively: middle maroon, right and left blue; middle green, right and left orange; middle blue, right and left maroon. The canopy (*har mi*) is blue and in the shape and design of a Chinese roof. Lozang Chophel Gyatso elaborates, saying that the outline of the canopy is drawn in blue and the design of the roofing in green. Right and left of the vases are victory banners, and hanging right and left from the ends of the toran beams are chowries, mirrors, victory banners, and flags.

The perimeters are not described in detail. Their basic forms and the designs used in them are considered to be well known, and the details are left up to the artist. The best way of describing them is by means of figure 2-36. At the bottom is the yellow earth perimeter with svastika designs. Sometimes these designs are simpler, but still with rectangular forms. Above is the (predominantly) white water perimeter, next the red fire perimeter, and above that the black wind perimeter. Next is the vajra garland with a green background (no space perimeter in this example), and finally the fire mountain, or garland of light.

Usually, the inner and outer bands of the space perimeter are blue, with the background of the central section green with a blue vajra garland drawn upon it. Lozang Chophel Gyatso states that this is an earlier method and that in many later examples the whole background area is blue and the vajra garland green. In that instance, the lines for the inner band are used only to determine the size of the vajras. A simplified version is shown here (fig. 2-37), just the vajra garland with a green background. At the top is the fire-mountain (*me ri*, also called the garland of light). This would usually have six different colors, of which three are seen here, black, green, and red. In current practice, the six would be, in counterclockwise order: green, blue, black, red, white, and yellow; in older texts they are described as: green, black, red, white, yellow, and blue.

The description now moves on to the seats of all the deities. The receptacle of the chief deity's lotus supports disks of moon, sun, and Rāhu (on top), respectively colored white, red, and deep blue. The lower two will simply be drawn as narrow concentric circles around the main disk of Rāhu. In the Gelug tradition a further yellow disk of Kālāgni is on top, giving a seat of four disks. Regarding the Jonang tradition, in his annotated commentary to the *Vimalaprabhā* (Phviman), Jonangpa Chokle Namgyal states that the triple seat is the purification in the outer worlds of the real sun, moon, and Rāhu, and, in the inner world, of the three channels: rasanā, lalanā and central, respectively. He goes on to state that the method of four seats as followed by Abhayākaragupta and Sādhuputra should be rejected as it contradicts the symbolism.

So, for the Gelug and some others that also use four seats, this derives from the tradition of the *Vajrāvalī*, despite the clarity of the *Vimalaprabhā* on this subject (see the fourth chapter for some further comments on this). In verse 57 of the third chapter, the *Kālachakra Tantra* states that: "On the multi-colored lotus of the Lord of Jinas, are moon, sun and 'fire,' on which is a 'HUM' letter. . . ." Fire is a word for either Rāhu or Kālāgni, and in commenting on this passage, the *Vimalaprabhā* explains that the term multicolored for the lotus means that it should be made green, and that "on its receptacle,

on a moon, sun, and Rāhu, draw in blue powder a letter 'HUM;' or draw a three-tined vajra into which it transforms." Why three-tined? This is a 2D drawing, and the full five tines could not be represented. There is further discussion of this topic in the fourth chapter.

Next, there are eight-petaled white lotuses with (red) sun seats on their receptacles in the following positions: in the four directions of the tathāgata-extension, right and left of East, right of North, right of West, and right and left of South on the mind deity podium, and in the eastern and northern doorways of the mind palace. There are eight-petaled red lotuses with (white) moon seats on their receptacles in the intermediate directions of the tathāgata-extension, left of North, left of West, and left of South, and in the intermediate directions on the mind deity podium, and in the southern and western doorways of the mind palace.

Beyond the mind palace, the four lotuses in the cardinal directions on the speech deity podium and the eight lotuses right and left of the cardinal directions on the body deity podium are all red. The four lotuses in the intermediate directions on the speech deity podium and the four in the intermediate directions on the body deity podium are all white. None of these has either a sun or moon on their receptacle.

The description by Banda Gelek now comes to the feature of the two-dimensional mandala that shows the greatest difference between the different traditions. This is discussed fully in the fourth chapter, and here I only describe the impact this has on the drawn mandala. The deities on the podiums of the speech and body palaces have mounts, animals on which they ride (*bzhon pa*, *vāhana*). In the Jonang tradition the central deity pair of each lotus rides on the animal, and the animal stands on the center of the lotus. In the Gelug tradition the deities stand directly on the lotus and the lotus sits on the animal.

For the Gelug tradition of the drawn mandala this presents no problem, as there is plenty of space on the podiums to draw the animals underneath the lotuses. But for the Jonang tradition, there is a considerable difficulty. If the mandala is drawn full size—just less than 20 feet—the receptacles of the lotuses in both the speech

The draft animals pulling these chariots are[4]:

Eastern door	seven boars
Southern door	seven horses
Western door	seven elephants
Northern door	seven lions
Above chariot	seven three-eyed garuḍas
Below chariot	seven eight-legged lions (*śarabha*)

Table 23

In the outer perimeters, the wheels of the charnel grounds are red in the cardinal directions and white in the intermediate directions, and the above and below chariots (there are no above and below wheels) are respectively green and blue. As with the earlier chariots of the wrathfuls, the above chariot is in the eastern direction.

These wheels are on top of animal mounts. These are:

East	red preta
Southeast	black garuḍa
South	red buffalo
Southwest	naturally colored peacock
West	white elephant
Northwest	white swan
North	white chief ox
Northeast	white lion

Table 24

The rhinoceros is clearly not known in Tibetan circles and so the texts usually describe the animal: it is a kind of deer, with the body of an elephant, the head of a buffalo, with a long neck, thick skin covered in needle-like bristles and a single horn on its forehead. The bherunda is a yellow seabird, smelling of dung, according to Tsok-

nyi Gyatso; the nīlākṣha is a demonic blue/turquoise bird, said to be like a large pigeon with a long turquoise tail.

This completes the description of the seats of the deities in the mandala. The description now moves on to the various ornaments in and around the mandala. For all three palaces, on the corners of the plinths, just beyond the corners of all the walls in the four intermediate directions, are crossed vajras. Also on the plinths, just outside of the porch projection walls inside the porch alcoves, are nine-pointed jewels on top of crescent moons. These jewels are pyramidal in shape with an octagonal base; the base has eight vertices and the ninth is on the top. They are also drawn on the fronts of the pillars (that support the torans) at their base.

The friezes, which are red, are decorated with jewels. These are triangular black, circular white, square yellow, and semicircular red jewels. On top of the parapets are, in the corners, parasols, and, symmetrically between them—that is, in pairs either side of the center of each side—chowries, banners, parasols, flags, and victory banners; these are all drawn as in general mandalas. However, Lozang Chophel Gyatso is a bit more specific: he agrees with the parasols in the corners, and adds that on either side of the torans are, sticking out of golden vases, victory banners, triple ribbons, chowries, and flags. However, the actual ones used depend on the artist's discretion.

The torans are fairly complex, as they each have three cells in each of their three stages. For the body torans in the East, the lower stage has in the middle cell a black Dharmachakra, with on the right a yellow male deer and on the left a yellow female deer. (Right and left here are the reverse of the positions when describing right and left within the mandala palace itself.)

In the South there is a red vase, with on the right a conch and on the left a lotus. In the West is a yellow bodhi tree, with on its right a male kinnara (*mi'am ci*) and on the left a female kinnarī. These human-like forms are said by Banda Gelek to be drawn in the form of

4. The garuḍas mentioned here should be of five colors, and the eight-legged lions are either blue or black, with yellow wings projecting from each of their shoulders and hips. The other draft animals are all the colors of their respective directions.

gandharva daughters, female spirits. The word nymph seems appropriate here.

In the North is a great white drum, on its right a white square club tipped with a jewel and on its left a white hammer with a square head. In the Jonang tradition, this description of right and left of the central object means in the cells to the right and left on the lower stage of the torans. However, some draw all three objects in the central cell, and have offering goddesses in the right and left lower cells.

Just outside the outer pillars of the lower stages of all the torans are lions supported on the backs of elephants, with their faces looking up and with their front two paws supporting the beams of the middle stage.

Similarly, just outside the outer pillars of the middle and upper stages are female figures supporting the beams above. These are called "shālabañjikā," and Banda Gelek states that they should be drawn like female kin-naris. He is a bit off the mark there. The shālabañjikā is a very particular form that evolved from the concept of the ashoka tree, that would not bloom until touched by a young female, and the image of a young woman grasping the bough of a tree, with one leg crossed in front of the other, became common in Buddhist art, evolving into these statues that support beams in the torans of maṇḍalas. Early examples can be seen at the great stūpa at Sāñcī.

In all the other cells of the torans are drawn various offering goddesses.

The sun and moon are drawn on the perimeter of earth, both half a body-DU in diameter. The white moon is drawn full, slightly to the east of Northeast (a little clockwise from Northeast), and the red-yellow sun is drawn slightly to the west (also a little clockwise) of Southwest. The *Vajrāvalī* gives these each a diameter of 12 mu.

Representations of the deities

There are four ways in which deities are represented in the drawn mandala—as little bindu (small circles drawn in the position of the deity), the seed character of the deity, the emblem of the deity, or the image of the deity itself.

Clearly the size of the mandala and the time available for drawing will have a big impact on the choice of representation. Taking the central deity Kālachakra as an example, on the central lotus are drawn a moon, sun, and Rāhu disk. This means that the Rāhu disk forms a circle slightly smaller than the receptacle of the lotus and narrow rims of red and white surround it, indicating the lower sun and moon disks.

The representation of the deity goes in the middle of this circle. The full forms of the deities are described in the fourth chapter, and these will not normally be drawn in a powder mandala for a major ritual. The full forms would normally only be drawn in a painted mandala, and in that instance the dimensions of the lotuses will usually be exaggerated.

Kālachakra is in union with Vishvamātā, and when the two of them are drawn in full, they are represented with their heads to the West. When a painted mandala is hung on a wall, the eastern side is placed downward, and so the deities are drawn upright for such an orientation, that is, heads facing West, feet facing East. A similar rule follows for other deities. They are drawn with their heads to their own relative west direction. For any deity, relative east is the direction toward either that deity's chief deity (for example, the yoginīs on the petals of lotuses) or the center of the mandala.

When they are drawn in full, one of the two deities is considered to be the chief of the pair. In the example of Kālachakra this is Kālachakra himself, and so the pair are drawn with Kālachakra facing the viewer of the drawing and Vishvamātā with her back to the viewer. In the three-dimensional mandala, Kālachakra faces East, and she therefore has her back facing East.

Similarly, a buddha such as red Ratnasambhava is represented as the chief of a pair in the South of the tathāgata-extension, and so his consort, white Māmakī, has her back to the viewer in a drawn mandala. However, in the Northeast of the tathāgata-extension, the same pair appears again, but Māmakī is in this instance

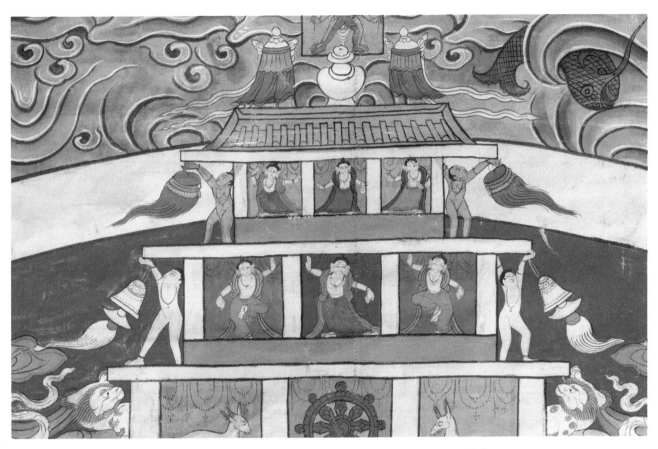

Fig. 2-37. Eastern body palace toran. Jayul Monastery mandala.

the chief, and she is drawn in union with Ratnasam-bhava, but it is then he who has his back to the viewer. In the three-dimensional mandala, in that latter instance, Māmakī is facing the center of the mandala and Ratna-sambhava has his back to the center.

The simplest representation of the deities is in the form of bindu. When there is a pair of deities, they are both represented with the bindu of the chief deity underneath and that of the other deity drawn on top, slightly smaller and usually on the eastern side. Banda Gelek describes that the male bindu is drawn on the right and that of the female on the left, and that they may also be respectively above and below as I have just described. When the male deity is the chief of the two, he states that the lower is drawn to the right and the upper to the left; however when the female is the chief of the two, the lower is to the left and the upper to the right. It is also sometimes the case that the two bindu are drawn separately side by side.

This description is best explained be means of the diagrams in figure 2-39, in which the two deities are indicated by the capital letters of their names. By right and left, Banda Gelek is maintaining the convention that these are from the point of view of the deity, as is the case when describing the positioning of deities right and left of the doorways. The simple case of two sepa-rate bindu is illustrated by the top diagram, with Kāla-chakra on the left from the point of view of an observer. If Kālachakra were actually drawn, he would be facing an observer of the diagram, and so his right would be to the left of the diagram. The arrangement in this top diagram would also be used if emblems were drawn for the deities, with a vajra in place of Kālachakra's bindu next to the bindu for Vishvamātā, who is not normally represented by an emblem.

The middle diagram shows Kālachakra as the lower (and larger) of the two bindu, with that for Vishvamātā drawn on top and to Kālachakra's left side (right as one looks at the diagram). The final diagram shows a more common format, with the bindu for Vishvamātā on

Fig. 2-38. Shālabhañjikā at Sanchi; she is supporting one end of the lowest stage of the toran.

top of Kālachakra's, but to the eastern side. This reflects their positioning in the full meditational form of the mandala, in which Kālachakra faces East, and Vishvamātā's back faces East.

Neither *The Illuminating Sun-rays* nor *The Melody of the Queen of Spring* gives a full list of the seed-characters or emblems of the deities. These texts simply state that if the seeds or emblems are to be drawn, then only that of the chief deity in any pair is used. (It should be pointed out that, at least in the case of Kālachakra and Vishvamātā, both emblems are often drawn.) These texts go through giving the colors, including those of both when

there is a pair of deities, and so they are mainly describing the deities from the point of view of the placement of bindu.

The main source in the Jonang tradition for the emblems is Tāranātha's text explaining the empowerment ritual, the *Ocean of Nectar* (Kacoin); also both the *Vimalaprabhā* and the *Vajrāvalī* give lists of most of the emblems. These lists mainly agree, particularly the *Vimalaprabhā* and Tāranātha. Both these sources give alternatives for some of the emblems and usually the alternative comes from the *Vajrāvalī*.

In any particular tradition use will be made of meditation texts in that tradition, in which the seeds and emblems of all the deities in the mandala are given together with descriptions of the deities. There will be differences in the application of some of these emblems due to artistic variation in, for example, how an incense burner should actually be drawn, but the other differences between the traditions all seem to have their origin in the choices given in the *Vimalaprabhā* itself, the original source for the description of the Kālachakra mandala.

The list given here is based on Tāranātha, with some variations and alternatives also described.

Blue and yellow are the colors needed for the two bindu, blue being that of the chief deity, in this case Kālachakra; HUM is the seed character that would be drawn, and the emblem is the three-tined vajra. Whichever of those is drawn, the color would be that of the chief deity, Kālachakra. Only his name is given, because the other deity, if there is a pair, is found in the full description given in the fourth chapter.

The order given is not that supplied in the *Vimalaprabhā*, which follows the categories of the deities. Instead, the following lists start at the center, and then East (or Northeast) and progresses clockwise. So for the central lotus of the chief deity, see Table 25 on the next page.

There will often be variations in texts between the use of a short "HUM" and long "HŪM" as the seed of Kālachakra, the vowel either being short or long. The long is generally associated with speech vajra and the short with mind vajra, and as this mandala is that of

Fig. 2-39.

the mind vajra Kālachakra, I have given here the short "HUM"; this is also the form given in this context in the two most authoritative texts, the *Vimalaprabhā* and Abhayākaragupta's *Niṣpannayogāvalī*. This difference is important in many instances in Kālachakra literature, not only with regard to the seed of Kālachakra, and the discrepancies between different texts are innumerable. It should also be mentioned here that the emblem divine food will often be represented as a torma in the

Center	blue, yellow	HUṀ	three-tined vajra	Kālachakra
East	black	A	censer	Kṛṣhṇadīptā
Southeast	black	HA	chowry	Dhūmā
South	red	AḤ	lamp	Raktadīptā
Southwest	red	HAḤ	chowry	Marīchī
West	yellow	Ā	conch	Pītadīptā
Northwest	yellow	HĀ	chowry	Pradīpā
North	white	AṀ	divine food	Shvetadīptā
Northeast	white	HAṀ	chowry	Khadyotā

Table 25

Tibetan traditions. As the stylised form of torma was devised in Tibet, this would almost certainly not have been the case in Indian representations. The chowries are the colors of their directions.

Southeast	black	HUṀ	wish-fulfilling jewel
Southwest	red	ĀḤ	Dharma-semantron
Northwest	yellow	HOḤ	wish-granting tree
Northeast	white	OṀ	Dharma-conch

Table 26

resented as either bindu or seed-characters, or by just using the emblems themselves.

The semantron is a long gong used in monasteries. For further details see the description by Gregory Sharkey in *Buddhist Daily Ritual* (Gsdarit).

The next set of deities is the buddhas and their consorts, and they have between them a set of eight vases. These are positioned right and left of the buddhas, and so in the eastern direction is the buddha Amoghasiddhi, and right and left of him, when viewed from the center of the mandala, are two vases. In most meditation texts the colors of the vases are given as white, and presumably their seed-characters would also be white. The *Vimalaprabhā* does not give the colors for these. The vases themselves are usually drawn, rather than rep-

Just outside the central lotus, in the corners formed by the inner beams of the tathāgata-extension, are four emblems, rather than deities. These can also be rep-resented by a seed. Each vase has a lotus in its mouth, the two vases given as being in the eastern and western doorways of the mind palace are drawn just above (that is, farther out from the center) the wrathful deities in those doorways, the above vase being in the East, and that below in the West. See Table 27.

The buddhas and their consorts are in the cardinal and intermediate directions of the tathāgata-extension. See Table 28.

Tāranātha (Kacoin) gives the alternative emblems above, such as Tārā's utpala flower rather than the sword. It should be noted that the utpala is often confused with a lotus but is in fact the famous Himalayan poppy, particularly the blue form. This and other alternatives, except where otherwise stated, come from *Vajrāvalī*,

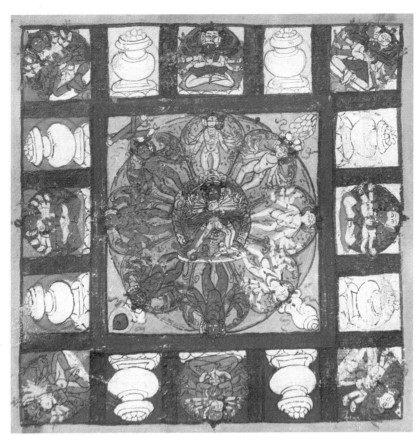

Fig. 2-40. The Circle of Great Bliss.

LoE	HI	RoE	HĪ
LoS	HṚ	RoS	HṜ
LoW	HḶ	RoW	HḸ
LoN	HU	RoN	HŪ
Eastern doorway	HAṀ	Western doorway	HAḤ

Table 27

East	black, yellow	I	sword	Amoghasiddhi
Southeast	black, yellow	Ī	sword or blue utpala	Tārā
South	red, white	Ṛ	jewel	Ratnasambhava
Southwest	red, white	Ṝ	jewel or lotus	Pāṇḍarā
West	yellow, black	Ḷ	wheel	Vairochana
Northwest	yellow, black	Ḹ	wheel	Buddhalochanā
North	white, red	U	lotus	Amitābha
Northeast	white, red	Ū	lotus or utpala	Māmakī

Table 28

which states that Ratnasambhava's jewel is nine-pointed. Notice that the utpala in the Southeast is given as blue. It is often the case that emblems or seeds in the East or Southeast are blue rather than black. This will be a deep blue, rather than the more primary blue for deities in the lower direction. Deep blue is interchangeable with black and often gives a better-looking result.

At this point the *Vimalaprabhā* mentions that emblems are not needed for the purity of the elements of space and consciousness (usually, awareness), as these are in fact the vajra in the center. In other words, the buddhas Akṣhobhya and Vajrasattva are considered to be inherent in Kālachakra just as their consorts are also inherent in Vishvamātā. They therefore do not have separate representation within the mandala.

LoE	blue, green	AṀ	vajra	Samantabhadra
RoE	black, yellow	E	sword	Khagarbha
Southeast	black, yellow	AI	sword or cloth	Sparshavajrā
LoS	green, blue	A	vajra	Vajrapāṇi
RoS	red, white	AR	jewel	Kṣhitigarbha
Southwest	red, white	ĀR	jewel or bowl of supreme flavor	Rasavajrā
LoW	green, blue	Ā	vajra or dharmodaya	Dharmadhātuvajrā
RoW	yellow, black	AL	wheel	Nīvaraṇaviṣhkambhin
Northwest	yellow, black	ĀL	wheel or conch of perfume	Gandhavajrā
LoN	blue, green	AḤ	vajra or vīna	Shabdavajrā
RoN	white, red	O	lotus	Lokeshvara
Northeast	white, red	AU	lotus or mirror	Rūpavajrā

Table 29

Next are the male bodhisattvas and their consorts, on the deity podium of the mind palace. See Table 29.

Alternatives are given here for each of the goddesses. They represent the purified sense objects, and the alternative emblems represent those sense objects themselves. Their association with the sense objects, in the same order as above, are: texture, taste, concepts, smell, sound, and form.

The next emblems are those of the wrathful deities in the doorways of the mind palace. See Table 30.

A point worth mentioning is that the *Vimalaprabhā* simply gives the characters as plain "YA," "RA," etc., but most later texts use the nasalized forms I have given here.

Finally, for the mind palace, there are the offering goddesses on the plinth. See Table 31.

Abhayākaragupta adds that the emblems in the

East	black, yellow	YAṀ	sword	Vighnāntaka
South	red, white	RAṀ	club	Prajñāntaka
West	yellow, black	LAṀ	hammer	Yamāntaka
North	white, red	VAṀ	lotus	Padmāntaka

Table 30

LoE	black	CCHJJHÑA	conch	Gandhā
RoE	black	CCHJJHÑĀ	garland of flowers	Mālā
LoS	red	ṬṬHḌḌHṆA	bowl of incense	Dhūpā
RoS	red	ṬṬHḌḌHṆĀ	lamp	Dīpā
LoW	yellow	TTHDDHNA	head ornament	Lāsyā
RoW	yellow	TTHDDHNĀ	jeweled necklace	Hāsyā
LoN	white	PPHBBHMA	fruit	Navedyā
RoN	white	PPHBBHMĀ	bowl	Amṛtaphala
Eastern toran	green	KKHGGHNGA	drum	Vādyā
Western toran	green	KKHGGHNGĀ	cloth	Nṛtyā
Northern toran	blue	ṢHPṢHṢHKA	vajra	Gītā
Southern toran	blue	ṢHPṢHṢHKĀ	lotus	Kāmā

Table 31

western direction are yellow and those in the northern direction white, the colors of their directions; also that Mālā's garland is of blue flowers and Dhūpā's incense bowl is red. He also adds that the bowls in the North are both skulls and that the toran drum in the West is a *paṭaha*, a traditional Indian kettledrum, a type usually used for proclaiming some event.

These characters are considered to be stacked. For example, with CCHJJHÑA, the character CA is on top, below it CHA, then JA, JHA, and finally ÑA on the bottom. The green and blue goddesses are to be drawn in the middle cells of the upper stages of the torans of the mind palace.

There is an inconsistency in the *Vimalaprabhā* regarding two of these goddesses. The current list is from the commentary to verse 62 of chapter three, but there the actual association given is: KKHGGHNA, cloth, Nṛtyā; KKHGGHNĀ, drum, Vādyā.

I have reversed the seeds for the goddesses, according to the order given in the *Vimalaprabhā* at verse 4 of chapter four; this is also the method most commonly used in later texts. I presume that the order given in chapter three is an error. There are other inconsis-

tences regarding these goddesses in chapter four of the *Vimalaprabhā*. Gītā and Nṛtyā are reversed in verse 4. According to Dolpopa, this is due to an error in one of the original Sanskrit texts used; the modern critically edited Sanskrit edition does indeed show variants that support this. Also, in verse 42, six of the goddesses are in different positions. This is during the description of the creation process: Vādyā and Nṛtyā are above rather than in the North; Gītā and Kāmā are below rather than above; and Navedyā and Amṛtaphala are in the North rather than below. Again, according to Dolpopa, the arrangement in the third chapter follows the elemental classification of the seeds, but the arrangement in verse 42 is not wrong and is according to the elemental classification of the channels that they purify. As he uses in his sādhana the arrangement from chapter three, I have done the same here, with the one correction of swapping the long and short vowels for Nṛtyā and Vādyā.

The *Vajrāvalī* adds some interesting details by stating that left of South is a censer rather than just a bowl of incense, left of North is a skull bowl full of white fruit, and right of North is a skull bowl full of white nectar.

This completes the deities of the mind palace, and

we now come to the deities on the eight lotuses in the speech palace. On each lotus there is a male and female deity (with the female the chief, facing the center of the mandala) surrounded by eight yoginīs.

Care needs to be taken with the ordering of the lotus petals. In most texts they are described in the order: front, back, right three, and then left three. The front petal is the one facing the center of the mandala, and so is in front of the chief goddess of the lotus. The rear petal is the reverse of this, behind the central goddess. The right three are the three next to the front petal, in clockwise order, and the left three are those following the rear

petal, also clockwise. Sensibly, as well as describing them in this order, the *Vimalaprabhā* also numbers the petals, the front being number one, and then simply counting around in clockwise fashion, the rear petal therefore being number five. I shall follow this numerical order.

As an example, on the eastern lotus, arisen from "HA" is black, yellow Charchikā in union with her male consort, yellow Indra. Immediately in front of her is Bhīmā arisen from "HI," next around to the right is Ugrā arisen from "YA," etc. All are black and wielding a curved knife. See Table 32. In the following, "C" stands for center, the chief goddess of the lotus.

East:

C	HA	Charchikā
1	HI	Bhīmā
2	YA	Ugrā
3	YI	Kāladaṃṣṭrā
4	YṚ	Jvaladanalamukha
5	HĪ	Vāyuvegā
6	YU	Prachaṇḍā
7	YḶ	Raudrākṣhī
8	YAṂ	Sthūlanāsā

Table 32

South, where each is red and wielding a club:

C	HAḤ	Vārāhī
1	HṚ	Kaṅkālī
2	RA	Kālarātrī
3	RI	Prakupitavadanā
4	RṚ	Kālajihvā
5	HṜ	Karālī
6	RU	Kālī
7	RḶ	Ghorā
8	RAṂ	Virūpā

Table 34

Southeast, where each is black and holding a wheel:

C	KṢA	Vaishṇavī
1	KṢI	Shrī
2	YĀ	Māyā
3	YĪ	Kīrti
4	YṚ	Lakṣhmī
5	KṢĪ	Vijayā
6	YŪ	Shrījayā
7	YḶ	Shrījayantī
8	YAḤ	Shrīcakrī

Table 33

Southwest, where each is red and wielding a spear:

C	KṢAḤ	Kaumārī
1	KṢṚ	Padmā
2	RĀ	Anaṅgā
3	RĪ	Kumārī
4	RṚ	Mṛgapatigamanā
5	KṢṜ	Ratnamālā
6	RŪ	Sunetrā
7	RḶ	Klīnā
8	RAḤ	Bhadrā

Table 35

West, where each is yellow and holding a vajra:

C	HĀ	Aindrī
1	HḶ	Vajrābhā
2	LA	Vajragātrā
3	LI	Kanakavatī
4	LṚ	Urvashī
5	HḸ	Chitralekhā
6	LU	Rambhā
7	LḶ	Ahalyā
8	LAṀ	Sutārā

Table 36

North, where each is white and wielding a trident:

C	HAṀ	Raudrī
1	HU	Gaurī
2	VA	Gaṅgā
3	VI	Nityā
4	VṚ	Turitā
5	HŪ	Totalā
6	.VU	Lakṣhmanā
7	VḶ	Piṅgalā
8	VAṀ	Kṛṣhṇā

Table 38

Northwest, where each is yellow and holding a bowl:[5]

C	KṢĀ	Brahmāṇī
1	KṢḶ	Sāvitrī
2	LĀ	Padmanetrā
3	LĪ	Jalajavatī
4	LṜ	Buddhi
5	KṢḶ	Vāgīshvarī
6	LŪ	Gāyatrī
7	LḸ	Vidyut
8	LAḤ	Smṛti

Table 37

Northeast, where each is white and holding a lotus:

C	KṢAṀ	Lakṣhmī
1	KṢU	Shrīshvetā
2	VĀ	Chandralekhā
3	VĪ	Shashadharavadanā
4	VṚ	Haṁsavarṇā
5	KṢŪ	Dhṛtī
6	VŪ	Padmeṣā
7	VḶ	Tāranetrā
8	VAḤ	Vimalashashadharā

Table 39

East	yellow vajra	Southeast	yellow needle
South	white trident	Southwest	white axe
West	black blazing sword	Northwest	black wheel
North	red club	Northeast	red spear

Table 40

5. An alternative emblem is given in the *Vimalaprabhā*: a needle. The term "bowl" (*snod* in the *Vimalaprabhā*) is considered by some to mean the type of bowl used as a monk's alms bowl. The Tibetan term for this (*lhung bzed*), annotated here by Buton, suggests this. The term used in the Jonang tradition is *par bu*, which usually simply means a small bowl with a lid. The *Vajrāvalī* has instead here a yellow-tipped brahmadaṇḍa. Similarly, in the Northeast, the *Vimalaprabhā* has sword rather than lotus.

Above, Tāranātha also gives the emblems for the male consorts, should one wish to include them. He states that if these are used, then the chief goddess's emblem is placed in the center and the male emblem on its right.

Next are the deities of the body palace podium. There are twelve lotuses on the podium, each with twenty-eight petals. On the receptacle of each lotus there is a male and female deity (with this time the male the chief, instead of the female, facing the center of the mandala) surrounded by twenty-eight yoginīs.

The ordering of the lotus petals is quite different from the lotuses in the speech palace, and the structure of the list of characters from which these deities arise is also different. There are deities in each group, and their seed-characters are a combination of a group of five consonants with six vowels. For example, on the lotus right of the eastern door, the set of consonants is CA, CHA, JA, JHA, and ÑA. These are combined in reverse order with the vowels: A, I, Ṛ, U, Ḷ, and AṀ. This produces the following list of 30 characters:

ÑA, ÑI, ÑṚ, ÑU, ÑḶ, ÑAṀ, JHA, JHI, JHṚ, JHU, JHḶ, JHAṀ, JA, JI, JṚ, JU, JḶ, JAṀ, CHA, CHI, CHṚ, CHU, CHḶ, CHAṀ, CA, CI, CṚ, CU, CḶ, CAṀ.

These represent the thirty lunar days of the month of Chaitra, and the deities for the fifteenth (full moon) and thirtieth (new moon) lunar days are respectively the female and male deities on the receptacle of the lotus. Their characters are JṚ and CAṀ. The remaining twenty-eight characters are placed sequentially on the petals of the lotus, but exactly how is not described clearly in the *Vimalaprabhā*.

The description of these characters is given in the fourth chapter (verse 84), but the text reads as if there were two rings of petals, each with fourteen petals. This would actually make a lot of sense symbolically, with one ring for the remaining lunar days of each lunar fortnight. However, when the lotuses themselves are described, earlier in chapter four and also in chapter three, they are given as having three rings of petals, of four, eight, and sixteen petals each. Perhaps there were

alternative, even competing designs, as the final structure of the mandala was being developed. It is possible that this is the reason for the few inconsistencies such as this that we see in the *Vimalaprabhā*.

With the *Vimalaprabhā* being somewhat unclear on this point, there is not complete agreement on how these characters are arranged. In the *Niṣpannayogāvalī* (Niṣpann), his companion text to the *Vajrāvalī*, Abhayākaragupta states that the characters are arranged starting from the eastern petal of the outer ring of petals. (The eastern petal is the one facing the center of the mandala.) However, in an early comment in the fourth chapter of the *Vimalaprabhā*, the inner ring of four petals is called the first ring, the middle ring the second, and so forth. This seems to imply the method of both the seventh Dalai Lama, Kalzang Gyatso, in his sādhana for Kālachakra (Kgkdzhal), and Banda Gelek (Bgslos) in his text on the 3D Kālachakra mandala, who both state that first is the eastern petal of the inner ring.

The order then proceeds clockwise, moving to the eastern petal of the middle ring after the inner is complete, and so on. The characters are placed in the order given above, with "JṚ" and "CAṀ" omitted, as their deities are on the receptacle.

Moving around the mandala clockwise, the next lotus is in the Southeast, and the vowels are now long, and combined with the same consonants, but in the normal order:

CĀ, CĪ, CṜ, CŪ, CḸ, CAḤ, CHĀ, CHĪ, CHṜ, CHŪ, CHḸ, CHAḤ, JĀ, JĪ, JṜ, JŪ, JḸ, JAḤ, JHĀ, JHĪ, JHṜ, JHŪ, JHḸ, JHAḤ, ÑĀ, ÑĪ, ÑṜ, ÑŪ, ÑḸ, ÑAḤ.

As before, the fifteenth and thirtieth of these, JṜ and ÑAḤ, are respectively for the female and male deities on the receptacle, and are omitted from the group when placing them on the petals.

In this way the twelve lotuses, taken in six pairs, have sets of characters on them combining six different groups of consonants with the six vowels, alternately in short and long forms. The full list, together with the

LoE	green, blue	KA KHA GA GHA ṄA	wheel	Viṣṇu
RoE	black, yellow	CA CHA JA JHA ÑA	sword	Nairṛti
Southeast	black, yellow	CA CHA JA JHA ÑA	wishing tree	Vāyu
LoS	green, blue	KA KHA GA GHA ṄA	club	Yama
RoS	red, white	ṬA ṬHA ḌA ḌHA ṆA	lance	Agni
Southwest	red, white	ṬA ṬHA ḌA ḌHA ṆA	spear	Ṣaṇmukha
LoW	blue, green	SA ḤPA ṢA ŚA ḤKA	mace	Yakṣha
RoW	yellow, black	TA THA DA DHA NA	vajra	Shakra
Northwest	yellow, black	TA THA DA DHA NA	needle	Brahmā
LoN	blue, green	SA ḤPA ṢA ŚA ḤKA	trident	Rudra
RoN	white, red	PA PHA BA BHA MA	bond	Samudra
Northeast	white, red	PA PHA BA BHA MA	axe	Gaṇapati

Table 41

emblems that may be drawn instead of the characters and the chief deity names, is:

Left of West, Tāranātha has a jewel-tipped mace, whereas the *Vimalaprabhā* has a mace and the *Vajrāvalī* a jewel. In each group, the male deity is the chief of the two in the center and has the same color as the surrounding yoginīs, the yoginī with whom he is in union being the opposite color. For example, on the first lotus, Nairṛti is black; he is in union with yellow Jṛvajrā; and they are surrounded by twenty-eight black yoginīs.

There is a difference here in the tradition of the *Vajrāvalī* (particularly as followed in the Gelug tradition), for in that system the deities left of each of the doorways are the colors of their respective directions instead of blue or green. This means, for example, that the chief deities on the lotuses left of East, right of East, and in the Southeast will all be black with yellow consorts. Their retinues will also all be black. Identification of this feature is the easiest way to recognise a mandala from Abhayākaragupta's tradition.

Next are the wrathful deities in the doorways of the body palace, plus one above and one below. As mentioned before, these all ride chariots, each drawn by seven draft animals. Pairs of seeds are given for each of these, and these are listed here in the order: male, female. They are sometimes given the other way around, because the chariots belong to the female deities, and so in that sense they are the chief deities within the pairs. However, of the main four, the females are facing out of the doorways—riding out of the palace, looking ahead—and their male consorts face in toward the center of the mandala. In that sense, the males are the chief deities and would be drawn as such in a full mandala. Perhaps for this reason, Tāranātha lists the emblems for both male and female deities. The *Vimalaprabhā* gives these seed-characters somewhat differently. For example, the eastern YA and LĀ are given as YAṀ and LĀḤ. I am using here the normal convention followed by Tāranātha and others.

There are also differences between the traditions for the above and below deities. The *Vajrāvalī* has for above just a green vajra and for below a blue trident. The *Vimalaprabhā* gives these same emblems but does not describe their colors. Tāranātha seems to be following the hand emblems of the deities; both green deities are identical in their main forms, and so are the blue. The green deities hold in their first right hand an axe, and the blue deities hold in their second right hands a vajra.

The trident is held in the second right hand of the green deities, and so one wonders why Tāranātha has the female emblems as he does. There is no blue deity holding a trident, as the *Vajrāvalī* seems to suggest.

In Chokle Namgyal's annotations to the *Vimalaprabhā* (Phviman3) he notes that the above vajra is the emblem of the blue female deity and the below trident is that of the green female deity. That solves the problem of there being no blue deity holding a trident and is compatible with Tāranātha's position. Buton does not agree, and in his *Vimalaprabhā* annotations he associates the vajra and trident with the male deities, a position that seems illogical.

In the following list, the colors, seeds, and emblems are given with the males first:

Eastern door	black, yellow	YA & LĀ	club & mace	Krodhanīladaṇḍa
Southern door	red, white	RA & VĀ	arrow & pestle	Ṭakkirāja
Western door	yellow, black	LA & YĀ	mace & club	Mahābala
Northern door	white, red	VA & RĀ	pestle & arrow	Achala
Above	green, blue	HAṀ & HĀ	axe & vajra	Uṣṇīṣhachakrin
Below	blue, green	HA & HĀ	vajra & trident	Sumbharāja

Table 42

Next are the seeds and emblems for the nāgas. These are on the plinths, right and left of the doorways of the body palace. Tāranātha states that the emblem for each of these is a vase, which makes sense as each deity holds a vase in its first right hand. Although he gives no colors for these, they presumably should be the colors of the directions. The *Vimalaprabhā* gives a different set of emblems, as given in the following list:

LoE	black, yellow	HYA	victory banner	Karkoṭaka
RoE	black, yellow	HYĀ	victory banner	Padma
LoS	red, white	HRA	svastika	Vāsuki
RoS	red, white	HRĀ	svastika	Shaṅkhapāla
LoW	yellow, black	HLA	vajra	Takṣhaka
RoW	yellow, black	HLĀ	vajra	Mahāpadma
LoN	white, red	HVA	lotus	Ananta
RoN	white, red	HVĀ	lotus	Kulika

Table 43

There is something that does not seem quite right about this *Vimalaprabhā* description. Going back to the listing of the seats of these deities, the disks of the elements were then described as being marked with bindus, svastikas, vajras, and lotuses. This earlier description reads as a decoration of the elemental disks, and yet the current list is of the emblems of the deities. It does not seem right, for example, to draw a yellow square of the element of earth, have this marked or decorated with a vajra, and then draw another vajra on top of this as the emblem of the deity.

The description of these emblems is given twice in this manner in the *Vimalaprabhā*, the only difference being the alternative victory banner as an emblem, and

Thekchog Dorje, for example, gives a direct choice here: a drop or victory banner. Although this might seem surprising, it is in fact usual that the elements themselves when represented are considered to be marked with these emblems: the water element marked with a lotus, and so forth. See, for example, the description of the elemental disks in the world-system mandala, in the third chapter. In sādhanas, the nāga deities also form from these emblems, and so, continuing the example, on top of a disk of the element of water, marked with a lotus, from another lotus arises Ananta, and so on. In practice, of course, it would not make sense to draw, say, one lotus on top of another. However, if drops are used to represent the deities, the emblems still need to be drawn as marking the elemental disks. Tāranātha's method of vases for the emblems solves this problem.

There are also two nāgas for above and below that are usually represented in the mandala. According to Banda Gelek (Bggthig), these are placed on the circular disks of the respective elements, described earlier, green space element just beyond (outside of) the position of the above chariot in the East, and blue awareness, just beyond the position of the below chariot in the West. Unfortunately, he gives neither seeds nor emblems for these, just their colors: on the green space disk the male is green and the female blue, on the blue awareness disk the male is blue and the female green. Tāranātha would presumably have vases as the emblems for these two, although he does not explicitly say so.

As it happens, the *Vajrāvalī* states, in the context of describing the elemental disks for the other nāgas, that these two nāgas are represented by vases of nectar, green Jaya (consort is blue) right of the circular disk of wind, right of the doorway in the East, and blue Vijaya (consort is green) left of the square disk of earth, left of the doorway in the West. He places them in different positions, but the vase emblems seem appropriate.

As far as seed-characters are concerned for these two, in the Gelug tradition the seed for Jaya is HUṀ and for Vijaya KṢUṀ; these are also found in the early Indian sādhana, *Kālacakrasādhana*, by Sādhuputra (Spksadh) and in the writings of Karmapa Mikyö Dorje (Mdphend). Tāranātha (Kasain) notes these seeds, but states they are

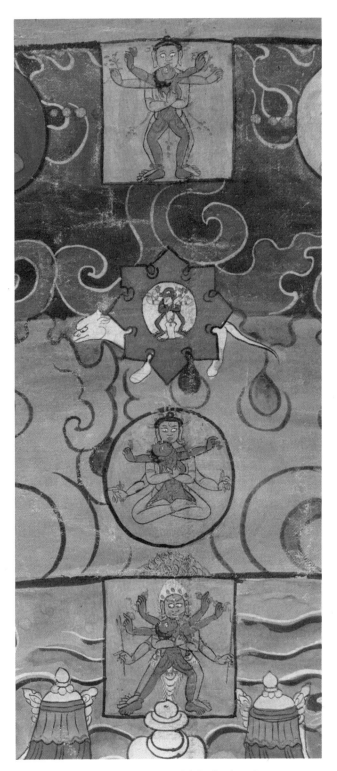

Fig. 2-41. Chariots and wrathful wheel in the eastern direction. From the bottom, the upper wrathful, the upper nāga, eastern prachaṇḍā, and, upper prachaṇḍā.

not given in his tradition, and Banda Gelek follows this by stating that seeds are not necessary for these two. This difference is almost certainly due to the fact that these seeds are not given in the *Vimalaprabhā* during the creation process of the Kālachakra mandala; they are only found in the protective sphere practice during which the ten nāgas are imagined adorning Vajravega, the wrathful form of Kālachakra. Each is associated with a mantra, and the mantras contain these seeds.

Next are the seeds and emblems for the prachaṇḍā goddesses on the wheels in the charnel grounds. All of the following eight have a curved knife as emblem:

East	black, yellow	KKHGGHṄA	Shvānāsyā
Southeast	black, yellow	CCHJJHÑA	Kākāsyā
South	red, white	LVRYKṢA	Shūkarāsyā
Southwest	red, white	ṬṬHḌḌHṆA	Gṛdhrāsyā
West	yellow, black	SḤPṢṢḤKA	Jambukāsyā
Northwest	yellow, black	TTHDDHNA	Garuḍāsyā
North	white, red	LVRYHA	Vyāghrāsyā
Northeast	white, red	PPHBBHMA	Ulūkāsyā

Table 44

There is something very odd about these characters. In texts by such writers as Tāranātha and Kalzang Gyatso all the characters for these stacks, except the first, are reversed. So the first stack remains "KKHGGHṄA," but the second is "ÑJHJCHCA," and so forth. Not only is this contradictory to this list in the *Vimalaprabhā*, but leaving the first stack as it is seems counterintuitive. Why should one alone not be reversed?

The list as I have given it here is from the commentary to verse 67 of the third chapter—the long list of seeds and emblems for the mandala. However, in the commentary to verse 85 of the fourth chapter, when giving the seeds for the meditation, the *Vimalaprabhā* gives the set of seven stacks reversed, as with the Tibetan sādhana traditions.

We do not find consistency in other texts in the original Indian tradition. There are four major Kālachakra sādhanas translated from Sanskrit into Tibetan: The short sādhana by Kālachakrapāda does not give these seeds, but his longer one does, and is in agreement with the *Vimalaprabhā*'s third chapter. However, the sādhana by Sādhuputra gives the seeds with the seven reversed. Also, the sādhana by Maitripa, although not quite as unambiguous, seems to agree with Sādhuputra.

An interesting point is that Sādhuputra gives the characters explicitly for the goddesses in the South, West and North, but for the one in the East, he simply states "the stacked KA-group" (*ka sde brtsegs pa*). He does not say which way up they are supposed to be, but one can presume that he is following the listing of the fourth chapter, but perhaps had some doubt about this first set. Otherwise, why not list the stack explicitly?

There are two other goddesses in this grouping, but their seeds and emblems are not given as part of this list in the *Vimalaprabhā*. They are not on wheels as the other deities are, but on chariots just beyond the eastern and western weapon wheels. Tāranātha does not give seeds or emblems for these deities, but Kalzang Gyatso gives seeds, respectively, for the females and their male consorts:

Above (East)	green, blue	HA & KṢUṀ	Atinīlā
Below (West)	blue, green	HAḤ & HUṀ	Vajrākṣhī

Table 45

Fig. 2-42. Southeast, Vāyu, etc., together with a group of pratīcchā goddesses.

At this point, the *Vimalaprabhā* surprisingly also gives seeds for the sun and moon that are drawn in the earth perimeter, respectively AḤ and AṂ.

Similar to the offering goddesses on the plinth of the mind palace, there is a group of thirty-six goddesses (*'dod ma, icchā*) on the plinth of the speech palace, and an equivalent group of thirty-six goddesses (*phyir 'dod ma/ mi 'dod ma, pratīcchā*) on the plinth of the body palace.

Their colors, hand emblems, directions, etc., all match between the two groups, and their seeds are easily converted between the two. For example the seed of Vidveṣhecchā on the speech plinth is CAḤ, and of the equivalent Vidveṣhapratīcchā on the body plinth is CAṂ.

These goddesses are all considered to be emanations of thirty-six goddesses within the main palaces: the four consorts of the buddhas on the tathāgata-extension, the six consorts of the bodhisattvas, the four consorts of the wrathfuls in the mind palace, the eight chief goddesses in the speech palace, the six consorts of the wrathfuls

riding on chariots, and the eight prachaṇḍā. This grouping will be discussed further later and is also found in the mandala of the 100 yoginīs.

Regarding their positions, there are considerable differences between the descriptions of their placement in the *Vimalaprabhā* and in later texts. The following is a list based on the placement of these goddesses as described by Tāranātha and Banda Gelek.

These goddesses are standing on the plinths of the speech and body palaces, with five to the right of each doorway and four to the left, right and left meaning from the point of view of the center of the mandala, as usual. According to Banda Gelek, the fifth of the group on the right is actually standing on the corner of the plinth.

In the following list, the goddesses are enumerated from the doorways. This means that for the plinth on any particular side of the palaces, R1 (in the left column) is the first on the right of the doorway, R2 is the next, and so forth.

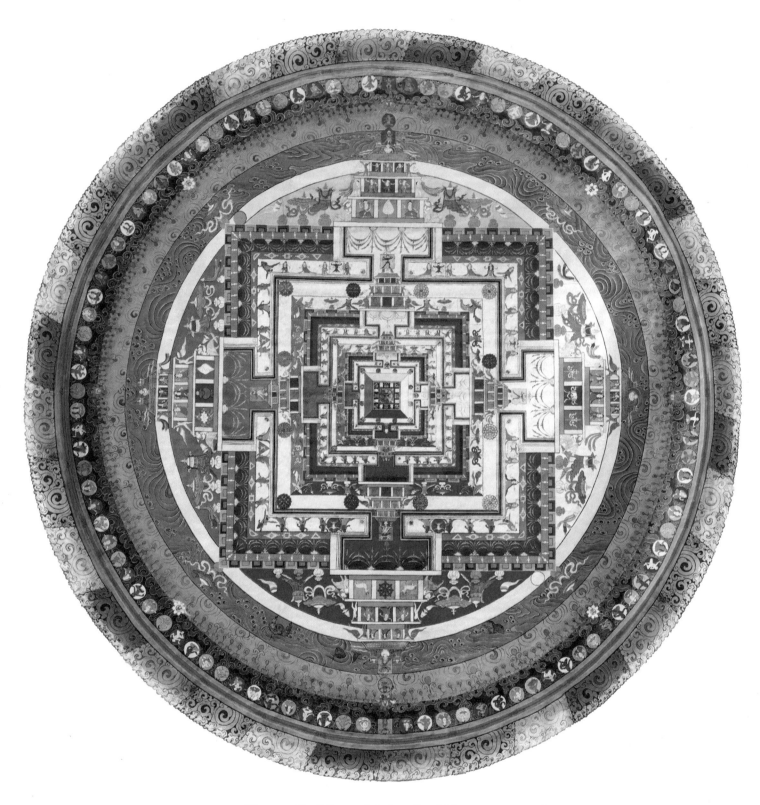

Fig. 2-43. The full mandala from Jayul Monastery, Dzamthang.

The emblems of these goddesses are taken from Tāranātha. The *Vajrāvalī* gives different emblems for many of them, and they are not listed in the *Vimalaprabhā*. Taking the following entry as an example:

R4: black JHAḤ sword Sparshanecchā

East, all black in color:

R1	CAḤ	utpala	Vidveṣhecchā
R2	CHAḤ	clothing	Ashukecchā
R3	JAḤ	wheel	Vadanagatakaphotsarjanecchā
R4	JHAḤ	sword	Sparshanecchā
R5	ÑAḤ	curved knife	Ucchiṣhṭabhaktecchā
L1	SAḤ	3-tined vajra	Saṁtāpecchā
L2	ḤPAḤ	sword	Ucchātanecchā
L3	ṢAḤ	trident	Kaṇḍūyanecchā
L4	ŚAḤ	curved knife	Sarvāṅgakṣhodanecchā

Table 46

South, all red in color except L1, which is green:

R1	TAḤ	lotus	Stobhanecchā
R2	THAḤ	bowl of food	Bhojanecchā
R3	DAḤ	spear	Nṛtyecchā
R4	DHAḤ	hook	Ākṛṣhṭicchā
R5	NAḤ	curved knife	Saṁgrāmecchā
L1	ḤKAḤ	axe	Dhāvanecchā
L2	KAḤ	club	Shoṣhnecchā
L3	KHAḤ	arrow	Aṅgemlecchā
L4	GAḤ	curved knife	Mūtraviṭsrāvaṇecchā

Table 47

Sparshanecchā arises from a JHAḤ character and is fourth from the doorway on the right; her equivalent pratīcchā on the body plinth is in the same relative position, has the same emblem, but arises from the seed JHAṀ.

West, all yellow in color except L1, again green:

R1	TAḤ	wheel	Stambhonecchā
R2	THAḤ	Dharma-conch	Gandhecchā
R3	DAḤ	bowl	Plāvanecchā
R4	DHAḤ	needle	Kīlanecchā
R5	NAḤ	curved knife	Ahibandhanecchā
L1	RAḤ	dharmodaya	Maithunecchā
L2	YAḤ	wheel	Bandhanecchā
L3	HAḤ	vajra	(Shayane) majjanecchā
L4	KṢAḤ	curved knife	Sattvānāmvañchanecchā

Table 48

North, all white in color except L1, which is blue:

R1	PAḤ	utpala	Paushṭikecchā
R2	PHAḤ	mirror	Bhūṣhaṇecchā
R3	BAḤ	lotus	Rajyecchā
R4	BHAḤ	hammer	Bandhanecchā
R5	MAḤ	curved knife	Dārakākroshanecchā
L1	GHAḤ	vīna	Vādyecchā
L2	ṄAḤ	hammer	Mṛduvacanecchā
L3	LAḤ	trident	Āsanecchā
L4	VAḤ	copper knife	Bahukalahecchā

Table 49

The *Vimalaprabhā* gives a very different set of positions for these goddesses. For the speech plinth, it gives the following:

RoE	CAḤ CHAḤ JAḤ JHAḤ ṄAḤ
LoE	SAḤ ḤPAḤ ṢAḤ ŚAḤ HKAḤ
RoS	ṬAḤ ṬHAḤ ḌAḤ ḌHAḤ ṆAḤ
LoS	KAḤ KHAḤ GAḤ GHAḤ ṄAḤ
RoW	TAḤ THAḤ DAḤ DHAḤ NAḤ
LoW	KṢAḤ
RoN	PAḤ PHAḤ BAḤ BHAḤ MAḤ
LoN	LAḤ VAḤ RAḤ YAḤ HAḤ

Table 50

There are many variations between the different traditions with these goddesses, and this is almost certainly due to the fact that the *Vimalaprabhā* gives no help at all. There is much agreement between the *Vajrāvalī* and Sādhuputra's mandala text (Spmancho), the only two Indian texts that list the emblems, but the agreement is incomplete, with several differences.

Finally, there are the beings of the perimeters. Above the border between the perimeters of fire and wind are many deities, associated with the planets, lunar mansions, zodiacal signs, and lunar phases; also direction-protectors, field-protectors, and various others. In the Jonang tradition, these are considered to be so numerous that they are not usually represented in the mandala in any specified form.

However, they can be represented, and if this is done, they are placed in the outer half of the perimeter of wind—the inner half (and the outer half of the perimeter of fire) is taken up by the charnel grounds. There are said to be a total of 35 million spirits, plus other beings, and so one would place as many as appropriate, choosing them from the normal lists and giving them various forms, colors, and hand-emblems.

The *Vimalaprabhā* gives little information about these perimeter beings, and most Tibetan traditions have taken the *Vajrāvalī* as their main source. Tāranātha (Kasain) and the *Vajrāvalī* give the eight planets, the lunar mansions, the twelve signs of the zodiac, the sixteen lunar phases, the ten direction protectors (*phyogs skyong, dikpāla*), the ten field protectors (*kṣetrapālas, zhing skyong*), Ṛṣhi (*drang srong*, presumably the constellation of the Great Bear), Dhruva (*brtan pa*, the Pole Star), Agastya (*ri byi*, the star Canopus), Mahākāla (*nag po chen po*), Nandi (*dga' byed*), Ghaṇṭākarṇa (*dril bu'i rna ba can*), Bhṛṅgī (*nyam chung*), Hārītī (*'phrog ma*), together with large numbers of messengers (*pho nya, dūtī*) and siddhas.

There are two traditions in which a specific number of these beings are represented. The main method is used in the Gelug and Sakya schools, and originally comes from Buton (Bukhory). This includes eighty-eight deities represented around the border between the fire and wind perimeters and eleven between each of the wheels of the prachaṇḍā goddesses. These are normally represented by their seeds, although many mandalas in which these deities are depicted also show their forms. When the seeds are drawn, this is nearly always done in old Rañjana (decorative/ornamental) script.

The other tradition is the one coming from the translator Tsami, passing through the Karma Kagyu school. In this method, instead of eighty-eight deities around the perimeter, there are 112: fourteen between each of the wheels of prachaṇḍā goddesses in the charnel grounds. This makes it very easy to recognise a mandala from the Tsami tradition. In both these traditions, for each being the seed used is the nasalized first letter of their Sanskrit name. For example, the seed for the zodiac sign Pisces, Mīna in Sanskrit, is "MĪṀ." The origin of the list of 112 is not clear.

This completes the description of the drawing of the main triple mandala of Kālachakra. Further details regarding the deities are given in chapter 4.

Mind mandala

The mind mandala of Kālachakra is arguably the next most important of the Kālachakra mandalas, as the mind-mandala practice is the one most commonly used in a retreat situation. As a result, representations of this mandala are relatively common in museums and art books. The drawing of the mandala is explained by Banda Gelek in his work *The Illuminating Sun-rays* (Bggthig); the same description is also to be found preserved in *The Melody of the Queen of Spring* (Mtkmand). I shall follow Banda Gelek's description, but only giving the very briefest details—all the components of this mandala are the same as their equivalents in the main triple mandala, and the method of drawing is simply a subset of that for the triple mandala.

For the mind mandala, the speech and body palaces are not drawn, and the mind palace and all its contents are increased in size by a factor of four, making it the same relative size as the body palace in the triple mandala. There are no wheels for prachaṇḍās, no nāgas on the plinth, no chariots among the perimeters, and no perimeter beings, but the main six perimeters are drawn and the charnel grounds are included in their usual place.

Banda Gelek describes the first stage as the drawing of the eight main lines, and then dividing a central line, from the center to the extreme edge, into thirteen equal parts. Then, find the point halfway between the eight and ninth division, and draw a circle through that point. Connect up the points where this circle intersects the diagonal lines, and the square that is formed consists of the parapet lines for the palace.

The thirteen divisions made of the central line are all one door unit in length, and one-sixth of these DU are a minor unit. The parapet lines are therefore each 12 DU in length; 72 mu. The next step is to draw further squares that are ⅓ and ⅔ the size of the square forming the parapet lines. For these, the diagonal lines are divided into three parts measured from the center to the points from where the parapet lines were drawn. These will form, respectively, the outer square of the Circle of Great Bliss, and the baseline of the palace walls. Apart from the baseline, these squares consist of final lines and will not need to be erased.

Measuring in along a central line from the baseline, first 1 and then 4 mu, draw further squares to form the deity podium. Then, inside of the square for the Circle of Great Bliss, draw another square exactly half its size, measuring from the center 6 mu along the central lines. This is the inside edge of the inner beams. Measure out 1 mu from this square, and in 1 mu from the main square of the Circle of Great Bliss, and draw further squares. Measuring out from the center, along a central line, there are now four squares, at 6, 7, 11, and 12 mu, forming the beams of the Circle of Great Bliss.

Right and left of the central lines, between the two most recently drawn lines, measure 2, 3, 6, and 7 mu, drawing lines to form the pillars. The space between the base and parapet lines are next divided up to produce the doorway and the walls, jeweled frieze, garlands, pipes, and parapet. The distance between the base and parapet lines is first divided into two; the inner of these is divided into four, the middle of which is discarded; the outer is also halved, and then its outer half is also halved. From the baseline, this gives the widths of the components of the walls as 1½, 3, 1½, 3, 1½, and 1½ mu. As before, the space for the walls is divided into eight parts—two for each of the walls and one for the gaps between them.

Construction lines are then drawn to define the porch: measure right and left of the central line and draw lines parallel to it: 3 mu, then 1½, 4½, 1 ½, and 1½ mu. The last such construction lines form the outside of the main toran pillar. These lines are used to construct the porch projections, extensions, and sides.

For the toran, measure out (along a central line) three door units from the parapet line. From the parapet line, these three sections are divided: 1, 1, and 4 mu; ½, 1, 3, ½, and 1 mu; 2, ½, 1½, and 2 mu. The last of these marks the top of the toran vase. Next, construction lines are drawn right and left of

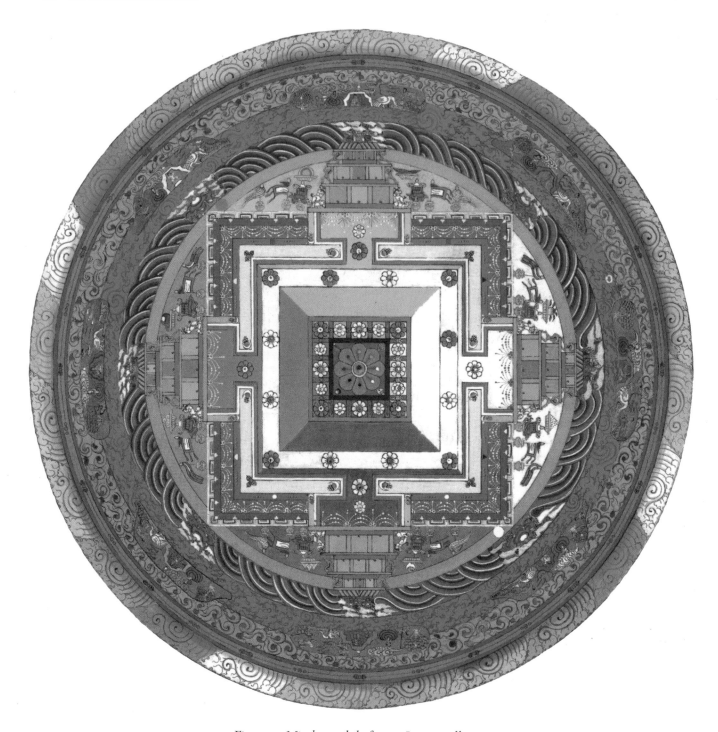

Fig. 2-44. Mind mandala from a Jonang collection.

the central line, up from the parapet line, each being 1 mu apart, the outer ones being 2 DU either side of the central line. These are used as guides for drawing the final horizontal lines that will form the beams, guardrails, and so forth. Working from the parapet line, the first line needed (for the first beam) extends 12 mu either side of the central line, the next are: 8,

9, 9, 6, 7½, 7½, 4, 6, 6, 4, and 1, also either side of the central line.

For all three stages, the outer edge of the pillars are flush with the end of the guardrail. For the first stage, between the second and third horizontal lines, to draw the pillars, measure 2, 3, 7, and 8 mu; for the second stage, between the fifth and sixth: 1½, ¾, 3, and ¾ mu;

for the third stage, between the eighth and ninth: 1, ½, 2, ½ mu.

For the shape of the covering connect the end of the eleventh horizontal line to the point on the tenth where it is intersected by the fifth vertical construction line.

The proper end of the central line is the point where central line meets the upper line of the uppermost guardrail (the eighth horizontal line drawn for the toran). A circle drawn through that point creates the inner line of the first perimeter (earth). Further circles are required to create the perimeters in the usual manner, measuring out from this inner circle, ½, 1, 1, 1, ½, and 1 DU. The first of these, the outer circle of the earth perimeter, was already drawn at the beginning of the drawing. The space perimeter needs to be further subdivided, either into three or into four, and taking the innermost two bands together. The latter method is preferred, having been described by Dolpopa and his students. The middle band is the vajra garland.

The charnel grounds are drawn as before: eight of them, in the outer half of the perimeter of fire and the inner half of the perimeter of wind. One difference here, which is not mentioned by Banda Gelek, is that as the prachaṇḍās are not involved in this mandala, the protectors of the directions (*dikpāla*) and the protectors of the field (*kṣetrapāla*) should be included in the charnel grounds.

The description then returns to the center and describes from there the drawing of the various lotuses, starting with that of the chief deity in the center. As with the triple mandala, the lotus is drawn with a radius of 6 mu and its receptacle with a radius of 2. In the cells in the cardinal and intermediate directions of the tathāgata-extension are needed lotuses of radius 2 mu; in the other cells are lotuses for the vases with a radius of 1½ mu. The radius of their receptacles are one-third the lotus radius. Working outward, on the deity podium are needed a total of twelve 2-mu radius lotuses: one in each corner, and eight others measuring in 3 mu from each corner. There are also similar 2-mu radius lotuses in each of the doorways for the wrathful deities. Finally, just beyond the wrathful deity lotuses these doorways in the East and West are 1½-mu radius lotuses for the

above and below vases, respectively. All of these are eight-petaled lotuses and are drawn exactly as with the mind palace in the triple mandala.

At this point, Banda Gelek states that all the construction lines can now be erased, and he goes on to describe the colors of the mandala. The first comments he makes refer to the situation when the mandala is intended to be made from powder. First, cover the whole area up to the extent of the offering ground (that is, the inner circle of the perimeter of earth) in green or whatever color is appropriate for the intended activity. Then, on top of this, spread the colors of the directions between the bordering diagonal lines. On top of these colors place the structure of the palaces, the podium, lotuses, and so forth. He comments that this method is as explained by Dolpopa. He further adds that when placing the base color and colors of the directions, one should only cover between the final lines so as not to obscure them and thereby cause mistakes when coloring the podium, lotuses, and other structures.

The center of the Circle of Great Bliss, the ground for the chief deity lotus, is blue. The colors of the directions are applied to: the cells in the tathāgata-extension, the colored ground within the podium, the small gap beyond the podium, inside of the porches, and the offering ground. The three walls are, from the inside, black, red, and white.

The chief deity lotus is green; the inner beams of the tathāgata-extension are blue, the outer green; the sixteen pillars are the colors of their directions. Regarding these pillars, the swords on those in the East are black and have their tips pointing outward; the jewels in the South are red and one-eyed. The wheels in the West are yellow, and in the North the lotuses are white. There should be one emblem on each pillar.

The other ornaments need to be placed, such as the vajra garlands on the beams, the jewels on the frieze, the crossed vajras on the corners of the plinths, the crescent moons with jewels, flags, parasols, and so forth. The frieze, garlands, pipes, and parapet are all drawn as with the main mandala. The torans are also colored in the same manner as with the mind palace in the triple mandala.

The perimeters are also the usual colors; the inner and outer bands of the space perimeter are blue, with the background for the vajra garland green, the vajras themselves being blue. The fire mountain swirls to the left, in any of the five colors or green, blue, black, red, white, and yellow. On the earth perimeter, a little to the east of Northeast (it has to be a little offset, because the corner of the parapet is in the way here) is the moon in the form of a white full moon. In the southwest, a little to the west, is the red disk of the sun. These two are circular, half a DU in diameter.

Banda Gelek continues by describing the colors of the deities and refers to other texts if one wishes to draw their seeds, emblems, or forms. The most basic method is to use drops or even small piles of rice on a powder mandala. Whichever is used, these would all be exactly as with the triple mandala, but a few points are worth stressing.

The central lotus has on it disks of moon, sun, and Rāhu. In the corners of the space around the central lotus are the black wish-fulfilling jewel (SE), red gaṇḍi (SW), yellow wishing tree (NW), and white Dharma-conch (NE). All the vases in the tathāgata-extension are white, as are the upper and lower vases, drawn on lotuses in the eastern and western doorways. In addition to the four wrathfuls, if in the accompanying meditation the fifth, upper, wrathful is included and needs therefore to be represented in the mandala, then this is placed on a white lotus with sun seat, just beyond the lotus of the upper vase, in the eastern doorway. The male is green and the female blue. This would be a very tight fit, and the lotuses would probably be best reduced in size slightly.

The offering goddesses (*gzungs ma, dhāriṇī*) are needed on the plinth, two in each direction, either side of the doorways, with the other four in the middle cell of the upper stages of the torans: in the East, green Nṛtyā; in the South, blue Kāmā; in the West, green Vādyā; and in the North, blue Gītā. All the other cells of the torans contain various offering goddesses. Beyond the parapet, within the offering ground, draw various offering objects, such as excellent vases and so forth.

This completes the description of the drawing of the mind mandala.

3. The Mandala in Three Dimensions

THE DRAWN KĀLACHAKRA MANDALA that was described in the previous chapter is a representation, in the same sense as a floor plan, of a three-dimensional structure. The full form of this includes the world-system mandala with the mandala palace on top. Actual three-dimensional models of mandala palaces are relatively common, but a full representation of the world system is not included as part of such a structure, simply because it is so large compared to the palace.

When a three-dimensional model of the palace is created, the world system is represented by encircling perimeters, as in the drawn or painted mandala, and it is only in Kālachakra meditations that the whole structure

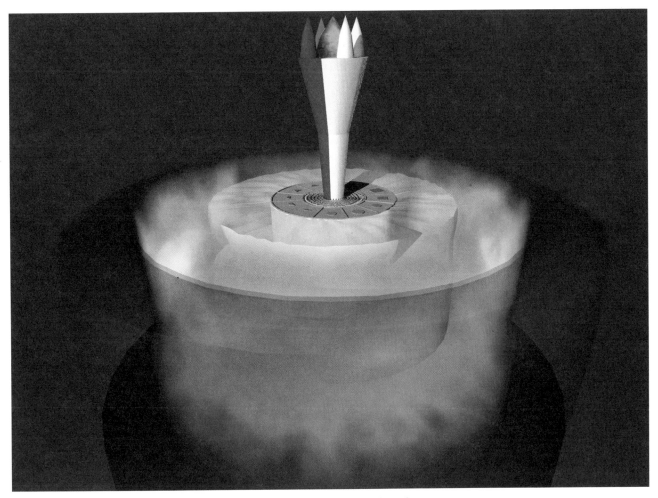

Fig. 3-1. Mt. Meru and the four elements.

is imagined, with the palace sitting on top of Mt. Meru, itself on top of huge disks of the four elements.

In this chapter the full three-dimensional structure will be described. The description of the world system is based on meditation instruction texts, but the details for the palace are based on texts describing both the meditation of Kālachakra and also the construction of physical models of the palace.

World-system mandala

The world system according to Kālachakra is relevant in two different circumstances: 1) when the mandala of Kālachakra is imagined in a creation process practice and the world system is therefore part of this as its support, and 2) in the preliminary practices, when the world-system mandala is imagined as offered to buddhas, teachers, yidams, and so forth as a means for developing the accumulations.

More details are usually given in descriptions based on the preliminary practices, and some texts on the creation process state that some details need not be imagined when the world system is the support for the mandala palace. Such texts, and the meditation itself, are more concerned with the symbolism and the purification function of the various components of the world-system mandala than details of those components. On the other hand, there are a few points that are unique to creation process texts.

To give more details than would be expected for creation process meditation, the description that follows is mainly based on a text that describes the preliminary practices by Banda Gelek, *The Chariot that Transports to the Kingdom of the Four Kāyas* (Bgkuzi).

At the bottom of the base of the world system is a black disk of wind, 400,000 yojanas in diameter. Above this is a red disk of fire, 300,000 yojanas in diameter; above that a white disk of water, 200,000 yojanas in diameter; and above that a yellow disk of earth, also known as the great golden ground, 100,000 yojanas in diameter. All of these are inside a spherical protective sphere containing a slightly smaller, spherical dharmodaya. These are of the space element, therefore green. The internal diameter of the protective sphere is 500,000 yojanas; that of the dharmodaya is not specified, but it has to be a little smaller.

All four disks are circular in shape and are all equal in thickness, each 50,000 yojanas. They are stacked one on top of the other, with each one extending 50,000 yojanas in all directions beyond the one above it, and from these extensions material rises up to encircle the disk of the earth and be level with it.

This is an interesting point, rarely depicted in artwork. It is as if the disks are the sources of the materials experienced in the world. In particular, water rises up from the disk of water to be level with the top surface of the disk of earth, thereby forming a great ocean around the surface of the earth.

In creation process texts each of the disks is also marked by certain identifiers. In the middle of the disk of wind is the identifier of wind in the shape of a bow (a semicircular shape), with victory banners of wind marking the two limbs of the bow. Similarly, the disk of fire has at the center a triangular shape marked with a svastika design; the disk of water has a circular shape marked with a lotus design; and the disk of earth has a square identifier, marked in the center by vajra designs. Also, above and below each of the four disks are crossed vajras—not solid and thick, but like drawings on the surfaces of the disks.

Sitting in the middle of the top surface of the disk of earth is the circular Mt. Meru, 100,000 yojanas in height. From where the lower surface of this is in contact with the earth disk, for a distance upward of 1,000 yojanas, the diameter is 16,000 yojanas. This diameter of 16,000 yojanas continues up to the summit of Meru and forms the core of the mountain. It is green and composed of emerald.

All around the base of Meru, 1,000 yojanas in both height and width, is the ledge or step (*'gram stegs*) of Meru. From the top of this, Meru widens, increasing gently in diameter up to half its height (of 50,000 yojanas), and from there increasing more quickly, until

the edge of the top surface is directly over the outer edge of the lower Cool Mountains (*bsil ri*, *Sītā*).

The diameter of the top of Mt. Meru is 50,000 yojanas. From halfway up Meru up to the top the thickness is increasing, spreading further out from the core, to the diameter at the top of 50,000 yojanas. Down from the halfway point, Meru becomes thinner, all the way down to the base. The sections that spread out from above the ledge are not made of emerald as is the core. To the east of the central core it is made out of blue sapphire; to the south, red ruby; to the north white moonstone; and to the west, yellow quartz. The last is not a particularly safe identification; the intention here is some form of quartz. These spread out, getting thicker, until at the top they are in total the diameter of 50,000 yojanas.

This description suggests that the core of Meru is like a green pillar, the same thickness all the way, but extra material of these four precious stones surrounds this central core and increases in thickness toward to the top. One refinement here is given by Tāranātha, who states that the core itself thickens toward the top and has an upper diameter of 25,000 yojanas.

Meru is described as having five peaks (*rtse mo/rwa*, *śṛnga*). The central emerald core protrudes from the surface as the mountain's central peak or summit. Similarly, from the eastern sapphire surface arises the blue eastern peak or summit, and so forth. These five peaks or summits are 25,000 yojanas in height and they look like five pointed tormas placed on a mirror (mandala offering base).

Not all writers agree that the fives peaks are atop the surface of Meru. Others, such as Chokle Namgyal, describe the five peaks as five platforms formed from large rings encircling the central core of Meru. The largest platform forms the top surface of Meru and the diameter of the lower platforms decreases the lower they are.

The outside edge of the base of Mt. Meru is encircled by six continents, oceans, and mountain ranges, each with a width of about 890 yojanas. From the innermost, these are, listed by continent, ocean, and mountain range:

Chandra	sweet	Nīlābha
Sitābha	ghee	Mandara
(Varaparama-) Kusha	curd	Niṣhaṭa
Kinnara	milk	Maṇikar
Krauñcha	water	Droṇa
Raudra	alcohol	Sītā

Table 51

As the outer edge of the Sītā mountains is directly below the upper edge of Meru, all these eighteen mountains, continents, and oceans are underneath the overhang of Meru. These six continents are the abodes of beings; the oceans surround them are like trenches and the mountains are at the edges of the oceans, circling them like iron mountains, complete with peaks.

The heights of these seven continents, six mountains, and six oceans are not stated clearly, but measuring from the top of the disk of earth they should be quite deep, with the continents and oceans at the same level, and the mountains rising above them.

Beyond and surrounding the Sītā mountains is the Golden Ground, the upper surface of the disk of earth, which is the base of Great Jambudvīpa. This reaches from the outer rim of the Sītā mountains to the outer edge of the disk of the earth. From its inner edge to the outer is a distance of 25,000 yojanas. Counting from the continent of Chandra as the first, this Great Jambudvīpa is the seventh continent. The base of Great Jambudvīpa is divided like a lotus of twelve petals into twelve regions by a raised border. This wall-like raised border is essentially many closely connected mountains. Each region has a width on the inside of 12,500 yojanas and on the outside of 25,000. Clearly, the circumference is an approximation, and Banda Gelek is taking Pi as = 3.

The surfaces of the three disks of water, fire, and wind below the disk of earth, which each protrude beyond the one above by 50,000 yojanas, spread up to become level with the upper earth disk, encircling it. Of these, tongues of fire reach up from the disk of fire, higher

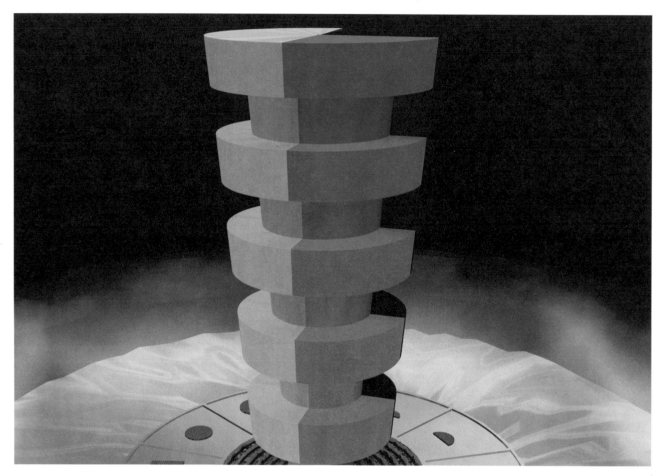

Fig. 3-2. Chokle Namgyal's view of Mt. Meru.

than the level of the disk of earth, forming a perimeter. This forms the outer iron mountains, which, counting from the Nīlābha mountains, is the seventh mountain range. This also is given the name "fire from the mare's mouth" (*rta gdong gi me, vāḍavāgni*), a powerful fire said to exist in the ocean to the south of Jambudvīpa.

The perimeter of water, material rising up from the lower disk of water, is the salt ocean, and rivers feeding this ocean form from water all over the twelve regions. Each of these regions consist of hundreds of countries and islands rising out of the ocean, on which live humans who have the great ability to achieve enlightenment in one lifetime through the practice of the mantra path. As a result of the accumulated power of this ability, this Jambudvīpa is known as a land of action.

In the middle of the eastern region of Jambudvīpa, surrounded by salt water, rises a semicircular continent, with the straight side to the inside, in width 7,000 yojanas, called Eastern Videha. In the middle of each of the two regions right and left of this eastern region are, surrounded by water, two further semicircular continents, also with their straight sides to the inside, the one to the west (to the left, looking toward Meru, which is to the north) being the continent of Deha, and the one to the east being Videha.

Similarly, in the middle of the southern region rises a triangular continent, 8,000 yojanas in width, with a vertex pointing outward (to the south, away from Meru), called Southern Jambudvīpa or Lesser Jambudvīpa. In the regions to its right and left rise further triangular continents, the one to the west being Chāmara and the one to the east being Avara-chāmara.

In the middle of the northern region rises a circular continent, 9,000 yojanas across, called Northern Kuru. In the two regions to its right and left are two further circular continents, the one to the west being Kuru and the one to the east being Kaurava.

In the middle of the western region rises a square con-

tinent, 10,000 yojanas across, called Western Godānīya. In the two regions to its right and left are two further square continents, the one to the west being Shāthā and the one to the east being Northern Mantriṇa.

The size of the minor continents of Deha, Videha, and so forth are not given in the tantra, but when these are contemplated, Tāranātha has said that as they are called "minor continents" they should be imagined as a little smaller than their respective central main continents.

In each of the twelve regions, the central continents and minor continents are surrounded by salt oceans, from which rise many small islands. The shape and size of these is not specified and so is uncertain.

This completes the description of the world system from the *Kālachakra Tantra*, and the above contains more details than are really required for the creation process. These details have been given more or less as a straight translation from Banda Gelek's text of instruction on the six yogas (Bgkuzi), in which he describes Mt. Meru and the continents for the purposes of the offering mandala. For the purposes of the creation process meditation, however, the emphasis is on the

Fig. 3-3. Lotus on top of Mt. Meru.

four element disks, their identifiers and emblems, the crossed vajras, Mt. Meru and the five peaks. In another text (Bgdubum), for example, Banda Gelek states that it is not necessary to imagine the continents and oceans on the top surface of the disk of earth. For this reason I have not listed the details of the rotation of the sun and moon, the stars and planets, and the realms of the different beings; these details are not relevant here and can be found elsewhere.

The palace

As was mentioned earlier, the above scene would be imagined in the meditation and then the palace imagined sitting on top of Meru. It is quite impractical to construct the elements and Meru for a three-dimensional mandala model and so these are represented by molded perimeters around the main structure of the palace. The following is mainly derived from a text on the Jonang three-dimensional mandala by Banda Gelek. The description is for a physical model, but the only real difference with the imagined palace concerns the elements and Meru. It seems best to describe both methods here, and so what follows also includes information from the major instruction texts for the triple-mandala meditation.

In that meditation, sitting on the very top of the peaks of Mt. Meru is a multicolored lotus, in diameter the same size as the top of Meru. The receptacle of this

lotus has a diameter one-third that of the lotus itself. Sitting on top of the receptacle, and the same size as the receptacle, are disks of moon, sun, and Rāhu, lying flat, one on top of the other, Rāhu being on the top.

Lying on top of these triple disks is the vajra ground (*rdo rje'i sa gzhi, vajrabhūmi*)—referred to in the previous chapter as the offering ground. In diameter this is the same size as the outer rim of the top surface of Meru, and so from above it completely obscures the lotus and three disks. The vajra ground is fairly thick, blue on the inside, and the upper surface has the colors of the four directions. In the meditation, this vajra ground is underneath a protective tent, but that need not concern us here.

Some other dimensions need to be described here to which we will return later in more detail. In the meditation, one first imagines on top of the vajra ground the

Fig. 3-4. The palace foundations.

foundation for the speech palace, on top of that one for the mind palace, on that the one for the Circle of Great Bliss, and finally one for the chief deity dais. If we consider the units used in the previous chapter for the mandala dimensions, the diameter of the vajra ground is 384 mu. The width of the foundation for the speech palace is 144 mu, that for the mind palace is half that, 72 mu, and so on. Banda Gelek describes these foundations as looking like the steps or terraces of a stūpa.

The next point in the meditation is to imagine the palace sitting on top of all this. The walls for the body palace sit directly on the vajra ground. The internal size of the palace is the distance from the inside of one wall to the inside of the opposite wall—baseline to opposite baseline in the terminology of the previous chapter. This distance is 192 mu, exactly half the diameter of the vajra ground. The walls for the speech palace sit on the top surface of the first foundation, and the internal size is 96 mu—half that of the body palace. And so on.

These ratios are important, as they are similar to the ratios that we find with the elemental disks—the disk of water is half the diameter of the disk of wind, the disk of earth half again, and the top surface of Meru half the diameter of the disk of earth. The description that I have given in which the diameter of the vajra ground is the same as that of the top of Meru is that given by Banda Gelek, but not all writers agree with this. The Indian Kālachakra literature suggests in places that the internal size of the body palace is 400,000 yojanas, the

same as the diameter of the disk of wind; similarly, the inside of the speech palace matches the size of the water disk and the mind palace the earth disk. This is given directly in the tantra, but as that text also gives some other possibilities, this has led to some confusion and a variety of opinions.

Based on three different quotations from the *Kāla-chakra Tantra*, Tāranātha describes three different relative sizes of the mandala palace, known generally as the "mandala equal to the world system," "mandala equal to the top of Meru," and "mandala equal to half of Meru." In the first of these, the internal width of the body palace is considered to be literally 400,000 yojanas, the same unit of measurement and therefore the same size as the diameter of the disk of wind. Although Tāranātha does not mention this, one result of this would be that the diameter of the vajra ground becomes 800,000 yojanas; I am yet to find a discussion describing quite how this then fits inside the protective sphere with its diameter of 500,000 yojanas.

In the second version, the "mandala equal to the top of Meru," the internal width of the body palace is identical to the diameter of the top of Meru, 50,000 yojanas, making the diameter of the vajra ground 100,000 yojanas, equal to the diameter of the disk of earth.

Finally, with the "mandala equal to half of Meru," the internal width of the body palace is half that of the diameter of the top of Meru, making the vajra ground equal in diameter to the top of Meru. This is the sizing described above as given by Banda Gelek and favoured by Tāranātha, although he does state that the sizing of palaces is not defined.

Tāranātha points out that there were many variations on these themes put forward, the most bizarre being based on the "mandala equal to the world system." In this the lotus of Kālachakra was thought to be identical to that on top of Meru and so the Circle of Great Bliss therefore sits on this top surface. The mind palace sits on the surface of the element of earth, the speech palace on the surface of the disk of water, and the body palace on the disk of wind.

Regardless of such oddities, just what are we to make of the size of the body palace being given as 400,000

yojanas? This is almost certainly a symbolic reference—the numbers give the relative sizes of the palaces and associate them symbolically with the elemental disks and the rest of the world system. In fact, the *Vimalaprabhā* comments on the section of the tantra which gives these sizes under the heading: "The purity of the powder mandala through the purification of the world system." It is hardly a discussion of the three-dimensional structure and is clearly concerned with symbolism.

We now turn to the description of the palace itself, in particular the details from Banda Gelek's text (*The Jeweled Garland,* Bgslos) on constructing a three-dimensional model. Of course, we now go back to the beginning, as in such a model the world system is represented very differently from the description above from the meditation.

Banda Gelek starts by redefining the units he will use, and these are the same as those used in the previous chapter: the distance from the center to the outer edge is 13 body-DU; each body-DU equals 12 fingers or 24 mu (minor units). The first step is to prepare the flat and firm surface on which the palace is to be built and then to draw the main construction lines. Having located the center of the surface, draw the central and diagonal lines, and, as in the previous chapter, the distance along one of these is divided into thirteen equal parts; each of these parts being one body-DU.

The basic dimensions are exactly the same as with the two-dimensional mandala and so, just as in the last chapter, the starting point is 8 body-DU from the center; first, a circle is drawn with that diameter. This is the inner line of the innermost perimeter (the earth element) and is also the outer boundary of the vajra ground. From that circle, one measures outward and draws further circles, first half a body-DU, then one whole body-DU, then another body-DU, another body-DU, then half a body-DU, and finally one more body-DU. These produce the perimeters for: 1) earth, 2) water, 3) fire, 4) wind, 5) space, and 6) garland of light. The final circle is at the edge of the whole structure, with a diameter of 13 body-DU.

The perimeter of space is divided again into three parts, the middle being the vajra garland and the inner and outer the space-perimeter.

Next, a square is drawn between the points of intersection of the inner circle of the water perimeter (at 8½ body-DU) and the diagonal lines. This produces the usual line for body palace parapet. Here, this marks the limits of the physical palace structure—the parapet will of course be constructed on top of the walls and not on the ground, but looking at a two-dimensional mandala it will be seen that the front of the porch is directly flush with the parapet line. For this reason, this line marks the limits of the physical structure. The walls that will

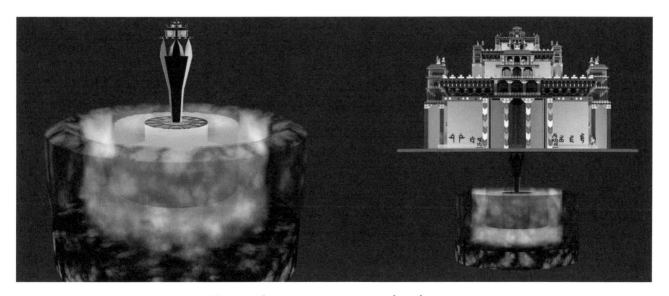

Fig. 3-5. The two extreme views on the palace size.

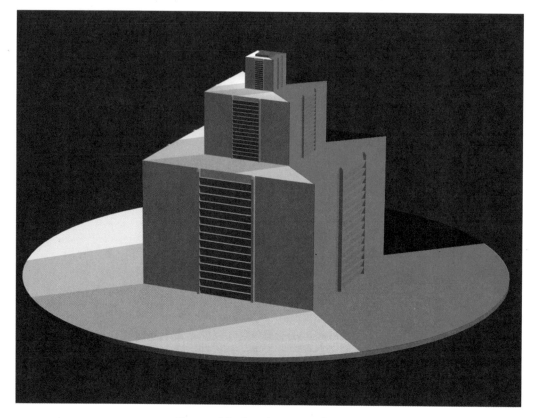

Fig. 3-6. The foundations with stairs.

be built, both for the main palace and the porch, are in exactly the places that the walls are drawn for the two-dimensional mandala. As far as the walls are concerned, the two-dimensional mandala is an exact floor plan.

Next, we need to find the position of the walls. The first step is to draw a square on the points of intersection of the central lines with the inner circle of the earth perimeter. Where this square intersects with the diagonal lines another square is drawn. The sides of this square exactly bisect the central lines—although we have drawn them longer, they properly end at the 8 body-DU point, the edge of the vajra ground. This last square therefore has a width from side to side of 8 body-DU and is therefore the baseline for the body palace.

Measure in one minor unit from the baseline and draw a square. This is for the small gap. Then, measure in half a body-DU (12 mu) and draw another square; this is the inner line for the body deity podium. Finally, measure in from the podium 11 mu and draw another square for the construction of the speech foundation—this is the outer edge of the speech foundation. The

space between this line and the inner line of the deity podium is for the colored ground of the body palace.

The speech foundation is built up from the last square drawn—6 body-DU in width—and is built to a height of 4 body-DU (96 mu). The structure needs to be perfectly square and the top completely flat.

Next, stairs need to be constructed on all four sides of the foundation. Each side is divided into three equal parts and the stairs form the middle third. This may seem rather wide, but this exactly matches the width of the outside of the porch of the palace that will be built above; in practical terms, anybody walking out of that palace into the porch area would find the stairs filling the whole of the edge of the foundation to which they have access. The stairs protrude out from the foundation side by 3 mu (one-quarter of a speech-DU). Banda Gelek writes that one draws stairs on the protrusion, but of course constructing actual stairs (more like a step-ladder, actually) would make sense. He also says that for all three foundations that have stairs, those stairs should have either eight or sixteen steps.

On top of the speech foundation are then drawn the

usual central and diagonal lines. The outer edge of the foundation is itself the usual parapet line for the speech palace—it therefore is also the extent of the speech structure, and the walls of the porches reach right to the edge—exactly where the stairs have been placed. Divide the diagonal lines into three, measured between the outer corners of the parapet lines and the center. On the four outer points (the inner points of the outer third) draw a square; this is the baseline for the speech palace.

From that square measure inward 1, 4, and then 7 minor units and draw squares. These respectively mark out the small gap, speech deity podium, and the speech colored ground inside the speech palace. The inner line of the colored ground determines the width of the mind palace foundation. This is constructed with a height of 2 body-DU, measured up from that inner line. On the sides of this foundation also construct stairs, protruding out one-quarter of a mind-DU (1½ mu).

Next, draw on the top surface of the mind foundation the eight major lines, the central and diagonal lines. Similar to before, the outer square edge of the foundation is the (usual) line for the mind parapet. Divide the distance between this line and the center into three, and on the outer division draw a square for the mind baseline. Measure in from there 1, 4, and 7 minor units, for the narrow gap, podium, and colored ground.

The square formed by the inner line of the colored ground of the mind palace (24 mu across) determines the size of the foundation for the Circle of Great Bliss. This needs to have a height equal to 1 body-DU (24 mu). In the middle of each of its four sides, with a thickness of 1 minor unit, also place protruding stairs.

Banda Gelek makes the point here that these foundations are projections from the lower vajra ground; they are protrusions of that vajra ground. They are not, in other words, solid blocks placed one on top of the other. In fact, they need to be hollow, for some deities will be located within them.

Once more, on top of the foundation for the Circle of Great Bliss, draw the eight major lines. The outer edge of the foundation is the outer line for the outer beams of the Circle of Great Bliss. Divide the portions of the diagonal lines between the center (and the corners) into two, and there draw a square. Outside of this square is the Circle of Great Bliss and inside is the chief deity dais. The base for the site of the chief deities (built up from this square, rather like a small foundation) is in height ¼ mind-DU (i.e., 1½ mu) and is upright and in the shape of a cuboid. In the center of this is the chief deities' eight-petaled lotus.

Then, on the top surface of the Circle of Great Bliss, find the center of each edge, and accurately place marks there. At the outer edge of the tathāgata-extension, which is the edge of the foundation, place four pillars in each direction: from the marks in the center, right, and left measure 2 mu, then 3, and there place each pillar. There are four pillars on each side, each one is 1 mu in width, and the intention here is that one measures from the center 2 mu, places a pillar, then from the far side of that pillar measures another 3 mu, and place the next pillar. There are no pillars in the extreme corners of the top surface of the foundation.

Then, another square set of pillars is constructed. These lie flush with the edge of the dais for the chief deities. First, the center of each edge of the dais is determined, and then pillars are placed 2 mu either side of that center. Then, pillars are placed at each corner of the dais. This makes a total of twelve pillars, and there is a precise symmetry here with the outer set of sixteen pillars. The distances between the pillars along any side of the inner set are exactly the same as those between the outer set. All these pillars, the outer sixteen and inner twelve, are all 1 mu in thickness and 10 mu in height.

Between these two sets of pillars is the area for placing the lotuses for the buddhas, their consorts, and the eight vases. This is commonly called the tathāgata-extension. The height of the chief deity dais is given by Banda Gelek as 1½ mu. Tāranātha tells us (Kasain) that the chief deity dais should be a little bit higher than the tathāgata-extension, and he suggests that it should be around one-quarter of a mind-DU (1½ mu). This is clearly the figure that Banda Gelek uses.

The outer sixteen and inner twelve pillars then have beams erected upon them that are 1 mu in thickness, and on top of these inner and outer beams are arranged joists and roof covering, also 1 mu in total thickness—

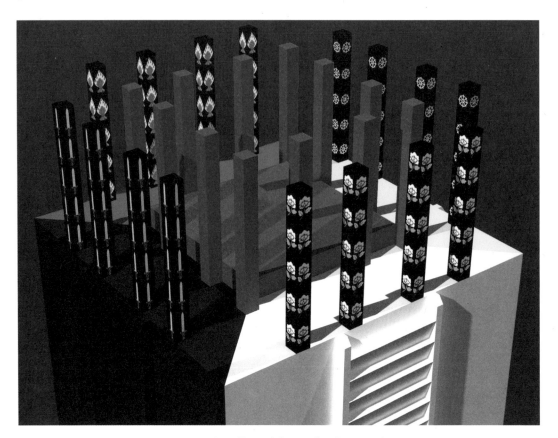

Fig. 3-7. The pillars of the Circle of Great Bliss.

half a mu thickness for the joists and half for the roof covering. The main Gelug text on the 3D mandala (Mskslos) tells us that the flat roof covering is made from slats of wood and clay of jewels (jewel powder).

Overall, the height of the Circle of Great Bliss—from the foundation to the flat upper surface of the roof—is half a body-DU (= 12 mu). The number of joists is not specified, as is the case with many similar minor details of a construction such as this. For example, in the models shown here the joists project a little beyond their supporting beams (on the outside of the structure, not the inside) and the roof then projects a little beyond the ends of the joists. This is very common in Tibetan temple and mandala design, but it would also be perfectly correct to have the beams, rafters, and roofing all flush.

At the corners where the four beams meet, they are mitred and joined together.

Banda Gelek adds at this point that if a large palace is being built—itself a building rather than a structure within a temple—then in place of the outer sixteen pil-

lars one should construct walls 1 mu in thickness. He gives no further details than this, and presumably the intention is to strengthen the structure. Another possible variation is also given by Jonangpa Chokle Namgyal (Phmangom) who suggests that the structure will look better if corner pillars are placed supporting the outer beams, making a total of twenty outer pillars. He may have a valid point. If the number of pillars is based on descriptions of 2D mandalas coming from India, then in such descriptions any corner pillars could not be described; how could they be depicted in a 2D mandala? We simply do not have any detailed descriptions of the 3D mandala from the original Indian Kālachakra authors.

For the roof, the cornice is double, or otherwise, and on top of it place a parapet; under the joists hang pipes, in size equal to the thickness of the beam. This completes the Circle of Great Bliss.

There are several terms here introduced in one sentence that need explanation. However, it is important first to point out that these translations are those that

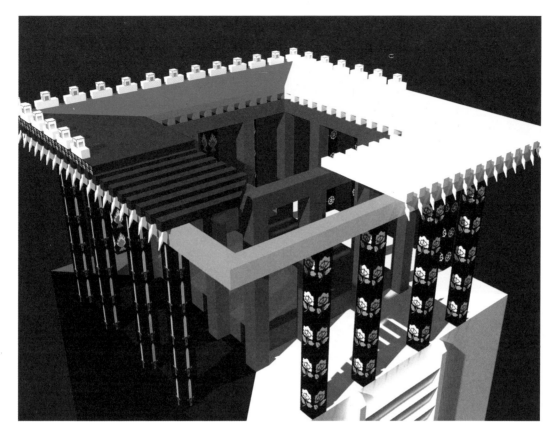

Fig. 3-8. The flat roof above the Circle of Great Bliss.

seem most relevant to the Kālachakra mandala, and the use of the terminology can be different in other systems. For example, the term that I have translated as cornice (*phyi tshe*) is sometimes used to describe the parapet on the top of the roof or a row of little pillars supporting a beam that supports the roof.

Here, the cornice is the top section of the main roof that sits on top of the upper beams. This consists of the parallel joists that normally extend out beyond the beams and then the sheeting, the flat and solid roof structure that is supported by the joists and most likely also projects out beyond them. This can also consist of more than one layer, the upper layers extending beyond any below. Running around the edge of this flat roof, and either right at the edge or a little bit in from the edge, is the parapet. There are several designs for this that are possible, the original consisting of merlons forming a battlement. Literally translated, the Tibetan term for parapet (*mda' yab*, *kramaśīrṣa*) is "arrow shelter/shield," hence the equivalence with a battlement—it forms a protective shield, the gaps between the merlons provid-

ing the opportunity for archers to attack the enemies outside. Although it does not occur in the Kālachakra literature, the Tibetan term for merlon seems to be *stag so/btag so*; I have not yet found a Tibetan equivalent to a parapet's crenels, the gaps between the merlons.

The merlons can either be placed right at the edge of the roof or set back a little from that edge. Sometimes the outer edge of the flat roof is curved downward, in which case the parapet has to be set back a little.

As in the West (and perhaps these basic designs have a common source), the parapet evolved for more peaceful purposes into a row of merlons that are each in the shape of half-lotus petals, forming a small wall, right on the edge of the roof. It is this form that Banda Gelek mentions in his text.

It should be pointed out that instead of placing merlons as just described, many will erect sloping Chinese-style roofs on top of the flat upper surface. No particular design for these is given in the texts.

For the roof over the chief deity dais, erect twelve further pillars directly over the twelve inner pillars of

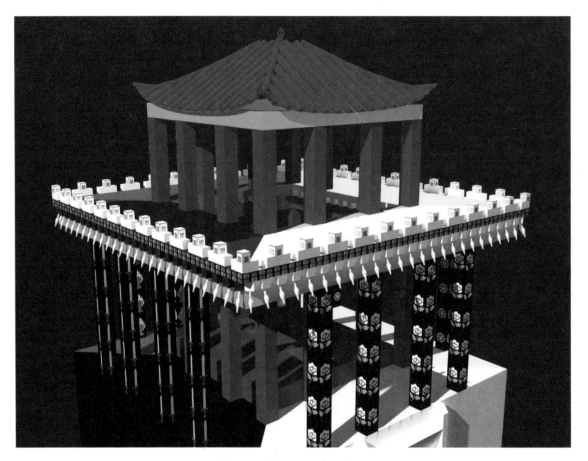

Fig. 3-9. The top roof in place.

the Circle of Great Bliss, placing them on the surface of the roof, as if they were extensions of the pillars below. These are also 1 mu across, but only 8 mu in height.

On top of these twelve pillars arrange as before beams 1 minor unit in thickness, and above these the Chinese roof, a total of 2 mu in height; finally, on the top of this place a (half-)vajra finial that is 1 mu in height. However, in actual practice, Jonang lamas tend to create much larger finials when constructing

a palace. I have been told that the reason is simply aesthetics.

This makes the height from the upper surface of the roof over the tathāgata-extension to the tip of the vajra finial, half a body-DU, or 12 minor units. It is not necessary that the upper pillars should be exactly this length of 8 mu, and if it looks better to have 3 minor units for the Chinese roof, then these pillars should be 7 minor units in length and so forth, as appropriate.

The mind palace

The colors of the various components of the structure and the placement of the lotuses for the deities are all explained later. As far as the structure is concerned, we now move down a storey to the mind palace. The foundation for the Circle of Great Bliss extends up from the top surface of the mind foundation, and the wall and other structures for the mind palace are built on that surface.

The outer edge of the surface would be called the parapet-line in a 2D structure and is the extent of the physical structure—the porches reach to this line. Banda Gelek continues by stating that the space between the parapet line and the baseline is divided into two, and this gives the position for placing the porch sides. Strictly speaking, this is the limit of the inner edge of the porch sides (also the inner line of the porch

extensions inside the porch); this is an important point that will be mentioned again later and then again when describing the torans. Measuring in 1 mu from the inner line of the walls, the baseline, determines the outer edge of the deity podium. This runs around the entire structure and has a width of 4 mu and a height of a quarter of a mind-DU, that is 1½ mu. This leaves a gap of 7 mu between the inside edge of the podium and the outside edge of the Circle of Great Bliss foundation.

The walls are in total one-quarter mind-DU (1½ mu) in width, and consist of three walls, or leaves, together, standing parallel. For (the width of) each of these, divide the quarter of a mind-DU (which is the total width) into eight, and make each wall two of these units in thickness, leaving two gaps between them each of one unit. This means that each wall has a thickness of ⅜ mu and the width of the gaps between the walls is ³⁄₁₆ mu. The height of the walls is two and three-quarters mind-DU (16 ½ mu). With other mandalas, the height of the walls of the porch projections, porch extensions, and so forth are much lower than the main walls, however with this method, the height of the main walls, the porch projections, porch extensions, and porch sides are all the same.

Measuring from the corner on the baseline, the porch projections extend out for 1 DU. Then to the side, the porch extensions extend also for 1 DU. From that point, the porch sides extend out 1 DU, reaching precisely to the parapet line, the edge of the foundation. I have interpreted this as meaning that all these measurements are taken along the extension of the inner line of the wall—the extension from the baseline. However, another interpretation could be that the length of the porch sides is defined from the outer corner at the join of the sides and extensions. This would mean that the walls do not reach the parapet line by a distance of 1½ mu. I have seen photos of 3D mandalas that suggest that some at least follow this interpretation. In all the images in this book I follow the first interpretation; however, this does create a problem with the toran that we'll come to later.

Then, for the actual door, in the middle of the porch projections to the left and right and top and bottom are the four parts of the triple door frame, one-fourth of a mind-DU in width. Between these is the actual doorway, from right to left in width half a mind-DU (in total) and in height from top to bottom 2¼ door units. The door itself is double, consisting of two leaves.

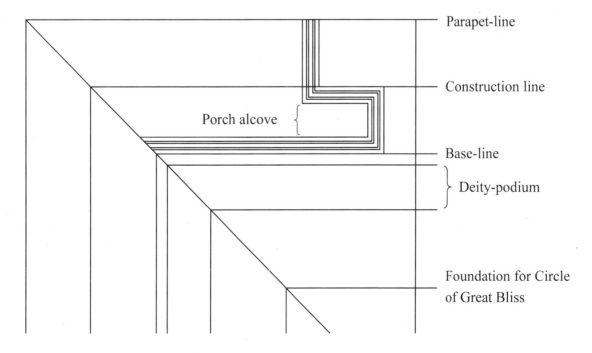

Fig. 3-10. The wall floor plan for the mind palace.

On top of the main triple wall is the continuous encircling frieze, one-quarter of a mind-DU in height. The inner edge of the frieze is flush with the inner edge of the inner wall, but the outer edge extends beyond the outer edge of the outer wall by one-quarter of a mind-DU (1½ mu).

The frieze does not follow along the tops of the porch projections, porch extensions, and porch sides. Instead, it goes from right to left of the doorway, following continuously along the top of the wall, crossing over the doorway. The outside face of the frieze is decorated with small jewels. The peaceful ones are circular, increasing are square, controlling are semicircular, and destructive are triangular.

On the top of the frieze are short pillars, sixteen in number (per side) or a similarly suitable number, ½ mind-DU (3 mu) in height and one-quarter mind-DU in width, with the pillars flush with the inside edge of the frieze.

On top of these pillars is a golden beam that completely surrounds the structure, one-quarter of a mind-DU in thickness. The inner edge of this beam is flush with the inner edge of the pillars, but the outer edge protrudes beyond the pillars by one-quarter of a mind-DU (1½ mu). If it is required to make this more attractive, arrange three golden beams on top of the pillars, one on top of the other, with the inner edge of all three flush with the inner edge of the pillars. Have

each beam protruding farther out than the one below, with the outer edge of the upper beam protruding by one-quarter mind-DU (1½ mu). The overall thickness of the three beams together should not be more than one-quarter of a mind-DU. These are called golden beams, but in fact their color is blue rather than yellow.

In between the short pillars, beneath the golden beams, are heads of makaras; from the two corners of their open mouths hang garlands to the right and left connected to the next makara mouth corner. From the middle of each makara mouth hang single drops. The ends of each of the drops are ornamented with mirrors and yak-tail chowries.

For the arrangement of the roof on top of the golden beams, twelve pillars are erected on the colored ground of the inside of the mind palace, pairs of pillars in each direction, and one in each of the four corners. They each sit inside of and touch the inner edge of the mind deity podium, and in height they come up to the same height as the outer short pillars; their height is therefore 22½ mu. In width they are one-quarter of a mind-DU (1½ mu).

The next steps are essentially the same as for the roof of the Circle of Great Bliss: on top of these inner pillars are placed inner golden beams, their top surfaces level with the tops of the outer beams, and on top of these inner and outer beams are arranged joists to form the roof. On top of the joists is flat sheeting, as before.

Fig. 3-11. One section of wall plus a close-up showing the gaps between the walls.

The inner edge of the roof is flush with the inner edge of the inner beams and the outer edge protrudes beyond the golden beams by one-quarter of a mind-DU (1½ mu), making it directly over the (outer edge of the) lower desire podium (or plinth).

The cornice at the very edge of the flat roof is either double- or triple-stepped. At the edge of the top surface arrange a parapet in the shape of lotus petals. The cornice is made of alternating small jewel-joists and flat covering, but however it is constructed, it should be no more than about one-quarter of a mind-DU in thickness. (It is clear that the top of the flat roof surface should be level with the top surface of the foundation of the Circle of Great Bliss.) Although Banda Gelek describes the parapet as consisting of lotus shapes, it would be quite correct to place them in the form of battlement-style merlons.

He goes on to state that it is also correct to make the roof in the form of a Chinese roof, but writes that in his tradition, in order to be compatible with Indian methods, apart from the roof over the chief deity, the roofs of the mind, speech, and body palaces should all be flat, level surfaces. Inspection of actual Jonang 3D mandala palaces suggests that the preference, at least in recent times, is certainly for Chinese-style roofing in place of either the battlement- or lotus-style parapet.

Below the joists are pipes hanging down (these are for water drainage from the flat roof above), their lower tips being level with the undersides of the golden beams. The pipes are shaped like little bottles pointing downward.

The white mind palace plinth is on the outside of the wall, and each of the four sections runs from one porch alcove to the next. It is half a mind-DU in width and a quarter of a mind-DU in height and encircles the structure like a ledge along the base of the walls.

The toran

We now come to the torans for the mind palace, and I shall follow Banda Gelek's example by first giving a quick overview followed by the details of their construction.

Each of the torans consist of four (sets of) beams, three guardrails, and three stages. Each stage has four (pairs of) pillars forming three cells. On top, on the highest main beam is a Chinese roof, and on top of that a vase.

In this method the torans are constructed over the porches; the beams that have been mentioned are golden beams on top of the pillars. Each guardrail consists of a balustrade that runs around the outside of the pillars of the toran and completely surrounds them so as to protect anyone intoxicated from alcohol from falling over the edge. For this reason they are called (literally) "drunk protectors" (*myos pa srung ba, mattavārana*).

Regarding the heights and widths of the beams, guardrails and so forth, taking the current example of the mind-toran, the (set of) golden beams that are laid over the porch, together with their covering, are in length, from right to left, 4 mind-DU (24 mu) in depth, front to back, 1 mind-DU (6 mu); and in height (thickness) one-sixth of a mind-DU (1 mu). The guardrail on top of this is in length, from right to left, 2⅔ mind-DU (16 mu), from back to front one mind-DU (6 mu), and in height one-sixth of a mind-DU (1 mu). There is a problem here, to which we shall return when looking at the details of the construction.

On top of the covering are the outer and inner sets of four pillars of the first stage. These are each in length (height) 5 mu, and in width they are one-sixth of a mind-DU (1 mu). The spaces between the pillars form three cells, all equal in width, from right to left, at two-thirds of a mind-DU (4 mu).

On top of the pillars of the lower stage are further golden beams together with covering, in length, from right to left, 3 mind-DU (18 mu), in thickness one-half of a mu, and in width, from front to back, 1 mind-DU (6 mu). The guardrail on this is in length, from right to left, 2 mind-DU (12 mu) and one-sixth of a mind-DU in height (1 mu).

Within the guardrail are the outer and inner sets of four pillars of the middle stage. These are 4 mu in

Fig. 3-12. Structure of the doorways.

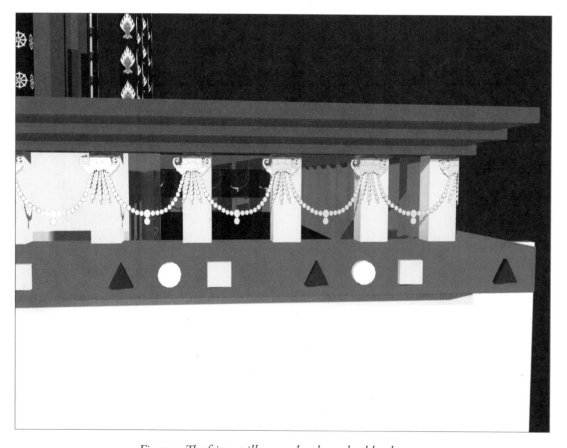

Fig. 3-13. The frieze, pillars, garlands, and golden beams.

length, and in width they are three-fourths of a mu. The cells between them are each in width, from right to left, half a mind-DU (3 mu).

On top of the pillars of the middle stage are golden beams together with covering, in length, from right to left, 2½ mind-DU (15 mu). They are ½ mu in thickness and in width, from front to back, 1 mind-DU (6 mu). The guardrail on this is 1⅓ mind-DU (8 mu) in length, from right to left, and one-sixth of a mind-DU (1 mu) in height.

On this are the outer and inner sets of four pillars of the top stage. These are half a mind-DU (3 mu) in length and ½ mu in width. The cells between them are each in width, from right to left, one-third of a mind-DU (2 mu). These upper storey pillars support a set of golden beams that is 2 mind-DU (12 mu) in width from right to left, 1 mind-DU (6 mu) from back to front, and in thickness half of a sixth of a mind DU (½ mu).

Above this the width, right to left, of the Chinese roof is on the underside 1⅔ mind-DU (10 mu), and the upper side is 1⅓ mind-DU (8 mu). The thickness (height) is one-fourth of a mind-DU (1.5 mu). On top of this is the vase which is in both height and thickness one-third of a mind-DU (2 mu).

With the exception of the heights of the pillars that surround the porch, all the vertical and transverse dimensions just given are the same as those for the drawn 2D mandala.

The structure of the toran

There is a problem with the depth of the toran here. In his introduction, Banda Gelek told us that the depth of the first stage is 1 mind-DU (6 mu). Now, he writes that "Regarding the structure of the mind torans, right and left of the porch sides, at the front and flush with the front of the side walls, and at the back flush with the corner of the porch extensions, and just touching the walls of the porch, are pillars in the four directions, a

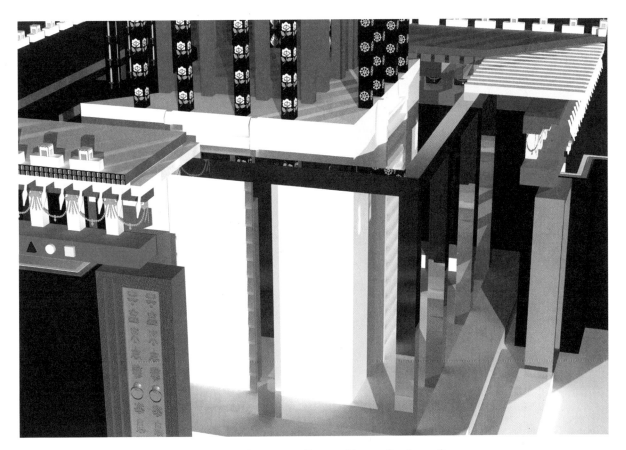

Fig. 3-14. The main pillars and beams for the roof.

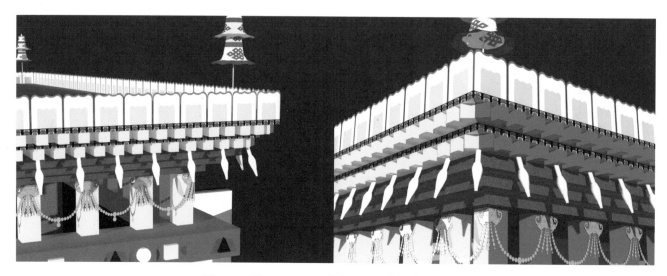

Fig. 3-15. The cornice, with lotus petal–style parapet.

quarter of a mind-DU in width and in height equal to the walls."

The *Vimalaprabhā* tells us that the three components of the porch, the porch projections, the porch extensions, and the porch sides, are all in size the same as the doorway, that is, 1 DU. These dimensions are measured along the line that is an extension of the baseline, the line that runs on the inside of the porch. This can only be the case, as the line on the outside of the projection can only have a length of half a DU. For the porch side, there are two possible dimensions—the internal line clearly has a length of 1 DU, but the external line has a length of 1¼ DU (7.5 mu).

If we follow Banda Gelek literally and have the depth of the toran as 1 DU and place it flush with the front of the porch side, then the top of the walls of the porch extensions will be exposed. Also, if we take his later comments about the placing of the pillars flush with the front of the side walls and also the corners of the extensions, then the depth of the toran needs to be greater than he gives it, at 1¼ DU. There are only two solutions to this: either the porch sides are shorter and, unlike the projections their dimension of 1 DU is measured on the outside, or the depth of the toran is 1¼ DU. In the computer images in this book the latter method is followed; this is because this seems also to be the case with mandala palaces that I have been able to inspect directly or via photographs.

Those just described are the four main toran pillars, but in addition the space between the right and left porch sides is divided into three, and at the two intermediate points are erected decorative pillars identical in height and width to the others.

Arrange crossbeams between the decorative pillars and the points where the projections and extensions meet; arrange a perimeter of beams across the tops of the main pillars, also across the decorative pillars at the front and along the walls of the porch extension at the back. All the beams are connected by half-lap joints.

Above this arrange joists and flat covering. The thickness of the flat roof together with the golden beams is one-sixth mind-DU (1 mu). The implication here is that the relative thickness of the beams, joists, and covering is left to individual taste; also, as can be seen in some 3D mandala designs, the joists and flat covering can be double or triple (similar to the cornice, described earlier). The right and left toran pillars are flush with the beams across the porch side at the front and at the back with the porch extension. All the upper beams are similarly flush at both front and back. The space above the doorway between this roof over the porch and the main wall is filled with flat jeweled paneling, the color of the directions.

On top of this is constructed the lower stage of the toran. This consists of outer and inner sets of four pillars, each in width one-sixth mind-DU (1 mu), and in

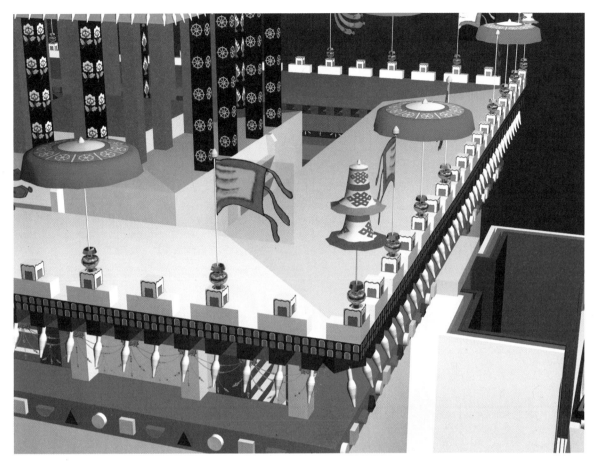

Fig. 3-16. The completed roof of the mind palace.

length 5 mu. For the sites of the pillars, find the center between the right and left of the covering and mark this position. Place two pillars one-third of a mind-DU (2 mu) right and left of that mark, and then two-thirds of a mind-DU (4 mu) beyond those pillars place two further pillars. At the same positions place four pillars on the back side of the covering to produce four pillars at both the back and front.

These eight pillars are placed a little bit in from the edges of the covering in order to make room for the thin guardrail that is to be erected around them. All the stages are constructed the same way. Outside of the outer and inner sets of four pillars, surrounding them on all four sides, is the guardrail, one-sixth of a mind-DU in height (1 mu). The thickness of the guardrail is not specified and should be made as suitable.

On top of the inner and outer pillars arrange the second set of golden beams and then also arrange joists and flat covering, as before. The golden beams together with the covering are in length, from right to left, 3 mind-DU and in height one-twelfth of a mind-DU (½ mu).

On this place the front and back sets of four pillars for the middle stage. The length of each of the pillars is 4 mu, and in width they are three-fourths of a mu. For the position of these pillars, find the midpoint between the right and left edges of the flat covering of the middle stage, and from that point measure right and left 1½ mu and place two pillars. Half a mind-DU (3 mu) beyond those pillars place another two pillars, with another similar set of pillars on the back side. Around these outer and inner sets of four pillars erect the second guardrail, one-sixth of a mind-DU (1 mu) in height.

On top of these outer and inner pillars arrange the third set of golden beams, and on top of these arrange joists and flat covering. The thickness of the golden beams together with the covering is one-twelfth of a mind-DU (½ mu). The length from right to left is two and a half mind-DU (15 mu).

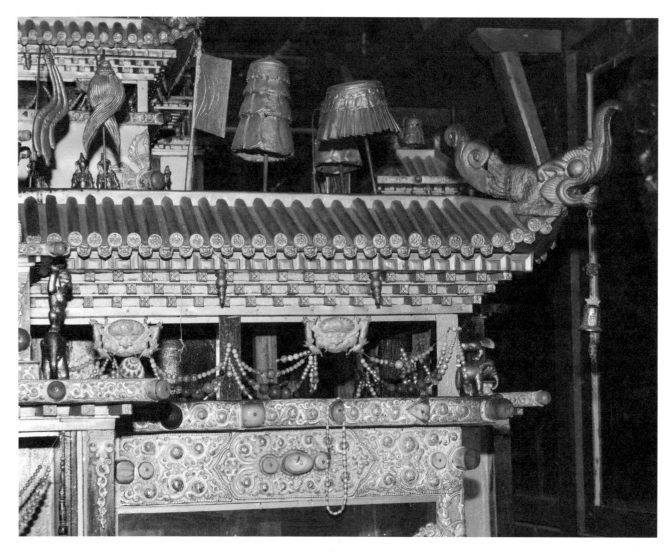

Fig. 3-17. Example of Chinese-style roofing on the mandala palace in Tsangwa monastery, Dzamthang.

On this place the front and back sets of pillars for the third and topmost stage. The length of each of the pillars is one-half a mind-DU (3 mu), and in width they are one-twelfth of a mind-DU (½ mu). For the position of these pillars, find the midpoint between the right and left edges of the flat covering of the top stage, and from that point measure right and left one-sixth of a mind-DU (1 mu) and place two pillars. At 2 mu beyond those pillars place another two pillars, with a similar set at the back. Around all of these front and back pillars arrange the third guardrail, one-sixth of a mind-DU (1 mu) in height.

On these eight outer and inner pillars arrange a perimeter of the fourth set of golden beams, and on top of these arrange joists and a flat covering. The flat covering plus the beams are in thickness one-twelfth of a mind-DU (½ mu) and in length from right to left 2 mind-DU (12 mu).

On top of these is the Chinese roof. This is in height one-fourth of a mind-DU (1½ mu), in length, from right to left, on the underside 10 mu and on the top side 8 mu. On top of the roof is a vase, in height one-third of a mind-DU (2 mu) and in width, from right to left, either one- or two-thirds of a mind-DU (2 or 4 mu).

In this way, of the four coverings of the toran, the lowest has a thickness of 1 mu; the other three are all equal in thicknesses at one-half mu. All the guardrails are equal in height at one-sixth mind-DU. Notice that Banda Gelek does not give depths for the beam sets and coverings above the first stage. They are all assumed to

be equal, but it is sometimes the case that, when constructed, the higher beam sets are made progressively smaller in depth, from back to front. This completes the structure for the mind palace.

The speech palace

Having described the structure of the mind palace, it is now relatively trivial to describe the speech and body palaces. For the speech mandala, on the top surface of the speech foundation, divide the space between the baseline and the parapet line into two. As before, follow the description for the mind palace, but replacing mind-DU with speech-DU and also replacing units of one-third, one-sixth, or one-twelfth of a mind-DU with units of one-third, one-sixth, or one-twelfth of a speech-DU. Remember that any units given in minor units (mu) have to be doubled for the speech palace and quadrupled for the body palace. Otherwise, from the construction of the walls to the torans, there is only one difference from the structure of the mind palace.

The body palace

For the body mandala, repeat as before, dividing the space between the baseline and the parapet line on the ground for the body palace into two, and continuing up to the vase on the top of the torans. Replace all measurements of units of mind- or speech-DU with body-DU. As with the speech palace, the structure is the same as that of the mind palace, except that the heights, widths, thicknesses, and so forth of the walls and other parts are all four times those of the mind palace, twice those of the speech palace.

The ornaments of the mandala

The three palaces of body, speech, and mind have on the (outside) corners of the walls, either in the middle or at the base, vertical crossed vajras. These are solid, that is, not painted on. Their sizes and colors are not given. In the porch alcoves, on top of the plinths, are crescent moons standing up, on top of which are nine-pointed jewels.

On the first, or bottom, stage of the torans, right and

The heights of the walls, and so forth, and their lengths and widths, are for the speech palace double those of the mind palace. However, the one difference is that there are five walls for the speech palace (and also the body palace), but there is no difference in the overall structure. To construct the five walls, divide the width of the space for the walls, one-fourth of a speech-DU (3 mu) into 14. Make each wall two of these units in thickness and the gaps between the walls one of these units: each wall has a thickness of three-sevenths of a mu and each gap three-fourteenths of a mu.

However, for the body palace there are also five walls and so the method of constructing them is the same as with the speech palace. The width of the deity podium in the speech palace is the same as that in the mind palace. However, the deity podium in the body palace is larger, at half a body-DU (12 mu) in width. The heights of the two deity podiums are one-fourth of their respective door units. Notice that although the podiums in the mind and speech palaces have the same width, the height of the mind podium is half that of the speech podium.

left of the four outer pillars, are stacked elephants and lions, made out of jewel and arranged like pillar ornaments. The lower elephants are facing inward and the upper lions are facing outward, with their two front paws supporting the upper beams. It is said that these should be placed in the four corners of the torans (next to each of the outer pillars).

The sets of pillars on the three stages of each toran

Fig. 3-18. The problem if Banda Gelek is taken literally, on the right, exposing the tops of the walls.

form three cells on each stage. In the central cell of the lower stage of the eastern body mandala toran is a black wheel, on its right a male deer and on its left a female deer; the male deer has horns and the female does not. Similarly, in the South is a red vase, on its right a Dharma-conch and on its left a lotus. In the North is a white drum, on its right a club and on its left a hammer. In the West is a yellow bodhi tree, on its right a male kinnara and on its left a female kinnarī.

The club described as on the right in the North is a club tipped with a jewel, and the hammer that is on the left is a club with a square top. The deer and so forth that are described as being on the right and left of the wheel and other central objects are either placed with them in the middle cells, or they can be placed in the cells that are to the right and to the left. The latter is the method mainly used in practice.

Banda Gelek states that in all the cells of the middle and upper stages of the torans are shālabañjikās; these are forms of goddesses carved from jewels. They are supports, and with their hands hold up the beams. The positioning of these is a mistake, as Tāranātha and others (including Banda Gelek when describing the 2D mandala) place these in a similar position to the lions

and elephant supports—outside of the outer pillars, supporting the main beams. It would be expected that all the other cells in the torans (the middle and upper stages of the body torans and all the cells of the speech and mind torans) contain offering goddesses.

To the right and left of the vases on top of each toran are victory banners, and from below the four sets of beams, to the right, left, front, and back hang various offerings of bells, mirrors, flags, chowries, and so forth.

On top of the parapets of all three mandalas, at the four corners are victory banners, and in between them, all around the edge, are many parasols, flags, pennants, chowries, and so forth. These comments do not apply to the Circle of Great Bliss, although some people may adorn them in this way. There are also ornaments such as the garlands, the frieze jewels, torans, pipes, and so forth; these have already been explained.

On the external offering ground should be arranged as many offerings as possible, of vases and so forth. Right at the level of the body mandala parapet, over the perimeter of earth, in the sky in the Northeast is the rising full moon, and in the Southwest is the setting disk of the sun.

The perimeters

The diameter of the offering ground (or vajra ground) was given earlier as twice the internal width of the body

palace, at 384 mu. On the outside edge of this offering ground, touching the inner line of the first perimeter, is

the wall of the offering ground, rising above it one-sixth of a body-DU both in height and width. The outside edge of this wall is therefore flush with the outside edge of the offering ground, and the wall stands on the outermost one-sixth of a body-DU (4 mu) of the offering ground.

Beyond the offering ground wall are the six perimeters, with exactly the same dimensions as given in the 2D mandala. The perimeters are, together with their widths in mu:

Earth: 12
Water: 24
Fire: 24
Wind: 24
Space: 12
Light: 24

The total width of these is 120 mu. If we add double this to the diameter of the offering ground, we find the diameter of the overall structure as 624 mu (26 body-DU)—the same figure given in the previous chapter for the 2D mandala.

Just as with the offering ground, at the outer edge of the earth perimeter, flush with the inner line of the water perimeter, is a wall rising up from the earth perimeter, also one-sixth of a body-DU both in height and width. There are similar walls on the edges of the three perimeters of water, fire, and wind. There are no walls for the perimeters of space and garland of light.

The insides of the perimeters of the four elements are filled with representations of those elements. Either these representations are molded, or they can simply be painted onto the flat surfaces of the perimeters, the designs being the same as those used for a 2D mandala. In the middle of the space perimeter is the vajra tent; erect there a colored vajra garland. Around the outside of this arrange a garland of light.

The way that these perimeters are described has them flat—all at the same level. However, many 3D mandala palaces in the Jonang tradition have them stepped, with the earth a little higher than water, that a little higher than fire, and so forth. I have been told that the reason for this is that a lama once managed to visit Shambhala and reported that the palace built there by Suchandra had stepped perimeters!

Although they are often not included in 3D structures of this kind, Banda Gelek mentions briefly the representation of the charnel grounds and that these would be placed above the border between the perimeters of wind and fire. He states that, as with the 2D mandala, the usual protectors of the directions and protectors of the land are not drawn as they are replaced by the prachaṇḍās on their wrathful wheels. All the other contents of the charnel grounds—the eight mountains, eight clouds, trees, and so forth—are needed, together with various corpses, skeletons, and so on. He also mentions placing emblems in the wind perimeter for the various perimeter beings.

Fig. 3-19. *The first pillars and beams. The matte color on the right is used to aid clarity.*

Fig. 3-20. Constructing the first stage of the toran.

Seats for the deities

This completes the architectural description of the mandala palace, and we now move on to the seats for the deities, starting at the very top of the structure.

The lotus for the chief deity and the eight shaktis is green with eight petals, and on its receptacle are disks of moon, sun, and Rāhu (respectively, white, red, and black). The size of both the lotus and its receptacle should be clear from the 2D mandala, as is the case with most of the lotuses to be described here.

The space in which the central lotus sits is square, and in the four corners of that square are four eight-petaled white lotuses for the four emblems. These can have a diameter of 2 mu, but if the palace being created is for the nine-deity mandala, they will have to be smaller, for pillars need to be placed between these lotuses and the main lotus. These four lotuses are not represented in the 2D mandala, and suprisingly they are not normally mentioned in meditation practice texts, although they are required.

In the four cardinal directions of the tathāgata-extension are four eight-petaled white lotuses with sun disks on their receptacles, and in the intermediate directions are four eight-petaled red lotuses with moon disks on their receptacles; this is the area between the two sets of pillars. In between the right and left pillars in the four directions are eight eight-petaled white lotuses as seats for the vases; these have no moon or sun seat.

On the next level down, on the mind deity podium,

right and left of both East and South, and right of North and West are eight-petaled white lotuses with sun disks on their receptacles. In the four intermediate directions, and left of both North and West, are eight-petaled red lotuses with moon disks.

In the eastern and northern doors of the mind palace are eight-petaled white lotuses and sun disks, and in the Southern and Western doors are eight-petaled red lotuses with moon disks. There is a necessary difference here with the drawn mandala, as in the 2D drawing, the door frames and door leaves are not represented. In the 3D mandala these effectively fill the porch extensions, and so these lotuses need to be placed farther out in the porches.

On the next level down, on the deity podium of the speech palace, in the four cardinal directions are four eight-petaled red lotuses, and in the intermediate directions four eight-petaled white lotuses. Notice that these are the other way around from the mind palace. There we have red lotuses in the intermediate directions.

Down again, and on the deity podium of the body palace, right and left of the four cardinal directions are eight red lotuses with twenty-eight petals, and in the four intermediate directions four white lotuses with twenty-eight petals. These lotuses in both the speech and body palaces do not have sun or moon disk seats, as in place of them, the deity mounts that stand on top of the lotuses are the seats for the deities.

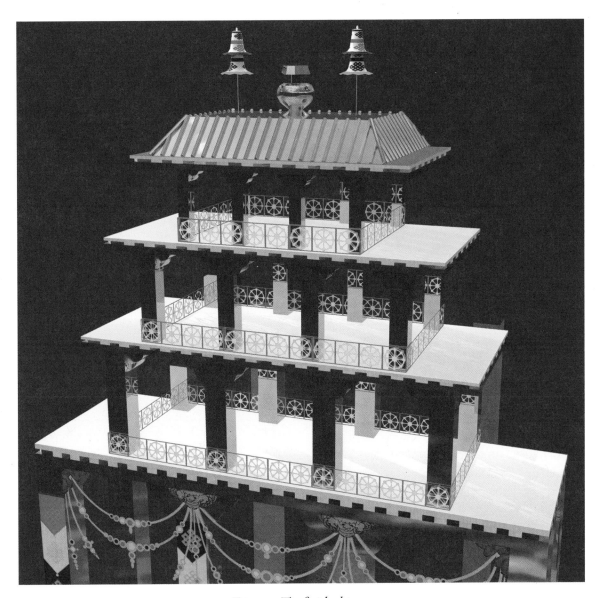

Fig. 3-21. The finished toran.

Indicating right or left is from the point of view of the four-faced chief deity, whose four faces look in the direction of the four doors, and from that point of view, right and left are described within the mandala. For example, if a person moves from the center of the mandala in the four directions, right and left are their right and left.

The lotus for the chief deity, those in the Circle of Great Bliss, and those in the mind palace all have long stalks. The lotuses in the speech and body palaces have somewhat shorter stalks.

In the four doorways of the body palace are chariots that are each one-half a body-DU in length and breadth. In the eastern door is a black chariot pulled by

seven boars. In the southern door is a red chariot pulled by seven horses. In the northern door is a white chariot pulled by seven lions. In the western door is a yellow chariot pulled by seven elephants. These are the seats for the male-female wrathful door-protectors. As these chariots are under the control of and being driven by the female deities, and as the females are facing outward, the fronts of the chariots are facing outward and they are being pulled outward by their draft animals.

There are also above and below door-protectors. The wrathful above door-protector is in the empty space of the upper section of the speech foundation. The green chariot is facing East and pulled by seven garuḍas. The wrathful below door protector is in the empty space

below the ground of the body palace. The blue chariot is facing West and pulled by seven eight-legged lions (*śarabha*).

Banda Gelek tells us that "The garuda is three-eyed, and from the feet up to the hips is yellow; from there to the navel is white; from there to the throat is red; from there to the eyebrows is black; and from there to the crown is green. In this way it is a five-colored bird that is as fast as the wind." The eight-legged lion is either blue or black, and at the two shoulders and the tops of the two hips has yellow or multicolored little wings, the extra four legs.

Next is the positioning of the seats (disks of the elements) for the ten nāgas. In a 2D mandala these are placed level with the inner toran pillars on top of the body-plinth. For a three-dimensional mandala they are on the offering ground, at the base of the body mandala desire-podium (plinth), by the side of the rear toran pillars, and right up next to the plinth. In the East are two black circular seats; in the South two red triangular seats; in the North two white semicircular seats; in the West two yellow square seats. The seat for the above nāga is inside the speech foundation, below the above wrathful (door-protector) and the seat for the below nāga is below the ground of the body palace, under the below wrathful. The seat for the above nāga is a green (circular) disk of space, and the seat for the below nāga is a blue (circular) disk of awareness.

The ten prachandās are next. The eight in the cardinal and intermediate directions are above the border between the perimeters of fire and wind, that is, in the four cardinal and the four intermediate directions; the other two are below the above and below nāgas. The seats for the prachandās in the cardinal and intermediate directions are eight-spoked weapon wheels, each half a body-DU in size; those in the cardinal directions being red and those in the intermediate directions white. They are each on their animal mounts, which are on the hubs of their respective wheels. The seat for the above prachandā is a green chariot and that for the below prachandā is a blue chariot; they are both the same size as the chariots of the wrathfuls, but without any draft animals. If the eight charnel grounds are modeled, clearly the wheels for the main eight prachandās will be placed within them.

The colors for the mandala

The colors for the directions are East black, South red, North white, West yellow, and center blue. The (square) ground of the chief deity seat is blue. The lower (part of) the chief roof is green, the upper Chinese roof blue; however, it is very common in Tibetan constructions of the Kālachakra mandala that this is in fact golden. As this is quite attractive, many of the computer images in this book also have a golden upper Chinese roof. The twelve pillars immediately below the Chinese roof and the twelve pillars holding the inner beams of the Circle of Great Bliss are blue or green. Of the sixteen black pillars supporting the outer beams, the four in the East are decorated with garlands of swords; similarly, four pillars in the South with jewels, in the North lotuses, and in the West wheels. The inner beams of the tathāgata-extension are blue and the outer beams green.

Regarding the ground of the Circle of Great Bliss, if this is given the colors of the directions, then also the upper and lower parts of the roof above it should be the colors of the directions; if this ground is made green, then both the upper and lower parts of the roof are blue; if it is made blue, then both upper and lower roof are green.

The sides of the foundation for the Circle of Great Bliss should be made the same colors as the upper ground (the top surface of the foundation). However, in the main Jonang meditation practice texts, the ground of the Circle of Great Bliss, the upper and lower parts of the roof, and the sides of the foundation are all the colors of the directions.

The tops and sides of the speech and mind foundations; the colored grounds; the small gaps; the insides of the doorways of the mandalas of body, speech, and mind; the external offering ground and its bounding

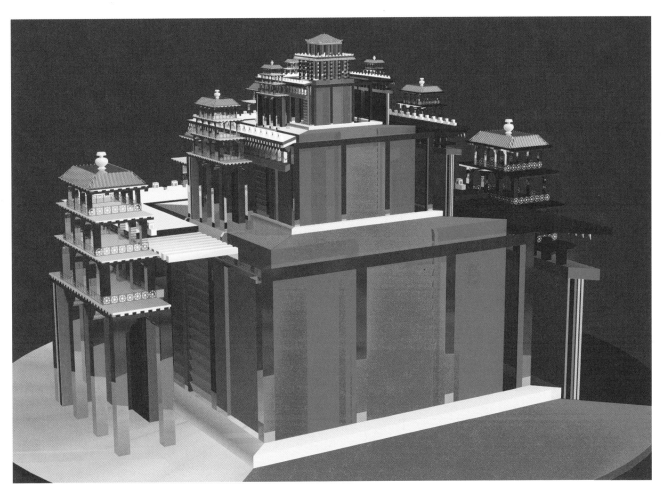

Fig. 3-22. Exposed view of the complete palace.

wall; the upper and lower surfaces of the roofs of all palaces; the upper and lower coverings of the torans; plus the little pillars above the friezes are all the colors of the directions. There are different ways of defining the borders between the colors of the directions, but the method in the Jonang tradition is to take the diagonal lines. There are on top of each frieze little pillars in the corners, and these are made half one respective color and half the other.

The three deity-podiums and the three plinths are white. The friezes are red. The garlands and drops are all white. The beams above the little pillars are blue. The pipes are white. The parapet merlons are white. The upper and lower pillars of the torans, the four beams, and all the guardrails are yellow, golden-colored. The top roofs of the toran are yellow, green, or blue (blue the most commonly used) and the vases on top are yellow.

The three walls of the mind palace are, from the inside, black, red, and white, and the five walls of each of the speech and body palaces are, from the inside, green, black, red, white, and yellow.

The perimeter of earth and its wall are yellow in color. Similarly, the water perimeter is white with designs of water drawn on it; the fire perimeter is red, with drawn on it a fire-mountain swirling to the right; the wind perimeter is black, with wind designs drawn on it. The vajra fence is blue, and the garland of light is shaded green, black, red, white, yellow, and blue.

As a final point, Banda Gelek states that the positioning of the above and below deities—which in the meditation are literally above and below the center of the mandala palace—can be similar to the 2D drawn mandala within a 3D structure. As some of these would otherwise literally be invisible within the foundations, this makes considerable sense.

He states: "For the previously explained two vases

that are above and below the Circle of Great Bliss, the two pairs of offering goddesses that are above and below the mind palace, the above and below door-protectors, nāgas, and prachaṇḍā that are above and below the body palace, they are placed above and below during meditation, but when a mandala is drawn or constructed, the arrangement is different. The upper vase is placed behind (farther from the center) the wrathful in the eastern door of the mind palace, and the lower vase is behind the wrathful in the western door; the two pairs of offering goddesses are in the middle lower cells of the mind palace torans: above Vādyā in the North and Nṛtyā in the East; below Gītā in the South and Kāmā in the West.

"Of the above and below wrathfuls of the body palace, the above wrathful is behind the wrathful in the eastern door of the body palace, and the below wrathful is behind the one in the western door. Behind each of these are the nāgas together with their seats. Behind the eastern prachaṇḍā is the above one, and behind the western, the below prachaṇḍā."

There is one inconsistency here in that the arrangement of the above and below offering goddesses differs from that given in the second chapter. That was based on the *Vimalaprabhā* and Tāranātha's description of the mandala in his empowerment text (Kacoin). In his text on the three-dimensional mandala, Banda Gelek agrees with Nṛtyā in the east, but the other three are in different positions. The reason for this is not clear. There is a different arrangement for these goddesses given in the fourth chapter of the *Vimalaprabhā*, but that swaps two of the first eight of these offering goddesses with the two below. It does not explain the different arrangement given here. Perhaps it is an error; in *The Illuminating Sun-rays* Banda Gelek gives the same arrangement as is given in the second chapter.

This completes Banda Gelek's description of the support mandala. At this point in his text on the 3D mandala he lists the deities and their positions. Here, that is the subject of the next chapter.

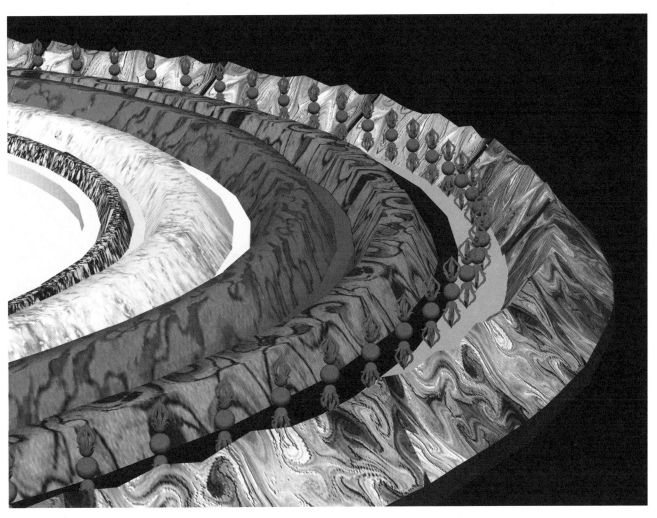

Fig. 3-23. The six perimeters.

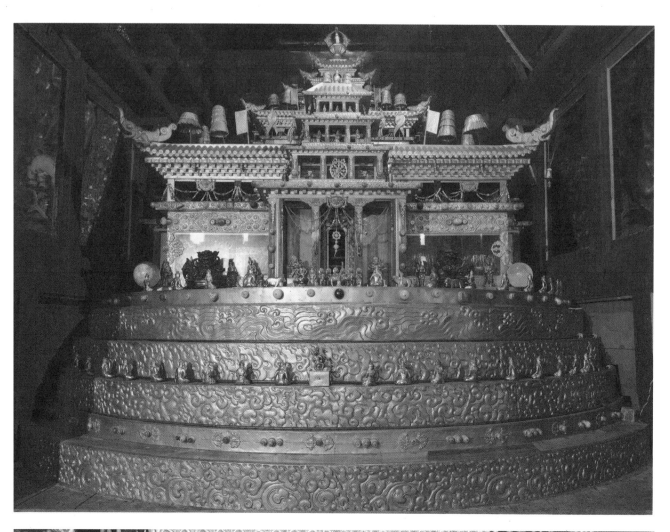

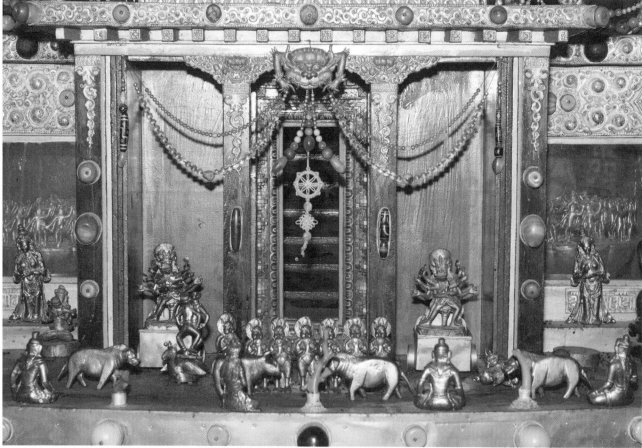

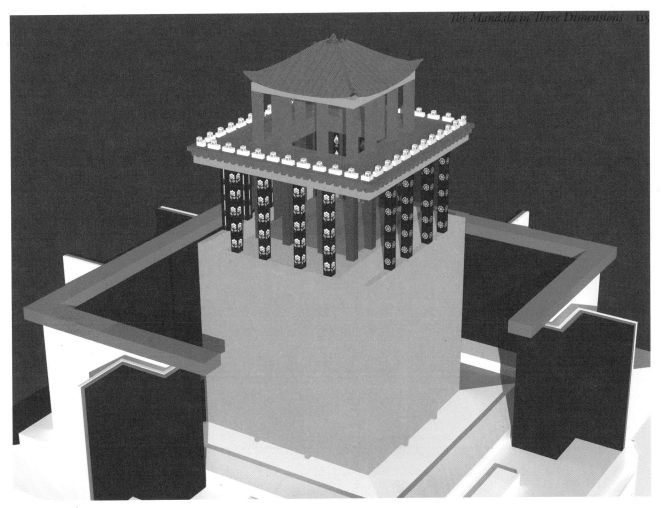

Fig. 3-26. Alternative coloring for the Circle of Great Bliss.

Facing page:

*Top: Fig. 3-24. Completed in 1992 and constructed under the direction of Yontan Zangpo,
the mandala palace structure in Tsangwa Monastery, Dzamthang.*

*Bottom: Fig. 3-25. View of the eastern body doorway of the Tsangwa Monastery mandala palace. The seven garuḍa draft
animals for the upper chariot are clearly visible; the boars that pull the eastern chariot are hidden behind them.
The two chariots are clearly visible to the right and left of the garuḍas.*

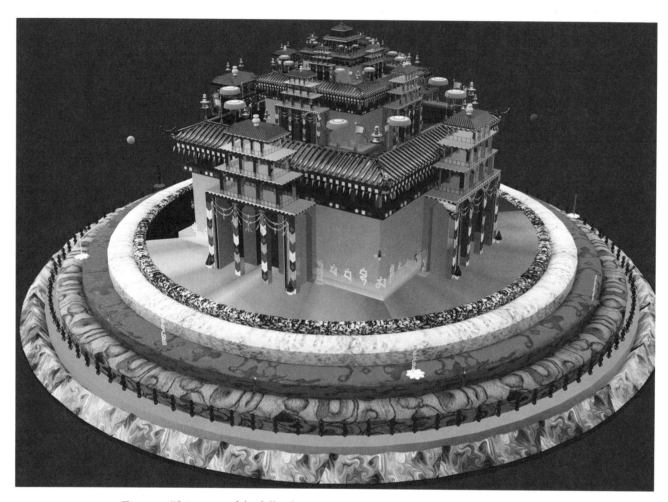

Fig. 3-27. This image of the full palace structure shows the perimeters in stepped form.

4. The Deities of the Mandala

The Mind Mandala Palace

Kālachakra and Vishvamātā

KĀLACHAKRA STANDS in union with his consort Vishvamātā in the middle of the central lotus, on a seat consisting of disks of the moon, sun, and Rāhu. The center of the lotus is covered by these three disks, all horizontal, thin, and equal in diameter. The white moon disk is on the bottom, next is the red sun disk, and on top is the deep blue disk of Rāhu. These symbolize, or are considered to be the essence of, the three main channels in the body, respectively the left lalanā, the right rasanā, and the central channel, the avadhūtī.

In the Gelug tradition the seat is described as consisting of four disks, that of yellow Kālāgni being on top of the three just described. In support of this, Detri Rinpoche (Kajazhal) gives two quotations from the *Vimalaprabhā*. The first of these comes from the introductory praises at the very beginning of the *Vimalaprabhā*, which state: "I bow my head to the foremost of those worshipped by the lords of the gods; whose feet are placed together with those of the Mother of Existence on the heads of Īshvara and Māra, upon the disks of wind, fire, water, and earth, Meru, lotus, moon, sun, and fire."

In the Tibetan translation of that verse, the word for fire (*teja*) has been translated as *dus me*, which is the usual translation for the Sanskrit *kālāgni*, although there is no clear justification for this (other than the

Tibetan word "me" meaning fire). Elsewhere in the *Vimalaprabhā*, another word for fire (*agni*) in a similar context has been translated simply as "fire" (*me*) and is glossed in that text as referring to Rāhu.

As Detri Rinpoche points out, both nodes of the moon, Rāhu and Kālāgni, can cause eclipses, and so to some extent they are interchangeable—either may be intended by a word that literally means fire in this context.

However, the most important point in this quotation would appear to be that a seat is described as consisting of three components, whether the third is intended to be Rāhu or Kālāgni is not clear, and this is after all a poetic praise, not a technical description of a meditation.

This is not convincing, but the other passage he cites is more cogent. At the end of the discussion of the attraction and absorption of the awareness beings, the *Vimalaprabhā* states that the absorption of the awareness beings takes place on top of "moon, sun, Rāhu, Kālāgni." The Sanskrit simply lists the four disks, without any word or grammatical particle for "and" or "or." I have checked three different Tibetan translations, all of which use the word for "and" between the first three disks; however between Rāhu and Kālāgni, one version has "and," one has "or," and the other has nothing (presumably implying three disks in total). No doubt these

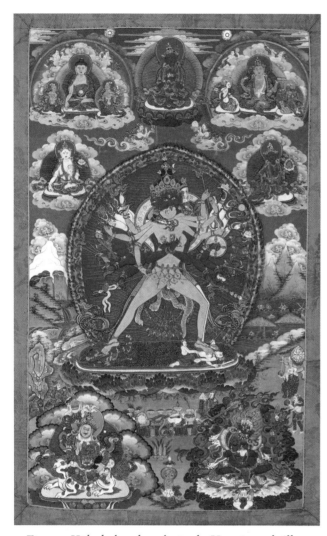

Fig. 4-1. Kālachakra thangka in the Victoria and Albert Museum, London. © Victoria and Albert Museum

comment that "one-third of the (size of) the lotus is the receptacle, as are the disks of moon, sun, and Rāhu."

After the creation of the palace comes the creation of Kālachakra, which is said to take place above the "disks of moon, sun, and Rāhu." During the subsequent description of Kālachakra, the seat is mentioned again as "moon, sun and fire," and these three are identified with the three channels, respectively the lalanā, rasanā, and avadhūtī. If it really were intended for the seat to consist of four disks, this section is where one would expect to find a clear reference to the fact.

Another aspect of the symbolism here is that the disk of Rāhu is on top of, and therefore obscuring, the two disks of the moon and the sun. They are together as at new moon, when they can be obscured by Rāhu, considered to be the cause of eclipses.

I should point out that many recent representations of Kālachakra in the Jonang tradition have four disks as his seat. I have been told that this is because of a comment in the oral traditions, which seems to boil down to one comment by Banda Gelek in just one text (Bgkuzi). Given the clear statements against this by earlier writers (such as Chokle Namgyal, quoted in the second chapter) and the fact that important early paintings such as the famous mural by Tāranātha in Takten Phuntsokling do not have four seats, this is presumably an influence from some other tradition.

Kālachakra has four faces, two legs, and twenty-four arms, and Vishvamātā similarly has four faces and two legs but eight arms. He embodies the five awarenesses, and indicating this the whole of his body blazes with light of the five colors—black (perhaps more correctly, deep blue), red, white, yellow, and green.

His two legs trample on the hearts of Kāmadeva (*'dod lha*) and Rudra (*drag po*). They are also respectively called Māra and Klesha. This indicates that he suppresses the two extremes of samsara and nirvana, and also that with his skill he defeats the four māras and with his perception of reality he defeats all emotional defilements (*nyon mongs pa, kleśa*).

The four māras (*bdud bzhi*) are demonic personifications of factors that ensnare beings in cyclic existence, samsara. Their primary source is the five emotional

differences stem from the different oral instructions received by the various translators.

This view of four seats was not held by all Gelug writers, including the founder of the tradition, Tsongkhapa, nor by one of the main influences on the Gelug practice of Kālachakra, Buton. He identifies the source of these ideas as the works of Abhayākaragupta and Sādhuputra, and certainly it is found in the former's *Niṣpannayogāvalī* and the latter's Kālachakra sādhana (Spksadh).

In the main discussion of the creation process in chapter 4 of the *Vimalaprabhā*, the seat of Kālachakra is mentioned three times. At the end of the description of the formation of the palace, the dimensions are given of various parts of the palace, and this concludes with the

defilements in the minds of beings, and their existence is referred to as the mara of emotionality (*nyon mongs pa'i bdud, kleśamāra*).

These emotional defilements cause the accumulation of evil, nonvirtuous actions; this is referred to as the mara of the divine child (*lha'i bu'i bdud, devaputramāra*).

The result of these evil actions is that the aggregates are created that experience suffering; this is known as the aggregate mara (*phung po'i bdud*).

Once these material aggregates have been created they eventually are destroyed; this is known as the mara of the lord of death (*'chi bdag gi bdud, mṛtyupatimāra*).

The right leg of Kālachakra is red and is the essence of the pure right rasanā channel. This is extended and represents the use of skill to defeat completely both subtle and gross forms of the four māras, symbolized by the essence of māra in the form of the red deity Kāmadeva.

Kāmadeva, who is under this right leg, is red in color and has an expression of combined peace and passion. He has one face, his hair is black in color, and he wears silken clothes and jewel ornaments. Of his four hands, the first right holds five flower arrows that create the

five emotional defilements of desire, anger, and so forth. According to Tāranātha, the term "flower arrow" means that the tips of the arrows are flowers. According to O'Flaherty, the arrows are made from the following five flowers: sun lotus, ashoka, mango, jasmine, and blue lotus; they cause infatuation, excitement, parching, heating, and paralysis; these are reminiscent of some of the stages of passion mentioned in the next chapter.

His second right hand holds an iron hook. His first left hand holds a bow and the second holds a bond. He is lying on his back with his head to the right, and Kālachakra tramples on his heart, preventing him from moving.

The left leg of Kālachakra is white and is the essence of the pure left lalanā channel. This is bent inward and represents that his awareness that understands the nature of reality defeats completely both subtle and gross emotional defilements, symbolized by the essence of emotional defilement in the form of the white deity Rudra.

He is white in color with one face and three eyes. His appearance is of a combination of peace and anger, and he bares his fangs. His hair is ruddy yellow in color and

Fig. 4-2. Kālachakra's left foot tramples on Rudra. Tsangwa Monastery, Dzamthang.

bristles upward. His body is stout, and he wears a tiger skin and human skulls.

Of his four hands the first right holds a trident, the second a ḍamaru. The first left hand holds a khaṭvāṅga and the second a skull. He is also lying on his back with his head to the left, and Kālachakra tramples on his heart.

The consort of Kāmadeva, Rati (*dga' ma*), is by the side of Kāmadeva, with her hands under the sole of Kāla-chakra's right foot, attempting to lift it off Kāmadeva. Similarly, Umā, the consort of Rudra, is attempting to lift up the left foot. Their faces hang down with depressed expressions due to their suffering, as they are completely unable to move the feet of Kālachakra that are crushing their consorts.

This posture of Kālachakra is known as the right-extended posture and is also that of the wrathfuls in the doors of the mind and body palaces. In his work on deity proportions (Tnkutsd), Tāranātha states that the stretch between the legs is given as five spans, but that this is uncertain. He goes on to add that reliable reports state that some old images in India and Nepal had a stretch of seven spans. This is indeed quite a stretch, and for this reason, the distance is presumably measured between the tips of the toes, from right to left. This would give a distance between the heels of just less than five spans; maybe this is the source of these two differ-ent measurments.

The color of Kālachakra's body (by this the torso is really meant) is blue. This symbolizes the essence of body, the purity of the white lunar aspect, and the essence of mind, the purity of wind; also the purity of the central avadhūtī channel. Banda Gelek also gives an alternative explanation (Bglha9) that the blue color symbolizes that he is the embodiment of the true nature of reality, free from all conceptual elaboration.

It is important to note here that unlike most other tantras, the body and main face of Kālachakra are dif-ferent colors. The body of Kālachakra is blue, and the main face, one pair of shoulders, and the corresponding upper arms and forearms are all black.

Kālachakra has three throats. One of these is in the usual place, underneath the lower jaw, between the two shoulders. The rest of the neck is divided into two further throats, extending from the edges of this front throat around to the center of the back of the neck. These are called the right and left throats.

The right throat is red, the color of the sun, symbol-izing the purity of the quality (*yon tan, guṇa*) of rajas (*rdul*), which, through compassion that is devoted to all beings, spontaneously performs whatever activities are needed to influence them. For further information in the three qualities, or principles, (*guṇas*) articulated in Sāṁkhya philosophy, see Larson.

The left throat is white, the color of the moon, sym-bolizing the purity of the quality of sattva (*snying stobs*), which is the emptiness that is the essence of compassion.

The central throat is black, the color of a bee, symbol-izing the purity of the quality of tamas (*mun pa*), which is the awareness that destroys all clinging to reality and is free from all impure and erroneous appearances.

Of Kālachakra's four faces, the front face is black and is the essence of the mind vajra, created from the aware-ness of unchanging great bliss. Another way of express-ing this is to say that it is created from mind vajra. This face has an angry expression, with the four canine teeth slightly bared, symbolizing cutting through the error of dualistic appearances. These teeth are said by Tāranātha to be those of one with the body of a yaksha, half-fangs, meaning that half of each tooth is thick and the other half tapers to a point.

The right face is red, created from speech vajra. Sym-bolizing the compassionate devotion to all beings, this face has a passionate expression, with glancing eyes and so forth.

The left face is white, created from body vajra. Sym-bolizing the pacification of all the elaborations of thoughts and obscurations, this face has a peaceful expression, free from passion and anger.

The back face is yellow, created from awareness vajra. Symbolizing the unwavering absorption in the true nature of reality, this face has an expression of medita-tive absorption.

These four faces primarily have the expressions just described, but they all slightly bare the teeth and there-fore have a slightly angry expression.

Symbolizing the unobscured vision of all things of the three times through the purity of the twelve sun signs, each of these four faces has three eyes, the third being in the middle of the forehead, making a total of twelve.

These four faces are arranged on his single head, one each pointing in the four directions. Each face has two ears, and each ear is positioned back to back with an ear from the next face.

There is not one throat for each face, but it appears this way if one were to look directly at each face in turn. The front face has a black throat, the right face has a throat that is on the front side black and the rest red, the throat of the left face is on the front black and the rest white, and the throat of the rear face, although without any physical form, is half red and half white.

The locks of Kālachakra's long hair are bound up on top of his head, with some hanging free at the back. It is usually described as being arranged in three buns, with the largest at the bottom and the smallest at the top. This symbolizes the cessation of the 21,000 impure drops in the central channel, and the perfection of all the aspects of the 21,000 unchanging drops arranged in the central channel up to the minor channels of the crown center.

On the top of the front side of his bound-up hair is a crossed vajra, standing upright. This symbolizes that through the power of the unchanging seed at the crown he unceasingly performs the four sublime activities.

On the left side of his bound-up hair is a crescent moon, symbolizing the purity of the lalanā channel and the white element. Similarly, Banda Gelek gives as an alternative symbolism, the perfection of the sixteen joys. These joys arise through the purification of the activity of the white element, bodhichitta.

Symbolizing that Kālachakra embodies the essence of Vajrasattva, the purity of the six elements of awareness, and so forth, on the top of his bound-up hair sits blue Vajrasattva, devoid of ornaments, in the vajra posture, with the two hands forming vajra fists, holding the thumbs, and pressed into the thighs. This description applies to the first creation of Kālachakra, during the Mastery of the Mandala. In the second creation of Kāla-

chakra, during the Mastery of Activity, he has instead green Akṣhobhya on the crown.

Kālachakra wears six vajra ornaments, symbolizing the six perfections. These are composed of diamond and are generally in the shape of five-tined vajras or are embossed with vajra shapes. They have all five colors, but predominantly yellow, and so all his jewelry is golden in color.

The essence of the perfection of generosity is the head ornament and vajra jewel. The head ornament is tiara-like in form, consisting of upstanding wish-fulfilling jewels in the form of one-eyed jewels, composed of diamond. There are five of these jewel shapes above each of Kālachakra's four faces, representing the five classes of buddhas. These jewel shapes have vajra shapes embossed on them and are edged by swirling (*patra*) designs. "Patra" is Sanskrit for "leaf," and these designs are based on the outline edges of leaves.

On the very top of his bound-up hair is a vajra jewel. This is a single jewel, the upper part of which is in the shape of a five-tined vajra and the lower half is in the shape of the circle of lotus petals on a vajra. The descriptions here are somewhat unsatisfactory, and Banda Gelek states that mention is only made in the original texts of the vajra jewel, and yet most Indian and Tibetan statues of Kālachakra depict the crown of the five classes on his head. Tāranātha points out that some held the view that Kālachakra should have a head ornament of dry skulls, and this variation is probably due to the lack of description of the head ornament in most texts. In a similar vein, Chowang Drakpa (Cgsadle) tells us that according to the Ga translator Zhonnu Pal (*rga lo gzhon nu dpal*) the jewel is made from human bone and is in the shape of a vajra.

Indicating the perfection of tolerance, he wears vajra earrings. These are round, consisting of vajras joined tip to tip without any gap.

Around his neck, indicating the perfection of effort, is a (short) vajra necklace, similar in design to the earrings. In one text (Bgdubum) Banda Gelek includes here the garlands and drops that hang down from the vajra belt, reaching down to the level of the ankles.

Indicating the perfection of discipline, he wears

armlets, bracelets, and anklets on his upper arms, wrists, and ankles, and rings on his fingers.

The next two items are described differently by Banda Gelek in two different texts.

In his nine-deity mandala instruction text (Bglha9) he states that the silken scarf plus long vajra necklace, reaching down to the navel, represent the perfection of wisdom, and that the vajra belt represents the perfection of meditation. In his general instruction text on the full creation process (Bgdubum) he states that the scarf alone represents the perfection of wisdom and the long vajra necklace alone the perfection of meditation. Presumably in that latter case the belt is included with the garlands that hang from it.

The vajra scarf is also made of vajra material and is in the form of one single piece of silk brocade embroidered with vajra designs. Its ends hang down from the binding of the head ornament, behind the two ears of Kālachakra's main face.

For a single-faced deity, like a tiara, the head ornament crosses over the hairline above the forehead and ends in two loops just behind and above the ears. The scarf passes around the back of the top of the head and is tied through these loops, hanging down behind each ear. Just how this works with Kālachakra and his four faces is not explicitly described.

These jewels, from the vajra earrings to the bracelets, are similar to bone ornaments, but in place of bone garlands they have garlands of vajras joined tip to tip.

Indicating that he has abandoned delusion, that he has cut through the conceptual clinging to identity as real, he wears around the waist a fresh tiger skin. The skin has been cut upward from the lower part of the belly and peeled off. It is worn with the fur facing outward. It is folded along the line of the spine, and this is wound around the waist, the head of the tiger on the inside of the right leg of Kālachakra and the tail on the inside of his left leg. Banda Gelek states that this description is according to old traditions regarding the style of images made in India, and that modern paintings depict all deities wearing skins in a similar fashion.

An alternative method, not found in modern texts, is that a hole is cut into the middle of the tiger skin, which is then placed over the head, brought down to the waist, and bound there. In fact, many images and paintings would appear to use this method, as the tiger's tail is often visible hanging in the middle between Kālachakra's legs.

Kālachakra has six shoulders. The front pair are black, symbolizing the purity of tamas, the nature of mind vajra; the middle pair are red, symbolizing the purity of rajas, the nature of speech vajra; the rear pair are white, symbolizing the purity of sattva, the nature of body vajra.

Alternatively, these six symbolize the abandonment of impure mind, speech, and body by the pair of method, great bliss, and wisdom, the awareness of emptiness.

Similarly, the three pairs of shoulders symbolize, from front to back, the purity of the central channel inseparable from mind vajra, the purity of the right rasanā channel inseparable from speech vajra, and, the purity of the left lalanā channel inseparable from body vajra.

The shoulders—equally sized with raised ridges—run parallel from the base of the neck to the balls of the shoulder-joints, three on either side.

To each of these six shoulder-joints are attached two upper arms, each the color of their respective shoulders, making a total of twelve. These similarly indicate the purity of the three qualities and the essence of body, speech, and mind, but also the perfection of the twelve pure levels (levels of attainment on the bodhisattva path).

To the elbow of each upper arm is attached two forearms, making a total of twenty-four, each the color of its respective upper arm. These also indicate the purity of the three qualities and the essence of body, speech, and mind, but also the right-hand twelve indicate the twelve aspects of the awareness of the ultimate twelve links in progressive order, and the left twelve indicate the twelve aspects of the awareness of the ultimate twelve links in regressive (reverse) order.

Associated with the sets of upper arms and forearms, the symbolism of the twelve levels and the two sets of progressive and regressive links are also considered

inseparable from the vajras of mind, speech, and body, as with the shoulders.

Each of these aspects of the awareness of the progressive ultimate twelve links and regressive ultimate twelve links are subdivided according to the five types of awareness, and for this reason each hand has five differently color fingers. Each thumb is yellow, symbolizing the purity of the element of earth, mirror-like awareness, the essence of Vairochana. The index fingers are white, symbolizing the purity of water, distinctness awareness, the essence of Amitābha. The middle fingers are red, symbolizing the purity of fire, equality awareness, the essence of Ratnasambhava. The ring fingers are black, symbolizing the purity of wind, accomplishing awareness, the essence of Amoghasiddhi. The little fingers are green, symbolizing the purity of the element of space, reality awareness, the essence of Akṣhobhya. For each hand that might be black, red, or white, these colors of the fingers extend from the base of each finger to its tip.

The knuckle-joints of each finger are each colored, from the base outward, black, red, and white, these being like rings painted right around each joint with a brush. These symbolize that each of the five awarenesses is inseparable from the purity of the three channels and the essence of the three vajras.

In his right hands, Kālachakra holds, first in the black four, a five-tined yellow vajra (indicating the essence of unchanging great bliss) in length equal to twelve of Kālachakra's finger-widths; a method, (which is) great bliss, and wisdom; (which is) the awareness of emptines; a sword that cuts through misperception; an iron trident that destroys by piercing all nonvirtuous acts of body, speech, and mind; and a curved knife that cuts through defiled unstable bliss. This knife has a blade with three curves, sharp points, and a handle topped with a half vajra.

In the four red right hands, he holds: a fire arrow, one cubit in length, which is usually interpreted as three

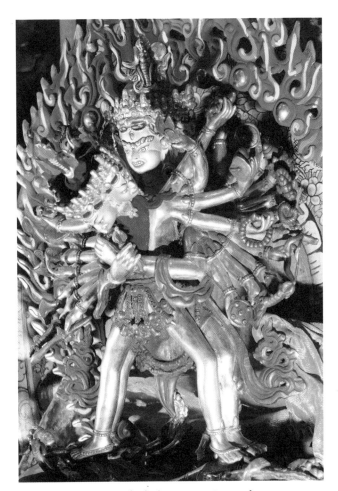

Fig. 4-3. Kālachakra statue. Dzamthang.

arrows of fiery nature, each of the three complete with feathers and head, that destroys the poisons of the five emotional defilements;[6] with shaft one cubit in length and with attached vajras, a vajra hook that pulls all winds into the central channel; a ḍamaru being played and making the sound of the reality of bliss and emptiness; and smashing the pot of incidental defilements, a hammer that has on the top of the handle a flat crossed vajra, one section of which is in the shape of a hammer head.

In the four white right hands he holds: a Dharma wheel that turns all the teachings of the buddhas of the three times or that indicates Kālachakra performs the activities of the buddhas of the three times. This yellow wheel has a hub that is one unit across, surrounded by

6. However, the original intention is very likely to have been that a fire arrow is a particular kind of weapon, such as is described in the first chapter of the tantra.

an inner rim of half of one unit, eight spokes that are 1¼ units, and an outer rim of one unit; a sharp lance, in length two or three human body heights, that pierces the conceptual clinging to subject and object distinctions as real; a square, white club topped by a vajra, that destroys all the four māras. This club (*dbyug pa, daṇḍa*) is not particularly thick along its length, but it is at least two cubits long, perhaps much longer, and has some kind of top ornament—here, a white vajra; cutting through the trunk of self-clinging misperception, a vajra axe with two sharp blades fixed back to back, to the right and left of which are attached half vajras crosswise, with a five-tined vajra on the top. This indicates that the axe is in the form of a handle with a flat crossed vajra affixed, the front and back sections of which are replaced by blades, and which is tipped with a vajra.

In the left hands, first in the black four he holds: a vajra bell, made of jewel, in length equal to twelve of Kālachakra's finger-widths, indicating the essence of emptiness possessed of all positive characteristics; a white shield of awareness that protects from the enemy of conceptualization, being the armor of the awareness of emptiness that is not penetrated by clinging to characteristics; an open khaṭvāṅga, on the top of the shaft of which is a five-tined half vajra, with the tines opened out, indicating that he fully possesses all the qualities of the three bodies;[7] and a skull cup full of blood, indicating his continuous experience of pure bliss as a result of the destruction of the attachment to dualistic clinging.

In the four red left hands he holds: a bow that is ten spans (from tip of thumb to tip of middle finger when outstretched, approximately half a cubit) in length, symbolizing that he has the fully developed five awarenesses that are the basis of activity and abilities; a bond with vajras on each end that binds all subtle winds and drops in the central channel; a nine-pointed jewel, the essence of that realization of the nature of reality that is the origin of the teachings of all three yānas; an eight-

petaled white lotus, indicating that he is not stained by the faults of emotional defilements.

In the four white left hands he holds: a white conch that resounds the sound of the Dharma throughout the three realms; a mirror that reflects to all beings the clear light nature of reality; vajra iron shackles that bind all actions and emotions to reality; and the four-faced head of Brahmā adorned with a garland of flowers along the hairline, indicating defeat of the perversities of the four Vedas, as he holds by the neck the source of those Vedas.

His first two hands, the lowest, which are attached to the front black pair of shoulders, embrace his consort Vishvamātā and are crossed behind her back. This means that the next two hands, holding the sword and shield, are held out in front on either side of the consort. The shield should be facing forward. The lines of the following hands sweep around up to the top hands that hold the axe and Brahmā head. These are attached to the rear white shoulders, which hold the axe and Brahmā head and are held up to the right and left of Kālachakra.

The consort Vishvamātā is golden in color, symbolizing her nature of the awareness vajra, wisdom, the purity of the red solar aspect, and the purity of the awareness element together with the shaṅkhinī channel (the central channel below the level of the navel).

Indicating the essence of the four vajras from the point of view of wisdom, she has four faces. All four faces are created from wisdom, the awareness of emptiness.

Her front face, which faces Kālachakra, is yellow and the essence of awareness vajra. Her right face is white, the essence of body vajra. Her rear face is black, the essence of mind vajra. Her left face is red, the essence of speech vajra.

Indicating the nature of the wisdom aspect (from the pair of method and wisdom) of the awareness of the ultimate twelve sun signs, each of the four faces has three eyes, making a total of twelve.

7. A khaṭvāṅga is described (Mtkmand) as having a white shaft surmounted by a golden vase, then a crossed vajra, then three human heads (one old and decaying, one fresh, and the third a dry skull), and on top of that the half vajra. Small golden bells and streamers hang from below the vase. A khaṭvāṅga also has a half vajra at the bottom end of the shaft; it is not stated whether this also has open tines.

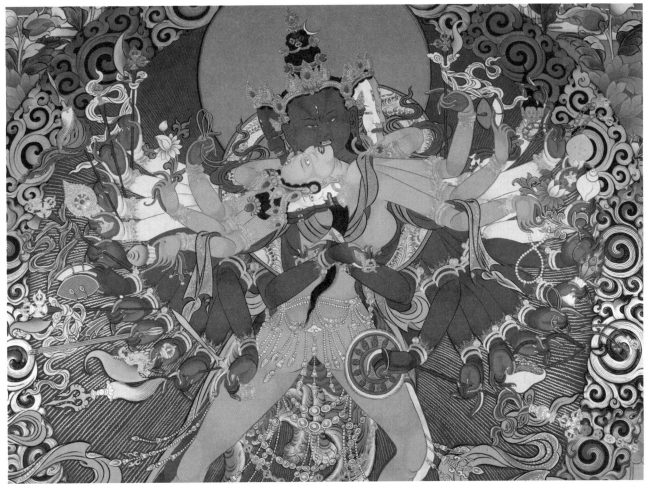

Fig. 4-4. Close-up on the arms of Kālachakra and his consort. As is often the case, the shield in the second left hand is not facing forward, as it should. Tsangwa Monastery, Dzamthang.

She has eight arms. In one text (Bgdubum) Banda Gelek states that these symbolize the purity of the three qualities of rajas, sattva, and tamas, and the five sense objects of form, sound, smell, taste, and texture. In another text (Bglha9) he states that she is the embodiment of pure awareness that is free from impure materiality, and indicating that this is in the manner of the eight forms of scrying image, she has eight arms. According to Anupamarakṣhita (Tgpets), these scrying images are seen in: a mirror, a sword, a thumb(-nail), a lamp, the moon, the sun, water, and a hearth. It is worth pointing out here that by her first arms or hands is intended the uppermost pair of arms. This is the case with all the other deities in the mandala except Kālachakra—his arms are enumerated from the bottom upward.

Her first (that is, uppermost) right hand holds a curved knife that cuts right through all defiled bliss through the understanding of emptiness. Her second right hand holds an iron hook that pulls in the awareness of bliss and emptiness. Her third right hand holds a ḍamaru that naturally resounds with the sound of understanding emptiness. Her fourth right hand holds a jewel rosary indicating the ability to assess the whole of the reality of samsara and nirvana in a single awareness.

Her first left hand holds a skull of blood, symbolizing the intoxication with the blood of great bliss from the liberation into nondual awareness of all erroneous perversions of dualistic clinging. Her second left hand holds a bond that binds in nondual wisdom all the armies of the four māras. Her third left hand holds an eight-petaled white lotus, symbolizing that she is not stained by the fault of the extreme of peace (nirvana). Her fourth left hand holds a nine-pointed jewel that is

the source of the treasure of the awareness of bliss and emptiness.

There is a problem here with the eight-petaled lotus held in her third left hand, and for similar lotuses held by other deities in the retinue. The *Vimalaprabhā*, in both Sanskrit and the main Tibetan translations, has 100-petaled lotus. Other writers, such as Kalzang Gyatso, also have the same. However, the later Jonang translation of the *Vimalaprabhā* and writers such as Dolpopa and Tāranātha consistently have eight-petaled lotus. It is easy to see how mistakes could occur. Eight and one hundred are, respectively, in Tibetan *brgyad* and *brgya*, and in Sanskrit *aṣṭa* and *śata*!

The first generation of Kālachakra is the Causal Vajradhara, Kālachakra being included in the "great bliss" category of unexcelled yoga tantras. During the following Mandala Mastery practice sequence, both Kālachakra and his consort Vishvamātā have a living Vajrasattva as their crown ornament.

She wears the five bone ornaments: on the top of her head is a bone wheel, the essence of generosity. From her ears hang bone earrings, the essence of tolerance. Around her neck is a bone necklace, the essence of effort. On her upper arms, wrists, fingers, and ankles are bone armlets, bracelets, rings, and anklets, the essence of discipline. Around her waist is a bone belt, the essence of meditation. In common with other female yidams, as she herself is the essence of wisdom, she wears no ornament symbolizing wisdom (with Kālachakra, this was the vajra scarf).

Indicating freedom from all elaborations of clinging to characteristics, she is naked.

Half her curly hair is bound up on top of her head, with half hanging free; it is just like Kālachakra's. With her right leg bent and the left leg extended, she embraces Kālachakra.

The eight shaktis

The central lotus of the mandala palace, on the center of which stand Kālachakra and his consort, has eight petals. These lie open, or flat, and on each one stands one of the eight goddesses that comprise Kālachakra's immediate retinue. These are known as the eight shaktis (*nus ma brgyad*). They are all similar in form, each with eight arms. The four in the cardinal directions hold various implements, and those in the intermediate directions hold chowries. These eight goddesses are all naked and are wearing the five bone ornaments similar to those previously explained for Vishvamātā. They stand in the even stance (*mnyam pa'i stabs, samapada*), with neither of their legs bent and the feet facing forward. On each of their crowns sits Vajrasattva.

As with other deities in the mandala, these goddesses are the colors of their respective directions. Therefore the goddesses in the East and Southeast are black, those in the South and Southwest are red, in the West and Northwest yellow, and in the North and Northeast white.

All these goddesses face inward, toward Kālachakra, and for each one the main front face is the same color as her body. The other faces are then colored in the same clockwise order as those of Kālachakra. For example, the main face of the goddess in the South is red; her right face is therefore yellow, her back face white, and her left face black.

In the East is Kṛṣṇadīptā (*nag mo 'bar ma*). She holds in her left hands bell, lotus, pārijāta, and flower garlands;[8] in her right hands she holds bowl of incense,

8. The pārijāta flower (*yongs 'du'i me tog*) is said to be a branch from a divine tree with white flowers; some say that the flower is the mandārava, also that the flowers can be five-colored. As the flowers of the mandārava, or coral tree, are red, that identification seems unlikely. In Ayurvedic medicine, the parijata tree is also known as night-flowering jasmine, with many medicinal uses; its flowers are white. The identification of the flower as the pārijāta is only found in Jonang texts and can be traced back to the sādhana by Maitripa. Other original Indian sādhanas and Tibetan ones such as those of Buto, Khedrubje, and Kalzang Gyatso have "flowers of a divine tree" (*lha shing gi me tog*). The parijata is considered to be one of five such divine trees. Banda Gelek adds that the garlands of various flowers are flowers from the realms of the gods, nāgas, and humans.

bowl of sandalwood paste, bowl of saffron perfume, and bowl of camphor and musk.⁹

In the South is Raktadīptā (*dmar mo 'bar ma*). She holds in her left hands clothing/material, belt, jeweled earrings, and jeweled anklets; in her right hands she holds lamp, jeweled necklace, jeweled silken diadem, and jeweled silken bracelets. The bracelets that she holds in her fourth right hand refer to rings, bracelets, and armlets. The clothing or material is said to be divine clothing, and the belt is jeweled.

In the West is Pītadīptā (*ser mo 'bar ma*). She holds in her left hands vīṇā (*rgyud mangs*), terracotta drum, gong, and copper horn; in her right hands are conch, flute, wish-fulfilling jewel, and ḍamaru.¹⁰

In the North is Shvetadīptā (*dkar mo 'bar ma*). She holds in her left hands bowl of nectar, bowl of alchemical essence, bowl of amla fruit, and bowl of rice. In her right hands she holds bowl of milk, bowl of water, bowl full of the ultimate medicine, and bowl of wine.¹¹

The goddess in the Southeast is Dhūmā (*du ba ma*), black in color, with her four faces the same colors as those of the main goddess in the East, Kṛṣṇadīptā, that is, black, red, yellow, and white. She holds eight black chowries. Similarly, in the Southwest is red Mārīchī (*smig rgyu ma*), in the Northwest yellow Pradīpā (*mar me ma*), and in the Northeast white Khadyotā (*me khyer ma*). They all hold chowries the same color as their bodies.

These eight goddesses represent the purity of the eight channels of the heart center, or the cessation of the movements of the winds of the various elements in those channels (four on the right and four on the left)

when those winds have returned to the central channel. There are actually considered to be ten goddesses in total, the other two being Paramakalā (*mchog gi cha ma*), the purity of the central channel, and Bindurūpiṇī (*thig le'i gzugs can ma*, or, *thig le ma*), the purity of the shaṅkhinī channel (the extension of the central channel below the navel). These two are respectively identified with Vajradhātvīshvarī and Prajñāpāramitā (see the later section on the male and female sugatas), and are considered to be inherent in Kālachakra's consort, Vishvamātā; they are not represented separately in the mandala. Even so, Tāranātha (Kacoin) gives descriptions for them: Paramakalā, the upper shakti, is green, and the lower Bindurūpiṇī is blue. Each has their main face with the same color as their body. Their other faces are the same color as those of Kālachakra, and in the eight arms they hold the same things as Vishvamātā.

Refining this idea, Tāranātha (Kasain) states that one can consider here also the ten vases of the mind mandala. These are in essence the male consorts of the ten shaktis, and from the point of view of method and wisdom, the shaktis and the vases represent respectively the purity of the channels and winds of the heart center.

In the six yogas of Kālachakra, particularly the first yoga, ten signs of success are experienced during meditation, and each is associated with the cessation of the movement of one of the winds of the heart center. The names of the goddesses are identical to, or are variations on, the names of these signs. Four are mainly experienced at night (that is, in darkness meditation), and six during the day (when meditating outside in the light).

The order in which the signs are usually listed, night

9. The bowl of incense is said to be a bowl filled with incense smoke (presumably this means smoking incense). Sandalwood paste is sandalwood powder soaked in water; it is used in Ayurvedic medicine for its cooling effect on both body and mind.

10. According to Tāranātha, the drum is either a round drum or a terracotta drum, but according to Banda Gelek, it is a round terracotta drum, which would presumably have two heads. The original Sanskrit has *ḍhakkā*; in Newari, the word *ḍhāka* refers to a drum with two heads, and that is almost certainly the intention here. The Tibetan word *rdza rnga* here translates the Sanskrit *ḍhakkā*, but later, with the offering goddess Vādyā, it is used as a translation for *paṭaha*.

11. It is generally stated that the ultimate medicine is that single medicine which will cure all ailments. Chowang Drakpa states that some confuse this with the so-called "great medicine" which consists of several components. Banda Gelek states that the bowl of wine in her fourth right hand contains intoxicating liquor made from grapes and other fruits. The alchemical essence is the mercurial preparation that grants immortality. Buton also adds that this essence can transform iron and so forth into gold, merely by contact. Tāranātha identifies the fruit in the bowl of the third left hand as mango, but this is probably due to a confusion between similar Sanskrit names: *amṛtaphala* (amla) and *āmraphala* (mango). Amla (*bdud rtsi'i 'bras bu*, emblic myrobalan) is also well known for its special medicinal properties, which are certainly appropriate here. He points out that this fruit should not be confused with arura, as was apparently the case with some Tibetans. This is a name for another form of myrobalan.

then day signs, are associated with a particular goddess and elemental wind, as follows:

Smoke	Dhūmā	right earth-wind
Mirages	Marīchī	right water-wind
Fireflies	Khadyotā	right fire-wind
Lamps	Pradīpā	right wind-wind
Blazings (fire-like)	Pītadīptā	left earth-wind
Moon	Shvetadīptā	left water-wind
Sun	Raktadīptā	left fire-wind
Vajra (black forms)	Kṛṣhṇadīptā	left wind-wind
Ultimate flashes (like lightning)	Paramakalā	left space-wind
Drops (blue)	Bindurūpiṇī	right space-wind

Table 52

Vishvamātā is the consort of Kālachakra—like a wife, as Banda Gelek puts it—but the relationship of the ten shaktis is different. They are not like his wives, but more like attendants, goddesses that go wherever he goes.

In the four corners of the square structure that supports the central lotus are the four emblems. In the Southeast is a black wish-fulfilling jewel (*yid bzhin gyi nor bu, cintāmaṇi*), the essence of mind vajra; in the Southwest a red Dharma-semantron (*chos kyi gaṇḍī, dharmagaṇḍī*), the essence of speech vajra; in the Northwest a yellow wish-granting tree (*dpag bsam gyi shing, kalpavṛkṣa*), the essence of awareness vajra; and in the Northeast a white Dharma-conch (*chos kyi dung, dharmaśaṁkha*), the essence of body vajra.

As these four vajras are the manifestation of the four vajras of body, speech, mind, and awareness of the chief deity, Kālachakra, and as the four faces and eight arms of the shaktis also symbolize the essence of the four vajras and as they are also attendants of the chief deity, all these are contemplated in his area of the mandala, the Circle of Great Bliss.

The symbolism of the rest of the deities in the mandala is far less detailed than that for Kālachakra and his immediate retinue, and further discussion of symbolism will mainly be left until the fifth chapter.

The male and female sugatas

There are a further four groups of deities in the mind mandala palace, together with the vases. These are the sugatas or tathāgatas, male and female; the bodhisattvas, male and female; the door-protectors; and offering goddesses.

The words "sugata," "tathāgata," and "jina" are synonyms for a buddha. In the usual classification of the buddhas that appear in meditation practices, there are five: the five classes of jina (*rgyal ba rigs lnga*). The Kālachakra cycle extends the common fivefold classification to six, with the inclusion of Vajrasattva in this group. They each have a consort, and these twelve form the first group. However, they are not all represented in the mandala. The six buddhas symbolize the purified six aggregates (another group extended from five in the Kālachakra cycle) and the consorts the purified elements.

Next is a group of six bodhisattvas and their consorts. The bodhisattvas symbolize the purified six senses and their consorts the purified objects of those senses. All of these are represented in the mandala.

Next, are the six wrathfuls and their consorts, the purification of the six action organs and their activities. Depending on the tradition and the style of practice, either four, five, or all of them may be represented in the mandala. This group of thirty-six deities is key to the symbolism of the mandala as a whole, and in particular the symbolism associated with the ritual of empowerment.

Finally, arranged around the mind palace plinth and in the four torans of the palace are twelve offering goddesses.

Apart from the door-protectors, the twenty deities that are the male and female sugatas of the Circle of Great Bliss, and the male and female bodhisattvas of the mind podium, are all mostly similar in form.

The hair of the buddhas is bound up on the crown

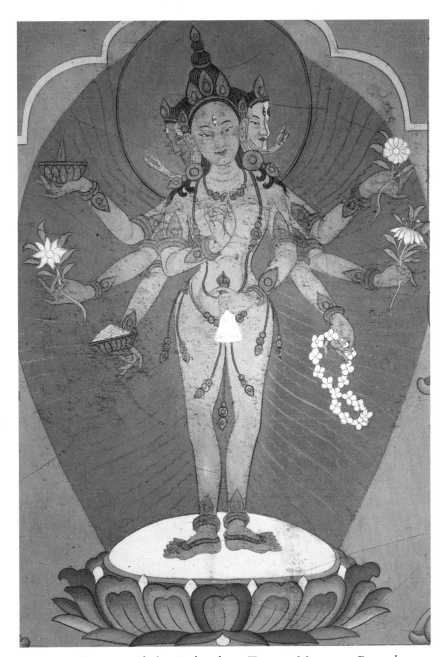

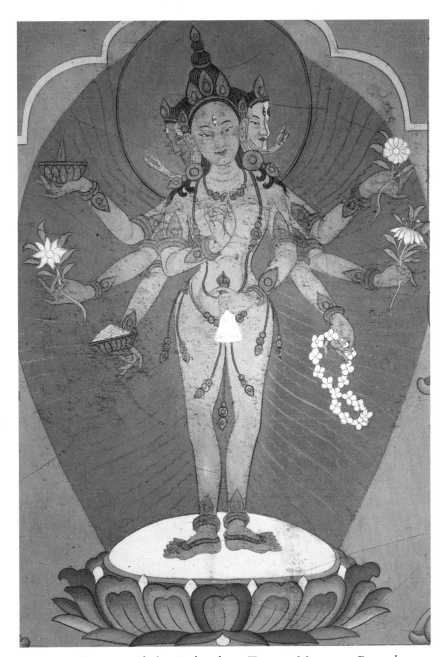

Fig. 4-5. The eastern shakti, Kṛṣṇadīptā. Tsangwa Monastery, Dzamthang.

of the head in a topknot of long locks, and that of the bodhisattvas and consorts into jeweled topknots. Some say that therefore the buddhas should all wear bone ornaments and the bodhisattvas and their consorts jeweled ornaments. Tāranātha states (Kasain) that this is not wrong, but that in practice, apart from the difference in their topknots, they all wear skimpy upper and lower garments of fine silk together with jeweled ornaments.

For each, the main central face is the same color as the body. For those pairs in which the male is the chief deity, he sits in the vajra posture (*rdo rje'i 'dug stangs,*

vajrāsana) and his consort sits in union with him on his lap, with her legs wrapped around his back, also making the vajra posture. When the goddess is the chief, she sits in the lotus posture (*padma'i 'dug stangs, padmāsana*), with her legs in the circular lotus formation, with the soles of the feet together; her consort also sits in union with her on her lap, with his legs wrapped around her back, also forming the lotus posture.

There is a difference here between the traditions: in Gelug texts it is stated that all the male deities are in the vajra posture and all the females are in the lotus posture. For example, with Vairochana as the chief deity, he

would be in the vajra posture with Tārā in union with him in the lotus posture. In the Jonang tradition, both would be in the vajra posture.

Between the two sets of pillars around the central lotus are eight lotuses; four white in the cardinal directions with sun disk seats, and four red in the intermediate directions with moon disk seats. On the cardinal four are seated four buddhas, and on the intermediate four their consorts. They are all in pairs, however. For example, on the eastern lotus is Amoghasiddhi as the chief deity (facing the center of the mandala) in union with his consort Buddhalochanā, and on the northwestern lotus is Buddhalochanā as the chief deity, in union with Amoghasiddhi. Each individual deity therefore appears twice.

All of these buddhas and their consorts are similar in form, with three faces, three eyes in each face, and six arms. However, two of the full set of buddhas are not represented in the mandala itself, but during the practice are radiated and absorbed at different times into Kālachakra. These are Akṣhobhya (*mi bskyod pa*) and Vajrasattva (*rdo rje sems dpa'*), and for the sake of completeness these should also be described here.

Akṣhobhya's body is green, with his main face also green, left face white, and right face red. He holds in his six hands vajra bell, vajra, skull bowl, curved knife, four-faced head of Brahmā, and axe. He is in union with his consort Vajradhātvīshvarī (*rdo rje dbyings kyi dbang phyug ma*). She is the same color as he, also holding the same emblems.

Vajrasattva's body and main face are blue; otherwise he is identical to Akṣhobhya, holding the same things. He is in union with his consort Prajñāpāramitā (*shes rab kyi pha rol tu phyin ma*), who is also identical to himself.

On the eastern lotus is Amoghasiddhi (*don yod grub pa*), black in color with two additional faces, white and red. He holds shield, sword, skull, curved knife, white khaṭvāṅga, and trident. He is in union with his consort, yellow Buddhalochanā (*sangs rgyas spyan ma*), whose other two faces are black and white and whose hands hold conch, wheel, vajra shackles, club, sounding bell, and wrathful vajra.

On the southern lotus is Ratnasambhava (*rin chen 'byung ldan*), red in color with two other faces black and white. In his hands he holds bow, fire arrow, bond, vajra hook, radiant nine-pointed jewel, and sounding ḍamaru. He is in union with his consort, white Māmakī, whose other two faces are red and black. She holds in her hands eight-petaled white lotus, hammer, mirror, lance, rosary, and trident.

On the western lotus is yellow Vairochana (*rnam par snang mdzad*), in union with his consort, black Tārā (*sgrol ma*). On the northern lotus is white Amitābha (*snang ba mtha' yas*), in union with his consort, red Pāṇḍarā (*gos dkar mo*). These other buddhas and their consorts are identical to those just given of the same color. For example, yellow Vairochana holds the same emblems as yellow Buddhalochanā, given above.

Next are the consorts as chief deities, on the lotuses in the intermediate directions, again identical in form to those just given of the same colors:

Southeast	black Tārā	yellow Vairochana
Southwest	red Pāṇḍarā	white Amitābha
Northwest	yellow Buddhalochanā	black Amoghasiddhi
Northeast	white Māmakī	red Ratnasambhava

Table 53

In between each of the lotuses on which these buddhas and their consorts sit are eight further white lotuses supporting vases of nectar, each with a white lotus in its opening. In the full mandala palace there are ten vases, one above and one below, in addition to the eight on the tathāgata-extension. In the East, in the cells on either side of Amoghasiddhi, are two vases of arrested marrow; in the South are two vases of arrested blood; in the West are two vases of arrested feces; and in the North are two vases of arrested urine. In the space above Kālachakra's head, seated on a white lotus, is a vase of arrested semen, and underneath Kālachakra, in the empty space inside the foundation that supports the Circle of Great Bliss, is a vase of arrested ovum.

The male and female bodhisattvas

These deities are seated on twelve lotuses on the podium of the mind palace, below the Circle of Great Bliss on which are the previously described deities. Right and left of the eastern and southern doors and on the right of the northern and western doors are eight-petaled white lotuses with sun disk seats and in the four intermediate directions, and to the left of the northern and western doors are red lotuses with moon disk seats.

As usual, right and left of the various doorways means to the right and left as viewed from the center of the mandala. And, as before, they are identical in form to the buddhas and consorts given above of the same colors. The one difference lies in their pairing: with the buddhas, the blue and green males are in union with females of the same color; with the bodhisattvas, they are in union with females of the opposite colors, green and blue, respectively. Clockwise, from the East:

RoE	black Khagarbha	yellow Gandhavajrā
SE	black Sparshavajrā	yellow Nīvaraṇaviṣhkambhin
LoS	green Vajrapāṇi	blue Shabdavajrā
RoS	red Kṣhitigarbha	white Rūpavajrā
SW	red Rasavajrā	white Lokeshvara
LoW	green Dharmadhātuvajrā	blue Samantabhadra
RoW	yellow Nīvaraṇaviṣhkambhin	black Sparshavajrā
NW	yellow Gandhavajrā	black Khagarbha
LoN	blue Shabdavajrā	green Vajrapāṇi
RoN	white Lokeshvara	red Rasavajrā
NE	white Rūpavajrā	red Kṣhitigarbha
LoE	blue Samantabhadra	green Dharmadhātuvajrā

Table 54

The eight wrathfuls (door-protectors)

This group of four pairs of deities is similar to the previous buddhas and bodhisattvas, holding the same emblems in their hands as their counterparts in those groups, but in wrathful form. They stand on lotuses in the doorways of the mind palace: in the eastern and northern doorways are white lotuses with sun disk seats, and in the western and southern doorways are red lotuses with moon disk seats. Each has three red eyes in each face, with their red-yellow hair bristling upward; they are extremely angry and terrifying; they are adorned with snakes and the six bone ornaments (the females, five) and wear lower robes of tiger skin. They wear a head ornament of five dry skulls and a long necklace of fifty fresh human heads. The males stand with their right legs outstretched, and the females with the left outstretched; in this way they are standing just like Kālachakra and Vishvamātā, but with their legs together—the consort does not have one leg wrapped around the male deity, although in some traditions they

are described in this way. Although I have not found it stated explicitly, the male deities are facing inward.

East	black Vighnāntaka or Atibala	yellow Stambhakī
South	red Prajñāntaka or Jambhaka	white Mānakī
West	yellow Yamāntaka or Stambhaka	black Ativīryā
North	white Padmāntaka or Mānaka	red Jambhakī

Table 55

In his instruction text (Kasain), Tāranātha discusses the placing of above and below wrathfuls, and states that if they are drawn in the mandala, they are placed in the eastern and western doorways, behind the above and below vases which themselves are placed behind the eastern and western wrathfuls. However, these are

not included in his full triple mandala sādhana (Kapjon), although a fifth wrathful is given in the sādhana of his predecessor Dolpopa. If a fifth pair is included, this is green Uṣhṇīṣha (*gtsug tor can*) in union with blue Atinīlā (*shin tu sngon mo*).

Tāranātha explains that there is some variation in whether or not these other wrathfuls are included. He states that if the meditation is on just the mind palace, then they are not needed, although he does include the upper wrathful pair in his mind mandala practice (Kalanyin). Certainly the *Vimalaprabhā* includes Uṣhṇīṣha, although it does not mention his consort; she is assumed. These wrathfuls are very similar to the six pairs of wrathfuls in and around the body palace, and in some instances just five pairs in each of the mind and body palaces are described. I have not come across an instance where six pairs are described in both mind and body palaces, although this would seem to complete the intended symbolism.

Regarding the consort of the fifth, Atinīlā literally means extremely blue and so her color should be obvious; presumably for this reason most sādhanas omit her color; however, Tāranātha does give her color as blue in his mind mandala sādhana. When the fifth pair is included, they both have three faces and six arms, holding the same implements as other blue and green deities.

In the Gelug tradition, this pair is included in the full triple mandala, and Uṣhṇīṣha has the same form, with six arms. However, Atinīlā has just one face and four arms. Interestingly, in the Gelug mind mandala practice by Kalzang Gyatso, a sixth, lower pair is also included, clearly adapted from the body palace protectors.

Twelve offering goddesses

Each of the three mandala palaces has a group of goddesses arranged on the plinth that runs around the outside of the palace walls, between the four porches. For the mind palace, these are the twelve offering goddesses.

LoE	black Gandhā	perfume
RoE	black Mālā	garland
LoS	red Dhūpā	incense
RoS	red Dīpā	lamp
LoW	yellow Lāsyā	sensuousness
RoW	yellow Hāsyā	laughter
LoN	white Navedyā	food
RoN	white Amṛtaphalā	fruit
Above	green Vādyā	music
Above	green Nṛtyā	dance
Below	blue Gītā	song
Below	blue Kāmā	desire

Table 56

Eight of these are actually on the plinth, one each to the right and left of the doors on each side, two are above the center of the mandala palace, and two below. In the Kālachakra system they are usually referred to as *dhāriṇī* (*gzungs ma*), a word which means "bearer," as in "bearer of gifts."

In Table 56, the name of each goddess is also given in English translation as the name of each one represents the offering that she is carrying or signifying.

Texts such as those by Tāranātha simply state that each goddess is carrying offerings as suggested by her name. Table 57 shares a more explicit description is given by Abhayākaragupta.

All the goddesses are standing in the even stance and facing the chief deity of the mandala, Kālachakra. Abhayākaragupta has them in the lotus posture.

Regarding the position of the upper and lower goddesses, Banda Gelek also states that the upper goddesses are in the "upper door" of the mind palace, and that this is the upper part of the empty space inside the foundation that supports the Circle of Great Bliss. He adds that the lower goddesses are in the "lower door" of the mind palace, and this is the upper part of the empty space of the ground of the mind palace, meaning inside

Gandhā	conch full of perfume		Navedyā	white fruit
Mālā	garland of flowers		Amṛtaphalā	vessel of white nectar
Dhūpā	incense vessel (perhaps a censer)		Vādyā	plays a kettledrum (*paṭaha*)
Dīpā	offering lamp		Nṛtyā	holds clothing and dances
Lāsyā	yellow head ornament		Gītā	a vajra
Hāsyā	yellow necklace		Kāmā	a lotus

Table 57

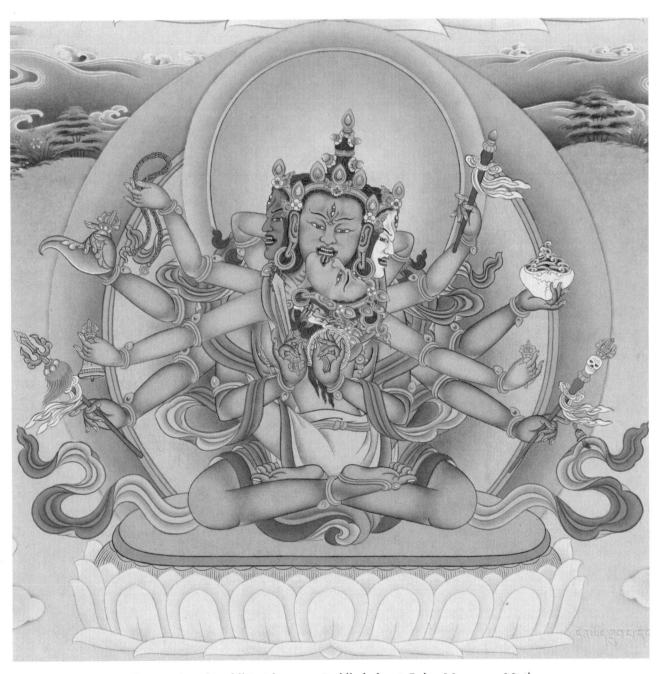

Fig. 4-6. Amoghasiddhi with consort Buddhalochanā. Bokar Monastery, Mirik.

the foundation in the speech palace on which the mind palace sits.

Interestingly, Banda Gelek also states that when a mandala palace is constructed, rather than imagined in meditation, the upper and lower offering goddesses are depicted in the middle lower cells of the mind palace torans: upper Vādyā in the North and Nṛtyā in the East; lower Gītā in the South, and Kāmā in the West.

Each of these goddesses is surrounded by countless other similar offering goddesses, often said to be carrying many different kinds of offerings.

As mentioned in the second chapter of this book, the arrangement given here by Tāranātha is taken from the third chapter of the *Vimalaprabhā*. However, in the *Vimalaprabhā*'s fourth chapter, Vādyā and Nṛtyā are given as in the North on the plinth, Gītā and Kāmā are above, and Navedyā and Amṛtaphalā are below. So why did these writers and the others on whose work theirs is based make that decision? The association of the seed syllables with the respective offering goddesses is very well known and repeated many times in any Kāla-

chakra ritual in the mantras for presenting the offerings. These mantras are given in the third chapter, and the elements associated with the seed syllables match the arrangement of the goddesses also given in that chapter.

Further to the comments on these inconsistencies by Dolpopa given in the second chapter, Detri Rinpoche (Kajazhal) states that the other arrangement given in the fourth chapter is according to the goddesses' own particular classification or the elements of the channels of which they represent the purification. Gītā and Kāmā are said to represent the purity of the upper channels and Navedyā and Amṛtaphalā the purity of the channels of feces and urine (below); this is also mentioned by Tāranātha. However, that description in the *Vimalaprabhā*'s fourth chapter is for the meditation and does not say anything about the arrangement in the drawn or constructed mandala, and so need not be of further concern here, although it is important in any study of these goddesses.

The speech mandala palace

Similar to the mind palace, the speech palace contains on the inside a podium on which reside three groups of deities, and on the outside another group arranged on the plinth that runs along the outside of the wall between the porches.

The names of the chief deities on the eight lotuses on the podium are well known in Hinduism; these are the eight mothers (*ma mo brgyad, aṣṭamātṛkā*). They are in union with their consorts, and although the names of these eight male deities are also well known from Hinduism, mostly gods that appear in the *Upaniṣhads*, these are not normally the consorts of the *mātṛkas*, and are an unusual grouping.

These couples are on the receptacles of the eight lotuses on the deity podium, standing on a single mount: preta, buffalo, and so forth. As the female is the chief of the pair, she faces the center of the palace; her consort therefore has his back to the center. The animal mounts are in place of the sun or moon seats that dei-

ties are seated on in the mind palace. The reason for this is given in the *Vimalaprabhā*: these are worldly deities. Perhaps for this reason the word "deity" is not really appropriate here; the *Vimalaprabhā* calls them *daitya* (*lha min*), meaning demons or asura. Banda Gelek adds that these eight are *mātṛkas*, types of spirits that, according to circumstances and place, can be pleased by satisfying them with flesh and blood; in this way they cure smallpox and other diseases. They are of the same family as the divine group of eight that do not like flesh and blood but are pleased with divine nectar; they differ due to their habitats and behavior.

Thus, the eight speech yoginīs are emanations in the form of mātṛkā spirits and are not emanations in the form of the divine group with the same names, Charchikā, and so forth. Also, their retinues are emanations in the form of the retinues of mātṛkā spirits. In their spirit realm, the mātṛkas take charge and act for the benefit of beings; for this reason, when making

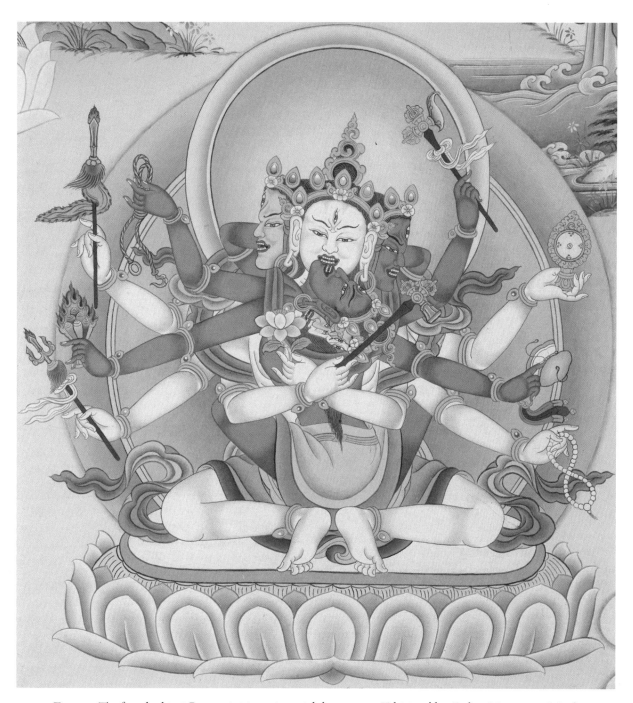

Fig. 4-7. The female chittā Rūpavajrā in union with her consort Kṣhitigarbha. Bokar Monastery, Mirik.

offerings to the hundred types of yoginī, the speech yoginīs are offered flesh and blood in order that they cure illnesses, infectious diseases, and so on.

Each lotus has eight petals on each of which is a yoginī, making a total of sixty-four yoginīs on the petals of all eight lotuses. Anybody familiar with Hindu goddesses will also recognise this second grouping of goddesses: the sixty-four yoginīs. There were many different lists of sixty-four yoginīs, and no records available in India today match exactly those in the Kālachakra speech palace, but many names do match.

Vidya Dehejia points out (Yoginct) that among the many different traditions of sets of sixty-four yoginīs, some of these contain among their number the eight mātṛkās and others do not. Of the latter, some consider the yoginīs to be derived from the eight mātṛkās. Dehejia maintains that by the eleventh century C.E. this latter association of the eight mātṛkās and sixty-four yoginīs

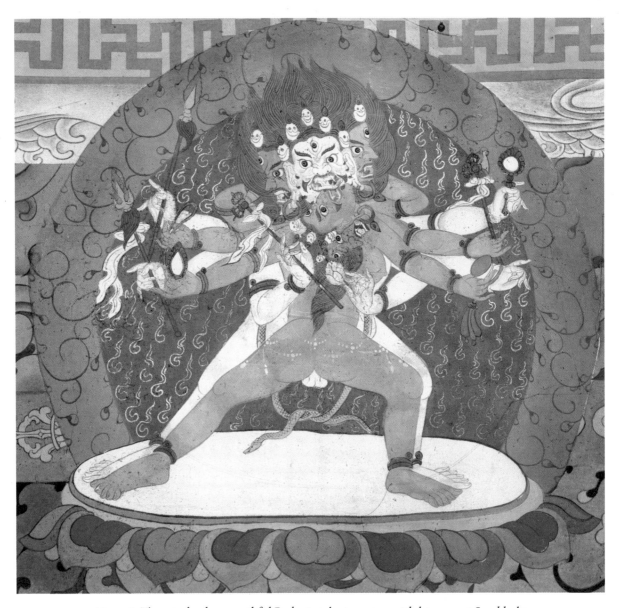

Fig. 4-8. The mind palace wrathful Padmāntaka in union with his consort Jambhakī.

had become common; this is approximately the time that the Kālachakra system appeared, and its yoginīs certainly seem to be of this type. However, the names of these yoginīs are very different from those given in the various lists in Dehejia's book, with only a few matches. There are said (Orisrev) to be a total of 12 lists of sixty-four yoginīs in India, and apparently no two lists are the same. No doubt the yoginīs included in the lists of sixty-four reflected the traditions and needs of the local communities in which they developed.

The primary Indian sources for cycles of sixty-four yoginīs belong to the Kaula tradition, and two particularly important texts, the *Kaulajñānanirṇaya* (Kaula-jñā, chapter 8) and the *Kulārṇava Tantra*, both describe rituals focusing on the sixty-four yoginīs in eight groups of eight. Interestingly, one Indian Kālachakra text translated into Tibetan is a torma offering to the sixty-four yoginīs in eight groups of eight. This forms part of the basis of the mandala of 100 yoginīs and its associated practices mentioned in the first chapter.

The fourth group of deities is on the plinth that surrounds the wall on the outside. This is a group of thirty-six goddesses known as icchās (*'dod ma*). They are all considered to be emanations of certain groups of other goddesses in the mandala and have a similar role to the offering goddesses of the mind palace.

These icchā goddesses are said to be emanations of the four buddha consorts, six bodhisattva consorts, four mind palace wrathfuls' consorts, the eight chief goddesses of the speech palace, the six wrathfuls' consorts on chariots, and the eight prachaṇḍās. They are also associated with another group of thirty-six mātṛkā goddesses in the mandala of 100 yoginīs, which are themselves connected to the thirty-six professional castes in medieval Bengal.

The deities of the podium

Here, in the speech palace, the chief deities are female, but by contrast, the chief deities on the twelve lotuses in the body palace are male. Eight of these are the same as the male consorts of the speech palace, although most are in union with different (at least differently named) female partners. The differences and associations between these two groups will be described later.

These eight goddesses are also said to be identical to the so-called eight yoginīs of the changing of time (*dus rgyu'i rnal 'byor ma*). These are also known from Hindu mythology. As goddesses of time they are used in a minor divination system derived from Kālachakra but keep the names of the eight mātṛkās; they are not given the list of names such as that given by Dehejia: Maṅgalā, Piṅgalā, Dhanyā, Bhramarī, Bhadrikā, Ulakā, Siddhidā, and Sankatā (Yoginct).

In brief, the names of the main eight goddesses and their male consorts are as follows, the goddesses given first:

East	Charchikā	Indra
Southeast	Vaiṣṇavī	Brahmā
South	Vārāhī	Rudra
Southwest	Kaumārī	Gaṇapati
West	Indrī	Nairṛti
Northwest	Brahmāṇī	Viṣṇu
North	Raudrī	Yama
Northeast	Lakṣhmī	Ṣaṇmukha

Table 58

It is worth here expanding a little on the interrelationships between these deities before giving their descriptions. There will also be more on their relationships when the body palace is described. As these eight goddesses are in the form of worldly deities, they are called the eight mātṛkās and should be considered equivalent to those that are well known from the various worldly tantras.

In the East, Charchikā is also called Chāmuṇḍā or Rākṣhasī; that third name does not imply that she is the queen of Rākṣha, but is his sister. Similarly, Vaiṣṇavī (Southeast) is the sister of Viṣṇu, and so on; it is generally the case that when a goddess has a name which is the female equivalent of a god's name, then the two are brother and sister. Rākṣha is identified with Nairṛti (West). Here, Charchikā is in union with the lord of the gods Indra (East). Vaiṣṇavī (Southeast) is the sister of Viṣṇu (Northwest); she is in union with the great god Brahmā (South). Vārāhī (South) is the sister of the earth-lord Vārāha (not in the speech palace); she is in union with Rudra. Kaumārī (Southwest) is the sister of Kumāra Ṣaṇmukha (Northeast); she is in union with the great god Gaṇapati (Southwest). Indrī (West) is the sister of Indra (East); she is in union with Nairṛti (West), also known as Rākṣha. Brahmāṇī (Northwest) is the sister of Brahmā (Southeast); she is in union with the great god Viṣṇu (Northwest). Raudrī (North) is the sister of Rudra (South); she is in union with the underground Yama. (There are two Yamas: one that lives in the South and the one that lives below. The one intended here is the one below.) Lakṣhmī (Northeast) is here the Lakṣhmī who is the queen of Viṣṇu, and as the goddess Lakṣhmī she is the sister of Vaishravaṇa and is in union with Kumāra Ṣaṇmukha (Northeast). She is not the Mahālakṣhmī who is the consort of Viṣṇu among the lunar day deities of the body palace.

Tāranātha writes that these eight goddesses are all of

the same family as the consorts of the eight great gods in the body palace; there are twelve couples in the body palace and eight of those female goddesses are identified with the eight in the speech palace, but are not in union with the same male gods.

To classify these goddesses of the speech palace, although they are of the same family they appear in different aspects: those that only act in a divine manner and those that act in daimonic manner, bringing both benefit and harm to the world; here, the mātṛkās and yoginīs are of the latter form.

These daimonic goddesses are in union with deities that command spirits that seek only worldly activities, and their union is founded on sexual energy (*nus ma*).

The elements of these deities are uncertain, as are the directions they inhabit, and although these are not fundamentally fixed, they should be understood as accomplishing/performing according to their empowerment within the tantra; in other words, according to their directions and associated elements and activities within the mandala.

For example, Raudrī is suitable to join with all the leaders of the gods as a shakti, but she has no certain master. Here, she is in the North, in union with Yama, the two being empowered as the purification of water and fire; however, in other general mātṛkā tantras she is explained as consort of the hosts of Bhairava or of Mahākāla.

The mount for each pair is on the center of the lotus and is facing the center of the palace, and the deities are on its back in the manner of riding it; they are not standing on the creature as if suppressing it, as is often the case with deities, such as Kālachakra trampling on Kāmadeva and Rudra. The mount is in each case that of the chief deity. Very often, the mount of a particular goddess is the same as that of her normal male consort, and so the mount is the same regardless of which is the chief. But where each has a particular mount, the mount for the pair is that of the one that is the chief.

A good pair to take as an example is Gaṇapati and Kaumārī, both very well known from the Hindu tradition. They appear in union in both the speech and body palaces. In the speech palace, Kaumārī is the chief deity,

and so the mount is her traditional peacock; in the body palace, Gaṇapati is the chief deity and so their mount is his mouse.

Each pair of deities is in union, both in the vaishākha posture (*sa ga'i stabs, vaiśākhapada*). In this posture, the deities are standing, with a distance of about one cubit between the feet, and the front of the feet pointing outward—to the right and to the left.

The retinue of eight yoginīs for each central pair are on the eight lotus petals, each facing the central pair of deities on the receptacle. They are all in the lalita posture (*rol pa'i stabs, lalitapada*): this is also a standing position, in which the front of either the left or right foot points forward and the heel of the other foot is placed against its ankle, with the front of the other foot pointing away. Either way is acceptable, but it seems that for the left foot to be straight is more common. In an alternate form of this posture, the feet are simply four finger-widths apart.

In all cases, the objects held in the hands of the retinue goddesses are identical to their respective chief goddess. The male is different in each case. All have one face, three eyes, and four hands, except Kaumārī and her surrounding yoginīs, who have six faces and four hands, and Brahmāṇī and her yoginīs with four faces and four hands. In both cases the male consort has only one face.

East: On the center of this lotus is a red preta (*yi dags*)—sometimes considered to be a corpse or the spirit of a deceased person. On this is black Charchikā, with one face and four arms, holding a skull-cup, curved knife, khaṭvāṅga, and trident. She is in union with yellow Indra, who also has one face and four arms that hold bell, vajra, bow, and arrow.

They are surrounded by eight yoginīs on the eight lotus petals. In the following list the first, Bhīmā, is on the petal immediately in front of Charchikā, the next on the petal immediately behind her; the next three are on the three petals to the right (clockwise) of the front petal, and the final three on the three petals to the right of the rear petal. The same applies to the other seven groups of yoginīs. Their Tibetan names are given in parentheses. In this and the other lists that follow,

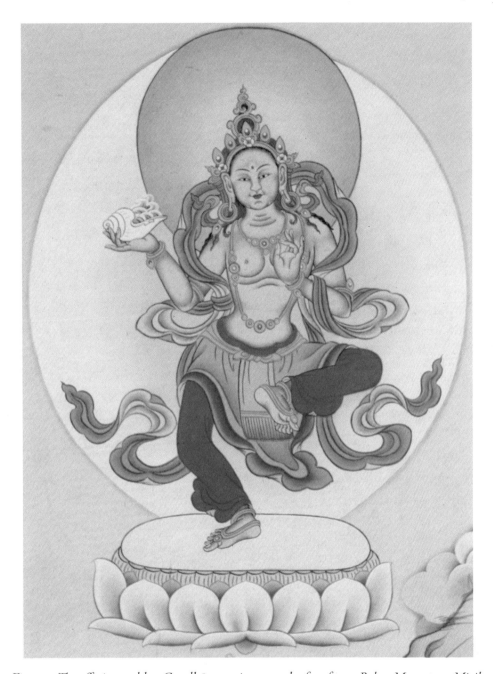

Fig. 4-9. The offering goddess Gandhā, carrying a conch of perfume. Bokar Monastery, Mirik.

some alternative names are given. These lists are based on Tāranātha (Kapjon) and the fourth chapter of the *Vimalaprabhā*; there are some differences between these and the lists in both the third chapter and in other texts. Minor variations have been ignored.

Bhīmā (*'jigs ma*)
Ugrā (*drag mo*)
Kāladaṃṣṭrā (*dus kyi mche ba ma, mche ba nag mo*)
Jvaladanalamukhā (*me 'bar gdong ma*)

Vāyuvegā (*rlung shugs ma*)
Prachaṇḍā (*rab gtum ma*)
Raudrākṣhī (*drag mig ma*)
Sthūlanāsā (*sna chen ma, sna sbom mo*)

Southeast: On the center of this lotus is a garuḍa, on which is black Vaiṣhṇavī (*khyab 'jug ma*), with one face and four arms that hold lotus, wheel, conch, and mace. The mace (*be con, gadā*) is a club no longer than two cubits, with a round shaft and large head of eight

sections forming a sphere, tipped with a vajra. Another name given for this goddess in the *Vimalaprabhā* is Khagapatigamanā (*mkha' 'gro'i bdag pos 'gro ma*). She is in union with yellow Brahmā (*tshangs pa*), with four faces and four arms that hold lotus, needle, water pot, and rosary.

They are surrounded by the following eight yoginīs on the eight lotus petals:

Shrī (*g.yang mo, dpal mo*)
Māyā (*sgyu ma*)
Kīrti (*grags ma*)
Lakṣhmī (*dpal mo, bkra shis ma*)
Vijayā (*rnam par rgyal ma*)
 or Paramavijayā (*mchog tu rnam par rgyal ma*)
Shrījayā (*dpal ldan rgyal ma, dpal ldan ma*)
Shrījayantī (*dpal ldan rgyal byed ma, rgyal ldan ma*)
Shrīchakrī (*dpal ldan 'khor lo can ma*)
 or Chakrī (*'khor lo ma*)

South: On the center of this lotus is a buffalo, on which is red Vārāhī (*phag mo*, also called *Shūkarī*), with one face and four arms holding shackles, club, shield, and sword. She is in union with white Rudra (*drag po*), with one face and four arms that wield a snake-entwined khaṭvāṅga, trident, bow, and arrow.

They are surrounded by the following eight yoginīs on the eight lotus petals:

Kaṅkālī (*keng rus ma*)
Kālarātrī (*dus mtshan ma*)
Prakupitavadanā (*rab khros gdong ma*)
Kālajihvā (*dus kyi lce ma, lce nag ma*)
Karālī (*gtsigs ma, lce gtsig ma*)
Kālī (*nag mo*)
Ghorā (*drag mo, 'jigs rung ma*)
Virūpā (*gzugs ngan ma*)

Southwest: On the center of this lotus is a peacock, on which is red Kaumārī (*gzhon nu ma*), with six faces and four arms holding a jewel, spear, bond, and hook.

Another name given for her in the *Vimalaprabhā* is Ṣhaṇmukī (*gdong drug ma*), meaning six-faced. The spear (*śakti*) she holds is a short lance, explained as having a head pointing forward in the shape of an axe, that is, rounded, not pointed. She is in union with white Gaṇapati (*tshogs bdag*), with one face and four arms that hold bond, axe, jewel, and vajra.

They are surrounded by the following eight yoginīs on the eight lotus petals:

Padmā (*padma ma*)
Ratnamālā (*rin chen 'phreng ba ma*)
Anaṅgā (*lus med ma, yan lag med pa*)
Kumārī (*gzhon nu ma*)
Mṛgapatigamanā (*ri dags bdag pos 'gro ma*)
Sunetrā (*mig bzang ma*)
Klīnā (*rul ma, rul ba ma*)
Bhadrā (*bzang mo*)

West: On the center of this lotus is an elephant, on which is yellow Indrī (*dbang mo*), with one face and four arms holding vajra bell, vajra, bow, and arrow. She is in union with black Nairṛti (*bden bral*), with one face and four arms holding shield, sword, skull-bowl, and arrow.

They are surrounded by the following eight yoginīs on the eight lotus petals:

Vajrābhā (*rdo rje 'od ma*)
Chitralekhā (*bkra ba'i ri mo, sna tshogs ri mo*)
Vajragātrā (*rdo rje'i lus ma*)
Kanakavatī (*gser ldan ma*)
Urvashī
Rambhā
Ahalyā (*zug rngu med ma*)
Sutārā (*shin tu sgrol ma*)

Northwest: On the center of this lotus is a goose, on which is yellow Brahmāṇī (*tshangs ma*), with four faces and four arms holding water pot, lotus, bowl, and brahma-club.[12]

12. The brahma-club (*tshangs pa'i dbyug pa, brahmadaṇḍa*) is carried in the hands by brahmins. This is in two forms: single-staffed and triple-staffed. The former is a straight single staff, tipped at both ends, with the whole length entwined by white cord approximately every span of four fingers.

Brahmāṇī and her consort are surrounded by the following eight yoginīs on the eight lotus petals:

Sāvitrī (*mchod sbyin 'don ma*)
Vāgīshvarī (*ngag gi dbang phyug ma*)
Padmanetrā (*padma'i spyan ma*)
Jalajavatī (*chu skyes ldan ma*)
Buddhi (*blo gros ma*)
Gāyatrī (*glu ma*)
Vidyut (*glog ma, glog 'od ma*)
Smṛti (*dran ma*)

North: On the center of this lotus is a chief ox, on which is white Raudrī (*drag mo*), with one face and four arms holding khaṭvāṅga, trident, snake, and ḍamaru. She is in union with red Yama (*gshin rje*), with one face and four arms that hold khaṭvāṅga, club, bond, and sword.

They are surrounded by the following eight yoginīs on the eight lotus petals:

Gaurī
Totalā (*'debs ma*)
Gaṅgā
Nityā (*rtag ma*)

The icchā goddesses

The last group of deities in the speech palace is that of the icchā goddesses on the plinth surrounding the palace. Their names indicate their objects of desire. For example, in the first group to be listed, the name Ashukecchā would translate as "Lady that likes clothing." On the body palace plinth is an identical group of goddesses known as pratīcchās. They have the opposite desires, and the equivalent on the body podium would be "Lady that does not like clothing." The only difference between the goddesses on the speech and

Turitā (*myur ma*)
Lakshmaṇā (*mtshan nyid ma, mtshon byed ma*)
Piṅgalā (*dmar ser ma*)
Kṛṣṇā (*nag mo*)

Northeast: On the center of this lotus is a lion, on which is white Lakṣmī (*dpal mo*), with one face and four arms holding a water-born, lotus, jewel, and rosary. Water-born (*kamala, chu skyes*) is another name for a lotus (*padma*). The intention here is poetic variation rather than to suggest two different flowers. Lakṣmī is in union with red Ṣhaṇmukha (*gdong drug*), with one face and four arms holding jewel, spear, mirror, and lance.

They are surrounded by the following eight yoginīs on the eight lotus petals:

Shrīshvetā (*dpal ldan dkar mo*)
Dhṛtī (*'dzin ma*)
Chandralekhā (*zla ba'i ri mo can ma*)
Shashadharavadanā (*ri bong 'dzin zhal ma*)
Haṃsavarṇā (*ngang pa'i mdog ma*)
Padmeshā (*padma'i dbang mo*)
Tāranetrā (*skar mig ma*)
Vimalashashadharā (*ri bong 'dzin ma*)

body plinths are with their names and seed-characters. For this reason, the body palace pratīcchās will not be described separately later.

These goddesses are all considered to be emanations of other goddesses in the mandala. An example will make this clear. In the meditation, the seed-character (these were given in chapter two) CAH transforms into the goddess Tārā, and she then in turn transforms into Vidveshecchā. The goddess Tārā is therefore called the emanation-base (*sprul gzhi*) of Vidveshecchā.

The total length is the same as the owner's height. The latter consists of three thin parallel staffs bound together by three white, red, and black cords, one span from each end, the binding between being unspecified. According to a note by Chokle Namgyal (Phviman), this has just two ends—therefore presumably a single staff—and each is shaped like the top of a water pot. In the *Vimalaprabhā* this goddess is also called Abdhivaktrā (*chu gter gdong ma*). She is in union with black Viṣhṇu (*khyab 'jug*), with one face and four arms holding lotus, wheel, fifth-born conch, and club. A fifth-born conch is described (Mtkmand) as a conch made from the bone of the asura Pañchan/Pañchaja. This asura lived in the ocean in the form of a timi, a fabulous fish said to be 100 yojanas in length. In the (presumably) original story, Pañchaja lived in a conch, which was stolen by Kṛṣhṇa after he killed the asura. As the conch had belonged to Pañchaja, it was named Pañchajanya (fifth-born).

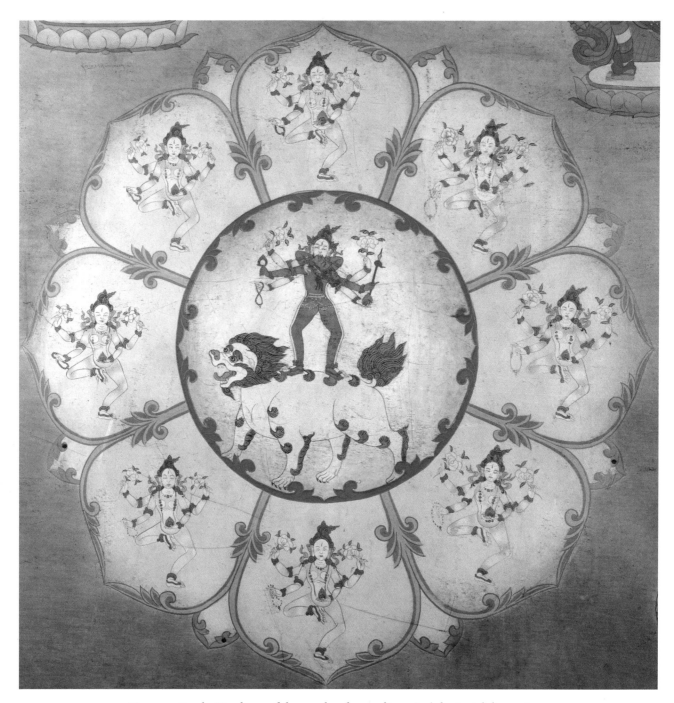

Fig. 4-10. On the Northeast of the speech palace podium, Lakṣmī with her retinue.
Tsangwa Monastery, Dzamthang.

All these goddesses, on both the speech and body plinths, have three eyes, are wearing silk and jewels, are standing in a dancing posture, and are peaceful and sensuous. In *The Melody of the Queen of Spring* (Mtkmand), they are given as in the even stance, the same as the offering goddesses on the mind palace plinth.

Even those such as the eight that emanate from the wrathful prachaṇḍās are peaceful in form.

Their forms are not described in Tāranātha's sādhana. However, according to both Tāranātha and Banda Gelek, the preferred method is that given by Abhayā-karagupta in his *Vajrāvalī*, which is the method I will follow here. In that method, all icchās and pratīc-chās have the same number of faces and same number of hands holding the same hand emblems as their emanation-base.

However, as Tāranātha points out, there are other methods. He mentions the sādhana by Sādhuputra, which uses a simplified version of Abhaya's method: all the icchās have just one face and two hands. Their two hands hold the same emblems as the first two hands of their emanation base. Also worth mentioning here is the sādhana by Kālachakrapāda, in which all the icchās are facing the walls, have just two hands, and instead of holding anything in their hands, they hold each other's hands, forming a chain around the base of the walls.

In the following, the emanation base is given first, after the positioning in parentheses, as given in the second chapter. The order in which they are given here brings together goddesses with the same forms; the description follows Banda Gelek's text on the 3D mandala (Bgslos); he lists them in their groups in the cardinal directions. He gives a similar listing in his text (Bgdubum) on the main creation process, and in both those texts there are a couple of differences with the descriptions in other works. These two changes appear to be editing errors and are the same in both these texts. These are indicated by footnotes. The relative positioning of the goddesses on the plinths is given in the second chapter. Also given here after the Tibetan name is an English equivalent to the object of the goddess's desire.

First, are the goddesses on the right and left of the plinth in the East:

(R1) Vidveshecchā (*dbye 'dod ma*, separating, keeping apart) and (R2) Ashukecchā (*gos 'dod ma*, clothing) on the right and (L2) Ucchāṭanecchā (*bskrod par 'dod ma*, expelling) on the left are black, and all have three faces and six hands. Their other two faces are white and red, and their hands hold shield, sword, skull, curved knife, khaṭvāṅga, and trident.

(L1) Saṁtāpecchā (*kun tu gdung 'dod ma*, penance, mortification) on the left is blue, has one face and four hands, which hold skull, curved knife, vajra, and bell.

(R3) Vadanagatakaphotsarjanecchā (*mchil ma 'dor 'dod ma*, spitting) on the right is black, with one face and four hands holding lotus, wheel, conch, and mace. (Banda Gelek [Bgslos and Bgdubum] has the conch

in the first left hand and lotus in the second. This is a mistake.)

(L3) Kaṇḍūyanecchā (*lus phrugs 'dod ma*, scratching the body) on the left is black, with one face and four hands holding skull, curved knife, khaṭvāṅga, and trident.

(R4) Sparshanecchā (*reg bya 'dod ma*, touching, binding) on the right is black, with one face and four hands holding shield, sword, snake, and vajra.

(R5) Ucchiṣṭabhaktecchā (*lhag ma za 'dod ma*, eating leftovers) on the right and (L4) Sarvāṅgakṣhodanecchā (*yan lag bskyod 'dod ma*, moving the limbs) on the left are both black, with one face and two hands that hold skull and curved knife.

On the plinth in the South:

(R1) Stobhanecchā (*bskyod par 'dod ma*, arousing) and (R2) Bhojanecchā (*zas 'dod ma*, food) on the right and (L2) Shoṣhanecchā (*skem 'dod ma*, drying out) on the left are red, with three faces and six hands. The other two faces are black and white, and the six hands hold bow, fire arrow, bond, vajra hook, nine-pointed jewel, and ḍamaru. Banda Gelek (Bgslos and Bgdubum) has shackles instead of vajra hook.

(R3) Nṛtyecchā (*gar 'dod ma*, dancing) on the right is red, with six faces and four hands holding jewel, spear, bond, and hook

(L3) Aṅgemlecchā (*lus kyi dri 'dod ma*, bodily odors) on the left is red, with one face and four hands holding shackles, club, shield, and sword.

(R4) Ākṛṣhṭīcchā (*'gugs par 'dod ma*, coercing) on the right is red, with one face and four hands holding bow, arrow, bond, and hook.

(L1) Dhāvanecchā (*rgyug par 'dod ma*, running) on the left is green, with one face and four hands holding snake-bond, axe, khaṭvāṅga, and trident.

(R5) Saṁgrāmecchā (*g.yul 'dod ma*, making war) on the right and (L4) Mūtraviṭsrāvaṇecchā (*bshang gci zag 'dod ma*, excretion of feces and urine [by others, it would seem]) on the left are red and have one face and two hands that hold skull and curved knife.

On the plinth in the West:

(R1) Stambhonecchā (*rengs par 'od ma*, paralysing) and (R2) Gandhecchā (*dri 'dod ma*, aromas) on the right and (L2) Bandhanecchā (*gnyen 'dun 'dod ma*, captivating, befriending) on the left are yellow, with three faces and six hands. Their other faces are black and white, and the hands hold conch, wheel, shackles, club, sounding bell, and wrathful vajra.

(R3) Plāvanecchā (*chu la brkyal 'dod ma*, swimming, bathing) on the right is yellow, with four faces and four hands holding water pot, lotus, bowl, and brahma-club.

(L3) (Shayane-) Majjanecchā (*mal stan snyes 'dod ma*, lying on bedding) on the left is yellow, with one face and four hands holding vajra bell, vajra, bow, and arrow.

(R4) Kīlanecchā (*phur bus 'deb par 'dod ma*, striking with a stake) on the right is yellow, with one face and four hands holding conch, wheel, jewel, and club.

(L1) Maithunecchā (*'khrig par 'dod ma*, having sexual intercourse) on the left is green, with three faces and six hands. The other faces are white and red, and the hands hold vajra bell, vajra, skull, curved knife, four-faced Brahmā head, and axe.

(R5) Ahibandhanecchā (*sbrul 'ching 'dod ma*, catching snakes) on the right and (L4) Sattvānāmvañchanecchā (*sems can bslu 'dod ma*, deceiving beings) on the left are yellow, with one face and two hands holding skull and curved knife.

On the plinth in the North:

(R1) Pauṣhṭikecchā (*rgyas par 'dod ma*, increasing) and (R2) Bhūṣhaṇecchā (*rgyan 'dod ma*, jewelry) on the right and (L2) Mṛduvachanecchā (*'jam par smra bar 'dod ma*, speaking gently) on the left are white, with three faces and six hands. The other two faces are red and black, and the six hands hold eight-petaled white lotus, hammer, mirror, lance, rosary, and trident.

(L1) Vādyecchā (*rol mo 'dod ma*, music) on the left is blue, with three faces and six hands. The other faces are white and red, and the hands hold vajra bell, vajra, skull, curved knife, four-faced Brahmā head, and axe.

(R3) Rajyecchā (*rgyal srid 'dod ma*, authority, royalty) on the right is white, with one face and four hands that hold water-born, lotus, jewel, and rosary.

(L3) Āsanecchā (*mal bstan 'dod ma*, bedding [in a sexual sense]) on the left is white, with one face and four hands that hold khaṭvāṅga, trident, snake, and ḍamaru.

(R4) Bandhanecchā (*'ching bar 'dod ma*, catching, binding) on the right is white, with one face and four hands holding lotus, hammer, mirror, and lance.

(R5) Dārakākroshanecchā (*byis pa khro bar 'dod ma*, intimidating children/inferiors) on the right and (L4) Bahukalahecchā (*rtsod par 'dod ma*, hostility) on the left are white, with one face and two hands holding skull and curved knife.

This completes the description of the deities of the speech palace.

The body mandala palace and beyond

There are essentially two groups of deities within the body palace. On the podium, on twelve lotuses, there are twelve male deities in union with twelve goddesses. In addition, each pair is surrounded by a group of twenty-eight goddesses on the petals of their lotus, those goddesses being identical in form—number of faces, hand emblems, etc.—to the couple in the center. These males and females taken together number 360 and are associated with the 360 lunar days of the lunar year.

In the doorways of the body palace are wrathful deities, door protectors riding in chariots, in union with their consorts. There are also above and below wrathful

pairs, also on chariots. This completes the main deities; the rest are known as follower or attendant deities (*rjes 'brang gi lha*). On the plinth of the palace are the thirty-six pratīcchās, mentioned earlier; the speech mandala's icchās would also be categorised as attendant deities. Next is a group of eight nāgas also on the plinth; there are in addition above and below nāgas. The consorts of the nāgas are called prachaṇḍās, and these reside on wheels in the charnel grounds above the wind and fire perimeters. There are also above and below prachaṇḍās. Finally, there are the perimeter beings, around the perimeter of wind.

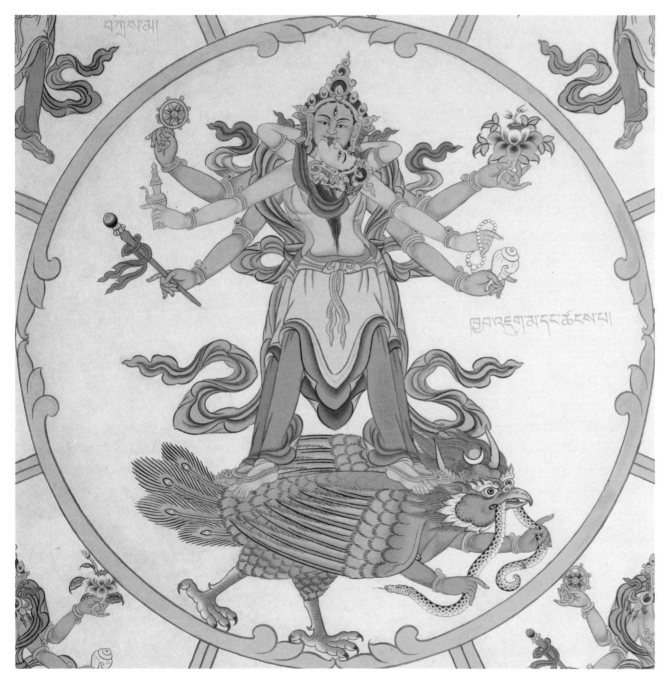

Fig. 4-11. In the Southeast, black red Vaiṣṇavī in union with Brahmā.
Bokar Monastery, Mirik.

Deities on the body podium

There are many similarities between the chief deities of the body palace and those of the speech palace. The first difference is that in each pair, whereas in the speech palace the female is the chief deity, in the body palace the male is. All of the eight mātṛkās of the speech palace are identified with one of the goddesses in the body palace, although not always with the same name and not always with the same male consort.

Although the male gods are the chief deities in the twelve couples of the body palace, both Tāranātha and Banda Gelek describe their relationships from the point of view of the goddesses, much as was done with the speech palace. First, an overall list of the names and positions, with the goddesses given first in each pair is shown in Table 59.

RoE	Rākṣhasī	Rākṣha
Southeast	Prachaṇḍā	Vāyu
LoS	Raudrī	Yama
RoS	Varuṇa	Agni
Southwest	Lakṣhmī	Ṣhaṇmukha
LoW	Kauberī	Dhanada
RoW	Vāsavī	Indra
Northwest	Vidyut	Brahmā
LoN	Yaminī	Rudra
RoN	Vārāhī	Samudra
Northeast	Kaumārī	Gaṇapati
LoE	Mahāshrī	Viṣhṇu

Table 59

In contrast to his comments about the worldly nature of the eight main goddesses in the speech palace, Banda Gelek states that the equivalent eight in the body palace are emanations in the form of the divine Charchikā and so forth; these eight yoginīs are not the worldly eight yoginīs, Charchikā and so on, their consorts are not the worldly Indra and so forth, and their retinues are not worldly. They are in fact enlightened, appearing in those forms, and are each aspects of the awareness of the pure channels of the throat and navel centers (chakras) of Kālachakra.

In the following description of their relationships, the first eight are those that are identified with the eight mātṛkās in the speech palace. After these are listed the remaining four. All are given in clockwise order from the East. Some comments are made about the mounts of the deities; where no comment is made, the mount is the usual mount of the male deity. All these deities have four arms.

RoE: On the body podium is Rākṣhasī, of the same family as the speech palace's eastern Charchikā (also known as Chāmuṇḍā). Rākṣhasī has no other name in this context, and although one might expect her to be the sister of Rākṣha, she is in fact his consort. The mount in both palaces is the same: a preta, that is, a human corpse or ghost.

Southeast: Prachaṇḍā is in union with Vāyu. She is the sister of Brahmā, and is identified with the speech palace's Brahmāṇī.

LoS: Raudrī is in union with Yama, the same pairing as in the northern position in the speech palace; she is the sister of Rudra. In the Kālachakra offering mantras she is called Yaminī (the goddess of night, also a name for Yamī, the first, or primordial, woman). According to Banda Gelek this is not a female version of Yama—although that is how the word would normally be understood—but has here a meaning similar to yoginī. In this sense Raudrī is the chief of all yoginīs; fittingly, in the *Niṣpannayogāvalī* she is called Kālī, and is here the consort of Yama.

Southwest: Lakṣhmī is the same as the Lakṣhmī in the Northeast of the speech palace. She is in union with (Kumāra) Ṣhaṇmukha, the same pairing as in the speech palace.[13]

LoW: Kauberī is in union with Dhanada; she is identified with the speech palace's (West) Indrī, the sister of Indra. Their mount in the body palace is an elephant because an elephant is the traditional mount of Indra. Dhanada is also known as Yakṣha or Kubera. According to Tāranātha, the mount here can be an outcaste servant; in that case the male is identified as Yakṣha. The mount of Kubera is known to be a human.

13. There is a complication in the Tibetan as the names of two of the twelve goddesses in the body palace, Lakṣhmī and Shrī, translate into Tibetan as *dpal mo*. The one here, in union with Ṣhaṇmukha, is the usual Lakṣhmī. The other *dpal mo* is Shrīdhāneshā (*nor gyi dbang mo*); the Shrī on its own translates to *dpal mo* in Tibetan. The latter goddess is not included in the eight mātṛkās. In the dhāraṇī of Vasudhārā (*nor rgyun ma*) the Sanskrit name Mahāshrī is given, and for this reason she is known as the goddess Mahālakṣhmī (*dpal chen mo*). Although Lakṣhmī is the wife of Viṣhṇu, here, in association with the lunar days, she is in union with Ṣhaṇmukha.

Northwest: Vidyut is in union with Brahmā; as Vidyut is a sibling of Viṣṇu, she is identified with the speech palace's (Southeast) Vaiṣṇavī. The same pair is in union in both palaces; in the speech palace the mount is Vaiṣṇavī's garuḍa, and in the body palace Brahmā's swan (sometimes given as a goose). According to Tāranātha, Vidyut is given in texts such as the *Bhagavad Gītā*, *Mahābhārata*, and histories, as the great sister of Viṣṇu.

RoN: Vārāhī is in union with Samudra; the mount in the body palace is Samudra's *makara*, or water monster. Vārāhī is identified with the speech palace's sister (South) of the earth-lord Vārāha.

Northeast: Kaumārī is in union with Gaṇapati; the same pair is in union in both palaces. In the speech palace their mount is Kaumārī's peacock, and in the body palace Gaṇapati's mouse. Kaumārī is the sister of Kumāra Ṣaṇmukha.

In addition to these eight goddesses that are identified with those in the speech palace, there are four more in the body palace: Vāsavī, Varuṇa, Gaurī, and Shrī. In a well-known and often used set of offering mantras (*na maḥ mchod pa*) to all the deities in the mandala, given in the *Vimalaprabhā*, for the offering to the body palace goddesses only these extra four are mentioned—the previous ones are clearly identified with the eight in the speech palace. A couple of them have different names in that offering.

RoS: Varuṇa (goddess of water) is in union with Agni, the god of fire (also Vahni); she is the sister of the nāga king Samudra, who is also known as Vāyu (*rlung lha*), the god of water.

RoW: Vāsavī (goddess of wind) is normally the consort of Vāyu, but here is in union with Indra, also known as Shakra.

LoN: Yaminī (*gshin rje mo*), identified with Gaurī (*ri sras mo*) and Umā (or Parvatī). She is the sister of Yama, who is also known in many tantras as Kālarātrī (*dus kyi mtshan mo*). Yaminī is here in union with Rudra and not the consort of Yama. She is not the same as Raudrī; however, in the North of the speech palace, Gaurī is in the retinue of Raudrī, they being of the same family.

LoE: Yakṣiṇī (*gnod sbyin mo*) or Mahāshrī (*dpal chen mo*); as explained earlier, she is the Mahāshrī that is in the same family as Vasudhārā. Generally, she is the consort of Vaishravaṇa (*rnam thos bu*) but is here in union with Viṣṇu. It should be understood that here she is not Viṣṇu's normal consort, Shrī, but is Vaishravaṇa's consort, Mahāshrī. As mentioned earlier, this Mahālakṣmī is not the same as Lakṣmī, the normal wife of Viṣṇu.

On the center of the lotus right of East is a preta, on which is black Rākṣha (*srin po*) in union with yellow Rākṣhasī (*srin mo*), surrounded by twenty-eight black yoginīs. These are the lunar days of the month of Chaitra (*nag pa*). They all hold shield, sword, skull, and curved knife.

On the center of the lotus in the Southeast is a deer, on which is black Vāyu (*rlung lha*) in union with yellow Prachaṇḍā (*rab gtum ma*), surrounded by twenty-eight black yoginīs. These are the lunar days of the month of Vaishākha (*sa ga*). They all hold sapphire jewel, wish-fulfilling tree, blue utpala, and pārijāta flower.

On the center of the lotus right of South is a sheep, on which is red Vahni (*me lha*) in union with white Varuṇī (*chu lha mo*), surrounded by twenty-eight red yoginīs. These are the lunar days of the month of Jyeṣhṭa (*snron*). They all hold lotus, lance, water pot, and club.

On the center of the lotus in the Southwest is a peacock, on which is red Ṣaṇmukha (*gdong drug*) in union with white Lakṣmī (*dpal mo*), surrounded by twenty-eight red yoginīs. These are the lunar days of the month of Āṣhāḍha (*chu stod*). They all hold jewel, spear, mirror, and lance.

On the center of the lotus right of North is a makara, on which is white Samudra (*rgya mtsho*) in union with red Vārāhī (*phag mo*), surrounded by twenty-eight white yoginīs. These are the lunar days of the month of Shrāvaṇa (*gro bzhin*). They all hold snake-bond, bond, crystal jewel, and jewel.

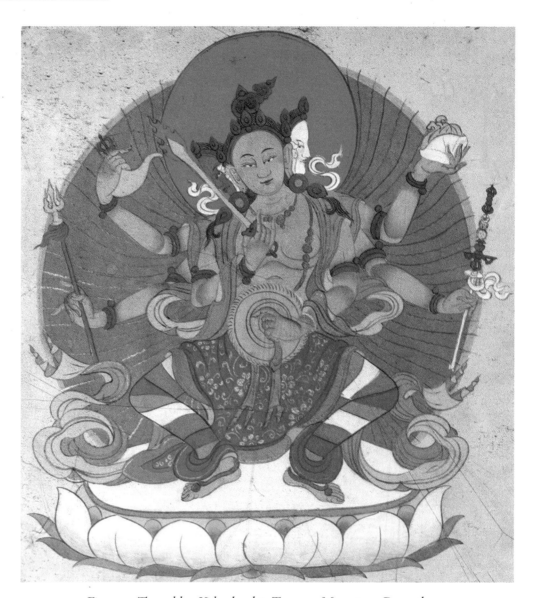

Fig. 4-12. The goddess Vidveṣhecchā; Tsangwa Monastery, Dzamthang.

On the center of the lotus in the Northeast is a mouse, on which is white Gaṇapati (*tshogs bdag*) in union with red Kaumārī (*gzhon nu ma*), surrounded by twenty-eight white yoginīs. These are the lunar days of the month of Bhādrapada (*khrums stod*). They all hold bond, axe, jewel, and vajra.

On the center of the lotus right of West is an elephant, on which is yellow Indra (*dbang po*) in union with black Vāsavī (*rlung lha mo*), surrounded by twenty-eight yellow yoginīs. These are the lunar days of the month of Āshvina (*tha skar*). They all hold bell, vajra, bow, and fire arrow.

On the center of the lotus in the Northwest is a swan, on which is yellow Brahmā (*mes po*) in union with black

Vidyut (*glog ma*), surrounded by twenty-eight yellow yoginīs. These are the lunar days of the month of Kārtikka (*smin drug*). They all hold lotus, needle, water pot, and rosary.

These first eight deities have the colors of their respective directions. There now follow four deities that are assigned to either above or below and are therefore either green or blue. These are all left of one of the doorways. In the Vajrāvalī tradition of Abhayākaragupta, these four are instead the colors of their respective cardinal directions.

On the center of the lotus left of North is a chief ox, on which is blue Rudra (*drag po*) in union with green Gaurī (*ri sras ma*), surrounded by twenty-eight

The Deities of the Mandala 149

blue yoginīs. These are the lunar days of the month of Mārgashīrṣha (*mgo*). They all hold snake-entwined khaṭvāṅga, trident, bow, and arrow.

On the center of the lotus left of West is an elephant, on which is blue Dhanada (*nor bdag*, Kubera) in union with green Kauberī (*nor gyi dbang mo*), surrounded by twenty-eight blue yoginīs. These are the lunar days of the month of Pauṣha (*rgyal*). They all hold mongoose, jewel, lotus, and mace.

On the center of the lotus left of East is a garuḍa, on which is green Viṣhṇu (*khyab 'jug*) in union with blue Shrī (*dpal mo*), surrounded by twenty-eight green yoginīs. These are the lunar days of the month of Māgha (*mchu*). They all hold lotus, wheel, fifth-born conch, and club.

On the center of the lotus left of South is a buffalo, on which is green Yama (*gshin rje*) in union with blue Raudrī (*gshin rje mo*), surrounded by twenty-eight green yoginīs. These are the lunar days of the month of Phālguna (*dbo*). They all hold shackles, club, bond, and sword.

Of the above, all the chief deities are in the vajra posture and facing the center of the palace, facing Kālachakra, as are the mounts on which they ride. The yoginīs in the retinues are all in the lalita posture and are facing their respective chief deities. Brahmā and all his retinue are four-faced; Kumāra, also known as Ṣhaṇmukha, in the Southwest and all his retinue have six faces; all the other deities have just one face.

The door-protectors of the body palace

These are six pairs of wrathful deities riding chariots, each chariot is pulled by a set of seven draft animals. Four of these chariots are in the doorways of the body palace; the chariots and their draft animals are the colors of their directions. In each case, the male deity is the chief deity and the chariot is that of the female. Therefore, for those in the doorways, the male deity is facing the center of the mandala and the female is facing away from the center, toward the front of the chariot; the draft animals are therefore in front of her, as if pulling the chariot out of the doorway.

The green chariot for the upper wrathful is in the upper part of the empty space in the hollow foundation of the speech palace, the foundation that is in the middle of the body palace and supports the speech palace. The chariot faces in the eastern direction and the draft animals are positioned as if pulling it slightly upward. The lower blue chariot faces West and is in the empty space under the ground of the body palace; the draft animals are pulling it slightly downward.

The draft animals are:
 East: boars
 South: horses
 West: elephants
 North: lions

Above: three-eyed garuḍas
Below: eight-legged lions

Of these, the garuḍa is said to be five-colored: in *The Melody of the Queen of Spring* (Mtkmand), it is given that the garuḍa is wrathful, from the feet to the hips yellow, from there to the navel white, to the throat red, to the eyebrows black, and the rest of the top of the head is green. The eight-legged lion was described in the second chapter: either blue or black, with yellow wings projecting from each of its shoulders and hips.

In the descriptions that follow, of the six pairs, there are only six distinct descriptions, the male and female deities being symmetrical in a manner similar to the buddhas and bodhisattvas in the mind palace; they are all written out in full here for clarity. Each female consort has the same form—color and hand emblems—as her male consort's opposite number, and her male consort has the same form as the opposite female. For example, the goddess in the East is identical in form to the male deity in the West; the male in the East has the same form as the female consort in the West; and so forth.

They all have four hands and one face with three eyes. They are extremely wrathful, adorned with snakes and wearing a head ornament of five dry skulls and

a necklace of fifty fresh human heads. The males have their right leg extended and the females the left.

On the chariot in the eastern doorway is Krodhanīladaṇḍa (*khro bo dbyug sngon can*) in union with Mārīchī (*'od zer can ma*). Krodhanīladaṇḍa is black and holds shield, sword, snake, and vajra. Mārīchī is yellow and holds conch, wheel, jewel, and club.

On the chariot in the southern doorway is Ṭakkirāja (*'dod pa'i rgyal po*) in union with Chundā (*skul byed ma*). Ṭakkirāja is red, and holds bow, arrow, bond, and hook. Chundā is white and holds lotus, hammer, mirror, and lance.

On the chariot in the western doorway is Mahābala (*stobs po che*) in union with Vajrashṛṅkhalā (*rdo rje lcags sgrog ma*). Mahābala is yellow, and holds conch, wheel, jewel, and club. Vajrashṛṅkhalā is black and holds shield, sword, snake, and vajra.

On the chariot in the northern doorway is Achala (*mi g.yo ba*) in union with Bhṛkuṭī (*khro gnyer can ma*). Achala is white and holds lotus, hammer, mirror, and lance. Bhṛkuṭī is red and holds bow, arrow, bond, and hook.

On the above chariot is Uṣṇīṣhachakrin (*gtsug tor 'khor los sgyur ba*) in union with Atinīlā (*shin tu sngon mo*). Uṣṇīṣhachakrin is green and holds snake-bond, axe, khaṭvāṅga, and trident. Atinīlā is blue and holds skull, curved knife, bell, and vajra.

On the below chariot is blue Sumbharāja (*gnod mdzes rgyal po*) in union with green Raudrākṣhī (*drag spyan ma*). Sumbharāja is blue and holds skull, curved knife, bell, and vajra. Raudrākṣhī is green and holds snake-bond, axe, khaṭvāṅga, and trident.

The nāgas on the plinth of the body palace

Here is another symmetrical pair of sets of deities: the nāgas together with their consorts on the plinth of the body palace, and their consorts, the prachaṇḍās, together with the nāgas on wheels above the disks of wind and fire. In each case there are eight in the main directions, plus one pair above and one below, making a total of ten. First are the nāgas.

Eight of the nāgas are on disks of elements situated on the body mandala plinth, on either side of the porches just behind the main pillars supporting the toran. The other two are disks of the elements of space and awareness, one above and the other below the center.

Apart from their colors, the nāgas are all similar in form, seated in the vajra posture, as are the consorts in union with them, adorned with jewels, with one face, three eyes and four hands, holding lotus, vase of nectar, jewel, and vajra.

There is a possible ambiguity in all texts here, starting with the *Vimalaprabhā*, in that the prachaṇḍās are not described at this point, but when they themselves are described, with the nāgas as their consorts, they alone are described, not the nāgas. In his sādhana, after the radiation of the nāgas, Tāranātha states that all of those just radiated have one face and four hands and this would seem to include the prachaṇḍās. This is confirmed by Banda Gelek, who states that the male and female deities have the same hand emblems and ornaments. So, here, the nāgas and prachaṇḍās both have four arms, but later, when the prachaṇḍās are radiated as the chief deities in each pair, they then both have two arms. All of the nāgas have five snake hoods around their heads, except the upper and lower nāgas, which have seven. Eight of the prachaṇḍās are animal-headed goddesses, their names describing the relevant animal; the animal names are given in brackets in the list that follows.

The eight nāgas on the plinth are best described in pairs. In the East are two black nāgas in union with their yellow prachaṇḍā consorts on black circular disks of the element of wind. The pairs are:

Left: Black Kārkoṭaka (*stobs kyi rgyu*) with yellow Garuḍāsyā (*mkha' lding gdong ma*, garuḍa).

Right: Black Padma with yellow Jambukāsyā (*ce spyang gdong ma*, jackal).

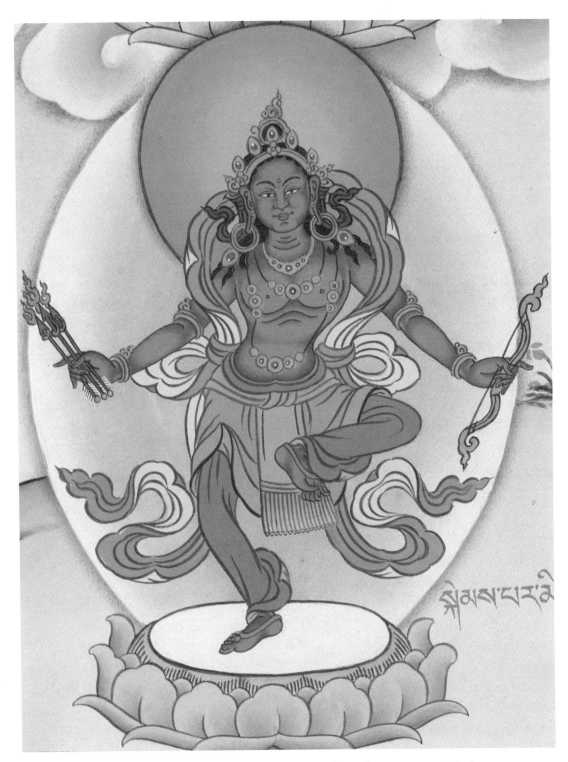

Fig. 4-13. Two-armed form of Shoṣanapratīcchā. Bokar Monastery, Mirik.

Left and right are described from the point of view from the center on the mandala. In the South are two red nāgas in union with their white prachaṇḍā consorts, on red triangular disks of the element of fire. The pairs are:

Left: Red Vāsuki (*nor rgyas*) with white Ulūkāsyā (*'ug gdong ma*, owl).

Right: Red Shaṅkhapāla (*dung skyong*) with white Vyāghrāsyā (*stag gdong ma*, tiger).

In the West are two yellow nāgas in union with their black prachaṇḍā consorts, on yellow square disks of the element of earth. The pairs are:

Left: Yellow Takṣhaka (*'jog po*) with black Kākāsyā (*khwa gdong ma, bya rog gdong ma*, crow).

Right: Yellow Mahāpadma (*padma chen po*) with black Shvānāsyā (*khyi gdong ma*, dog).

In the North are two white nāgas in union with their red consorts, on white semicircular disks of the element of water. The pairs are:

Left: White Ananta (*mtha' yas*) with red Gṛdhrāsyā (*bya rgod gdong ma*, vulture).

Right: White Kulika (*rigs ldan*) with red Shūkarāsyā (*phag gdong ma*, pig).

Inside the speech foundation, below the above wrathful and on a green circular disk of the element of space, is the above nāga, green Jaya (*rgyal ba*), in union with his prachaṇḍā consort, blue Vajrākṣhī (*rdo rje mig ma*).

Below the ground of the body palace, beneath the below wrathful and on a blue circular disk of the element of awareness, is the below nāga, blue Vijaya (*rnam par rgyal ba*), in union with his prachaṇḍā consort, green Atinīlā (*shin tu sngon mo*).

The prachaṇḍās on charnel wheels above the elements of fire and wind

Again, two of this group are above and below the center; the main eight are situated in the charnel grounds in the cardinal and intermediate directions above the border between the elements of wind and fire, on wrathful wheels mounted on animals; the wheels in the cardinal directions are red and those in the intermediate directions white. All are standing in the circular stance, as are the nāga consorts in union with them. In the circular stance (*zlum po'i stabs, maṇḍalapada*) the deity is standing with feet placed so that the heels are about a span or so apart, with the feet pointing outward. The legs are bent at the knees, with the knees pointing outward, making a shape like the wings of a swan. Also, it is said that the fists are placed on the hips with the elbows sticking out to the side, also forming a circular shape.

They are naked, adorned with the five (bone) ornaments and a necklace of twenty-five human heads. They each have one face, and three eyes, and two hands, holding in the right a curved knife and in the left a skull bowl.

In the eastern charnel ground Shūlabheda (*rtse mos 'bigs pa*), on a rhinoceros is black Shvānāsyā, in union with the yellow nāga Mahāpadma.

In the southeastern charnel ground Ucchiṣhṭabhaktra (*lhag ma za ba*), on a bheruṇḍa is black Kākāsyā, in union with yellow Takṣhaka.

In the southern charnel ground Shavadahana (*ro bsregs pa*), on a bear is red Shūkarāsyā, in union with white Kulika.

In the southwestern charnel ground Ghorayuddha (*drag po'i g.yul*), on a crane is red Gṛdhrāsyā, in union with white Ananta.

In the western charnel ground Pūtigandha (*rnag gi dri*), on a lion is yellow Jambukāsyā, in union with black Padma.

In the northwestern charnel ground Sarpadaṣhṭa (*sbrul gyis zos pa*), on a nīlākṣha is yellow Garuḍāsyā, in union with black Karkoṭaka.

In the northern charnel ground Saklinna (*rul ba dang bcas pa*), on a yak is white Vyāghrāsyā, in union with red Shaṅkhapāla.

In the northeastern charnel ground Bālamṛtya (*byis pa shi ba*), on a bat is white Ulūkāsyā, in union with red Vāsuki.

The final two prachaṇḍās are on chariots without draft animals, the above prachaṇḍā is below the above nāga and the below prachaṇḍā is below the below nāga. The above prachaṇḍā is blue Atinīlā (*sngon mo*) in union with the green nāga Vijaya (*rnam par rgyal ba*); the below prachaṇḍā is green Vajrākṣhī (*rdo rje'i mig ma*) in union with blue Jaya (*rgyal ba*). These two do not have animal heads.

The perimeter beings

These were dealt with in the second chapter, and as their forms are not described in Jonang texts, either in the context of drawing the mandala or the practice of the meditation, nothing need be added here. If they are drawn, various forms can be chosen for them or their colors and forms could be taken from sources in other traditions. For example, I have seen representations in Jonang paintings where they are drawn according to the tradition of Buton, as followed in the Gelug tradition.

The number of deities

The number of deities in the Kālachakra mandala is given in Jonang sources as 636. Banda Gelek (Bgslos) explains how this number is derived:

Chief deity site, tathāgata-extension, and mind palace:
The main Kālachakra couple: 2
The eight shaktis: 8
Akṣhobhya and consort, absorbed into the main couple: 2
The four buddha couples, the males as chief deities: 8
The four buddha couples, the females as chief deities: 8
The six bodhisattva couples, the males as chief deities: 12
The six chittā couples, the females as chief deities: 12
The four wrathful couples in the doorways of the mind palace: 8
The offering goddesses of the mind palace: 12

Speech palace:
The yoginīs on the plinth: 72
The consorts of the eight chief yoginīs: 8
The iccha goddesses on the plinth: 36

Body palace:
The deities of the lunar days: 360
The six wrathful couples: 12
The ten nāga couples, nāgas as chief deities: 20
The pratīcchā goddesses on the plinth: 36

Above the border of the perimeters of fire and wind:
The ten prachaṇḍā couples, prachaṇḍās as chief deities: 20

The count is that of the deities that are radiated from the womb of Vishvamātā and the two main deities that are responsible for this. For this reason, although Akṣhobhya and his consort do not have a place within the mandala, they are counted as they are radiated from the womb. The shaktis are counted, even though they are not radiated from the womb, because they are considered as in essence the same as Vishvamātā. The various perimeter beings are not radiated from the womb and are therefore not included in the total.

In the Gelug tradition, Akṣhobhya and his consort are not counted, but also included is a set of eighty-eight perimeter beings. This brings the total in that tradition to 722.

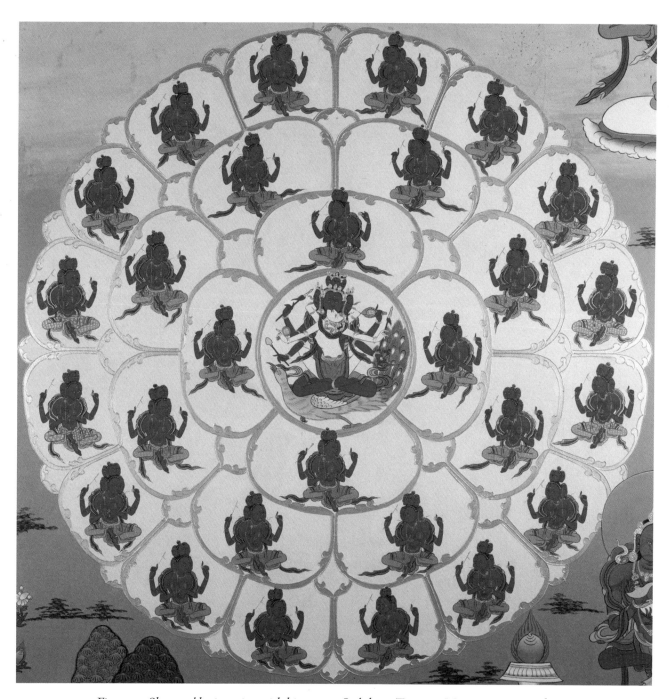

Fig. 4-14. Ṣaṇmukha in union with his consort Lakṣhmī. Tsangwa Monastery, Dzamthang.

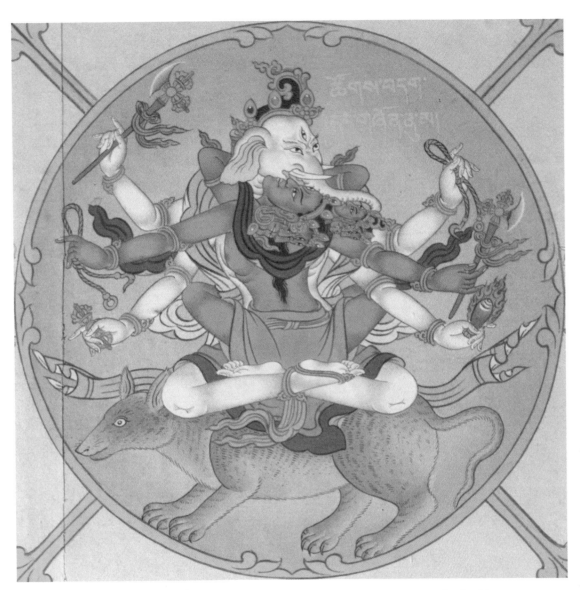

Fig. 4-15. Close-up of Gaṇapati in union with Kaumārī. As Gaṇapati is the chief deity, their mount is his mouse. Bokar Monastery, Mirik.

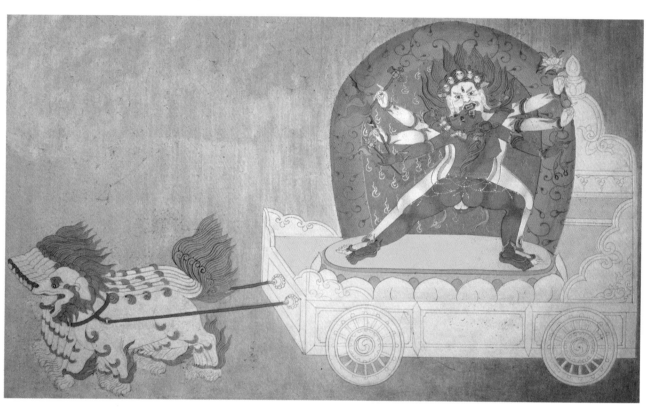

Fig. 4-16. In the northern doorway, white Achala in union with Bhṛkuṭī. Tsangwa Monastery, Dzamthang.

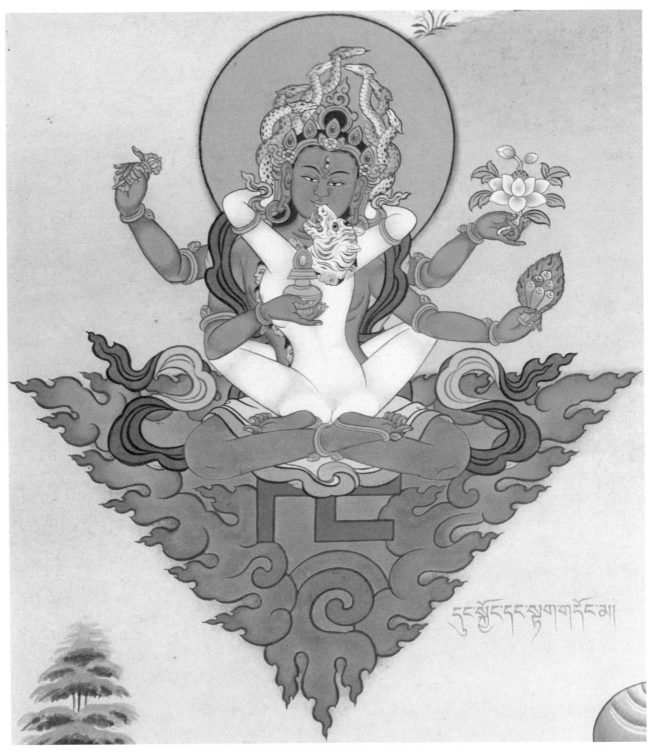

Fig. 4-17. The southern nāga Shaṅkhapāla in union with his tiger-headed consort Vyāghrāsyā. Bokar Monastery, Mirik.

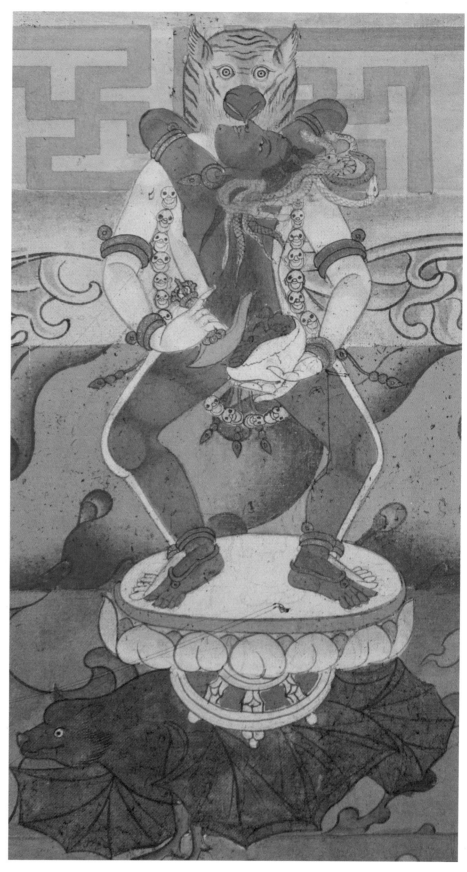

Fig. 4-18. The northeastern prachaṇḍā Ulūkāsyā in union with the nāga Bālamṛtya.
Their mount is a bat. Tsangwa Monastery, Dzamthang.

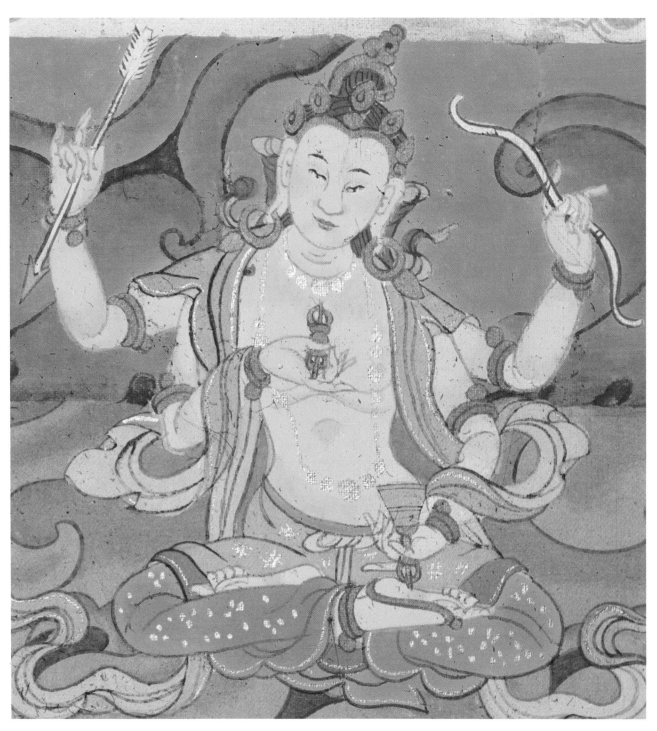

Fig. 4-19. Of the perimeter beings, this is the god Indra. This example is from a set that follows the tradition of Buton Rinchen Drup. Tsangwa Monastery, Dzamthang.

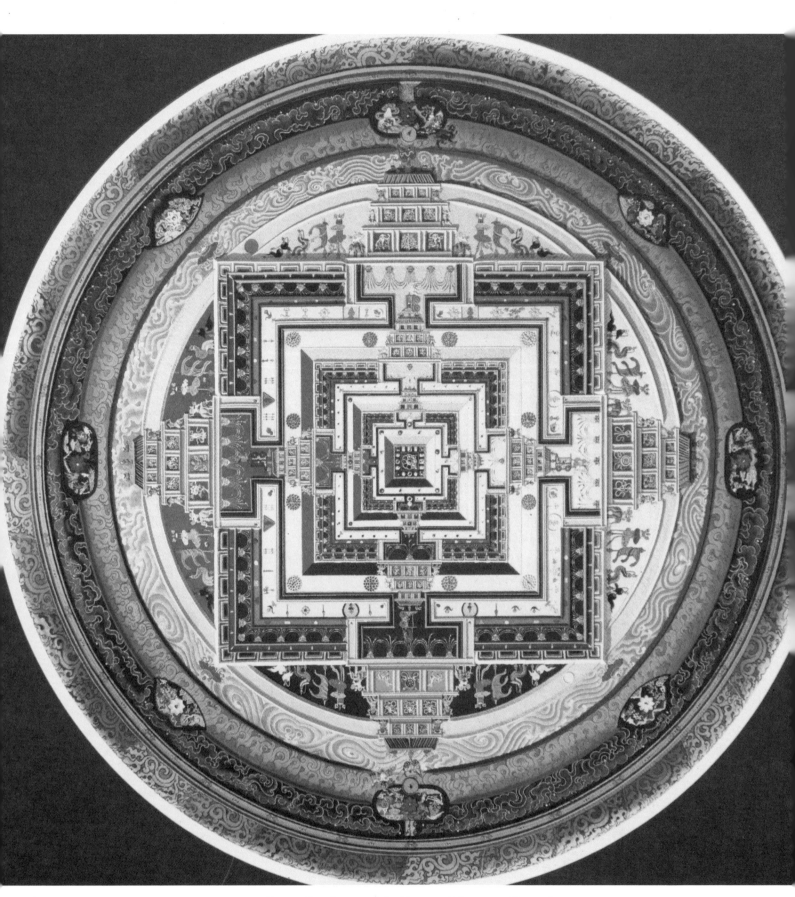

Fig. 5-1. Powder mandala. Tsangwa Monastery, Dzamthang.

5. Symbolism: The Purity of the Mandala

As mentioned in the first chapter, there are two quite different aspects to the symbolism of a mandala such as that of Kālachakra, and although no such equivalent terms exist in Tibetan or Sanskrit, I find it useful to refer to these as static and dynamic symbolism. I shall first deal with the former of these, the symbolism of the mandala and deities and then later describe the dynamic symbolism, concerning the function of the many stages in the process of generating the contemplated image of the mandala and deity.

Static Symbolism

The main sādhanas all approach the symbolism in a similar manner. After the mandala palace has been created and after it has been filled with all the deities, there are liturgical sections in which the symbolism of each is recited and contemplated. The first of these is concerned with the palace alone and the second with the deities, although there are a few other details included. These verses are mainly taken straight from the *Kālachakra Tantra* and its commentary, the *Vimalaprabhā*, predominantly from chapter four, but also partly from chapter five.

To describe this symbolism I am mainly going to follow the explanation of Banda Gelek in his commentary to these liturgical verses (Bgdubum), but I shall also draw on Detri Rinpoche (Kajazhal) and others where relevant, although the basic discussion is generally the same.

Symbolism of the mandala palace

This is in two sections, the second of which is used by most sādhanas but the first by fewer; for example, it does not appear in the main Gelug sādhana by Kalz-

ang Gyatso (Kgkdzhal).[15] At first sight these two verses appear to be referring to the 2D powder mandala, particularly as mention is made of placing colored powders (more than once in the *Vimalaprabhā* commentary). This may well be the reason that some sādhana writers do not use these verses, but the symbolism is clearly also relevant to the full 3D mandala.

Mandala palace symbolism from the fifth chapter

The relevant section in Banda Gelek's instruction text is entitled "Contemplating the purity of the vajra body," although, as we shall see later, the *Vimalaprabhā* takes things a little further to involve speech, mind, and awareness. This section is based on verses two and three of the *Kālachakra Tantra*'s fifth chapter.

All the outer and inner pillars of the mandala, from the twelve pillars in the chief deity's place to the pillars of the torans of the body mandala, are created from the pure awareness of the eight bones of the limbs in the two thighs, two shins, the forearms, and upper arms. It

15. A complete English translation of the fifth chapter of the *Kālachakra Tantra*, together with the *Vimalaprabhā*, is forthcoming soon from the American Institute of Buddhist Studies and Wisdom Publications.

is curious that Banda Gelek (and others) lists here eight bones, when there are in fact twelve. Presumably the intention here is the eight main segments of the limbs: the pairs of (upper) arms, forearms, thighs, and legs.

The vajra designs on the outer and inner beams and pillars of the Circle of Great Bliss, the perimeter of space, and the vajra garland fence are all created from the pure bones of the right and left ribs. (These vajra garlands, as the vajra designs on the beams are described in the tantra, are only relevant to the 2D mandala.)

The perimeter of the earth is created from the pure bones of the spine.

The walls of the mind palace are created from the pure bones of the hands and feet other than those of the fingers and toes. For this reason, the *Vimalaprabhā* adds that when a powder mandala is being created, because the walls and perimeters are the purification of bones in the body, powdered bone should be added to the powdered colors.

The colors of the directions of the top and bottom, inside and out, of the whole mandala are created from: East black, from pure flesh; South red, pure blood; North white, pure urine; and West yellow, pure feces. The blue color around the chief deity lotus is from pure ovum-seed. Both the *Vimalaprabhā* and Mipham's commentary on the tantra (MiKal) state first that in the center is pure semen and also the sixth colored powder, purified ovum-seed; neither gives any actual color here. So why does Banda Gelek only mention ovum-seed? The color blue is usually associated with the direction below, ovum-seed, and the color green with above, semen. As the color that does surround the lotus of Kālachakra is normally blue rather than green, he appears to have chosen just that one.

It would seem sensible to include both, as both green and blue are associated with the center, although in the drawn 2D mandala only blue should be used. Other than this point about the blue color, which seems specific to the 2D mandala, in discussing these colors, Banda Gelek is clearly biasing his description a little toward the full 3D mandala. The *Vimalaprabhā* talks in terms of applying powder colors of black, red, etc., in the various directions, including the two in the center.

The sun seats of the deities on the tathāgata-extension and in the mind palace are created from pure bile (*mkhris pa, pitta*), the moon seats from pure phlegm (*bad kan, śleṣmā*), and the lotuses on which these seats all rest from pure sinews (*chu rgyus*).

Of the fivefold walls of the speech and body palaces, regarding the speech palace, the yellow walls are created from the pure earth-element thumbs of the hands, the white walls from the pure water-element forefingers, the red walls from the pure fire-element middle fingers, the black walls from the pure wind-element ring fingers, and the green walls from the pure space-element little fingers; regarding the body palace, the yellow walls are created from the pure earth-element big toes of the feet, and so on, as with the hands.

The green lotus that is the support for the chief deity Kālachakra is created from the pure avadhūtī central channel; the seats of sun, moon, and Rāhu on its receptacle from the three purified channels for feces, urine, and semen, and the purified qualities of rajas, tamas, and sattva inside the central channel.

The lotuses and animals that are the seats for the speech palace yoginīs and the body palace deities of the lunar days, and also the chariots of the body palace door protectors, are created from the pure 72,000 channels other than the central avadhūtī: that is, the rasanā, lalanā, and the rest.

The perimeter of wind is created from pure skin; the fire perimeter from the pure blood inside the body; the water perimeter from the descent of pure ovum-seed. The earth and space perimeters were described earlier.

The twelve doors in the three palaces, four in each, are the pure twelve orifices. Banda Gelek lists eleven: the two ears, two noses, two eyes, the mouth and anus, the path of semen and the two holes in the nipples. The *Vimalaprabhā* adds to those the orifice for urine, making the total of twelve.

The various ornaments that have the nature of vajra jewels, the garlands and drops, and so forth, are the rows of pure teeth.

The wheels that are the seats for the prachaṇḍās in the eight charnel grounds on the border of the wind and fire perimeters are created from the pure nails of the fin-

gers and toes. In more detail, the nails of the right and left ring fingers are the wheels in the East and Southeast, similarly, the middle fingers South and Southwest, the index fingers North and Northeast, the thumbs West and Northwest; the nails of the little fingers are the chariots of the lower and upper prachaṇḍās. (This is based on the elements associated with the fingers: see above.)

In a similar manner, the seats of the ten nāgas are created from the awareness of the pure ten nails of the toes.

The garland of flames that exist in the cardinal and intermediate directions is created from the pure awareness of all the pores of the body. Banda Gelek states that this should be contemplated, imagining without doubt that the whole of the supporting mandala is created from the single pure awareness of the parts of one's body and seeing it as incorporated within one's conscious experience.

This is where the liturgy and Banda Gelek's explanation leave the original verses. However, the tantra and commentary continue the subject into the next verse (v.4), first explaining that the description just given is for the supporting mandala palace which has the nature of body vajra. The texts go on to state that the speech vajra is the various vowels and consonants that form into the various deities of the mandala, and that these forms are to be drawn in the powder mandala. Next, the mind vajra is the emptiness of the six senses and the six objects of those senses, and this is drawn in the mandala as the form of the chief deity Kālachakra. Finally, the awareness vajra—empty-form, free from all concepts— is represented by the form of the consort Vishvamātā.

Mandala palace symbolism from the fourth chapter of the Vimalaprabhā

This second section regarding the symbolism of the palace is found in verses in the fourth chapter of the *Vimalaprabhā*, after the explanation of verse 9 of the tantra. These verses are said to be a quotation from the *Kālachakra Mūlatantra* and have been translated by Wallace (Wallace 2010, pp. 31–34, "The mandalas of the mind, speech . . ."), albeit with rather odd mandala terminology.

"Just as a golden vase is made out of actual gold, so the mind, speech, and body mandalas are created respectively from the Buddha, Dharma, and Saṃgha." This seems quite a strong statement, and it is worth pointing out again here that this description of the symbolism by Banda Gelek comes from a text explaining the meditation, and the practitioner is expected to imagine strongly that this really is the mandala of Kālachakra, that it is a real representation of the enlightened mind of a buddha, and that by contemplating this properly, one will become enlightened. That is what the symbolism is for: to provide the substance and meaning of the images employed in the meditation.

Similarly, the square nature of the mandala, from the chief deity site out to the body mandala, is created from the four immeasurables (*tshad med pa, apramāṇa; tshangs pa'i gnas, brahmavihāra*), the love, compassion, joy, and equanimity of the ultimate goal. (The *Vimalaprabhā* has here the four vajra lines, presumably meaning the four central lines. Detri Rinpoche counts them differently, and writes of the central and diagonal lines.)

From this point on, some of the qualities that create the mandala are described as members of the thirty-seven factors oriented toward enlightenment (*byang chub kyi phyogs kyi chos, bodhipakṣadharma*), such as the four objects of close attention. These thirty-seven are very common in the symbolism of other mandalas. (In the description that follows, these are indicated at the end of a paragraph with [37].)

Here, the perfectly symmetrical square shape of the mandala is created from the four objects of close attention (*dran pa nye bar bzhag pa, smṛtyupasthana*): the body, sensations, phenomena, and the mind. [37]

The twelve doors, four in each of the three palaces of body, speech, and mind, are created from the purity of the cessation of the twelve links of dependent origination (*rten 'brel, pratītyasamutpāda*), misperception, and so forth.

Similarly, the twelve torans that adorn the palaces are created from the twelve buddha levels. The full list is given in the *Vimalaprabhā*. Here, I give the list with some of the longer names shortened, as given by Banda Gelek. The Sanskrit names are from the *Vimalaprabhā*:

Samantaprabhā (*kun tu 'od*)

Amṛtaprabhā (*bdud rtsi'i 'od*)

Gaganaprabhā (*nam mkha'i 'od*)

Vajraprabhā (*rdo rje'i 'od*)

Ratnaprabhā (*rin chen 'od*)

Padmaprabhā bhūmi (*padma'i 'od kyi sa*)

Buddhakarmakarī bhūmi (*sangs rgyas kyi las byed pa'i sa*)

Anupamā bhūmi (*dpe med pa'i sa*)

Upamā sarvopamā prativedhatodhitā bhūmi (*dpe thams cad kyi dpe rab tu rtogs par byed pa'i sa*)

Prajñāprabhā'nuttarā bhūmi (*shes rab kyi 'od bla na med pa'i sa*)

Sarvajñatā mahāprabhāsvarā bhūmi (*thams cad mkhyen pa nyid 'od gsal ba chen po'i sa*)

Pratyātmavedyā bhūmi (*so so'i bdag nyid rig pa'i sa*)

The eight charnel grounds are created from the noble eightfold path (*'phags pa'i lam yan lag brgyad, āryāṣṭāṅgomārga*) of right view, attitude, speech, pursuit, livelihood, effort, attention, and concentration. [37]

The sixteen pillars of the Circle of Great Bliss are created from the sixteen emptinesses, external emptiness and so forth, and also the sixteen that consist of the five emptinesses of the five aggregates, the five emptinesses of the five elements, the five emptinesses of the five senses, plus the emptiness possessing the totality of possibilities.

The body mandala palace is created from the pure earth element; similarly, the speech palace from the pure water element, the mind palace from the pure fire element, the Circle of Great Bliss from the pure wind element, and the chief deity site from the pure space element, each of these levels being higher than the previous.

The eight porch projections of the body palace (the two sides of each doorway) are created from the eight liberations (*rnam thar, vimokṣa*) that emphasize body: the liberation of seeing that which has form as form, that of seeing the formless as form, that of auspiciousness, that of infinite space; that of infinite consciousness, that of complete voidness, that of the pinnacle of existence, and that of cessation. Similarly, the eight

porch projections of the speech palace are created from the eight liberations that emphasise speech, and the eight porch projections of the mind palace are created from the eight liberations that emphasise mind. The last two sets of eight, speech and mind, are not listed by Banda Gelek, nor by other writers, as far as I can tell.

Earth, water, fire, and wind, created from the awareness of the enlightened state, together with form, smell, taste, and texture, are the eight physical materials; form, sound, smell, taste, and texture, together with rajas, tamas, and sattva, are the eight qualities; each of these have aspects of body, speech, and mind. The eight porch extensions and porch sides of the mind palace are respectively created from the mind aspects of the eight materials and eight qualities; the extensions and sides of the speech and body palaces are similarly created from the speech and body aspects of these materials and qualities.

The five colors of the palace are created from the five untainted collections (*zag med kyi phung po*) of discipline, absorption, wisdom, liberation, and liberated awareness.

The (inner) black walls of the mind palace are created from the awareness of the realizations of the universal vehicle; the red walls from the awareness of the realizations of the solitary buddha vehicle; and the white outer walls from the awareness of the realizations of the disciple vehicle.

The five walls of the speech palace are created from the five abilities (*dbang po, indriya*) of confidence, effort, attention, concentration, and wisdom. The five walls of the body palace are created from the five powers (*stobs, bala*), also of confidence, effort, attention, concentration, and wisdom. [37]

The walls of each palace have on the outside two plinths in each direction making a total of eight; these are created from the four absorptions and the four dhāraṇīs: the four absorptions (*ting nge 'dzin, samādhi*) are the absorption of bravery, of space treasury, of stainless mudrā, and of the playing lion; the four dhāraṇīs (*gzungs*) are the tolerance, mantra, dharma, and ultimate dhāraṇīs.

The friezes that are decorated with jewels are created

from the ten transcendent virtues, of generosity, and so forth (*pha rol tu phyin pa, pāramitā*).

The garlands and drops and other various ornaments of the palace are created from the eighteen unique attributes (*ma 'dres pa'i chos, āveṇika dharmā*) of a tathāgatha. These are the six concerning conduct: no bodily error, no babble in the speech, no failure of presence of mind, no lack of composure, no conflicting interpretations, and no unconsidered attitudes; the six concerning realization: no failure of aspiration, effort, mindfulness, absorption, wisdom, and completely liberated awareness; the three concerned with awareness: perceiving the past, the present, and the future with an awareness that is unattached and unhindered; and the three concerned with activity: all activities of body, speech, and mind are preceded by and enacted through awareness.

The pipes (fascia) hanging down from the eaves (or cornice) are created from the ten controlling powers: control over life, mind, activity, necessities, birth, interest, aspiration, transformation, awareness, and Dharma.

The parapet is created from the ten virtues, that of abandoning killing, and so forth.

The sound of ringing bells that fills the palace is created from the four doors of liberation (*rnam thar sgo, vimokṣamukha*): the door of liberation of emptiness, and so forth.

The victory banners in the four directions on top of each of the palaces are created from the four bases of transformation (*rdzu 'phrul gyi rkang pa, ṛddhipāda*): aspiration, effort, analysis, and mind. [37]

The mirrors glistening with light that adorn the palace are created from the four disciplines (*yang dag par spong ba, samyakprahāṇa*): to develop virtuous qualities, to protect those that have arisen, to not develop nonvirtuous qualities that have not arisen, and to abandon those that have arisen. [37]

The jewel-handled chowries that swing from the palace are created from the seven components of the path of enlightenment: concentration, discernment of phenomena, effort, joy, thorough training, absorption, and equanimity. [37]

The ornaments of garlands of jewels and flowers are created from the nine aspects of the teachings (*gsung rab kyi yan lag, pravacana*): discourse (*sūtra*), teachings in song, prophesies, teachings in verse, aphorisms, narratives, parables, history of previous lives (*jātaka*), and miraculous stories. These are also often found in a list of twelve.

The crossed vajras at the four corners of the palaces are created from the four methods of influence: generosity, kind speech, appropriate behavior, and exemplary behavior (*bsdu ba'i dngos po, saṁgrahavastu*).

The crescent moons adorning the junctures of the porches and porch projections (the porch alcoves are intended here) are created from the awareness that perceives the four truths: the truth of suffering, the truth of the origin (of suffering), the truth of cessation, and the truth of the path (*bden pa bzhi, catuḥsatya*).

The five external perimeters of earth, water, fire, wind, and space are created from the five superknowledges (*mngon shes, abhijñā*): knowing with the divine eye, divine ear, knowing others' minds, remembering previous existences, and knowing magical transformation.

The external vajra garland that surrounds the palace is created from the awareness of great enlightenment that understands all things.

The perimeter garland of vajra fire of awareness is created from the unchanging bliss of instantaneous enlightenment.

The full moon continually rising in the Northeast is created from method, great bliss; the sun continually setting in the Southwest is created from understanding, emptiness. Detri Rinpoche adds here that the full moon continually rising indicates the increase of positive qualities and the sun continually setting indicates the decrease of negative qualities.

The Dharma chakra in the lowest stage of the body palace East toran is created from mind vajra, the vase (South) from speech vajra, the great drum (North) from body vajra, and the bodhi tree (West) from awareness vajra.

Similarly, the four emblems that are created together with the main deities—the wish-fulfilling jewel, the Dharma-conch, the semantron, and the wish-granting tree—are also created from the four vajras.

Banda Gelek concludes this section with the comment: "In this way, the great mandala of Kālachakra is created from the awareness and qualities of enlightenment. One should contemplate it with the conviction that the vast aspects of the awareness and qualities of enlightenment appear in the form of the various parts of the mandala, because, in contemplating the purity, if one does not see the whole of the support and supported mandala as the essence of the body, speech, and mind of enlightenment, there will be no difference between (contemplating) this and contemplating the ordinary physical and animate worlds."

Symbolism of the deities

Banda Gelek starts his lengthy description of the symbolism of the deities—the recollection of the purity—with an introduction that explains just what it is that is to be purified. This is a description of the processes of conception, gestation, birth, and life that in some ways is a shorter version of a similar description that he gives regarding the dynamic symbolism, the purification of the development of the mandala in the meditation. That longer description is given later in this chapter.

The key feature of this short introduction is that it associates aspects of the life process with the four bodies (*kāyas*) of enlightened existence. Later, these four bodies are associated with groups of the deities in the mandala. This is the symbolism of the deities in the broadest strokes. This association of the four bodies with the life process comes from the second chapter of the *Vimalaprabhā* (Wallace 2004, p. 16). These four bodies, according to the Kālachakra tradition, are the wisdom truth body (*dharmakāya, chos sku*), the beatific

body (*samboghakāya, longs sku*), the emanation body (*nirmāṇakāya, sprul sku*), and the pure body (*śuddhakāya*) or orgasmic/innate (*sahajakāya, lhan cig skyes paʼi sku*).[16]

That which is to be purified

According to the tantra, there are two ways of associating the four bodies with the process of life. One way is to associate the bodies with the period of gestation and the period of life after birth taken together. The other is to associate the bodies with both periods individually, once with the period of gestation and then again with the period of life following birth.

The four bodies and the period of gestation and life after birth taken together

First, as with the pure body (*śuddhakāya*), which is the awareness of bliss, at the time of existing in the womb, thoughts are few, and for this reason the experience of bliss is great; as a result of this excess of bliss there is superknowledge, hence the association with the pure body. As with the wisdom truth body (*dharmakāya*), which is the absence of thoughts clinging to characteristics, after birth, until the teeth grow, there is also little clinging to characteristics, hence the wisdom truth body.

As with the beatific body (*sambhogakāya*), which here means completely experiencing the mahayana Dharma, the discourses of the teacher, from the time the teeth grow until they (the milk or deciduous teeth) fall out, one first experiences the ability to speak and

16. The careful reader will notice that the terminology of the Kālachakra literature regarding the four bodies differs from the standard exoteric mahayana presentation. Here we find the wisdom truth, beatific, and emanation bodies, as in the exoteric context, but in the *Kālachakra Tantra* and *Vimalaprabhā* the fourth body is called the pure body, translating the synonymous terms *śuddhakāya, viśuddhakāya, samśuddhakāya,* and *suviśuddhakāya* (see Wallace, 2004, pp. 17–18). The fourth is also called, as is clear in here, *sahajakāya*—the orgasmic or innate body. In the exoteric mahayana context, one finds the same first three bodies as well as the reality body (*svābhāvikakāya*), which has been translated elsewhere as "Essential Body" (Wallace 2001, p. 168) and "Natural Body" (Wallace 2010, p. 12). Wallace (2001 p. 168) observes that the *Kālachakra Tantra* itself does not use the term *svābhāvikakāya* but that *Vimalaprabhā* does, equating *sahajakāya* and *svābhāvikakāya* (and hence by extension *śuddhakāya,* etc.). Wallace (2001, pp. 168–69) explains that the reality body (*svābhāvikakāya*)—and thus the orgasmic body/pure body (*sahajakāya/śuddhakāya*)—is the objective aspect, the emptiness of enlightened awareness, while the wisdom truth body (*dharmakāya*) is the subjective aspect, enlightened awareness that remains eternally in meditative equipoise; the two are indivisible. For more on this, as well as the role of the intuition, or gnostic, body (*jñānakāya*), see Wallace 2001 chapter 7.

indulges in various recreational activities, hence the beatific body.

The emanation body (*nirmāṇakāya*) has two aspects: it performs various activities that influence beings in whatever way is necessary, the twelve acts, and so forth, and its nature entails the development of semen and so forth for the advancement of one's lineage; similarly, from the time the teeth grow again (the permanent, or, adult teeth) until death, one engages in various activities of the three doors (body, speech, and mind) and acts to increase one's lineage, hence the emanation body.

The four bodies and the lifespan from gestation to death

We now come to the second method. The first month in the womb is a time of blissful unconsciousness. In the second month, subtle prāṇa-wind (*srog rlung*) develops together with its support, a fine central channel; these cause only very minor thought processes. In the third month, the development of the ten channels of the heart center and the ten winds brings about clear mental and physical consciousness; the four channels of the crown also develop. Throughout this first period in the womb, the first three months, there is an absence of conceptual thought and one experiences the bliss of the merging of the white and red elements and mind; for this reason this period is associated with the pure body, or the orgasmic body (*sahajakāya*).

In the fourth month, even though the five aggregates and five elements develop in their coarse forms, the consciousness is devoid of any thoughts concerning the aggregates and elements. As this condition is similar to the wisdom truth body, it is associated with the wisdom truth body.

In the fifth month, the six sense organs—the eyes, and so forth—together with their objects, are formed and continue to develop until the ninth month. These are the basis for the experience of objects, and as this is similar to the beatific body, this period is associated with the beatific body. Following those months the hair and so forth start to develop, and from then until birth, various conceptual activities start, and for this

reason this period is associated with the emanation body.

Just as the orgasmic body has the ability to give rise to the wisdom truth body, the awareness that understands all that can be known, so as soon as birth has occurred, 56¼ movements of wind occur from the central channel, and these lead all the groups of winds, developing the awareness of form and other objects. This is therefore associated with the orgasmic body, or the pure body.

The word I am translating here as "group," which will occur later many times, is *dkyil 'khor, mandala*. It refers to particular discrete sets of 360 breaths associated with each of the five main elements. The total number of breaths in a single day is a full cycle (*'khor lo*) of 21,600, and these are correlated with each of the ascendants (*dus sbyor, lagna*, rising signs) throughout the day in twelve sets of 1,800. Each set of 1,800 is further subdivided according to the five elements, there being 360 breaths associated with each element. These are the groups. With each breath, winds of a particular element move from the navel center out through the nostrils and then back again. Once the group of 360 winds of that element has been completed, the next group starts (Bg6yspyi).

Following the 56¼ movements of wind, from that point until the teeth grow is similar to the wisdom truth body which cannot be named or expressed, because the inability to speak is associated with the wisdom truth body. In the period from teething until the milk teeth fall out one starts to experience properly the five objects of the senses, in particular the enjoyment of food, and for this reason it is associated with the beatific body. The teeth grow again, and in the period from then until final death one engages in many activities, in particular enlarging one's family, and so it is associated with the emanation body.

Purification: Recollection of purity

Having described that which is to be purified, Banda Gelek goes on to detail the purification itself. His description of the recollection of purity is divided into

seven sections: the four bodies, the channels, time, the aggregates and elements, the (hand) emblems, the postures, and additional.

1. The purity of the four bodies

The purity of the four bodies is based on the fourth chapter of the *Kālachakra Tantra*, from the second half of verse 94.

According to this tantric system, the four bodies both inside and outside of the womb; the ten shaktis, Kṛṣṇadīptā, and so forth (here Paramakalā and Bindurūpiṇī are considered to be combined within Vishvamātā); the four buddhas in the Circle of Great Bliss, Amoghasiddhi, and so forth, and the four consorts, Tārā and others; the four emblems, the wish-granting tree, and so forth; the ten vases—all these, together with the chief deity couple, since all of these are of the nature of the mind of unchanging great bliss of Kālachakra, should be contemplated as being identical with the the pure body of Kālachakra.

Similarly, the five mind wrathfuls (the upper wrathful, Uṣhṇīṣha, is considered to be combined within the other four wrathfuls) together with their consorts; the six bodhisattvas seated on the mind deity podium together with Rasavajrā and so forth; and, the six vajrās—since all these appear from the nature of the wisdom truth body, which is Kālachakra's awareness that understands without conceptuality all that is knowable, they are identified with the wisdom truth body.

The seventy-two speech yoginīs together with the eight male consorts (the consorts of the eight chief yoginīs) are created from the speech of Kālachakra, having the nature of the indestructible melody, and are therefore identified with the beatific body.

The six wrathfuls together with their consorts on the chariots in the four body doorways and above and below; the 360 deities on the body podium, the great gods and their consorts, such as Rākṣha in the Southwest and so forth, and their retinues; the eight nāgas, together with those above and below; the ten prachaṇḍās; plus, the thirty-five million spirits and others in the charnel grounds—as all these are identified as emanations of Kālachakra teaching beings in whatever ways necessary, they are considered to be the emanation body of the buddha Kālachakra.

It was mentioned before that the four bodies are not only associated with the process from entry to the womb up until death but are also associated once with life outside the womb after birth and once with the inner period inside the womb when the aggregates and senses are developing. Similarly, the four bodies can be associated once with the outer speech and body palaces of the full mandala and once with the inner mind palace. The latter is particularly important when the mind mandala is used on its own.

The period of the first three months in the womb, when one exists in the unconscious blissful state of the merging of the white and red elements and mind, with the aggregates and so forth (merely) as potentials; this time when the ten channels of the heart form together with the four channels of the crown with the potential to develop the body, speech, and mind; this period is the blissful orgasmic body.

This is purified by the teacher, the Kālachakra couple, the eight shakti goddesses, the four vajras (that is, the four emblems), and the ten vases; these are Kālachakra's awareness of orgasmic (*sahaja*) bliss and so their appearance is identified with the orgasmic embodiment of the jina (*sahajakāya*). These all reside in the heart of the mandala, in the middle of the Circle of Great Bliss.

Just as the development in the womb of the child's coarse forms of the five aggregates and the five elements are associated with the wisdom truth body, similarly, the purity of the five aggregates and the five elements are the four buddhas, Akṣhobhya and so forth, and the four consorts, Tārā and so forth, the result of purification of the wisdom truth body of the womb. As their essence is of the wisdom truth body perceiving the nature of the aggregates and elements, they are identified with the wisdom truth body.

Just as the development in the womb of the senses and their objects is associated with the beatific body, so when purified they are the six vajrās, Rasavajrā and so forth, and the six bodhisattvas, the result of the purification of the beatific body of the womb, as these are both

the experience of undefiled form, etc., by the embodiment of awareness, the undefiled form with the marks and characteristics, and also the form of that which is experienced, these are identified with the beatific body. The phrase "the experience of undefiled form, etc." is a reference to the purified six senses, and "the form of that which is experienced" is the six types of sense object.

Just as the development in the womb of the hair and so forth is associated with the emanation body, joints, hair, pores, and so forth that develop at that time, when purified, they are identified with the wrathfuls and consorts of the mind palace; as these are emanations of Kālachakra acting in whatever ways benefit beings and are therefore identified with the emanation body, one should consider that they are the emanation body.

As these are all of the Kālachakra mind type, they are in the heart of the mandala, the Circle of Great Bliss, and the mind palace.

Then, beyond the mind mandala are the speech yoginīs, Chāmuṇḍā and so forth, the eight goddesses and their retinues. These mātṛkās are greatly indulging their desired pleasures and as such correspond to the orgasmic body, and as they purify or cleanse the orgasmic body of the time of birth they should be considered as the pure body.

Regarding the twelve great gods of the body palace and their retinues, together with the male and female body door protectors: Kālachakra perceives each of the various actors, actions, and objects of the chief deities and retinues, but perceives them as equal from the point of view of empty reality, thereby indicating the wisdom truth body; and as these purify that which externally is associated with the wisdom truth body, these are identified with the wisdom truth body.

Regarding all those that are hooded, the ten nāga couples: as these are similar to the worldly nāgas below Paranirmitavasavartin (*gzhan 'phrul dbang byed*, the highest of the gods of the desire realm) that indulge in recreation and enjoyments, and as they purify the recreational activities enjoyed by the beatific body of the child outside (the womb), these are associated with the beatific body.

The ten prachaṇḍās and their retinues in the charnel

grounds are the emanation body acting with various behaviors, angry, passionate and so forth, for the benefit of beings as long as samsara endures, and as they purify the child, the emanation body outside of the womb, they are associated with the emanation body.

The deities of the speech and body palaces should be considered as in essence no different from those of the mind palace, but the deities of the mind palace appear in the worldly deity forms of the speech and body deities, and this is in order to accomplish the benefit of beings in need of influence.

Banda Gelek then goes into a more extensive description of the purity of the four bodies, still drawing from the *Kālachakra Tantra*'s fourth chapter, starting from the second half of verse 98. This section describes the purification of the four main sections of the creation process, from the dissolution into emptiness up to the repetition of the mantra. Each of these four sections is associated with bodies and also the four vajras of the path. Each of these purifies a corresponding body and vajra of the ground, producing the corresponding body and vajra of the goal. This is similar in approach to the dynamic symbolism that is the subject of the next chapter, but does not go into anywhere near the same level of detail.

Just as the body is the support for the speech and mind, so in the Mastery of the Mandala the palace is the body vajra of the path; supported by that are the resident deity couples in union, and as they are experiencing the bliss of their union, they are the orgasmic body of the path. These two exist in union. Furthermore, regarding the supported deities, that which gives rise to the deities, the sun and moon of method and wisdom of the true awakening are the support, being the origin of the deities, and so are the body vajra of the path; all the resulting deities as they experience the bliss of united method and wisdom are the sahajakāya of the path.

This union of the body vajra and the sahajakāya purifies the union of the body vajra and the orgasmic body of the ground. The body vajra of the ground is the body from the time of the oblong shape (*nur nur po*) to the formation of the nails, hair, and so forth. The sahajakāya of the ground is the development of bliss through the

power of semen, blood, and mind within the body. It is this that is purified (by the Mastery of the Mandala). This purification results, in the goal state, in the attainment of the union of body vajra and sahajakāya, the body vajra of the support and supported, the assembly of all the deities, which is created from the sahajakāya, unchanging great bliss.

In the Mastery of Activity, Kālachakra melts into a ball of light, and as this awareness free from all concepts that cling to characteristics is similar to the wisdom truth body, this is the wisdom truth body of the path; then, entreated by song, the deities arise again, and the pure essence of all action-winds, the chief deities and retinue, are radiated; as these pure winds are identical with awareness-wind, this is the speech vajra of the path, the beatific body.

Regarding this union of speech vajra and the wisdom truth body: from the time a child is born until the teeth grow, the inner five groups of winds flow from the nostrils, and as the behavior of these winds becomes the basis of the first speech, this is associated with speech vajra; also, the time from when the child is born until the teeth grow is understood to be similar to the wisdom truth body because the state of the mind is primarily of nonconceptual clarity, ground the wisdom truth body of the ground.

It is this union of ground speech vajra and the wisdom truth body that is purified by the Mastery of Activity, resulting when the goal is attained in the wisdom truth body, the mind of the awareness that perceives emptiness. That mind perceiving emptiness turns the wheel of the Dharma, revealing the whole of reality to those to be influenced while directly perceiving the extent of all that is knowable. This is speech vajra. This purification results in the attainment of the similar union of resultant speech vajra and the wisdom truth body.

During Drop Yoga, the descent of bodhichitta from the crown to the jewel (Kālachakra's penis) creates the experience of melting bliss, the mind vajra of the path; the one that experiences this, the embodiment of the deity, is the beatific body of the path. Regarding the

union of these two, the mind vajra and the beatific body of the path: as the child becomes an adolescent, the bliss within of the stirring of the ovum-seed is the mind vajra of the ground, and the ardent expression of sexual talk and so forth is the beatific body of the ground. The union of these two—mind vajra and the beatific body of the ground—is purified by Drop Yoga, resulting in the attainment of the union of the mind vajra and the beatific body of the result, the beatific body adorned with the signs and characteristics of purified wind and the conscious experience of nonconceptual great bliss.

During Subtle Yoga, the bliss which is the experience of the blissful ascent (return) of the ovum-seed is the awareness vajra of the path, and the radiation from the ovum-seed of blissful bodhichitta of limitless vajra deities is the emanation body of the path. Regarding this union of the awareness vajra and the emanation body of the path, as the adolescent comes of age (that is, passes through puberty), the experience of orgasm (the Tibetan translated literally is emission of semen; I have put this differently because the equivalent process in a woman is also intended here) is the awareness vajra of the ground, and the procreation of sons and daughters, together with all other various activities, is the the emanation body of the ground. It is this union of the awareness vajra and the emanation body of the ground that is purified by Subtle Yoga, resulting in the attainment of the awareness of unchanging great bliss, the awareness vajra of the goal. From this unchanging bliss are manifested many different forms to influence others as needed, the emanation body of the goal. The union of awareness vajra and the emanation body of the goal are the result of the purification of Subtle Yoga.

2. The purity of the channels

This section is based on the fourth chapter of the tantra, starting from the beginning of verse 101.[17]

The essence of method, the consorts of the eight

17. The following sections draw on pages 124–36 of Vesna Wallace's translation of the sādhanā chapter (Wallace 2010).

shaktis, the eight vases around the Circle of Great Bliss, together with the essence of wisdom, the eight shaktis themselves on the petals of the chief lotus, these are all the purification of the eight channels of the heart center, known as the dharmachakra (*chos kyi 'khor lo*).

The four vidyā (*rig ma*) consorts of the buddhas, Tārā and so forth, as main deities in union with their consorts, plus the four buddhas, Amoghasiddhi and so forth, as main deities in union with their consorts, make a total of sixteen; these are the purification of the sixteen channels of the forehead center in the head, the sahajachakra (*lhan skyes 'khor lo*) or mahāsukhachakra (*bde ba chen po'i 'khor lo*).

In the mind palace, the six bodhisattvas, the six chittās (or, vajrās, Gandhavajrā, etc.), and the four wrathfuls in the doorways, make a total of sixteen. Each of these also is in union with a consort, bringing the count to thirty-two. These are the purification of the thirty-two channels of the throat center, or sambhogachakra (*longs spyod rdzogs pa'i 'khor lo*).

The sixty-four goddesses on the petals of the lotuses in the speech palace, Bhīmā and so forth, these are the purification of the sixty-four channels of the navel center, or nirmāṇachakra (*sprul pa'i 'khor lo*).

In the body palace, the twelve great gods together with their consorts and retinues make a total of 360; these are the purification of the 360 channels of the karmachakras (*las kyi 'khor lo*), the centers (i.e., chakras) in the twelve joints. These are the centers in the shoulders, elbows, wrists, hips, knees, and ankle; each one has a central pair of channels surrounded by twenty-eight channels, making a total of 360.

The eight nāgas together with their consorts, sixteen, plus the eight prachaṇḍās together with their consorts, a total of thrity-two, are the purification of the sixty kriyāchakras (*bya ba'i 'khor lo*) of the hands and feet. These are small centers at each of the three joints in each of the fingers and toes. Of the deities, the first thirty are the purification of the thirty centers of the hands; the last two prachaṇḍās are the purification of the fifteen channels of the right foot taken together and the fifteen channels of the left foot taken together.

Banda Gelek states that the next few points are not explained in the tantra, but are explained in the commentary, the *Vimalaprabhā*, as implied in the tantra.

The four emblems around the chief deities' lotus, the Dharma-conch, and so forth, are the purification of the four channels of the crown center (*cakra, 'khor lo*).

The eight mātṛkās, Charchikā and so forth, in the speech palace together with eight of the dhāriṇī offering goddesses make a total of sixteen. Of the offering goddesses, the *Vimalaprabhā* simply mentions "the eight, Lāsyā and so forth." Banda Gelek also names Mālā and Dhūpā and the outer goddesses. Presumably he means the eight offering goddesses on the plinth of the mind palace. He then goes on to state that these sixteen, together with their male consorts, are the purification of the thirty-two channels of the genital center. The eight mātṛkās certainly have consorts, but the consorts of the offering goddesses are not identified.

Elsewhere, Banda Gelek states that the eight mātṛkās are the purification of the intermediate eight channels of the navel center and that their consorts are the purification of the middle circle of channels of the throat center. For each of these centers, first four channels branch from the central channel; these subdivide giving eight; these then subdivide further giving an outer circle of sixteen channels for the throat center and penultimate circle of twelve for the navel. Those twelve then subdivide further, giving either sixty or sixty-four channels in the outer circle for the navel.

Mipham (MiKal) gives two alternate explanations here. First, he states that the sixteen goddesses are the purification of the outer sixteen channels of the genital center, or that the goddesses are classified as both body and mind, making a total of thirty-two without the problem of the consorts of the offering goddesses.

Finally in this section, Banda Gelek states that Kālachakra is the purification of the upper three channels. These are the three vertical channels above the navel, the central avadhūtī channel (*dbu ma*), the right rasanā (*ro ma*), and the left lalanā (*rkyang ma*). Vishvamātā is the purification of the continuation of these channels below the navel, the three lower channels. Below the navel, the central channel is called shankhinī (*dung can ma*, conch, mother-of-pearl), the continuation of the

rasanā below the navel is called the piṅgalā (*dmar ser*, red-yellow), and the continuation of the lalanā is called the iḍā (*lug*, sheep).

3. The purity of time

This section is based on the fourth chapter of the tantra, starting from the third line of verse 102.[18] The purity of time only concerns the main couple, Kālachakra and Vishvamātā.

First, Kālachakra. The awareness of the purification of one year in the external world creates the single torso of Kālachakra; the purification of the two passages, northward and southward, the two legs; the purification of the three major seasons (*dus, kāya*), the three throats; the purification of the four seasons (*dus, yugasamaya*), the four faces; the purification of the six seasons (*dus, ṛtu*), the six shoulders; the purification of the twelve months, the winds of the inner twelve ascendants, and the twelve links of dependent origination, the twelve upper arms; the purification of the twenty-four fortnights, which are the waxing and waning fortnights of the twelve months, the twenty-four hands (forearms); the 360 aspects of the awareness of the purification of the 360 days create the 360 joints of the (120) fingers.

As with the Tibetan, I have used just one word here for these three divisions of the year. The Sanskrit, however, has a different word for each. Similarly, Newman translates these respectively as "time," "period," and "season."

In this way, time, being the outer year, the twelve zodiacal months of Capricorn and so forth that subdivide it, and the twelve inner ascendants that constitute the time of one day; plus, time which is the twelve links of misperception and so forth that occur within three lifetimes: the awareness of the purification of all these, and that which experiences such time, is the glorious vajra holder, Kālachakra.

Within this time, from the awareness of the purified twelve ascendants that arise each solar day is created

the body of Vishvamātā. Furthermore, she is identified with the undefiled awareness of the purified life-winds (*prāṇavayu*) of the twelve ascendants, but is not identified with the bundle of samsaric consciousnesses, which are created and destroyed; samsaric mind is referred to as day as it is created and as night as it is destroyed.

4. The purity of the aggregates and elements

This next section continues from chapter 4, verse 103.[19] Just as the last section concerned only the purity of the main couple, this section concerns their retinue—all the other deities in the mandala.

The ten shaktis are the purification of the elements of the ten winds of the heart center. The awareness of the purification of the ten winds, *prāṇa, apāna* (*thur sel*), and so forth, that move in the eight channels in the cardinal and intermediate directions of the heart center and the upper avadhūtī and lower shankhinī: from this awareness is created the ten shaktis, Dhūmā and so forth, and the ten vases that are in essence their consorts.

In a similar way, the purification of the four emotional defilements—desire, anger, delusion, and pride—is identified with purified emotional defilement, Rudra, together with his consort, under the left foot of Kālachakra. The purification of the four māras, aggregate māra, and so forth, is identified with purified māra, Kāmadeva (also known as Māradeva), together with his consort Umā, under the right foot of Kālachakra.

Of the four emblems surrounding the chief deities' lotus, the conch is the essence of body vajra, the semantron the essence of speech vajra, the jewel the essence of mind vajra, and the wish-granting tree the essence of awareness vajra.

Regarding the eight vases, the nectar they contain is identified with the subtle awareness of the cessation of marrow, blood, urine, and feces (two vases each); the Jaya vase (above), the cessation of semen, and the Vijaya vase (below), the cessation of ovum-seed.

18. See pages 125–27 of the sādhana chapter (Wallace 2010) for this verse and the commentary.

19. See pages 127–28 of the sādhana chapter (Wallace 2010) for this verse and the commentary.

The aggregate of reaction purified, awareness-reaction, is the buddha Amoghasiddhi in the Circle of Great Bliss; similarly, purified sensation is Ratnasambhava, purified recognition is Amitābha, purified form is Vairochana; created from the awareness of purified semen is Akṣhobhya.

It is also said that Amoghasiddhi is purified flesh, Ratnasambhava is purified blood, Vairochana is purified feces, and Amitābha is purified urine.

The six goddesses are the purification of the six elements. The element of the awareness of great bliss, free from all obscurations, is Prajñāpāramitā; the awareness of the element of space, free from all obscurations, is Vajradhātīshvarī; similarly, the awareness of the wind element is Tārā, the awareness of the fire element Pāṇḍarā, the awareness of the water element Māmakī, and the awareness of the earth element Lochanā.

Of the sense organs, the ears that are created from the awareness of the completely purified impure ears is Vajrapāṇī; similarly, the nose is Khagarbha, the eyes Kṣhitigarbha, the tongue Lokeshvara, the body Nīvaraṇavishkambhin, and the intellect is Samantabhadra.

Of the six objects of sense, forms (visible aspects) that are created from completely purified impure objects of form are Rūpavajrā; similarly of sounds are Shabdavajrā, of aromas Gandhavajrā, of taste Rasavajrā, tangibles Sparshavajrā, and phenomena Dharmadhātuvajrā. The essence of the pure awareness of the senses and their objects are therefore, respectively, the six bodhisattvas and their consorts.

The mind palace wrathfuls are the essence of the five powers (*stobs lnga*): Uṣhṇīṣha is the essence of Kālachakra's power of wisdom, Vighnāntaka the power of concentration (meditative absorption), Prajñāntaka the power of attention, Padmāntaka the power of effort, and Yamāntaka the power of confidence.

The body palace's five wrathfuls are the purification of the five action organs: the purified genital organ is Sumbharāja, the purified vocal organ Krodhanīladaṇḍa, the purified hands Ṭakkirāja, the purified legs Achala, and the purified rectum Mahābala.

Similarly, the purified activities of these organs are the consorts of the wrathfuls: the purification of orgasm/ejaculation is Raudrākṣhī; the purification of defecation, the activity of the rectum, is Ativīryā; the purification of grasping, the activity of the hands, is Jambhakā; the purification of walking, the activity of the legs, is Mānakī; the purification of talking, the activity of the organ of speech, is Stambhakī; and, although not normally included here, the purification of urination, the activity of the urethra, is Atinīlā. Tāranātha points out that when five wrathfuls are involved, the two organs of urethra and genitals are taken together, as are their activities of urination and ejaculation.

There are some differences here with the wrathfuls when the mind mandala is treated on its own. On this, Tāranātha states that when the mind mandala is on its own, the four antaka deities and Uṣhṇīṣhachakrin are associated with the five action organs; here, in the full triple mandala, the group starting with Nīladaṇḍa are associated with the organs. Regarding the association of the mind palace wrathfuls with the five powers, these are not associated with the five action organs as part of the grouping of the thirty-six aggregates and elements, but, as is understood from the attraction and absorption of the awareness beings, these are associated with the five elements of consciousness. (This association is explained later in this chapter.)

The eight yoginīs, Chāmuṇḍā and so forth, on the receptacles of the lotuses on the deity podium of the speech palace, are identified with the awareness of the purified eight watches (also called the eight sessions [*thun brgyad*]; these are divisions of a solar day) and the purified intermediate eight channels of the navel center. Bhīmā and the others of the sixty-four yoginīs on the petals of those lotuses are the purified sixty-four channels of the navel center; these are the sixty channels through which pass the sixty nāḍī of the inner twelve ascendants together with the four empty channels.

Each solar day is divided into sixty nāḍī (*chu tshod*); through each solar day, the twelve zodiac signs rise in the east; the one coming over the eastern horizon at any time is called the ascendant (*dus sbyor*). Each nāḍī is therefore associated with one of the groups of winds, described above.

The twelve great gods on the body podium, the asura Rākṣha and so forth, are the purification of the twelve months; their twelve consorts, together with the goddesses on the twenty-eight petals of each lotus and the twelve dhāriṇīs above them (the offering goddesses), a total of 360, are identified with, externally, the purified 360 lunar days of the year and, internally, the 360 breaths in each nāḍī. (Each nāḍī is divided into sixty pala (*chu srang*) and each pala into six breaths, each of four seconds' duration.)

The essence of the awareness of the sixty-four channels of the genital center is the eight nāgas in the cardinal and intermediate directions and the eight prachaṇḍās, each together with their respective consorts. (The point here is to count the eight nāgas together with the prachaṇḍās as their consorts, sixteen, and then add the eight prachaṇḍās together with the nāgas as their consorts, thirty-two. Each nāga and prachaṇḍā is represented in the mandala twice, once as a main deity and once as a consort, a total of thirty-two.)

The thirty-six icchās and the thirty-six pratīcchās are the purification of all the various activities of desire, aversion, and delusion, driven by their nature of the three qualities (*guṇa*). The essence of the awareness of the purification of the 21,000 hairs are all the 21,000 siddhas (in the outer perimeter). The purification of the thirty-five million pores are the thirty-five million spirits existing on the ground of the charnel grounds.

5. Purity of the deity's emblems

This section is from the last three lines of verse 106 of chapter 4 of the tantra.[20] The twenty-four tattvas (*de nyid nyer bzhi*) are the twenty-four principles of the phenomenal world from Sāṃkhya philosophy. From these manifest seven principles which are both created and creative in their behavior, and sixteen that are only created. Banda Gelek uses somewhat different terminology, and starts this section by listing these twenty-four, identifying nature (*prakṛti*) with the element of space:

Simply identified with nature:
 element of space

The seven identified with both nature and transformation:
 element of earth
 element of water
 element of fire
 element of wind
 consciousness
 intellect
 identity

The sixteen only identified with transformation:
 ears
 nose
 eyes
 tongue
 body (the organs of the five senses)
 sounds
 tangibles
 tastes
 forms
 smells (the objects of the five senses)
 rectum
 legs
 hands
 organ of speech
 urinary organ (the five action organs)
 sexual organ

Banda Gelek states that the twenty-four awarenesses of the total exhaustion of the twenty-four tattvas appear as the twenty-four hand-emblems—vajra, bell, etc.—of Kālachakra; therefore the twenty-four hand-emblems are identified with the purification of the twenty-four tattvas. He associates these with the twenty-four hand-emblems in the following list; he cites Chokle Namgyal as his main source and Tāranātha, giving the same list, cites former Indian and Tibetan teachers:

20. See pages 131–32 of the sādhanā chapter (Wallace 2010) for this verse and the commentary.

Vajra	space
Wheel	earth
Lotus	water
Jewel	fire
Sword	wind
Ḍamaru	ears
Axe	nose
Arrow	eyes
Short lance	tongue
Shield	body
Trident	sounds
Hammer	tangibles
Hook	tastes
Bond	forms
Club	smells
Bow	rectum
Conch	legs
Brahmā head	arms
Khaṭvāṅga	organ of speech
Bell	urinary organ
Curved knife	sexual organ
Mirror	consciousness
Shackles	intellect
Skull	identity

Table 60

Tāranātha points out that the last three are unclear from the original sources, but he considers associating them in this way to be appropriate. Banda Gelek gives the bow as the purity of the genitals, which seems wrong (the list already contains the urinary and sexual organs), and he points out that all texts miss this one out. Well, not quite all: I have given this here as rectum as this is the identification given by Chokle Namgyal in his

annotated *Vimalaprabhā* (Phviman). It is also the one missing from the list of motor organs.

The purification of the six qualities of forms, tastes, smells, etc., of the six elements of earth, water, fire, and so forth, are the six outer seals on the body of Kālachakra, the wheel on the crown or jewel, the earrings, and so forth.

The body of Kālachakra has the nature of body vajra, his speech of speech vajra, his nondiscursive mind of mind vajra, and the great bliss of his mind of awareness vajra; these are the four inner seals. The essence of these four inner seals combined is the character "HŪṀ" on a moon in the heart of Kālachakra.

Also, Kālachakra is created from the unchanging bliss of having abandoned the four unstable joys of the triple world; it is also added that his body, having abandoned structure, is unobstructed. Vishvamātā is created from the awareness that directly perceives emptiness while observing correctly everything knowable in the triple world; she has exhausted the obscuration of imputation, being by nature free from conceptualization.

As this pair of bliss and emptiness are always essentially indistinguishable, the Kālachakra couple are in union.

From the point of view of Kālachakra's being identified with pervasive mind vajra, the essence of the inner seals is "HŪṀ"; from the point of view of pervasive awareness vajra, the character is "HAṀ."

Further to the purification of the emblems is the cause and result purity of the four bodies. This is described in the fourth chapter of the tantra, verses 107 and 108.[21] Banda Gelek explains that the literal meaning of the verses in the tantra is to apply the terminology of the four bodies and describe the causal process of the four bodies in samsara.

All womb-born beings exist in an unconscious-like blissful state when semen, ovum-blood, and consciousness combine in the womb. This state, when the coarse five aggregates and five elements have not formed, is the glorious purity of samsara, the orgasmic body.

From the combined semen, ovum-blood, and

21. See pages 133–34 of the sādhanā chapter (Wallace 2010) for this verse and the commentary.

consciousness of the pure orgasmic body are created the coarse five aggregates and elements; this state, when the mind has no clear awareness, is the wisdom truth body of samsara, with the characteristics of deep sleep.

From the wisdom truth body arise the coarse six senses and sense organs together with the awareness that clearly experiences them; this is the excellent beatific body of samsara, with the characteristics of the dream state.

From the time of this beatific body with clear awareness of the senses and objects, until the time when the fingers and so forth are complete and the child is born, is the emanation body, which is similar to the waking state.

Similarly, the time following birth when the prāṇa-wind moves in the central channel is the glorious pure body (identified with the orgasmic body). From this pure body arises the wisdom truth body, until the time of teething. From the wisdom truth body arises the excellent beatific body, from the time of initial teething until the milk teeth are replaced by adult teeth. From the beatific body arises the emanation body, from the time the adult teeth appear until death.

The purification of these four bodies of samsara, both in the womb and out, is the lord of jinas whose nature is that of the four bodies, glorious Kālachakra; he acts appropriately according to their individual circumstances for the benefit of all beings who are womb-born and experience these four bodies.

This is the causality of the four bodies in the womb and from the time of birth until death.

Then, the four bodies are also applied to the four states that occur every day although with uncertain timing. These four states are as follows. The experience of the orgasmic bliss of engaging in sexual activity with body, speech, and mind is the fourth state. The time when one falls asleep into a deep sleep, this is the state of deep sleep. Different from both of these states is the time when dreams occur, the dream state. Distinguished by many different physical activities is the time when one is awake, the waking state.

In this way there is the mind or intelligence that experiences the body engaged in the physical activity of sex, the mind of the fourth state, together with its

defilements; also, the mind that experiences the body engaged in deep sleep, the mind of deep sleep, together with its defilements; also, the mind that experiences the body that is engaged in dreaming, the mind of dreams, together with its defilements; also, the mind that experiences the body engaged in the waking state, the mind of the waking state together with its defilements. As the mind that experiences these four states is the continuum of just one mind, the states are distinguished by bodily differences; the bodies of all creatures, all beings, give rise to the mind or intelligence experiencing the four states of sexual bliss, deep sleep and so forth. The continuum of a single mind experiences when awake the awake state, and so forth.

Existing in these states are: when engaged in the state of sexual activity, the disposition to the bliss of orgasm; in the deep-sleep state, the disposition to non-manifestation, the suppression of the appearance of objects; in the dream state, the disposition to the experience of pleasures only as appearances to the mind; and, when engaged in the waking state, the disposition to thoughts of desire, anger, and so forth, and various activities. These dispositions always exist in the mind.

When the term "the emanation body" is applied to these states, it is to that intelligence, the six consciousness groups that experience the coarse objects of form and so forth. Mental changes cause many different activities: the body engages in the activities of coming and going, the organs of speech in talking, and so forth.

When it is the beatific body, it is the mind that experiences forms, sounds, and so forth that are not experienced through the senses but only appear to the mind. When it is the wisdom truth body, it is the falling into deep sleep after the engagement of the mind gathers inwardly under the influence of the quality of tamas. When it is the pure body, it is the powerful experience of the bliss of orgasm.

Regarding this, at any time during day or night, the seeds of body, speech, and mind can be free and ejaculated; this is the experience of melting bliss. This bliss of orgasm, the fourth state, gives rise to an unconsciousness like deep sleep. From deep sleep arise dreams and from there the waking state. Again, in the waking state,

the source of the bliss of orgasm develops, unstable ovum-seeds. As from these arise all the obscurations of the four states, consider that in order to stabilize the ovum-seeds it is necessary for the yogin to practise day and night the six-limb yoga that stabilizes the ovum-seeds.

One should consider that the purification of the four bodies, in the womb, outside, and associated with the four states, is glorious Kālachakra, and that all the activities of contemplating the mandala, the (emanation of the) retinue deities, the radiation and absorption of light, and so forth, purify the erroneous four states.

6. Purity of the postures

This next section is from the tantra, chapter 4, verse 109.[22]

When beings in cyclic existence have their left leg extended, prāṇa-wind moves strongly in the left, moon, lalanā channel; at that time, if the right leg is drawn in, the winds do not move much in the right channel but remain there. This is purified by the similar stance of goddesses such as Vishvamātā, the mind and body wrathful goddesses, and so forth, who have their right legs bent and left extended.

In the reverse position, when the right leg is extended, prāṇa-wind moves in the right, sun, rasanā channel; at that time, with the left drawn in, the winds do not move much in the left channel. This is purified by the right extended and left bent stance of Kālachakra, the mind and body wrathfuls, and so forth.

The eight shaktis, the twelve dhāriṇīs, the icchās, pratīcchās and others that stand in the symmetric posture purify the movement of "fire," balanced movement of the winds in the central channel. Tāranātha explains that fire is here a term for Kālāgni, another name for Rāhu.

The deities that are in the vaishākha posture, the eight yoginīs of the speech palace, their consorts, and others, purify the movement of space-element prāṇa-wind in the even signs on the right and the odd signs on the left. (This is referring to the movement of winds associated with the ascendants, or rising signs, through the day, the even ones being Taurus, Cancer, etc., and the odd ones Aries, Gemini, etc.)

The ten prachaṇḍās and others in the circular posture purify the movement of wind-element winds in the even signs on the right and the odd signs on the left.

The sixty-four yoginīs of the speech palace, the deities on the petals of the lunar day lotuses in the body palace, and others in the lalita posture purify the movement of fire-element winds in the even signs on the right and the odd signs on the left.

The four females in the Circle of Great Bliss together with their male consorts (the buddhas), the six chittā goddesses in the mind palace together with their male consorts (the bodhisattvas), and others in the lotus posture (Banda Gelek uses here the equivalent term, *sems dpa'i skyil krung, sattvāsana*) purify the movement of water-element winds in the even signs on the right and the odd signs on the left.

The four buddhas in the Circle of Great Bliss together with their consorts, the six bodhisattvas in the mind palace together with their consorts, the twelve great gods of the body palace together with their consorts, the ten nāgas together with their consorts, and others in the vajra posture purify the movement of the groups of earth-element winds in the even (rising) signs on the right and the odd signs on the left.

7. Additional purification

This section is based on the fourth chapter of the tantra, verse 49.[23] All the deities of the mind mandala, the Kālachakra couple, the eight shaktis, the four vajras, the ten vases, the buddhas and their consorts, the wrathfuls and the bodhisattva couples, and the twelve dhāriṇīs, are all the essence of mind vajra. All the seed-characters from which the deities are created, the letters such as "I" and the vowels and consonants on the lotus and sun or moon seats in the Circle of Great Bliss, on the deity podium, in the doorways, and so forth, are all the

22. See pages 135–36 of the sādhana chapter (Wallace 2010) for this verse and the commentary.
23. See pages 72–77 of the sādhana chapter (Wallace 2010) for this verse and the commentary.

essence of speech vajra. The mind mandala itself (the palace) is the essence of body vajra.

Similarly, in the speech palace, the seventy-two yoginīs, the eight male consorts, and the thirty-six icchās are all the essence of mind vajra. The vowels and consonants of the seeds from which they are created according to type—"HA," "HI," "HĪ," "YA," "YI," and so forth—are all the essence of speech vajra. The speech palace is the essence of body vajra.

Dynamic Symbolism

The dynamic symbolism mainly concerns the two longest sections of any Kālachakra sādhana: the Mastery of the Mandala and the Mastery of Activity. Banda Gelek states that "At the beginning of the Mastery of the Mandala is the awakening to emptiness; from this point on it is necessary to meditate applying purification, perfection, and development."

He continues by describing in brief that which is to be purified in the practice: the process of the cycle of samsara of birth, death, and the intermediate state. Mainly, this concerns the two Masteries, but the Drop and Subtle Yogas are also involved here, although they only need to be described briefly. I'll follow Banda Gelek's method and first describe the cycle of samsara, mainly following his description.

Vajra vehicle Buddhism recognises four different types of birth: womb (*mngal skyes*), egg (*sgong skyes*), warm-moist (*drod gsher skyes*), and magical (*brdzus skyes*). These are all purified by meditation practices with different structures: respectively, these are known as the five awakenings, the four vajras, the three rituals, and instantaneous recollection. For further information on these topics see texts such as *Essential Points of Generation and Perfection* (Kyedzok) by Jamgön Kongtrul.[24] Here, the structure of Kālachakra sādhanas is of the five awakenings.

For all beings born from a womb, as the period of adult life comes to an end and the period of old age begins, the cooling water element that exists in the

In the body palace, the 360 lunar day deities, the six wrathful door-protectors, the ten nāgas, the ten prachaṇḍas, all with their respective consorts, also the pratīcchā goddesses and the perimeter beings of siddhas, spirits, and so forth are all the essence of mind vajra. The seeds from which they are created—"ÑA," "ÑI," "ÑṚ," etc.—are all the essence of speech vajra. The body mandala palace is the essence of body vajra.

body's flesh, skin, and organs is pulled by the pervasive wind (*khyab byed kyi rlung, vyānavāyu*) throughout all of the body, in particular by prāṇa-wind into the belly and other places. As a result of this spreading of the water element the strength of bodily heat declines; this includes the nutritional products of foods that pervade the body, the fiery heat of the intestines that create energy from digestion, and so forth.

As the pervasive fiery heat of the body's energy and nutrients progressively decline, the strengthening earth element of the flesh and bones loses that which enables it to maintain its strength, which gradually declines. As a result, the abilities of the mind which are dependent on this strength also gradually decline. Before long, the whole of the earth element has degenerated, and this time is the beginning of the process of death. When the strength of all aspects of the earth element have degenerated, there no longer being any earth element support for the mind, this point is described in other texts (such as the so-called *Tibetan Book of the Dead*) as the time that the earth element dissolves into the water element and associated here with the appearance of smoke-like signs. These signs are among those after which the immediate retinue of Kālachakra, the shaktis, are named. (See the fourth chapter for further information on these.)

At this time of the dissolution of the earth element, the body and mind have not separated. The cohesive quality of water exists throughout the body but no lon-

24. This is translated by Sarah Harding in Kongtrul 1996.

ger increases as it would have done previously; now, heat in the channels from subtle fire and winds throughout the body and in the channels combine to dry it out. Elsewhere (that is, in other traditions) this is explained as water dissolving into fire and associated with the appearance of mirage-like signs.

Although the water is dried out by both fire and wind, it is said at this point that it is dried by wind alone. As fire was earlier cited as causing the degeneration of the earth element, here, the degeneration of the water element is associated more with wind.

Once the water throughout the body and in all the channels has dried out and disappeared, the fire and its associated wind both start to degenerate, with first the fire disappearing irreversibly into the wind. Elsewhere, this is described as fire dissolving into wind and this stage is associated with signs like fireflies.

The *Kālachakra Tantra* describes water as being dried up by wind, but other than stating that water dissolves into wind does not describe water dissolving into fire; this is due to the reason just given, and the fact that the fire in the channels that would cause the disappearance (of the water) is only subtle (minor) fire. When the process of the fire disappearing is underway, the wind is also in the process of disappearing; however, once the fire has disappeared, at that time the wind element has not completely disappeared, and as the wind element continues to exist, this is described elsewhere as fire dissolving into wind.

Once the fire has been exhausted and only wind remains, before long the wind element disappears into empty space. Elsewhere this is described as wind dissolving into consciousness, and this time is associated with the appearance of lamp-like signs.

Next, consciousness dissolves into awareness, at which point occurs "death with appearances." Elsewhere, this time is described as consciousness dissolving into appearance, appearance dissolving into diffusion, diffusion dissolving into completion. These are the three manifestations (*snang ba gsum*).[25]

Later, it is explained elsewhere that completion dis-

solves into clear light, at which time the upper rasanā and lalanā channels collapse into the central channel and the lower urinal and fecal channels collapse into the shaṅkhinī channel; with no further activities of the central and shaṅkhinī channels, they become indistinguishable, with mind existing merely within the central channel of the heart. This is clear light, "death without appearances."

The time when others describe that completion dissolves into clear light and the time when there arises an appearance like a pristine autumn sky free from the three faults that spoil the appearance of the sky: these are when the subtle "deceased mind" is formed. Arising from that is the mental body of the intermediate state. Its immediate cause is the subtle drop-potential on the base consciousness, the deceased mind; this carries the subtle prāṇa-wind that is the supporting condition. The present supporting body has been shelved and transference to a new existence has occurred.

Then, with the visions of the intermediate state appearing, one wanders for seven, and so forth, days in the intermediate state. The details need not concern us here, but Banda Gelek describes the manner in which this occurs in his text, *The General Meaning of the Six Yogas* (Bg6yspyi).

After wandering in the intermediate state, the being is then born in a womb. One is born in the mother's womb as a result of the actions of both one's father and mother. Both one's present father and mother were also created from each of their father and mother. They also each came from their father and mother; and so on, through an effectively beginningless lineage of male and female ancestors.

One talks in terms of the primary parents; also the beginningless lineage of their parents which are the ancestral parents; of these ancestral parents, the first are the original ancestors and all those down to the primary parents are the ancestral parents. So there are the three: the original ancestral parents, the intermediate ancestral parents, and the (current) primary parents.

Every one of these parents incorporates the tenfold

power: a forehead center and the element of wind; similarly throat and fire; heart and water; navel and earth; indicating Mt. Meru, a central channel from the navel to the genitals; indicating the lotus seat on top of Meru, a secret lotus or vagina; indicating the triple seat of sun, moon, and Rāhu, the three channels for feces, urine, ovum-seed, and semen; and pervading all of these is the emptiness of space. In a father, in place of the mother's vagina is the secret vajra.

All previous parents have possessed bodies having these ten aspects; all have dissolved at death and been discarded; they then existed as the subtle elements of the mental body of the intermediate state and then finally took new coarse bodies having the ten aspects.

In the intermediate state one desires to take rebirth and consequently rushes around searching for a birthplace until finding one's future parents engaging in sex. One enters into the womb where, as a result of their sexual union, the semen and ovum-blood of the father and mother combine. At first, the semen and ovum do not completely join together, but in the process of this happening, the intermediate state being associates with the father's semen rather than with the mother's ovum.

As soon as the intermediate state being has come among the semen and ovum of the parents, it settles in the midst of the semen and not the ovum. At that time the intermediate state being has not died; it only does so once the semen and ovum have fully combined together.

Then, at the same time, the semen and ovum completely combine and the intermediate state being awakens from its deceased mind and is created as the "rebirth mind." When semen, ovum, and mind have combined as one, as mind has now associated with the mother's ovum, the stream of consciousness of the intermediate state being will later come to be reborn. Before semen, ovum, and mind have combined together there is no prāna-wind existing with the parents' semen and ovum; but when the two combine together with mind, the power of mind causes prāna-wind to spread throughout

the combined semen and ovum; semen, ovum, mind, and prāna-wind then exist together inseparably.

The fetus that is created in this way is formed from the father's semen and the mother's ovum. The father's semen consists of thirty-two factors which are associated with the lunar days, or phases, of the lunar month. The first of these is the white drop-potential in the sole of the foot (usually given as big toe) together with the "A"-wind that supports the existence there of the spirit in the first lunar day of the waxing fortnight; there are similar factors in the others of the sixteen lunar days of the waxing fortnight and then the sixteen lunar days of the waning fortnight. These spirit sites start at the right (in a man) big toe, up to the crown of the head, and down to the left big toe. In all, there are thirty-two drop-potentials that support the spirit sites; these all become agitated, melt, and flow into the mother's womb.[26]

First, when it descends and is emitted from the father's body, there are thirty-two drop-potentials, and the semen that is taken into the mother's womb is combined with thirty-two drop-potential factors. Of these thirty-two drop-potentials that descend and are emitted from the father's body and the thirty-two taken into the mother's womb, sixteen drop-potentials that exist on the left side of the body are seeds of the nature of method that have the tone of the short vowels, "A," "I," and so forth; the sixteen drop-potentials that originate on the right side are seeds of the nature of wisdom that have the tone of the long vowels, "LĀ," "VĀ," and so forth.

This is one of those subject areas in which the English language is rather limited. The word "bindu" (*thig le*) can refer to the gross physical semen or the subtler, nonphysical, potential associated with it. Rather than simply use the word "drop" or "seed," I have translated it here as "drop-potential" in order to cover this breadth of meaning. Also, the word "ovum" is more applicable to the female side of the conception process, which is next.

Similarly, the mother's ovum has eighty factors. The ovum is created from the five elements of earth, water,

<hr/>

26. The word I translate here as spirit (*bla* in Tibetan) is not easy to translate. This is sometimes given as soul, which seems quite inappropriate, or life force. For the association with different sites within the body, see Gerke 2012, 307–8.

fire, wind, and space, plus the ovum-seed element of the red factor of the blood, making a total of six elements. Each of these in turn has aspects of earth, water, fire, wind, and space, making a total of thirty combinations. Other than these thirty elements there are no other separate materials, but also added to this list are the following ten: the five elements of earth, water, fire, wind, and space that create the sense organs and senses, the eyes and eye-consciousness, etc.; the five elements of earth, water, fire, wind, and space that create the objects of forms, sounds, etc. These ten elements added to the previous thirty bring the total to forty. Each of these forty exists both as elements that generate clarity in the mind and that generate bliss in the body, bringing the total to eighty. The blood that descends from all parts of the mother's body also consists of eighty different element groups, classified in a reverse manner, similar to the ovum that is excreted in the womb.

Once the semen and ovum have combined together with the mind from the intermediate state that is to be reborn, in the first instant the semen and ovum combine, causing in the second instant the fetus to experience bliss; without paying attention to that bliss, the being exists for the first month in the womb as if unconscious. During the unconsciousness of this first month, the combined semen, ovum, and mind possess the full potential to develop the six groups of six aggregates, elements, senses, objects, action organs, and activities, and the channels, winds, and drops. As the being exists during this first month in a state of unconsciousness, unaware of anything, it is called the month of misperception, of Capricorn.

The twelve links, of which misperception is the first, are associated each with one of the signs of the zodiac. These associations, starting with misperception and Capricorn, are given in the first chapter of the *Kālachakra Tantra*, verse 113.

Next, during the second month in the womb, subtle prāṇa-wind is created together with its support, the central channel. The channel and wind bring about an awareness of subtle mental activity, and as this is the beginning of the development of mental reaction, this second month is known as the month of reaction.

Then, in the third month, from the side of the central, rasanā, and lalanā channels in the heart, the ten channels of the heart start to form, together with subtle beginnings of the ten winds. Once these have formed, the first suggestions arise of the channels of the four centers at the forehead, throat, heart, and navel. As a result, the ability develops more distinctly than before to create the four states associated with body, speech, mind, and desire.

During this third month, the five elements derived from the father's elements become the immediate cause for the development of bone, marrow, semen, and so forth, and are the supporting condition for the development of flesh, and so on; the five elements of the mother's ovum become the immediate cause for the development of flesh, blood, skin, and so forth and are the supporting condition for the development of bone, etc. As a consequence, the body's flesh, blood, bone, marrow, and so forth all gradually develop and grow. As a result of this month's creation of the ten winds there are developed clearly both a bodily awareness that experiences textures and a clear mental awareness of objects; as these become the seeds from which are able to develop the other four consciousnesses of sight, etc., this month is known as the month of consciousness.

In general, the branches of the central, rasanā, and lalanā channels exist in the space of the trunk, limbs, and minor parts of the body and need to grow, extending into those areas. After just some parts of the body in which channels exist have developed, it is necessary for all the channels to form. Banda Gelek explains in his *General Meaning* (Bg6yspyi) that during the second month the ten channels of the heart are formed. However, the full ten are not formed, but they start to grow; in the third month it is explained that the ten channels start to grow, meaning that all ten have by then started to grow.

During the first month in the womb none of the channels has formed, but during the second month, as a support for the subtle prāṇa-wind, parts of the central channel and, to the right and left, the rasanā and lalanā channels form. During the third month all the ten channels of the heart start to grow, and in each of them

subtle wisps of the ten winds develop. At this point the hubs of the four centers have not started to form, but the upper and lower openings of the central channel start to extend upward and downward, forming bulges which will form the hubs of the centers.

In the third month, all ten of the heart channels have started to grow, and, just as the swellings of flesh of the joints of the limbs are connected by flesh and skin, similarly, above the ten channels of the heart, like a skin, are the rudimentary four channels of the crown center. Increase of the capabilities of body, speech, mind, and sexual activities are dependent on the strength of the channels of the crown; they increase the capabilities of the four states.

During the fourth month, coarse forms of the five aggregates and the five elements develop; distinct forms of their channels also develop. The channels that give rise to the six bodily constituents (*lus zungs, dhātu*) also grow. Toward the end of this month the channels for the action organs form, as do the five protrusions that will form the head, arms, and legs. As in this month are created the aggregate of form and the four name-aggregates of recognition, etc., the fourth month is called the month of name and form.

These bodily constituents are usually given as a list of six. Here, the list would appear to be: blood, flesh, fat, bone, marrow, and semen.

Starting from some time after the end of the third month, between the heart and crown channel centers, which are joined together, a rudimentary forehead center develops in the form of a skin where they join. Also like an attached skin, the genital center starts to develop under the heart center and between the heart and crown centers a small gap starts to develop. The channels of the forehead center carry the winds that cause the development of the five aggregates and five elements, and the channels of the genital center cause the development of the action organs.

Considering the way in which the purification process is applied to this, it would seem that the forehead and genital centers are formed at the same time; however, the channels of the forehead center are formed a little earlier and after this the channels of the genital center. This is because the number and functions of the channels in the centers below the heart are not completed until after those above the heart. It is not necessary to go deeper into this; in brief, during the third and fourth months in the womb, the four centers of the heart, crown, forehead, and genitals are progressively formed.

During the fifth month, the six senses are formed: the organs of eyes, nose, ears, tongue, and body, together with the heart, the organ of the intellect. These six organs all possess the ability to appreciate objects. Therefore, this fifth month in the womb is known as the month of senses. In this month, the throat center forms like a skin between the forehead and heart centers, and the navel center forms, also like a skin between the heart and genital centers. The crown and forehead centers extend a little upward, and a small gap forms between these and the heart center. Also, the gaps between the navel and genital centers open slightly, as a result of which they move a little downward, a gap also developing between the heart and navel centers. Also during the fifth month, the previously created centers of the crown and so forth continue to increase in size.

Next, during the sixth month, the forms, sounds, smells, tastes, textures, and mental phenomena that exist throughout the body increase in strength, the ability of the sense organs to appreciate these objects also increases, and the six objects are able to arouse their respective sense organs. As a result of their potential fully developing, the intermediate twelve channel-petals (the minor channels forming the centers, or chakras) of the navel center are formed. In the fifth month the senses or organs were created together with the potential to apprehend their objects; here, in the sixth month, as this is increased, bringing the ability for the senses and their objects to come together into contact, this sixth month in the womb is called the month of contact.

Also during the sixth month, the channels of the throat center grow considerably, but they are as yet unable to perform their function of clear speech because that ability is not yet fully developed. The ability of the channels of the heart center to perform their function of

conceptualization becomes completed. Having started growing in the fifth month, the full number becomes completed of the inner circle of four channels and the third circle of twelve channels of the navel center.

During the seventh month, as their potential is fully developed, the sixty-four outer channels of the navel center are formed. At this time, winds flow from the navel channels and reach up to the channels of the throat, increasing the potential for speech. As a result, sensations become much clearer, and for this reason this seventh month is known as the month of sensation.

Also during the seventh month, between the inner circle of four channels and the third circle of (twelve) channels of the navel center the second circle of eight channels is formed. From the tips of the twelve channels of the third circle are formed the sixty-four channels of the outer ring; five channels growing from each of eight of the third circle and six channels from each of the other four. At the same time, the throat and navel centers move respectively up and down and arrive at their proper places. Through the joint effect of these two centers of the throat and navel, the prāṇa-wind travels up from the channels of the navel center and reaches the channels of the throat center; this greatly clarifies the ability to produce speech and both centers become able to perform their respective functions.

During the eighth month, the twelve channel centers of the twelve major joints are completely formed. Toward the end of this month, the channels of the palms of the two hands, the soles of the two feet, and the rectum are also formed. The crown center having reached its proper place, the channel for the *brahma-randhra* (the "brahma" opening at the top of the skull) is also formed. The genital and crown centers also reach their proper places and become able to perform their functions. This eighth month is called the month of craving because in the crown center the conditional cause of desire, the white element, increases and in the genital center the cause of generating the fierce craving for sexual union is developed.

As the crown and genital centers reach their respective positions, they develop the abilities to perform their respective functions: the genital center becomes able to produce ovum-blood, the cause of sexual craving, and the crown center to produce the white element, the cause of bliss.

The centers of the twelve joints are as follows. From the throat center grow the six centers of the arms, two each of the shoulders, elbows, and wrists. Also, from the navel center grow the six centers of the legs; two each of the hips, knees, and ankles. Toward the end of the eighth month, as the crown center reaches its proper position, its particular functionality is developed. The palms and soles also develop and the rectum channel and anus are created.

Although the previously mentioned channels of the upper six joints grow out from the throat center and those of the lower six main joints from the navel center, as the activities of the channels of the upper joints, such as grasping, are functions of the power of the forehead center, the forehead center is said to be the controller of the six centers of the arms; similarly, as the activities of the lower main joints, such as walking, are functions of the power of the genital center, the genital center is the controller of the six center of the legs.

These controlling sixteen channels of the forehead cause the appearance of the sixteen lunar days; these sixteen lunar days also occur as sixteen of the waxing fortnight, and sixteen of the waning fortnight, and that which causes their specific appearance is the thirty-two channels of the genital center. Of these, the sixteenth of the waxing fortnight is the end of the fifteenth, and the sixteenth of the waning fortnight is the end part of the new moon lunar day; these two not being counted separately, the two sets of sixteen added together, with the new and full moons taken together gives a total of thirty, or one month. Each month, due to the centers of the main joints, the twelve months of Chaitra and so forth appear. The purity of the days of the twelve months, the (360) lunar day deities, are associated as basis of purification and result of purification with the centers of the forehead and genitals and with the channels of the main joints.

The lunar months associated with the deities on each of these twelve lotuses were given in the fourth chapter;

they are given here again, together with the associated twelve joints:

RoE	left elbow	Chaitra
Southeast	right elbow	Vaishākha
RoS	left wrist	Jyeṣhṭa
Southwest	right wrist	Āṣhāḍha
RoN	left hip	Shrāvaṇa
Northeast	right hip	Bhādrapada
RoW	left knee	Āshvina
Northwest	right knee	Kārtikka
LoN	left ankle	Mārgashīrṣha
LoW	right ankle	Pauṣha
LoE	left shoulder	Māgha
LoS	right shoulder	Phālguna

Table 61

During the ninth month, the twenty fingers and toes are formed in all their details; each has three joints, making a total of sixty. Toward the end of this month all the features of the skin, hair, and pores are formed. Because during this month all the faculties for moving and using the limbs are developed, this ninth month in the womb is called the month of grasping.

Next, at the beginning of the tenth month, as a result of the internal winds stirring, the desire arises to leave the womb and any thought of remaining in the womb becomes unpleasant. The mind becomes aware of a whole range of pleasant and unpleasant sensations, and with the awareness becoming clear, a subtle intuition grows. The mother's nutrients have enabled the thirty-six aggregates and elements to fully develop. As at this time sensations and recognitions are particularly clear and the ability to think has greatly strengthened, this tenth month in the womb is called the month of involvement.

Banda Gelek explains in his description that there are many other details regarding the period of ges-

tation in the womb, but that the points made here are the ones that are important from the perspective of the purification of the creation process. Such other details would include the different states of the embryo within the womb, known as the tortoise, pig, and so forth. These follow the ten incarnations (*'jug pa, avatāra*) of Viṣhṇu from Hindu mythology. Also, descriptions of the formation of the bones, joints, and other organs of the body. Banda Gelek points out that some of this is explained in his text *General Meaning*. Some is also to be found in the *Vimalaprabhā* (see, for example, Wallace 2004, first chapter).

All of this, the process from conception to immediately before birth, is purified by the Mastery of the Mandala. Next follows that which is purified by the Mastery of Activity.

In the tenth month, the strength of the body, speech, mind, and drop-potentials of the embryo in the womb significantly increases. As a result of some of the winds in the channels increasing, the central channel becomes full with wind and becomes like an erect stick. At this point, external appearances are not perceived, but the previous life's activities of body, speech, and mind appear before the mind.

Previously, the winds existed throughout all of the channels, but apart from some moving in the nostrils, the other inner winds moved only a little into channels other than their own, and they all mainly moved around within their own channels. But, once the central channel fills with wind and becomes like an erect stick and previous appearances are visible, from the navel arise winds of the letter "HOḤ," wind and fire mixed in equal quantities.

As a result of this entering all of the body's channels, all of the winds in the body are disturbed and agitated and start increasingly moving into channels other than their own. As a result of this, the embryo in the womb experiences fiercely unpleasant sensations, causing it temporarily to lose consciousness. At the same time as it loses consciousness, the lower winds of the mother's womb turn the embryo upside down.

When the embryo is upside down, although the winds are not yet moving through the nostrils, as a pre-

cursor to doing so the previously mentioned mixture of fire and wind of the letter HOḤ that agitates all the winds causes the winds of the five elements, all equally mixed up, to gather in their respective places: the earth-winds gather in the channels at the navel, water-winds at the heart, fire-winds at the throat, wind-winds at the forehead, and the space-winds at the crown; once in their respective places they swirl strongly.

At this point, as a result of the winds' being agitated and swirling, the mind gradually wakes from the previous unconsciousness caused by the agitated winds and gradually appearances arise before the mind.

After this, the baby leaves the womb and is born. At the time of birth, the winds reach the nostrils, and as soon as birth occurs, the winds start to move through the nostrils. As well as the winds now moving through the nostrils, all the winds of the five centers are greatly disturbed, and led by one chief wind, they rise, starting from the navel and traveling up to the crown. Although the winds are moving outside through the nostrils, none of the winds is capable of leading all the winds upward. The four winds of earth, water, fire, and wind are greatly agitated, but are not a chief wind. Awareness-wind is a chief wind, but as it is not agitated, it is also unable to lead the others. Space-wind is both a chief wind and greatly agitated, and so as the baby is born, its conscious experience causes the space-wind of the crown to draw the other winds, of the navel and so forth, upward.

When the winds are drawn in this way, the combined effects of the channels of the crown and heart centers draw up the winds of the ten channels of the heart and these spread everywhere. From the middle of the centers of the forehead, throat, heart, and navel, all the winds become agitated and rise upward; they continue through to the site of the space wind, the crown, and then reach to the base of the nose; at the same time, the embryo's head and hands point toward the birth canal. At this time, a subtle external wind enters the nostrils of the baby; this external wind moves inside the body but does not stay there and moves back outside. This causes the winds of the navel and others of the five centers that had come to the base of the nose immediately to move outside from the nostrils. As soon as birth has

completed, all at the same time, it makes noises with crying, it is naked apart from any amniotic sac, its eyes perceive shapes, its ears hear sounds, and so on; all the sense organs and senses awaken to their objects.

As the winds come to move outside, at first they are drawn up by the space wind and reach to the base of the nose, and as they so move, the space-wind itself does not move, and the vitality of the winds causes them spontaneously to stir and they become very agitated. At first, the groups of (action-)winds do not move outside and only the awareness-wind moves from within the central channel. This central channel wind starts from the base of the central channel, travels up and reaches to the crown, and travels to sixteen fingers in front of the nostrils; it then returns back to the base of the central channel. Once 56¼ such movements of awareness-wind have completed, this having woken up the other winds, if (the baby is) born in one of the left ascendants (Aries, Gemini, etc.), groups of winds then move in the left channels, in the order of space, wind, fire, water, and earth. If the baby is born in one of the right ascendants (Taurus, Cancer, etc.), groups of winds move in the right channels, in the order earth, water, fire, wind, and space.

We will meet this number, 56¼, many times in what follows. It is found in the Kālachakra text by Vibhūti-chandra, *Antarmañjarī* (Nangnye): in each day, there are considered to be 21,600 breaths. Each breath is also considered to include a movement of winds within the channels; here, the association is particularly with the middle ring of channels in the navel center. These 21,600 breaths are subdivided into the twelve changes of rising sign, or ascendant: 1,800 breaths for each ascendant. Of these, one in thirty-two is considered to be a movement of balanced winds (that is, awareness-winds) in the central channel: ¹⁄₃₂ of 1,800 is 56¼. These are associated with the five elements, and so for each element there are 11¼ such movements; this number is also given in *Antarmañjarī*.

Once the winds have started to move in groups, at the same time winds move into and, agitated, start moving back and forth in all the channels of the body: the channels of the six centers, crown, forehead, throat,

heart, navel, and genital; the channels of the twelve main joints; the channels of the eyes and other sense organs; the centers of the action organs; the channels of the four palms, the crown and anus; the channels of the sixty centers of the finger-joints; and the innumerable minor channels of the pores and so forth.

From when these groups of winds start moving until they gather together at the time of death, without even a moment's break, winds enter and move in all the channels of the body. However, the purification of the Mastery of Activity applies only to movements of winds from the completion of the 56¼ breaths at the time of birth up until the age of fifteen; the period from the age of sixteen years is purified by the Drop and Subtle Yogas.

As was explained earlier, as soon as the baby is born, at the same time as the 56¼ movements of awareness-wind start, the organs and consciousnesses of the senses are awakened to their objects, with the organs and consciousnesses perceiving the objects of form and so forth. At first, the groups of winds are not moving, only the 56¼ awareness breaths move; this has the effect of stabilizing the life force.

A second function of awareness-wind is this: at the time of death, again, only awareness-wind moves and all channels other than the central channel disintegrate; at all other times, from age sixteen to the time of death, approximately at peaks during the movements of the groups of winds about ⅟₃₀ of the time they do not move. This is a reference to the idea that the ratio of movements of awareness-wind to action-wind is the same as the number of intercalary months to normal lunar months—1:32½.

The five groups of winds moving back and forth through all the channels stabilize the inner life force, and approaching objects, they cause the sense organs to observe their objects and the sense consciousnesses to apprehend them; in this way the winds moving in the five groups also have two functions.

Furthermore, immediately following birth, when the 56¼ breaths move through the central channel, aroused by those central channel winds, the base consciousness, which is identical to the fully developed nature of the

five (sense) consciousnesses, awakens to its objects and acquires the full ability to apprehend those objects. As the base consciousness wakens to external objects, the ear consciousness and mental awareness both awaken more strongly to apprehending their objects; similarly, the consciousnesses of the eyes, nose, tongue, and body complete their ability to apprehend their objects.

This awakening of the base consciousness and the six groups of consciousness happens at the same time, without one preceding the others. Starting immediately following birth, up until the end of the fifteenth year, the following all increase in strength or ability: the six elements of earth, water, fire, wind, space, and awareness; the abilities of body, speech, and mind; the six upper and lower channels; the six aggregates of form and the others; the strength of the winds in the body; the strength of the seminal drop-potential, the awareness element, the elements of space and other elements; also the ability of sexual activity. Of these, as the strength of body, speech, and mind increases, so the various activities of the three doors increase.

Earlier, when in the womb, there was no distinction between sleep and the waking state; but from the moment of birth there are the states of waking and sleep; the latter consisting of deep sleep and dream. Once the baby is born, the mother washes it clean with water and its hair is cut; the baby starts to laugh and talk; it starts to experience the five desirables, soft and rough textures, the tastes of food, and so forth; the baby is given a name. As its understanding improves, it is taught by its father the various practices of his caste—for example, a Brahmin will teach the practices of cleanliness, and so forth.

Whether the baby is a boy or a girl, its body, speech, and mind are balanced, but if a girl, awareness, or sexual desire, is stronger, and as a result of this the activities of body, speech, and mind driven by sexual desire are stronger in a woman than in a man. This surprising comment comes from the idea that a man has the function of white bodhichitta (semen), whereas a woman has both that function (sexual arousal, orgasm, etc.) but also has the function of red bodhichitta (ovum). Rather than interpreting this as greater sexual desire, I suspect that the original intention may have been to indicate the

ability to carry a fetus and the general maternal instinct. This becomes relevant in the empowerment, discussed later in this chapter.

This completes the description of that which is purified by the Mastery of Activity.

The process of purification

Having explained Banda Gelek's description of the life process that is the object of purification of the creation process practice, it would make sense now to give an overview of that practice. However, as such an overview was given in the first chapter, I'll instead give here a synopsis of the four sections of the creation process based on Banda Gelek's introduction to the four; this should help explain their function and interrelationship.

The four are also known as the four aspects of approach-accomplishment (*bsnyen sgrub, sevāsādhana*): approach, near accomplishment, accomplishment, and great accomplishment. (The second of those is more usually known as close approach; I am translating the terms as used in the Kālachakra system.) These four sections of the practice also respectively develop the vajras of body, speech, mind, and awareness, and bring about the completion of body, speech, drop, and bliss. These relationships are:

Mastery of the Mandala	Approach	Body–Body
Mastery of Activity	Near accomplishment	Speech–Speech
Drop Yoga	Accomplishment	Mind–Drop potential
Subtle Yoga	Great accomplishment	Awareness–Bliss

Table 62

The purpose of the whole practice is to achieve a clear and stable awareness of the whole mandala: the physical palace in all its details and the 636 deities, their forms, colors, postures, ornaments, and characteristics in their six places all the way to the pores of their bodies which

have the signs and characteristics. In the Mastery of the Mandala these are first generated, and this forms the basis for the realization of these deities from the bliss of the Subtle Yoga. As the forms imagined in the Mastery of the Mandala bring the practitioner closer to that realization, it is called approach.

Just as gold can be purified by melting and further processing, so in the Mastery of Activity the two main deities melt into light and are recreated, after which all the other deities in the mandala dissolve into the central couple and are reborn from the womb of Vishvamātā. This removes errors in the clarity of the forms imagined in the Mastery of the Mandala. Then, with the attraction of the awareness beings and other steps, the inspiration, power, and abilities of the deities are increased, bringing them nearer to those of the deities to be realized; for this reason, the Mastery of Activity is called near accomplishment.

In the Drop Yoga, the melting and descent of bodhichitta develops an awareness of the natural bliss of all the deities; as this brings the ability to radiate and absorb these deities appearing with this blissful nature, this is called accomplishment.

Finally, with the Subtle Yoga, the whole of the support and supported mandala appears at once, an appearance of essential bliss and emptiness; as the ability is developed to emanate whatever hosts of deities one wishes, this is known as great accomplishment.

As mentioned earlier, the Masteries of the Mandala and Activity are known respectively as the paths of the body and speech vajras. Similarly, Drop Yoga and Subtle Yoga are the paths of the mind and awareness vajras. The difference between these two is this: the first, mind, refers to the nonconceptual aspect of mind, the second, awareness, to the bliss aspect; similarly, bliss and emptiness is referred to by mind and the appearance of great numbers of deities by awareness; as Drop Yoga is the union of melting bliss and uncontrived mind, this is the path of mind vajra, and as Subtle Yoga is the awareness to which appears vast numbers of deities emanated from the six centers, this is the path of awareness vajra.

The perfection process of Kālachakra is known as the six yogas. They are well known by their Sanskrit names,

but in this list I also give English translations after their Tibetan names:

1. Pratyāhāra (*so sor sdud pa*): withdrawal.
2. Dhyāna (*bsam gtan*): mental focus.
3. Prāṇāyāma (*srog rtsol*): wind control.
4. Dhāraṇā (*'dzin pa*): retention.
5. Anusmṛti (*rjes dran*): consummation.
6. Samādhi (*ting nge 'dzin*): absorption.

The abilities of the first two, associated with the channels, are developed during the Mastery of the Mandala; the next two, associated with the winds, during the Mastery of Activity; anusmṛti during Drop Yoga and samādhi during Subtle Yoga.

Banda Gelek's description of the purification of the creation process includes thirty-eight discrete sections of the practice which are each associated with purification, perfection, and development. This effectively breaks the whole creation process into thirty-eight meditations (these are enumerated in the text that follows), for each of which the practitioner should contemplate that some part of the process of life is purified, some particular result or quality of enlightenment has been perfected, and the ability properly to practise part of the perfection process meditation has been developed. (Some sections do not have perfection or development associated with them.)

The following description of these stages in the creation process are taken entirely from Banda Gelek's *Excellent Vase of Realization Nectar* (Bgdubum), but I have restructured much of his description for clarity, and in order to avoid repetition, in the following each section is simply indicated by these headings: Meditation, Purification, Result, and Development. The intention here is not to describe the meditation in any detail (as Banda Gelek is doing in his writing), but to extract the simplest description possible, with some elaboration when relevant for the symbolism.

As an example of the original structure in his text, once the radiation of the yoginīs of the speech palace has been described, he writes:

"Once the speech yoginīs have been imagined, contemplate that: the growth of the channels of the throat center which starts in the fifth month and their strong development during the sixth; also, the growth of the outer channel-petals of the navel, which starts in the sixth month and completes in the seventh, is purified. When the goal is achieved, the seventy-two yoginīs together with the eight male consorts will be realized and emanations from them will act for the benefit of beings. Also, in the perfection process, consider that the ability is developed during the first stage of unwavering bliss, the fifth branch of dhyāna, to thoroughly purify the channels of the throat and navel centers, the winds inside them entering the central channel of their own accord, as a result of which the awareness is achieved that sees the beatific body of the seventy-two speech yoginīs and the eight male consorts."

Mastery of the Mandala

The creation process starts with the dissolution of the self and environment into emptiness, known as the awakening to emptiness (*stong pa nyid la byang chub pa*).

Meditation (1): This is in two parts: first a verse recollecting the nature of the meditation, then a short meditation on the successive dissolution of the elements into clear emptiness.

Purification: As death approaches, the appearance of the physical world, forms, aggregates, and so forth, declines, all the stages of death from the water element in one's body overpowering the fire element through to the rasanā and lalanā channels dissolving into the central channel and the experience of the clear light of death.

Perfection: Through perceiving all conventional phenomena to be unreal, the whole collection of impure aggregates and elements dissolves into the realm (or nature) of phenomena (*dharmadhātu*) and the wisdom truth body is attained, the ultimate awareness.

Development: The aspect of pratyāhāra awareness

that is free from conceptualization. This is without any appearances; the aspect of pratyāhāra with appearances is described below.

Meditation (2): Identification with the nature of emptiness by reciting and contemplating four mantras. This completes the preliminaries to the full creation process.

Purification: From the deceased mind the mental body of the intermediate state arises.

Perfection: The beatific body is obtained.

Development: The four indifferences and the aspect of pratyāhāra awareness with appearances: the appearance in meditation of many empty-forms.

Meditation (3): Creation out of emptiness of the sphere of the element of space.

Purification: The empty space of the world in which one is to take birth in samsara, plus the body and womb of the present mother and all ancestral mothers. In particular, the ten spokes of the sphere purify the mother's body, the space inside purifies her womb, and the empty space outside it purifies the physical space of the world system.

Perfection: Not given.

Development: Not given.

Meditation (4): Creation of the disks of the four elements, Mt. Meru, lotus, moon, sun, and Rāhu disks.

Purification: The world in which one is to take birth and the ten elements associated with the centers of the original (or archetypal) father and mother.

Following the world system existing as just emptiness, as it comes into being, within space there exists a mass of dispersed particles of wind; but as a result of the general actions of beings this gathers together from all directions and this primordial wind is purified by the seed "YAṂ." From this seed arise the disk of wind and the element of wind at the forehead of the original father and mother, both of which are purified.

Above the wind, primordial fire arises like a flash of lightning; this is purified by the seed "RAṂ," and from this primordial fire arise the disk of fire and the element

of fire at the throat centers of the original father and mother.

Above the disk of fire, like a bright fine rain arises primordial water; this is purified by the seed "VAṂ," and from this arise the disk of water and the water element at the heart centers of the original father and mother.

Above the disk of water, like scum arises primordial earth; this is purified by the seed "LAṂ," and from this arise the disk of earth and the earth element at the navel centers of the original father and mother.

Contemplating Mt. Meru purifies both the worldly Mt. Meru and the section of the central channel between the navel and genital centers of the original father and mother. The multicolored lotus above Meru purifies the throat, face, and crown of the world system and the secret lotus (vagina) of the original mothers. (The space above the top of Mt. Meru, 25,000 yojanas in height, in which exist the five peaks, is known as the throat of Meru; the space 50,000 yojanas above this is the face, and the next 25,000 yojanas the crown. These three sections are considered to house the realms of the gods.)

The sun, moon, and Rāhu on the receptacle of the lotus purify the external sun, moon, planets, and stars; also their constellations and the years, months, days, and double hours derived from them; also the three channels for feces, urine, and semen of the original mothers.

Perfection: The creation of the pure realm in which one will attain enlightenment; in particular the equivalent disks of wind and so forth of that pure realm.

Development: The method aspect of the ten signs associated with pratyāhāra. Respectively, the disk of wind develops the method aspect of the sign of smoke, and so on, up to the Rāhu disk which develops that of the sign of the great drop. These signs are given in the *Kālachakra Tantra* (chapter 5, v. 115): "Out of emptiness one comes to see smoke, mirages, pure and spotless fireflies, lamps, and blazings and the moon and sun, vajra, ultimate flashes, and drops." The first four of those are associated with night yoga and the other six with day yoga.

Meditation (5): The whole world system, the nine components from the disk of wind up to the disk of Rāhu

plus the ubiquitous particles of empty space (making ten) fuse together to form the "ten-powered" monogram of Kālachakra.

Purification: The dissolution into emptiness of the world system into which one is to be born, plus the ancestral parents leaving the physical body and existing in subtle intermediate state bodies.

Perfection: Through the application of the path, the impure appearances of the ten components—the disk of wind, and so forth—dissolve into their original state.

Development: Not given.

Meditation (6): The monogram transforms back into the world system, just as before.

Purification: After the world system is destroyed it is formed again; that new system is purified. Also, similar to before, the ten bodily elements of the present father and mother.

Perfection: The ability to create limitless world systems that appear to oneself as buddha realms.

Development: The wisdom aspect of the ten signs associated with pratyāhāra.

Meditation (7): Above the disk of Rāhu forms the ground, foundations, and the whole structure of the mandala palace, surrounded by the vajra tent.

Purification: The place where one is to take birth, the house, its furniture and surrounding locality; also the father's secret vajra (penis), the mother's lotus (vagina), and her three channels associated with feces, urine, and semen. The vajra tent purifies the father's penis; the palace and the deity seats within purify the house, its chairs and other furniture; the lotus for the chief deity purifies the mother's vagina; and, the seats of sun, moon, and Rāhu purify her three channels.

Perfection: The creation from the original state of the perfect environment and palace complete with all seats and ornaments, all identified with oneself.

Development: The appearance in pratyāhāra of empty forms appearing as images of the physical and animate worlds.

Meditation (8): The awakening of the moon (also known as the awakening to mirror-like awareness, *me long lta bu'i ye shes, ādarśajñāna*). Above the Rāhu seat appears a horizontal moon disk, arisen from and then marked with thirty-two vowels.

Purification: Of the semen from the father that goes to form one's body in the womb: the initial vowels from which the moon forms purify the thirty-two aspects of the bodhichitta streaming down from all parts of the father's body; the moon itself purifies the semen that enters the mother's womb; and the thirty-two vowels on the moon purify the thirty-two drop-potential factors of that semen.

Some care is needed with the terminology here. The Tibetan *khu ba* simply means semen, the coarse physical material; although it can often mean exactly the same, the Sanskrit word *thig le* here means the potential inherent in, or that gives rise to, semen. The word "bodhichitta" (*byang sems*) is a tantric term for either of these.

Perfection: Mirror-like awareness, Vairochana; together with the realization of limitless embodiments and awareness from the nature of Vairochana.

Development: At the beginning of the practice of dhyāna, the aspect of the wisdom branch of dhyāna which observes, mind merged with them, the appearance of the four night signs in the center of a great drop. The wisdom branch is the first of five branches in the practice of dhyāna: wisdom, appreciation, analysis, joy, and unwavering bliss.

Meditation (9): The awakening of the sun (or awakening to equality awareness, *mnyam nyid ye shes, samatā-jñāna*). Between the Rāhu disk seat and the moon disk just created appears a sun disk, arisen from and then marked with eighty consonants.

Purification: Of the ovum from the mother that goes to form one's body in the womb: the initial consonants from which the sun forms purify the ovum-blood with eighty types of ovum material streaming from all parts of the mother's body but not reaching the womb; the sun purifies the mother's ovum that does enter the womb; and the eighty consonants on the sun purify the

eighty types of ovum material of the blood in the womb. The reason that the moon is imagined above the sun is because white descends from above and fire rises from below: white refers to the water element whose nature is to flow downward from above, and red refers to that of the fire element which is to blaze upward from below.

Perfection: Equality awareness, Ratnasambhava; together with the realization of limitless embodiments and awareness from the nature of Ratnasambhava.

Development: In the practice of dhyāna, the aspect of the wisdom branch of dhyāna which observes merged together, mind merged with them, the appearance of the six day signs in the center of a great drop.

Meditation (10): The awakening of the character (or awakening to distinctness awareness, *so sor rtogs pa'i ye shes, pratyavekṣājñāna*). The character "HŪṀ" appears in the middle of the moon disk.

Purification: The intermediate state being enters the womb, but before it dies, it associates with the father's white element.

Perfection: Distinctness awareness, Amitābha; together with the realization of limitless embodiments and awareness from the nature of Amitābha.

Development: The appreciation branch of dhyāna in which the coarse appearance of mind and empty forms as a duality dissolves.

Meditation (11): The awakening of integration (or awakening to accomplishing awareness, *bya ba grub pa'i ye shes, kṛtyānuṣṭhānajñāna*). The "HŪṀ" dissolves into the moon which immediately combines with the sun to form a sphere, inside of which is a character "HI."

Purification: Inside the womb, the intermediate state being dies and its mind combines together with the semen and blood, starting the process of gestation that will lead to birth.

Perfection: Accomplishing awareness, Amoghasiddhi; together with the realization of limitless embodiments and awareness from the nature of Amoghasiddhi.

Development: As soon as the analysis branch of

dhyāna has commenced, the subtle appearance of mind and empty forms as a duality dissolves.

Meditation (12): The awakening of the formation of the body (or awakening to reality awareness, *chos dbyings ye shes, dharmadhātujñāna*). The sphere transforms into the Kālachakra couple, each with a character "HAṀ" in the center of their crown. The purification, perfection, and development described here only refer to the Kālachakra couple, but this awakening includes the formation of all the deities in the mandala created during the Mastery of the Mandala.

Purification: In the first month in the womb, after the white and red elements and the mind have combined together, the being exists in an unconscious state, but complete with the potentials for the development of all the body's aggregates, elements, senses, sense objects, action organs, their activities, channels, winds, and drops. In particular, imagining the complete form of the Kālachakra couple, with all body, speech, mind, faces, hands, and so forth, purifies the existence of all the potentials for aggregates, elements, and so forth that will develop into the coarse physical body. The "HAṀ" character that is imagined in the crown of both deities purifies the existence in an unconscious state during the first month.

Perfection: Limitless embodiments and awareness of Vajrasattva Kālachakra having the nature of unchanging great bliss that combines the five awarenesses, and limitless embodiments and awareness of Vishvamātā, the essence of the emptiness possessing the totality of possibilities that combines in one all mandalas of the five classes; plus the birth from the womb of the consort of embodiments that will be experienced by beings in need of influencing.

Development: During the analysis branch of dhyāna, as a result of the practice purifying the suṣumnā and shankhinī channels (these are the central channel above and below the navel), without deliberately trying to draw them there, the winds naturally gather into these channels and one perceives the beatific body of the chief deities, the Kālachakra couple.

Although with pratyāhāra and dhyāna it is not possible to bind the winds in the central channel, the winds are able to enter the central channel; when the winds enter the central channel of their own accord, this is due to the purification of their pathways, the channels. During pratyāhāra and up to the beginning of the analysis branch of dhyāna, basic dhyāna, all the 72,000 channels are equally purified; as a result, without particularly directing them, it becomes possible for the winds to move from their channels. Without particularly directing them, they are not able to enter the central channel of their own accord, but at the time of the analysis branch, the channels having been generally somewhat purified; in particular the central sushumnā and shankhinī channels are now purified and the winds gather of their own accord in the purified sushumnā, Kālachakra, and the purified shankhinī, Vishvamātā.

In the center of a large drop is seen the beatific body of the chief deities, the Kālachakra couple; then, once the start of the branch of joy is achieved and the pathways of the ten channels of the heart are further purified, winds enter them of their own accord and the beatific body forms of the ten shaktis are seen, and so forth, as will be explained below.

Meditation (13): The creation of the ten attendant shaktis. Two are considered inherent in Vishvamātā, and eight are on the lotus petals surrounding Kālachakra and Vishvamātā.

Purification: In the second month in the womb a subtle prāṇa-wind develops together with its support, a nascent central channel; also, in the third month, the ten channels of the heart start to develop as well as subtle beginnings of the ten winds.

The earlier HAM character imagined in the crown purifies in the second month in the womb the beginnings of the prāṇa-wind and its supporting central channel; imagining the ten shaktis purifies in the third month the beginnings of the ten channels of the heart center and the ten winds developing within them.

Perfection: The ten shaktis that are the essence of the ten transcendent virtues (*pha rol tu phyin pa, pāramitā*)

and the turning of the Dharma wheel of the ten transcendent virtues in the presence of those in need of influence. The two shaktis that are inherent in Vishvamātā, Paramakalā and Bindurūpiṇī, are respectively the essence of the transcendent virtues of wisdom and awareness.

Development: During the first stage of the joy branch of dhyāna, the three channels of the heart having been more thoroughly purified; the ten winds within them of their own accord move into the central channel, as a result of which the beatific body forms of the ten shaktis are seen.

Meditation (14): The creation of the four vajras, the black wish-fulfilling jewel, and so forth. These are a manifestation of the body, speech, mind, and awareness vajras of Kālachakra. Similarly, the four faces of the shaktis and their eight arms, making a total of twelve, also indicate the essence of the four bodies. For this reason the shaktis and the four vajras are considered as attendants to Kālachakra and are therefore imagined together with him: the ten shaktis, eight on the petals of his lotus, and the four vajras on the floor on which the lotus stands.

Purification: During the third month in the womb, once the ten channels of the heart have all formed, above them also form, like a skin, the rudimentary four channels of the crown. Due to their vitality the potentials of the four drops of body, speech, mind, and sexual awareness are increased; this is because the contemplation of the four vajras purifies the formation of the four channels of the crown during the third month, as a result of which the abilities of body, speech, mind, and sexual awareness are increased.

Perfection: The four vajras are realized together with the ability to turn the Dharma wheel of the four vajras for the benefit of those in need of influencing.

Development: During the second stage of the joy branch of dhyāna, the channel pathways of the crown having been thoroughly purified, their winds flow into the central channel of their own accord, as a result of which the beatific body forms of the four vajras are seen.

Meditation (15): In preparation for the radiation of the retinue deities from the womb of Vishvamātā, the sexual union of Kālachakra and Vishvamātā attracts from the whole of space all the buddhas and consorts, bodhisattvas and consorts, wrathfuls and consorts, all mandala deities, into the body of Kālachakra.

Purification: Toward the end of the third month in the womb, from the father's semen, development starts of bone, marrow, semen, and so forth, and from the mother's blood, development of flesh, blood, skin, and so forth.

Perfection: In order to radiate multitudes of deities to influence beings, the practice of (pure) sexual activity is developed.

Development: Not given, but Banda Gelek considers that an appropriate development would be: during dhyāna, the meditation on the path of desire using the bodies of oneself and another.

Meditation (16): Deities are born from the womb of Vishvamātā: first Akṣhobhya, who radiates into the sky and is then reabsorbed into Kālachakra, and then the four buddhas and the four consorts, who, like the other deities of the retinue that follow, radiate from the womb of Vishvamātā and then take their places in the mandala palace.

Purification: During the third month in the womb, at the time that the four channels of the crown develop, there are also formed the channels of the forehead center that increase the strength of the five aggregates and five elements. During the fourth month, coarse forms of the aggregates and elements develop and the winds of the five aggregates on the right and of the five elements on the left are created.

Perfection: The five buddhas and five consorts are realized as the purification of the five aggregates and five elements.

Development: During the third stage of the joy branch of dhyāna, by thoroughly purifying the channel pathways of the aggregates and elements on the right and left, their winds enter the central channel of their own accord, as a result of which the beatific body forms of the five buddha couples are seen.

Meditation (17): The creation of the ten vases.

Purification: During the third month, at the same time as the channels of the forehead are formed, so too are those of the genital center that create the action organs; during the fourth month primitive forms develop of the channels that give rise to the bodily constituents.

Perfection: The awareness is realized of the purification of marrow, blood, and so forth.

Development: During the fourth stage of the joy branch of dhyāna, by thoroughly purifying the channel pathways of the six nectars (marrow, blood, etc.), the winds within them enter the central channel of their own accord, as a result of which the beatific body in the form of the ten vases is seen.

Meditation (18): The radiation of the four wrathfuls of the mind palace.

Purification: At the end of the fourth month in the womb the channels of the five action organs form together with the ability to perform their activities and the five protrusions that will later form the head and limbs.

Perfection: The four activities that work for the benefit of beings and, ultimately, the wrathful deities are realized.

Development: During the fifth stage of the joy branch of dhyāna, by thoroughly purifying the channels of the action organs, the winds inside them enter the central channel of their own accord, as a result of which the beatific body forms of the wrathful couples are seen.

Meditation (19): The radiation of the bodhisattvas and their consorts.

Purification: In the fifth month of gestation, the development of the six senses of the eyes and so forth is purified by the six bodhisattvas (as chief deities), and their ability to grasp objects is purified by the consorts that embrace them; then, in the sixth month, the increase in the strength of form and so forth up to concepts and the increase in the ability of the eyes and other organs to apprehend them are purified by the six female chittās (as chief deities), and the ability of the sense

organs to awaken to these objects and focus on them is purified by the bodhisattvas that embrace them.

Perfection: The bodhisattva and chittā couples are realized.

Development: During the sixth stage of the joy branch of dhyāna, by thoroughly purifying the channel pathways of the senses, the winds inside them enter the central channel of their own accord, as a result of which the beatific body forms of the bodhisattva couples are seen.

Meditation (20): The radiation of the twelve offering goddesses.

Purification: The intermediate ring of twelve channels of the navel center that form from the fifth to sixth months.

Perfection: The twelve dhāriṇīs are realized.

Development: Not given.

Meditation (21): Now, the speech palace: the radiation of the yoginīs of the speech palace.

Purification: The channels of the throat center start to grow in the fifth month and develop strongly during the sixth. Also, the outer channel-petals of the navel start to grow in the sixth month and form fully during the seventh.

The navel's inner circle of eight channels is purified by the eight chief yoginīs; the outer circle of sixty-four channels by the yoginīs on the lotus petals. The inner circle of eight channels of the throat is purified by the male consorts of the eight chief yoginīs.

Once the channel-petals of the navel are complete and subsequently life-wind has moved upward and into the channels of the throat, the ability to speak is developed. As the speech yoginīs and the male consorts purify the navel and throat channels that are responsible for speech, they are called the deities of the speech mandala.

Perfection: The seventy-two yoginīs together with the eight male consorts are realized. Emanations similar to them act for the benefit of beings.

Development: During the first stage of unwavering bliss, the fifth branch of dhyāna, by thoroughly puri-

fying the channels of the throat and navel centers, the winds inside them enter the central channel of their own accord, as a result of which the awareness that sees the beatific body of the seventy-two speech yoginīs and the eight male consorts is developed.

Meditation (22): The body palace: the radiation of the lunar day deities.

Purification: During the eighth month in the womb, the forehead and genital centers that control the centers of the twelve joints reach their natural places. The ability to create the channels of the twelve joints is developed and, under the control of the forehead center, the channel centers for the two shoulders, the two elbows, and the two wrists grow out from the throat center; also, under the control of the genital center, the channel centers for the two hips, two knees, and two ankles grow out from the navel center. The twelve channel centers of the joints and the channel centers of the forehead and genitals that form them are purified.

Perfection: The lunar day deity manifestations of Kālachakra are realized. Emanations from them guide all types of beings, none excluded.

Development: During the second stage of unwavering bliss, the fifth branch of dhyāna, by thoroughly purifying the channel pathways of the forehead and genital centers and the centers of the main joints, the winds inside them enter the central channel of their own accord, as a result of which the awareness that sees the beatific body of the (360) lunar day deities is developed.

Meditation (23): The radiation of the door-protectors of the body palace.

Purification: In the later part of the ninth month, the channels form for the two palms, the two soles of the feet, plus the channel and orifice of the anus. The crown center reaches its proper place, and the channel forms for the brahmarandhra (small orifice at the crown of the head).

Perfection: The ability is obtained to benefit beings by wrathfuls emanated from the body door-protectors.

Development: Not given.

Meditation (24): The radiation of both the nāgas and prachaṇḍas.

Purification: During the ninth month in the womb are formed the sixty channels of the joints of the fingers and toes, there being three joints in each of the twenty fingers and toes of the hands and feet.

Perfection: The ability is achieved to emanate nāgas and prachaṇḍas to influence beings as needed.

Development: During the third stage of unwavering bliss, the fifth branch of dhyāna, by thoroughly purifying the sixty channels of the joints of the fingers and toes, the winds that move inside them enter the central channel of their own accord, as a result of which the awareness to which appears the beatific body of the nāgas and prachaṇḍas is developed.

Meditation (25): The creation of the perimeter deities (they are not born from the womb of Vishvamātā).

Purification: Toward the end of the ninth month are formed the skin and its pores.

Perfection: Bodies in the forms of siddhas and spirits are obtained, together with the ability to emanate such forms to act for the benefit of beings.

Development: During the fourth stage of the unwavering bliss branch of dhyāna, by thoroughly purifying all the channels of the body, but in particular all the innumerable channels of the pores and other minor channels, all the winds that move in the 72,000 channels enter the central channel of their own accord; as a result of this, the awareness to which appears the beatific body of the siddhas, spirits, and other perimeter beings is developed.

Meditation (26): Radiation of the icchās of the speech palace and the pratīcchās of the body palace.

Purification: In the tenth month in the womb, although the winds are not moving out through the nostrils, as they are very agitated within the channels throughout the body, the desire is formed to leave the womb; having been born in the womb, the attitude forms of no longer wishing to stay there.

Perfection: The ability is attained to act for the benefit of beings in the forms of icchās and pratīcchās.

Development: During the fourth stage of the unwavering bliss branch of dhyāna, as explained before, by thoroughly purifying all the channels of the body, but in particular all the innumerable minor channels, by their winds moving into the central channel, the awareness to which appears the beatific body of the icchās and pratīcchās is developed.

Meditation (27): This step is the very end of the fifth awakening, the awakening of the formation of the body. A mantra is recited recognising that all the deities have the nature of reality (*dharmadhātu*) awareness and the practitioner identifies with that awareness.

Purification: At the beginning of the tenth month, although being within the womb the winds are not moving in and out through the nostrils, internally, as all the different winds have been formed, the totality of pleasant and unpleasant sensations is completed.

Perfection: This is not given, but Banda Gelek suggests that by coming to identify with the wisdom truth body, bliss is obtained.

Development: When dhyāna is completed, the objective empty-form and subjective awareness are experienced as merged as one taste even more than before.

Meditation (28): The compassionate empowerment, in which all beings are imagined as attracted into the mandala palace and thirty-two of their thirty-six aggregate and element groups are transformed into pure divine forms. These thirty-two are the same deities as the equivalent groups in the Seven Empowerments Raising the Child (see the first chapter): five buddhas, the six bodhisattvas, and five wrathfuls, each with their respective consorts.

Purification: At the beginning of the tenth month in the womb, an intuition arises as awareness and its contents become clearer; the mother's nutrients fully develop the thirty-six aggregate and element groups. The earlier identification using the mantra purifies the experience of sensations in the womb; the empowerment purifies intuition within the womb; and contemplating all beings in the divine forms of their thirty-two

aggregate and element groups purifies the completion of the thirty-six aggregates and elements immediately prior to birth.

Perfection: The ability is attained to place beings in enlightenment by guiding them on the path of passion by teaching them the dharma of great passion.

Development: When dhyāna is completed, the five superknowledges are achieved, which are then used to act for the benefit of beings.

This completes the Mastery of the Mandala

Mastery of Activity

The Mastery of Activity is also described as consisting of awakenings, this time twenty, although they do not follow one after the other as in the Mastery of the Mandala. There are several ways these twenty awakenings are described; the one favored by Banda Gelek is associated with the purification of the winds, as is the Mastery of Activity. The basic ten winds move in the groups of winds on both the right and left of the body, giving a total of twenty. These are purified by the Mastery of the Mandala.

Meditation (29): The start of the Mastery of Activity. The two main deities, together with the eight shaktis and four emblems, are consumed by fire blazing in the central channel and melt into a ball of light. Banda Gelek elaborates on this section with many details; I give these details here, but structure them rather differently.

Purification: In the tenth month in the womb, as the time for birth approaches, the embryo's body, speech, mind, and drop-potentials all increase in strength; the winds also strengthening a little, the central channel becomes full of wind and stiffens like a stick. At that time, becoming mixed with fire-wind from the navel, all the winds in the body become disturbed, and as a result of this the body turns upside down in the womb.

In particular, the HOḤ letters in the crown and navel purify the increase in strength of the drop-potentials; contemplating the five syllables within the central channel purifies the increase in the body, speech, mind, and

drop-potentials as the time of birth approaches, also the memories of previous activities of body, speech, and mind; contemplating the central channel purifies the central channel, stiffening like a stick. Contemplating that light with the nature of bliss and heat radiates from the two HOḤ letters, filling the bodies of both Kālachakra and consort, purifies all winds becoming agitated by being mixed with fire-wind from the navel. Contemplating that the blissful heat causes the Kālachakra couple to melt into a ball of light purifies the disturbed winds, making the embryo unconscious and turning it upside down.

Perfection: The awareness is realized that creates speech, the beatific body. This has two components: great attachment to bliss, the subjective aspect which focuses one-pointedly on bliss, and that which is the object of one-pointed attention, the bliss aspect; this ultimate speech vajra is inseparable from the three vajras of body, speech, and mind and the indestructible awareness vajra; this awareness vajra is non-conceptual, uncontrived awareness. By contemplating the two HOḤ letters, the awareness vajra is obtained, which combines in union the ultimate subject, great attachment, the awareness that naturally attends to bliss and remains one-pointedly focused, and its object, unchanging great bliss. As the indestructible central channel is the essence of awareness vajra, by contemplating either the three syllables or the moon, sun, and Rāhu in the central channel, the ultimate speech vajra and the inseparable four vajras are obtained. By contemplating that the Kālachakra couple melts into a drop the nonconceptual nature of the four vajras is obtained.

Development: The ability is developed to travel the path of prāṇāyāma. During prāṇāyāma meditation the movement of winds in the rasanā and lalanā channels is blocked and all winds move only toward the central channel; as a result of this movement the strength of the tummo fire at the navel is increased and the power of this fiery light reaches to the crown. The drop in the crown melts a little, producing a subtle melting bliss. This blazing and melting in the central channel causes the ten groups of winds on the right and left, or

the winds of the twelve ascendants, to be bound more strongly into the central channel. Eventually, the winds of the twelve ascendants completely cease moving in the rasanā and lalanā and only move in the central channel; as a result, an intense awareness of clear emptiness and bliss is developed.

The term "tummo" (*caṇḍālī*, *gtum mo*, literally meaning "fierce woman"), which will occur many times in what follows, refers to a fire imagined blazing from drops—usually in the navel—and rising up the central channel. The word also refers to the specific practices in which this fire and its effects are imagined, the most famous being the first of the six dharmas of Nāropa. Here, the word specifically refers to the fire.

By contemplating the central channel and within it either three syllables or the three emblems, the ability is developed in all stages of prāṇāyāma for winds to cease moving in the rasanā and lalanā channels and instead move in the central channel.

By contemplating the HOḤ letters in the navel and crown, as a result of the winds' being bound within the central channel the fiery light of the navel tummo slightly melts the bodhichitta in the crown, causing melting bliss.

By contemplating that the passionate fire causes the melting into a drop, binding many winds in the central channel causes some blazing and melting to develop; thereafter, that blazing and melting binds the winds more strongly, and then any other winds are also bound in the central channel; eventually all winds move only in the central channel and an intense nonconceptual awareness of radiant bliss is developed.

In prāṇāyāma, even though winds are bound in the central channel, they do not dissolve into the drops; there is therefore only a subtle blazing and melting of the drops in the various centers, there mainly being just a minor blazing of the tummo below the navel and melting of the bodhichitta in the crown.

Meditation (30): Goddesses entreat the couple to reappear. Four goddesses appear around the seat of Kālachakra: Tārā, Pāṇḍarā, Māmakī, and Lochanā; a fifth, Vajradhātvīshvarī, is considered to be inherent within the four. The goddesses request the Kālachakra couple to arise from their clear light state and reappear.

Purification: As the time for birth approaches, disturbed by the fire-wind of the navel, the winds throughout the body gather at their respective centers: the earth-winds at the navel, water-winds at the heart, fire-winds at the throat, wind-winds at the forehead, space-winds at the crown. As a result, the baby awakens a little from its unconscious state.

Perfection: The five types of indestructible speech of the totality of utterances are realized; these are created from the vitality of the five elements.

Development: During the first half of dhāraṇā, the dhāraṇā awareness when the action-winds dissolve into the indestructible drop in the navel; similarly, the dhāraṇā awarenesses when the winds dissolve into the heart, throat, forehead, and crown drops.

In more detail, Lochanā is associated with the element of earth, and the entreaty by her purifies the earth-winds gathering at the navel before birth. One obtains the indestructible speech created from the ultimate vitality of earth and develops the dissolution during dhāraṇā of the action-winds into the indestructible drop at the navel. Similarly for the other four goddesses: Māmakī water, Pāṇḍarā fire, Tārā wind, and Vajradhātvīshvarī space.

Meditation (31): The two main deities, the shaktis, and the four vajras again arise in their normal forms. All the other deities are still unchanged and remain in their normal places.

Purification: When the time has come for the baby to be born, space-winds lead the other winds toward the crown; as a result of this, the ten channels of the heart fill with wind and the forehead and other four centers swirl with wind from their centers, all moving upward toward the crown. From there, the winds move to the base of the nose.

Contemplating the eight shaktis purifies the ten channels of the heart filling with wind; the four vajras purify the drawing of the winds to the crown, with the power to create body, speech, mind, and sexual awareness, also the movement of the winds from the centers

of the four centers up to the crown; the main couple purifies all of these equally.

Perfection: The realization of the chief couple, the eight shaktis, and the four emblems, identified with the awareness of bliss and emptiness that embraces all classes.

Development: During the first half of dharaṇā, the winds first dissolve into the navel drop, and then finally into the crown drop; once the winds have dissolved into the crown drop, the tummo blazes of the five awarenesses of the vitality of the five elements, principally space.

Meditation (32): As a result of the union of Kālachakra and Vishvamātā, buddhas, bodhisattvas, and all the retinue deities beyond the four vajras dissolve into Kālachakra through the mouth.

Purification: At the time of birth, when the head and hands point toward the birth canal, a little external wind enters the nostrils; as birth occurs, the external winds are inhaled through the nostrils, and within the central channel there occur 56¼ movements of awareness-wind; this supports the inner vitality and from then on does not move with the groups of winds.

Regarding the entry of the external winds into the nostrils, the absorption of the deities of the mandala into the body of the main deity purifies the initial 56¼ movements of awareness-wind and also the non-movement of awareness-wind together with the groups of winds up until the time of death.

Perfection: Not given.

Development: During the first half of dharaṇā, the winds successively dissolve into the drops in the centers, starting with the navel and going up to the crown; when the winds dissolve into the drop at the crown, the crown tummo blazes; at the same time, winds dissolve into the genital center and tummo also blazes there.

Also, the radiation and reabsorption of Vajrasattva (before the next step when all the mandala deities are again radiated) also develops the blazing of tummo at the genital center, they both being associated with the awareness element.

Meditation (33): In a manner very similar to the Mastery of the Mandala, all the retinue deities beyond the four vajras are radiated from the womb of Vishvamātā. As before, the perimeter deities appear from their seeds and hand emblems in their own places and are not radiated from Vishvamātā.

Purification: As soon as the baby has left the mother's womb and the first 56¼ movements of the awareness-wind in the central channel have completed, the right and left groups of winds increase, and from then on, although their strength will vary, winds move in all channels of the body.

After the initial movements of winds in the central channel, once the right and left groups of winds have started to move, winds start to move at the same time in all channels, from the rasanā and lalanā and the six centers to the minor channels.

Contemplating the male and female buddhas purifies the movements of the winds from the heart, forehead, and crown.

Contemplating the male and female bodhisattvas and wrathfuls of the mind mandala purifies the winds moving in the inner and outer circles of channel-petals in the throat center, the channels of the eyes and other sense organs, and the centers of the action organs.

The yoginī couples of the speech mandala together with their retinues, a total of seventy-two (the couples are counted as individuals), purify the winds moving in the eight channels of the middle circle of the throat center and the inner and outer circles of channel-petals of the navel center.

The 360 lunar day deities of the body mandala purify the winds moving in the channels of the twelve centers of the main joints.

The door protectors of the body mandala purify the winds moving in the genital center.

The nāgas and prachaṇḍās purify the winds moving in the sixty channels of the joints of the fingers and toes.

The dhāriṇīs, the icchās and pratīcchās, and the perimeter deities, siddhas, spirits and so forth, purify the winds moving in the innumerable minor channels throughout the body.

Perfection: The body, speech, and mind mandala is realized, consisting of all the various deities, being manifestations of each of the six elements, of earth and so forth, of the vitality of the conscious experience of the Kālachakra couple, the union of unchanging bliss and emptiness possessing the totality of possibilities.

Development: During the first half of dharaṇā, as was given before, the winds dissolve into the drops of the six (or seven) centers; at this time, when the winds dissolve at the forehead, tummo blazes mainly of the vitality of wind element; when at the throat, the fire element; at the heart, the water element; and at the navel, the earth element; the awareness of the blazing of tummo of the five elements is developed.

Quite why Banda Gelek mentions here without explanation the possibility of seven centers is unclear, but it may be because this is mentioned in Nāropa's *Sekoddeshaṭīkā* (Dbangdor) in the context of dharaṇā. That text describes an eight-channel seventh center inside the vajra jewel—the penis in a man, and, presumably, the clitoris in a woman.

The radiation from the center of great bliss (at the forehead) of the class of deities of the wind element, from Amoghasiddhi and Tārā to those among the icchās and pratīcchās, develops the dissolution of winds into the drop at the forehead and the subsequent blazing of tummo of the five elements, principally of wind.

Similarly, the radiation of Ratnasambhava, Pāṇḍarā, and others of the fire element class develops the blazing of tummo at the throat center.

The radiation of Amitābha, Māmakī, and others of the water class develops tummo at the heart center.

The radiation of Vairochana, Lochanā, and others of the earth element develops tummo at the navel center.

The radiation of Vajrapāṇi and Dharmadhātuvajrā in the mind mandala, the lunar day deities of the months of Māgha (left of East) and Phālguna (left of South), and others of the space element class, develops tummo at the crown center.

The radiation of Samantabhadra and Shabdavajrā in the mind mandala, the lunar day deities of the months of Mārgashīrsha (left of North) and Pausha (left of West), and others of the awareness element class develops tummo at the genital center.

The purification of the radiation of blue Vajrasattva is included in the last of these groups, and that of his consort, green Prajñāpāramitā, is included in the group prior to that.

Meditation (34): Vajravega rides out from the heart of Kālachakra on a blue chariot drawn by seven eight-legged lions to summon the awareness beings. Then four wrathfuls radiate to dissolve these into the commitment beings.

Purification: As soon as the baby has left the womb, the 56¼ movements of wind in the central channel awaken consciousness to its objects: stirred by these movements in the central channel, the base consciousness awakens to objects. Following the 56¼ movements, the central channel winds no longer move with the groups, and the five groups of winds that awaken the senses and their organs to their objects now continually move through the channels of the body until death. Apart from the base consciousness, the ear consciousness awakens to sounds, the mental consciousness to concepts; similarly the eye to forms, body to tangibles, tongue to tastes, and the nose to aromas.

The radiation of Vajravega, from the point of view of the awakening action, purifies the 56¼ movements in the central channel immediately following birth; his summoning of the awareness beings purifies the awakening of the base consciousness immediately following birth. Vajravega himself, together with the space element, his chariot, which is the chariot of Raudrākṣī (consort of the below wrathful, Sumbharāja), from the aspect of uniting the senses with their objects, purifies the movement of the space-wind. Vajravega's finally dissolving back into Kālachakra purifies the nonmovement in the groups of the central channel winds after the 56¼ have completed. This association of the blue chariot with the space element will at first not seem right. But, as Tāranātha points out, green Raudrākṣī is of the space element class, and therefore her chariot is also of the space element.

Also Vajravega purifies the senses of the ear and mental consciousness awakening to their objects. The radiation of Prajñāntaka, from the point of view of awakening of consciousness, purifies the movement of the fire element group of winds, and his action of entering the awareness beings into the commitment beings purifies the eye consciousness awakening to its objects. Similarly, Yamāntaka, from the point of view of awakening of consciousness, purifies the movement of the earth element group of winds, and his action of binding the awareness and commitment beings purifies the body consciousness awakening to its objects. Padmāntaka, from the point of view of awakening of consciousness, purifies the movement of the water element group of winds, and his action of pleasing the deities purifies the tongue consciousness awakening to its objects. Vighnāntaka, from the point of view of awakening of consciousness, purifies the movement of the wind element group of winds, and his action of making the deities to be of one taste purifies the nose consciousness awakening to its external objects.

Regarding the winds that are to be purified by the five wrathfuls, the reason the phrase "from the point of view of awakening of consciousness" is used is this. The movement of winds in the central channel immediately following birth is the object of purification of both the earlier radiation of Vajrasattva and of Vajravega to attract the awareness beings. From that time until death, the movement of the space-winds is purified by both the radiation of the deities of the space element class when the mandala is radiated and by Vajravega himself. Similarly, the movement of the fire-winds is purified both by the radiation of the deities of the fire element class and by Prajñāntaka. Similarly, the radiation of the deities of the five or six element classes and the radiation of the five wrathfuls and Vajravega are identical in the winds that are to be purified; however, when the mandala is radiated, the purification concerns the central channel winds and the winds of the five groups supporting the inner life force, but here, with the radiation of Vajravega and the wrathfuls, it concerns the stirring of consciousness and the uniting of the senses with their objects.

Perfection: Benefit of others is achieved through action, loving wisdom, and power; but the ability to help others is developed also by fostering in others the qualities of renunciation and realization by displaying to those possessing the five poisons, five classes of manifestations and by thus turning the wheel of the Dharma, giving rise to the true path in their conscious experience.

Development: During the first half of dharāṇā, as a result of the prāṇa-wind's dissolving into the drops of the six centers, the bodhichitta in the crown melts and merges with the blazing tummo of the space element at the crown. This then travels down to the forehead where it merges with the drop at the forehead and then with the blazing tummo of the wind element at the forehead. The bodhichitta continues downward to the throat and merges with the drop at the throat and then with the blazing tummo of the fire element at the throat. It then reaches down to the heart and merges with the drop at the heart and then with the blazing tummo of the water element at the heart. Next, it reaches the navel and merges with the drop at the navel and then with the blazing tummo of the earth element at the navel. In this way, the five tummos are developed, merged inseparably.

The melting of the drop at the crown and the merging with the tummo are developed by the radiation of Vajravega. Similarly, at the forehead by Vighnāntaka, at the throat by Prajñāntaka, at the heart by Padmāntaka; and the merging of the bodhichitta with the tummo at the navel and the merging of the five tummos inseparably are developed by the radiation of Yamāntaka.

Vajravega's summoning the awareness beings and bringing them into the presence of the (identical) commitment beings is similar to the tummo at the crown melting the bodhichitta at the crown and then merging with itself. The wind element, Vighnāntaka, bringing the awareness and commitment beings together, is similar to the blazing of the forehead tummo attracting downward the combined bodhichitta and tummo at the crown so that they merge with the forehead drop. Banda Gelek rather cuts the discussion short here and simply states that these comparisons continue down through the lower centers. This may be because the symbolism does not quite add up. Earlier, we had Vighnān-

taka associated with the action making the deities of one taste and not of entering the awareness into the commitment beings; that was the job of Prajñāntaka.

This is unusual for Banda Gelek, as he normally pedantically writes down every detail. My personal view is that this is a mistake. The order in the creation process of the summoning, entering, etc., is: Vajravega, Prajñāntaka, Yamāntaka, Padmāntaka, and then Vighnāntaka. However, in the perfection process, the order down the central channel from the crown, due to the associated elements, is: Vajravega, Vighnāntaka, Prajñāntaka, Padmāntaka, and then Yamāntaka. Tāranātha points out that the order does not matter, and he associates the forehead tummo with Vighnāntaka and the action of making the deities of one taste, as would be expected, and so on down through the centers. The best explanation seems to be that Banda Gelek made a simple mistake in associating the wrong action to Vighnāntaka and then let that train of thought drop.

Meditation (35): Empowerment of the deities. An empowerment of body, speech, and mind is always included in the sādhana; there is also an optional set of empowerments known as the Seven Empowerments Raising the Child; these have the same structure as the empowerments for the creation process given to Kālachakra students.

Purification: Following birth, the baby is washed and its body cleansed of any material from within the womb; the strength of its body, speech, and mind increase; it starts to act in various ways by means of the three doors (of body, speech, and mind); earlier in the womb there was no distinction between sleep and the waking state, but since birth it experiences the waking, dream, and deep sleep states; both boys and girls have the dispositions associated with semen, but in addition, girls also have the dispositions associated with ovum.

The placement of the syllables in the body, speech, and mind empowerment purify the increase in the power of the six elements; also, the placement of the syllables and the blessing and empowerment of body, speech, and mind and so forth purify the cleansing of the body of womb materials up to the development of

deep sleep. The placement of the Body, Speech, and Mind Vajras (these are deities, not literal vajras) at the three places of both Kālachakra and his consort purify the ordinary body, speech, and mind of both boys and girls; the additional three Vajras for the consort (at the navel, genitals, and crown) purify the special body, speech, and mind of girls.

Further to this, there is also the purification associated with the Seven Empowerments Raising the Child: after birth it is washed by its mother (Water); its hair is trimmed (Crown), the ears are pierced and the child is adorned with Silk Scarf caps; the child starts to laugh and talk (Vajra and Bell); it starts to experience the various objects of desire, of the five senses (Conduct); it is given a name (Name); and the father reads to the child, teaching it the various practices of the parents' caste (Permission).

Perfection: Innumerable emanations of body, speech, and mind teach Dharma to beings; they thereby cleanse defilements from the conscious experience of beings and bless and empower their body, speech, and mind.

By the radiation of the three deities of the Vajras one obtains the ability to teach Dharma to beings by means of emanations of body, speech, and mind; by these three deities empowering and then blessing one by coming to reside in the three places of the Kālachakra couple, one obtains the ability to bless the body, speech, and mind of beings and empower them.

Development: During the second half of dhāraṇā, the stream of bodhichitta flowing from the centers of the crown down to the genitals fills the whole body; from the radiance of the white element of the drops into which the winds have dissolved, deities compatible with the three Vajras radiate from the upper three channels, and from the blazing of the tummo many mandalas are seen; appearing from the red element and pure winds, from the six upper and lower channels radiate deities of the six elements.

The blessing and empowerment by the three Vajras develops the spreading of the nectar of bodhichitta through the whole body; the three Vajras arranged in the male deity develop the radiation from the white element in the upper three channels of deities similar to

the Vajras and the visions of mandalas; the arrangement of the six classes in the consort develop the radiation of deities from the upper and lower six channels.

Meditation (36): The five seals. These are: (1) the six-fold "lord of the class" seal, each deity having the buddha of its class on its crown; the seals of four vajras, first; (2) the seal of body vajra, with the six buddhas at the six places of all deities; (3) the seal of speech vajra, or seal of life, with five syllables at the five main places of each deity (not the genitals); (4) the seal of mind, or mind vajra, with four syllables at the four main places of the deities; and (5) the seal of awareness, the syllable "A," the essence of ultimate unchanging bliss, sealing the vajra jewel (penis) of each of the deities.

Purification: From the time the baby is born until the age of sixteen, it starts learning the activities of its caste; this is purified by the "lord of the class" seal. The body seal purifies the increasing strength of the six channels and the six aggregates; the speech seal purifies the increase in strength of the winds, the mind seal that of the factors of the drops, and the awareness seal purifies the increasing strength to full development of sexual awareness.

Perfection: By contemplating the "lord of the class" seal, mastery of the five pure aggregates is achieved; through the speech seal, mastery over all forms of expression by speech; through the mind seal, the purified four states; and through the awareness seal, totally uncontrived unchanging great bliss.

Development: Through the "lord of the class" seal, at the culmination of the practice of dhāraṇā, the stability of the drop at the crown is developed; through the body seal, the appearance of numerous empty forms of the vitality of the six elements from the blazing of tummo; through the speech seal, the five indestructible forms of speech created from the vitality of the five elements; through the mind seal, all forms of the four māras are defeated through the natural power of the bliss of body, speech, and mind; through the awareness seal, the stability is developed in which the coarse drop is bound from leaving the jewel (semen retention). Alternatively,

Tāranātha has here the bliss of the vajras of body, speech, mind, and awareness, which seems to make more sense.

This completes the Mastery of Activity.

Drop Yoga

Meditation (37): Drop Yoga, accomplishment, the third of the four aspects of approach-accomplishment. Blazing of tummo fire causes bodhichitta to descend all the way down the central channel, filling the Kālachakra couple and all the other deities with bliss.

Purification: Just as the fifteen phases of the moon develop through a period of fifteen days to be followed by the completion (full moon) of the sixteenth phase, so, through the fifteen years following birth, fifteen factors of bodhichitta develop, following which, on reaching the sixteenth year, the bodhichitta reaches completion, its sixteenth factor. The child, now an adult, displays many sexual expressions, teases women, holding their hands and in other ways acting like a partner; then, engaging in sexual intercourse, he experiences the four joys of normal melting bliss, with finally the orgasmic bliss of ejaculation. This is all described from the point of view of a male adult. The few texts that describe the female experience explain the same basic process, just in a somewhat different form. Women experience the four joys, the descent of bodhichitta, orgasm, and so forth.

On reaching the sixteenth year, the desire for sexual intercourse is caused by the completion of the factors of the drop-potential; this desire creates the physical and verbal expressions, also the first five of the (ten) stages of passion (*'dod pa'i gnas skabs, kāmāvasthā*): fixation, lust, fever, dryness of mouth, and loss of appetite; these are purified by the preliminaries for the Drop Yoga, the arrangement of the six syllables, etc. Engaging in sexual intercourse creates the experience of the four joys of ordinary melting bliss, the connate bliss of orgasm, and the second five of the stages of passion: trembling, delirium, giddiness, confusion, and unconsciousness; these are purified by the main practice of Drop Yoga.

Perfection: Free from all thoughts, the winds of all discursive imaginings having dissolved, mind vajra, the

nature of the four joys, understanding reality as it is and in its extent, is realized.

Contemplating that the tummo fire causes the right and left winds to dissolve into the central channel produces the later achievement of all winds dissolving; by contemplating the creation of the four joys and focusing on the bliss and the deities, a blissful mental state of the ultimate and uncontrived four joys is attained; by contemplating that the tummo light fills the whole body, the awareness that understands the whole of reality as it is and in its extent is obtained.

Development: Having completed dhyāna, but before true anusmṛti has been realized, from within a simulated anusmṛti are perceived numerous empty form divine couples. Associated with each of the three states of anusmṛti are ten consummations (*anusmṛti*), the purified ten stages of passion; when these are experienced, the ten groups of winds on the right and left dissolve into the drops, causing the eight channels of the inner circle at the navel and the outer circle of sixty-four, a total of seventy-two, to fill with blazing tummo, which spreads out through all the channels of the body. The tummo then ascends the central channel, reaching the crown, after which the drops of all channels accumulate at the crown. The letter HAM in the crown melts and descends down the central channel, successively creating the four and sixteen joys, the full awareness of descent joy. The bodhichitta reverses when it reaches the jewel.

Subtle Yoga

Meditation (38): Subtle Yoga, great accomplishment, the last of the four aspects of approach-accomplishment. In the bodhichitta swirling at the jewel at the end of Drop Yoga is vividly imagined the full triple mandala

of Kālachakra; the bodhichitta starts to return upward, reaching first the genital center; from the triple mandala awareness-element deities radiate into space. The bodhichitta continues to rise up the central channel, at each center the deities of the particular element class radiate from the deities in the bodhichitta.

Purification: Once adolescence has been reached at age sixteen, by repeatedly inseminating women many sons and daughters are produced; they in turn produce many grandchildren and one becomes the initial grandfather, known as the master of beings (that is, head of the family).

Perfection: The four normal drops are transformed into the nature of unchanging great bliss, and one becomes the ultimate master of beings, having realized the four bodies, the awareness of orgasmic unchanging great bliss; this enables numerous emanations to act for the benefit of countless beings.

Development: During samādhi, starting from the genital center, as the center fills with drops of unchanging bliss, the first and second levels are attained, and so on, up to the crown; as that center fills, so the eleventh and twelfth levels are attained. At the same time, as the drop fills up to the navel, the orgasmic body of the path is obtained; up to the heart, the wisdom truth body of the path; up to the throat, the beatific body of the path; and up to the forehead, the emanation body of the path.

Also, as the unchanging drop fills below the genital center, created solely from unchanging bliss, multitudes of vajra deities of the awareness element are actually radiated and absorbed back; similarly with the other centers, up to the crown, from which multitudes of vajra deities of the space element are actually radiated and absorbed back; this awareness of great bliss is termed the "master of beings," the path that actually radiates and absorbs deities.

And finally . . .

These last points concerning the very end of the creation process, in which are mentioned the actual radiation of deities, the full realization of enlightenment,

bring us back to the beginning of the first chapter, where I quoted Drakpa Gyaltsen describing the nature of mandala as being a manifestation of the awareness of

enlightenment. The mandala is contemplated in order to purify one's experience and achieve that awareness. His contemporary, Khedrubje, wrote that "The purification is as extensive as is the creation process, and to that extent the conscious experience can be developed. (Practising) in this way it becomes easy to give rise to the perfection process."

He is encouraging the use of the most complex form of the Kālachakra meditation, using the full triple mandala, rather than any shortcut. This is not to say that the shorter forms, such as the mind mandala and nine-deity mandala and their associated practices, do not have their place. Of course they do: the most commonly used practice in a retreat situation is probably the mind mandala. However, Khedrubje is explaining that even greater benefit is derived from the use of the full triple mandala.

After his explanation of the creation process, Banda Gelek makes some similar points. He explains that if the practice is done fully and properly, many practitioners do not have time even to perform any mantra repetition! He encourages that they should not do many, but at least repeat some mantras, as this helps master the main meditation. He clearly expects that the focus should be on the purification, perfection, and development aspects of the creation process together with the imagined forms of the mandala and deities.

The extensive purification, perfection, and development of the triple mandala are relatively easily adapted for the less complex mandalas; the main sections which become reduced concern the purification of the period of gestation. For example, in his instruction text on the nine-deity mandala practice (Bglha9), Banda Gelek assigns the purification of the whole process of gestation to the contemplation of a green HAM in the heart of the deities once they have first been created. A similarly reduced description could also be made for the mind mandala, although I have yet to see a text describing this.

I mentioned in the introduction that this process of creating the mandala and its purification is also relevant to other mandala practices from other tantric cycles. It is true that similar principles apply to other tantras, but it must be remembered that the Kālachakra was the last tantric cycle to emerge in India, and so it is only natural that these concepts are most fully developed in Kālachakra. It would not be correct to apply the full system retrospectively to other tantras, but I hope that the contents of this book not only help with understanding this specific Kālachakra system but also with understanding both the general concept and the use of mandalas within tantric Buddhism.

6. The Six Yogas of the Kālachakra Perfection Process[27]

THE SIX YOGAS are the perfection process (Skt. *utpannakrama*, Tib. *rdzogs rim*) meditations of the Kālachakra cycle and are often described as embodying the meaning of all the various creation and perfection processes of the different tantras and of being the pinnacle (*yang rtse*) of all Buddhist yānas.

As Günther Grönbold has pointed out, the classification of a system of yoga into six components (ṣhaḍaṅgayoga, and more famously eight, aṣhṭāṅgayoga) is very old, dating back to the time of the Upaniṣhads. It should come as no surprise that the Buddhist system that is considered to be the ultimate expression of Vajra vehicle practice should be styled in this way. The six yogas of Kālachakra share names with five of the components in the most common systems in early India, but their meditation practices are very different. These practices, the vajrayoga of six components (*rdo rje'i rnal 'byor yan lag drug*), are mainly described in the Kālachakra cycle, but there is also mention of them in both the Guhyasamāja and Hevajra literature.

In the following pages I shall explain something of the structure and theory of the six yogas as preserved in the Jonang tradition, relying mainly on the writings of Tāranātha and Banda Gelek (*'ba' mda' dge legs*). But first, a little history.

The Kālachakra system appeared in India around the beginning of the eleventh century C.E. and continued to be developed in India until the early thirteenth century, when the Muslim invasions of Magadha and Bengal destroyed the main monastic universities, leaving only pockets of Buddhism remaining.

Among the many Indian Kālachakra practitioners who specialized in the six yogas, certain individuals stand out. The foremost of these is Anupamarakṣhita. He was probably born late in the first half of the eleventh century, and two important texts by him on the six yogas survive in their Tibetan translations. Also surviving are two commentaries to these works by Ravishrījñāna, who lived about a century later. In terms of a simple word count, these four works of the Anupamarakṣhita tradition account for just over half of the original Indian six-yoga material that survives in Tibetan translation today.

A century or so after Ravishrījñāna, around the end of the twelfth century, these teachings passed through Vibhūtichandra, the abbot of the famous Tham Bahī in Kathmandu, the monastery founded by Atisha, another Kālachakra practitioner. Vibhūtichandra also received a direct transmission from the siddha Shabari and played a central role in the translation and transmission of these teachings into Tibet.

The next most important tradition comes from the two teachers having the title Kālachakrapāda. Kālachakrapāda the Elder was almost certainly the person who introduced Kālachakra into India, and the Younger was probably the famous teacher Nāropa (956–1040) of Nālandā. (See Newman 1987 for a useful discussion of this subject.) Vibhūtichandra was also involved in the

27. From *As Long as Space Endures*, edited by Edward A. Arnold, © 2009. Reprinted by arrangement with Shambhala Publications, Inc., Boulder, CO. www.shambhala.com.

translation and transmission of the Kālachakrapāda six-yoga teachings, but more importantly, these teachings passed through the Kashmiri Somanātha, who traveled to Magadha to meet the two Kālachakrapādas. He later traveled extensively in Tibet, teaching Kālachakra and helping with the work of translation, particularly with the famous translator Dro (*'bro lo tsā ba shes rab grags*).

These are just the leading figures known to us today, but there were many others. The Kālachakra system attracted a great deal of attention from Tibetans: the tantra itself was translated into Tibetan by at least twenty different translators, and the tantra and the various other Kālachakra texts found their way into Tibet by a great variety of routes. Naturally, there were many variations in these different traditions of the six yogas that entered Tibet, and the most important work on collating all of this in Tibet was performed by Kunpang Thukje Tsondru (*kun spang thugs rje brtson 'grus*, 1243–1313).

He identified and learned seventeen distinct traditions of the six yogas, and the great strength of the Jonang six-yoga tradition is that it preserves this great body of learning and experience in a single coherent system. The main instruction text by Tāranātha (Katodo) defines the system as consisting of fifty-three discrete meditation practices, with which are combined a total of 108 physical exercises, described most fully by Banda Gelek (6ykrab). Throughout these relevant instruction texts there are many comments indicating the origin of the various instructions, in the traditions originally identified by Kunpang Thukje Tsondru.

The following, adapted from Tāranātha (Kayolt), is a brief list of the traditions gathered by Kunpang Thukje Tsondru—many of these are simply identified by the name of the relevant translator or early teacher.

1. The instructions coming from the translator Gyijo (*gyi jo zla ba'i 'od zer*), who is reputed to have been the first translator of the *Kālachakra Tantra*.

2. The translator Magewai Lodro (*lo tsa ba rma dge ba'i blo gros*).

3. The translator Trom, Pema Weuzer (*khrom lo tsa ba padma 'od zer*).

4. The tradition from Atisha, which he learned from a teacher named as the "intuitive black teacher" (*bla ma nag po mngon shes can*). This is possibly Rāhulaguhyavajra, the master of the vihāra at Black Mountain, near Rājgriha.

5. The Dro tradition coming from the Kashmiri Pandit Somanātha.

6. The Rwa tradition, the teachings that Samantashrī taught to the translator Rwa Chorab (*rwa chos rab*). These two, the Dro and Rwa traditions, are generally considered to be the most important in Tibet.

7. The "Yoga garland" tradition, from the translator Tsami, Sangye Drak (*tsa mi lo tsa ba sangs rgyas grags*).

8. The tradition that Rechung Dorje Drakpa received from Amoghavajra.

9, 10 & 11. Three traditions from the translator Galo (*rga lo*), including one which is derived from the Hevajra cycle and one from the Guhyasamāja. The other, a Kālachakra system, was obtained from the translator Tsami, but as their methods of explaining the instructions are quite different these are counted separately.

12 & 13. Two traditions from the Kashmiri Pandit Shākyashrī (1127–1225). One of these concerned the Hevajra system and its six-yoga instructions as composed by Nāropa and was passed to Chal translator, Chozang (*dpyal lo chos bzang*). The other was the tradition passed to Sakya Panchen, known as the "oral tradition of the six vajra words."

14 & 15. Two traditions that passed through Vibhūtichandra. The first is the long lineage from Anupamarakshita that Vibhūti heard from Ratnarakshita. The second is the short lineage that Vibhūti received from Shabari when the latter visited him at Tham Bahī.

16. The tradition that Chag translator Choje Pal (*chag lo tsa ba chos rje dpal*, 1197–1264) heard from the Nepali Pandit Nyiwang Sungwa (*pan chen nyi dbang srung ba*).

17. The tradition of instructions of Rāhulashrībhadra, which passed through Manlung Guru (*man lungs gu ru*).

Kunpang Thukje Tsondru is also famous for having

founded Jonang Monastery, and the tradition that developed as a result became known as the Jonang tradition. They have always specialized in the practices of Kālachakra, and the structure of the six yoga practices found today in the Jonang tradition is very much as was originally described by Kunpang Thukje Tsondru.

Structure of the six yogas

Before going into any detail of the theory of the six yogas, it would be useful first to describe something of their overall structure and the nature of the practices they entail. I find it more useful to refer to each of the yogas by their Sanskrit names, but in the following initial list I also give English translations after their Tibetan names:

1. Pratyāhāra (*so sor sdud pa*): withdrawal
2. Dhyāna (*bsam gtan*): mental focus
3. Prāṇāyāma (*srog rtsol*): wind control
4. Dhāraṇā (*'dzin pa*): retention
5. Anusmṛti (*rjes dran*): consummation
6. Samādhi (*ting nge 'dzin*): absorption

1. The first yoga, pratyāhāra, is a nonconceptual meditation, completely free from any mental activity. Mostly performed in complete darkness, this practice is a very powerful method for developing a meditation of great peace, together with an unshakable presence of mind, or mindfulness. Once this has been properly developed and a certain degree of genuine nonconceptual awareness has arisen, images start to appear to the mind, completely naturally and without prompting. These are known as empty forms (Tib. *stong gzugs*, Skt. *śūnyabimba*), because they are not external and are clearly empty of any independent existence. They are natural manifestations from the mind. These empty-forms are classified into ten different types, known as the ten signs (*rtags bcu*).

These ten signs are very important within the Kālachakra system; in fact, the eight goddesses immediately surrounding Kālachakra in the mandala have the names of eight of the signs, the other two being considered inherent in Kālachakra's consort, Vishvamātā. The signs, as just detailed in the fifth chapter, are listed in the *Kālachakra Tantra* (chapter 5, v. 115): "Out of emptiness one comes to see smoke, mirages, pure and spotless fire-

flies, lamps, and, blazings (yellow blazing, Kālāgni) and the moon (white blazing) and sun (red blazing), vajra (black blazing, Rāhu), ultimate flashes, and drops."

The practice of pratyāhāra is divided into two parts: night yoga, which is performed in complete darkness, and day yoga, performed in a wide-open, desolate place, in view of a large expanse of sky. The first four signs in the above quotation are those associated with night yoga, and the other six are day yoga. The names in parentheses are alternative names to those originally given in the tantra.

In his excellent discussion of these (Bg6yspyi), Banda Gelek makes the point that the names of the signs are not intended to describe the forms of the images that will appear, rather the manner of their appearance. For example, the sign of smoke could well take the form of the image of a building or person, but the image will be smoky in form, flowing, floating upward, "like newly formed rain clouds."

Similarly, the mirage-like sign could take the same form of a building or person, but would shimmer like flowing water or "drizzling rain blown about by the wind." Banda Gelek gives similar but more extensive descriptions of all of these signs and associates each of them with the dissolution into the central channel of the winds of the five elements in the right and left channels.

Tāranātha (Kayolt) makes an interesting comment on the nature of these signs: "The word sign here should not be understood just as a sign of the path, but a sign of the nature of reality. For example, if you are traveling a long way at night and see in the distance a real light, this is a sign that when you reach the light it will be able to warm you up and remove the feeling of cold. Similarly, an empty form should be understood as a genuine expression of reality and a sign of the existence of that reality, tathāgatagarbha, and a sign of the quick realization of enlightenment."

Another point worth mentioning about pratyāhāra is that this type of practice is said to have its origins in the Prajñāpāramitā. Many writers, including Anupamarakṣhita, give the following quotation from the 8,000-verse Prajñāpāramitā:

> The king of gods, Shakra, said to Subhuti the Elder: ."Holy Subhuti, if someone wishes to practise this perfection of wisdom, what should he practise, and in what manner should he practise?"
>
> Subhuti the Elder said to the king of gods, Shakra: "Kaushika, someone wishing to practise this perfection of wisdom should practise with the sky. Kaushika, someone wishing to practise this perfection of wisdom should learn the practice in a roofless place."

This is considered to be the origin of the day yoga practice, performed in an open place.

2. In the second yoga, dhyāna, one settles the mind one-pointedly on these empty forms. Most importantly, the mind focuses on the equality and inseparable nature of mind and forms. There are several steps in this process of coming to perceive these empty-forms, understand them, and control them.

These first two aspects of the practice have the effect of calming the motion of the action-winds through the right and left rasanā (*ro ma*) and lalanā (*rkyang ma*) channels, developing the ability in the next practices to bring the winds into the central channel.

3. In prāṇāyāma, one combines the prāṇa-wind (*srog rlung*) and apāna-wind (*thur sel gyi rlung*) into one entity in the central channel through suppressing the movements in the rasanā and lalanā channels. This is mainly accomplished by means of vajra repetition (*rdo rje'i bzlas pa*) meditations, observing the coming and going of the breath, and other breath-manipulation exercises.

4. Dhāraṇā is concerned with the winds in the central channel that in prāṇāyāma originated from the ten aspects of the right and left winds. Here, these prāṇa- and apāna-winds that have been combined into one entity are made stable by means of breathing exercises, particularly various types of vase breathing (*bum can rlung*), and are merged into the indestructible drops in the central channel. This is the dissolution, or fading, of the coming and going of the winds—their dissolution back into the drops from which they originated.

5. In anusmṛti the practitioner's body is substituted by the mahāmudrā of empty form. This means that the practitioner's body is naturally perceived as appearing as Kālachakra in union with the consort Vishvamātā. When the practice is performed properly, it should appear naturally as an empty form and not as a contrived image.

Naturally, relative beginners practising anusmṛti may well need to imagine themselves in the form of Kālachakra in union with the consort, but when the ability has been more fully developed, the experience will be more one of observing oneself as the deity, an empty form, rather than a contrived "visualization." The process of developing this ability starts with the practice of pratyāhāra, allowing empty forms to arise spontaneously in nonconceptual meditation. Any attempt at any form of contrived visualization would be completely to miss the point.

Through the union of the male and female divine empty forms, based on the blazing-melting of the white and red elements of the practitioner's physical body, one repeatedly cultivates and perfects the four joys (*dga' ba bzhi*) in both progression and regression. This refers to the movement of the red and white elements up and down the central channel, and this increases the experience of bliss and also the experience of empty forms— one perceives more of them. Having brought the movement of the winds under control, the practitioner now starts to practise with the drops and winds and the forces that operate between them. This mainly entails tummo (*gtum mo*) meditation and similar practices.

6. With the sixth yoga, samādhi, the sexual desire of the empty form of the personal deity is transformed to create unchanging bliss. That desire is transformed into great bliss and compassion toward all beings. This has the nature of both method and wisdom, and is free from subject and object. This is explained as the equality of empty form and bliss. As the emptiness aspect of the practise has now been well developed through the earlier yogas, the emphasis now fully falls on the development of great bliss.

The structure here is straightforward, and the six

yogas are clearly arranged into three pairs: pratyāhāra and dhyāna are yogas of the channels, and by means of these practices the channels are purified, enabling control to be developed later over the winds. With prāṇāyāma and dhāraṇā the movements of the winds are reduced to nothing—the winds being returned to the drops from which they originate. Finally, anusmṛti and samādhi are yogas of the drops.

Other classifications of the yogas are given, and one or two of these will be described later. It is worth pointing out here that a full description of the six yogas would normally include a sixfold breakdown of each one, derived from the tradition of Kālachakrapāda. For each yoga, this would be the meaning of the name of the yoga; time for the practice; the characteristics of the practice; the confirmation, that is, signs of success in the practice; the type of purification achieved by the practice; and the final result of the practice. Space does not permit more than a mention of these here.

One point that should immediately be clear from the short description above is that there is a natural causal process through the six yogas, with each yoga building on what has previously been developed and creating the ability to perform the following yogas. This causal structure is much more obvious with these six yogas than with the famous six dharmas of Nāropa (*nā ro chos drug*, often misleadingly translated as the six yogas of Nāropa). Although the first of the six dharmas, tummo, is clearly the basis for the other practices, the causal relationship between the others is not clear. With the six yogas, that relationship is essential.

Terminology of the yogas

In the following I shall give a very brief description of the theory of the six yogas based on the long discussion of this given by Tāranātha (Kazuju). I shall basically be picking out some of the key and, to my mind, most interesting points that he makes.

There are several terms that need to be introduced before describing this theory, and these largely represent the particular Kālachakra view on the nature of existence and the means to achieve enlightenment.

We have already come across the channels (*rtsa, nāḍī*), winds (*rlung, vāyu*), and drops (*thig le, bindu*), often translated as "seed"; I find "drop" more meaningful in the context of a meditation practice; this best represents how they are imagined. It might well be better simply to use the equivalent Sanskrit term "bindu"; the word "potential" is also often useful here. These three form the so-called vajra body (*rdo rje'i lus, vajrakāya*), representing the structures, processes, and potentials that constitute our physical and mental existence. The main channels are three in number: the central channel (green, sometimes blue) and the right and left—rasanā (red) and lalanā (white). These are considered as running parallel through the center of the body, toward the back, near the spine.

The three channels extend below the navel area but with different colors. Underneath the navel the central channel is known as the shaṅkhinī (*dung can ma*) and is colored blue. The lower extension of the rasanā is black; it bends to the left, joining with the shaṅkhinī to reach the genitals. The lower extension of the lalanā is yellow and bends to the right and back, extending to reach the anus.

Groups of minor channels branch off from the central channel at six centers, at the level of the crown, forehead, throat, heart, navel, and genitals. These are associated respectively with the elements of space, water, fire, wind, earth, and awareness.

The numbers of channels in each of the six centers and their colors are as follows:

Crown	4				green
Forehead	4	8	16		white
Throat	4	8	32		red
Heart	4	8			black
Navel	4	8	12	60 or 64	yellow
Genitals	6	10	16		blue

With the four main centers, four minor channels branch off from the central channel and then subdivide to give the total numbers given above. Therefore,

for the throat center, four channels branch from the central channel; these each subdivide into two to give eight, and then again each into four to give thirty-two. The minor channels of the centers are curved like the spokes of an umbrella, with those of the crown, forehead, and throat curving downward, and the others curving upward. (Tāranātha does not actually mention the genital center here, but it seems safe to assume that its channels curve upward.)

There are also secondary centers associated with the twelve main joints: at the shoulders, elbows, and wrists, and hips, knees and ankles, and other more minor ones.

The winds move through the various channels and are of ten main types, in two sets of five, each associated with the elements. The ten winds are:

1. Prāṇa (*srog*): space
2. Samāna (*mnyam gnas*): wind
3. Udāna (*gyen rgyu*): fire
4. Vyāna (*khyab byed*): water
5. Apāna (*thur sel*): earth
6. Nāga (*klu*): awareness
7. Kūrma (*rus sbal*): wind
8. Kṛkara (*rtsangs pa*): fire
9. Devadatta (*lhas byin*): water
10. Dhanañjaya (*nor rgyal*): earth

Sometimes the element associations of nāgavāyu and apānavāyu are reversed. The following list describes the main locations of these ten winds and something of their functions.

1. Prāṇavāyu: in the central channel, above the navel, and in the upper channels of the heart; it maintains life and identity and creates many thoughts; if damaged, the concentration is broken, resulting in a lack of consciousness, craziness, and ultimately death.

2. Samānavāyu: in the channels on the front side of the heart; preserves the heat in the belly, maintains the separation of nutrients and waste in food, passing nutrients through the body and expelling waste downward; if damaged, stomach illnesses result.

3. Udānavāyu: in the Southeast (East is toward the front of the body) channel; controls speech, taste,

drinking, eating, spittle, vomiting; if damaged, fever and upper (body) ailments result.

4. Vyānavāyu: exists throughout the body; combines with the power of the rasana channel; in the joints it enables stretching and contraction of the limbs; if damaged causes paralysis, palsy.

5. Apānavāyu: in the central channel, below the navel, and the channels starting on the lower side of the heart; controls emission and retention of feces, urine, and drop; if damaged, cold and lower ailments result. Tāranātha makes the point that this wind and prāṇavāyu are material winds.

6. Nāgavāyu: in the Southwest channel; regulates eyesight, fatness, belching.

7. Kūrmavāyu: in the rear channel(s); regulates extension and contraction of the limbs.

8. Kṛkaravāyu: in the Northwest channel; controls anger, distraction, intoxication.

9. Devadattavāyu: in the left channel; controls yawning and creates ailments of the winds.

10. Dhanañjayavāyu: in the Northeast channel; earth ailments result. This wind remains in the body for a long time, even after death. This is presumably a reference to processes such as the growth of hair and fingernails that do indeed continue after death.

These are the primary locations for the winds, but they also permeate all channels in the body. Prāṇavāyu moves upward with great strength, but does not do so downward. However, there is some minor mixing with apānavāyu, and for this reason it moves a little downward. Similarly, apānavāyu moves downward, not upward, with great strength, but due to some mixing with prāṇavāyu it moves upward. Samānavāyu is mainly concentrated in the belly, maintaining heat (digestion), but to some extent permeates the whole of the body. And similarly for the others.

The drops are generally classified into two types: the conventional consciousness drop and the ultimate awareness drop. The latter is identical with ultimate reality, the buddha-nature or tathāgatagarbha, which eternally exists as unelaborated, unchanging great bliss. The purification, or realization, of this is the goal of all practice.

From the point of view of the conventional drop, there are two primary drops which are the basis for the creation of all drops. Below the navel exists the essence of blood, the "inner sun," chief of all red elements and source of warmth and heat, active tummo. Above the crown exists the essence of semen, the "inner moon" or "conventional spring," chief of all white elements, the indestructible letter "HAM," the nature of loosening bliss.

As these two are the basis for all other drops, they are described as having the nature of the syllables "E VAM."

Arisen from these are four drops located in the middle of the four main centers. At the forehead is the water-drop, the nature of moon, body. At the throat is the fire-drop, the nature of sun, speech. At the heart is the wind-drop, the nature of Rāhu, mind. At the navel is the earth-drop, the nature of Kālāgni, awareness.

The body-drop creates the errors of the waking state, the speech-drop the errors of the dream state, the mind-drop the errors of the deep sleep state, and the awareness-drop the errors of the fourth state—this latter is usually considered to be the experience of orgasm but includes some other experiences as well. These four drops are therefore described as being the potential for

the various aspects of experience, categorized by the four states.

On the path, these drops are the basis for the experience of the four joys, and when by means of the path the four conventional drops are transformed into the ultimate drop of reality, one attains the four kāyas: respectively, the nirmāṇakāya (*sprul pa'i sku*), saṁbhogakāya (*longs spyod rdzogs pa'i sku*), dharmakāya (*chos kyi sku*), and sahajakāya (*lhan cig skyes pa'i sku*).

Considered to be inherent in these four are the space-element drop at the crown and the awareness-element drop at the genitals. This gives a total of six drops, and these last two are considered to be in essence the same as the two primary drops mentioned earlier. It is also sometimes described that the awareness-drop is inherent in the other five.

Finally on terminology, Kālachakra uses three terms that are not found in other Buddhist literature but are taken from the Sāṁkhya system. These are the three qualities (Tib. *yon tan gsum*, Skt. *triguṇa*): gloom (Tib. *mun pa*, Skt. *tamas*), passion (Tib. *rdul*, Skt. *rajas*), and goodness (Tib. *snying stobs*, Skt. *sattva*). Other terminology will be introduced as necessary.

Theory of the yogas

The following will be a very reduced summary of the detailed theory of the six yogas as described by Tāranātha (Kazuju). The point of practices such as the six yogas is to transform the practitioner's experience: to achieve, as Tāranātha puts it, ultimate liberation, which he describes as "the direct knowledge of the nature and state of all things." He continues: "The path is the method to remove the errors that obscure that true nature. Once the direct knowledge of this nature has been achieved, one will never deviate from the path."

His theory describes the state of things as we find them, the state of samsara, or cyclic existence, the nature of which is suffering. Key to this discussion is the fact that the causes of samsara can be removed, the path being the methods used to this purpose and the final result being liberation from that suffering, nirvana.

This basic idea is summed up by the concept of the three tantras (*rgyud gsum*), and on this point Tāranātha quotes the main Buddhist definition of the word "tantra," from the *Guhyasamājatantra*:

Tantra is called continuity, and this tantra is classified into three aspects: ground, together with its nature, and inalienableness. Nature is the basic cause, ground is called the method, and inalienableness is the result. The meaning of tantra is contained in these three.

The terminology used in recent years has changed a little from that original quote, but this is clearly referring to ground (the state of things as we find them), path, and goal.

Tāranātha points out that this in fact reflects the

structure of the Kālachakra tantra itself, although it also has its own classification of outer, inner, and other. The tantra is divided into five chapters, the first of which describes outer Kālachakra, the physical worlds. The second describes inner Kālachakra, the body with the channels, winds, and drops. These two constitute the ground. The last three chapters are other Kālachakra, dealing with the empowerment, practices, and finally awareness. These describe the path and goal.

Outer and inner are known as the causal tantra/ continuum; other is both the method tantra and the result tantra. All things are contained in these three, which together describe the nature of reality.

The word "tantra," continuity, is used to indicate the fact that these three are essentially inseparable. Individuals experience the various phenomena of cyclic existence, the path, and the final goal of liberation, yet these are not different realities but different experiences of one reality.

The essence of causal tantra is known by many different names, such as the clear light ādibuddha, perfect enlightenment, or tathāgatagarbha, buddha-nature. This is simply the basic nature of mind, which has the characteristic of originally coincident bliss and emptiness.

Mind is described as being of two types: samsara-mind and nirvana-mind. There are many other pairs of words used to express the same distinction: conventional and absolute mind, mind and nature of mind, etc.

Conventional samsara-mind refers to mind afflicted with the incidental defilements of the eight consciousnesses, the fifty-one mental events, and so on. This experience is described by such concepts as the four states of waking. From the point of view of these four states, the causal continuum, the clear light nature itself has no components or subdivisions, but it exists as the essence of the four potentials or drops when afflicted by the incidental defilements. And, when the defilements are removed by the path, those same four potentials are the causal continuum for the four kāyas, or the four vajras— the body vajra, speech vajra, etc.

Looked at in this way, the ground and result are indistinguishable, and so these four drops are the four kāyas. But because all the experiences of beings flow

from these drops, they are included within the causal continuum, and because they are the basis for the four activities of enlightenment, they are included within the result continuum. A similar argument could be made regarding the method-continuum.

This basic nature of reality is both the ultimate cause and the ultimate result, and there is no such thing as cause or result. However, from the point of view of ordinary beings, we talk in causal terms.

The word "incidental" that qualifies the defilements is important here. The basic nature of mind is the essence of the experiences of both samsara and nirvana, and it is merely the presence of these defilements that creates that distinction. The defilements are incidental because there is nothing essential in the difference between samsara and nirvana. The defilements are empty of inherent existence.

Tāranātha continues this discussion by pointing out that there are other pairs of terms with the same distinction. For example, ultimate reality is referred to as the "five letters of great emptiness" because it is the essence of the five elements and the causal continuum which is the nature of the five awarenesses. The word "great" here does not imply that emptiness—the mere absence of inherent existence—is great, but indicates that emptiness itself is awareness.

Similarly, ultimate reality is referred to as the "six unchanging empty potentials" because it is the essence of the six aggregates and the six elements and the causal continuum of the six types of buddhas and their six consorts. The potentials are said here to be empty because the potential of great bliss is free from all artifices of subject and object.

In the same way, ultimate reality is the essence of the twelve links of dependent origination (*rten 'brel bcu gnyis*) and also the essence of the twelve changes of (inner) winds, and it is the causal continuum of the dharmakāya awareness that perceives the twelve realities (*bden don bcu gnyis*).

There are many analogies given for the process of removing the incidental defilements, and the following should serve as a summary. Copper possesses a certain color, luster, and other qualities, but when it is in

the form of ore, these are not observed because of the presence of other elements and impurities. However, once those impurities have been removed by the right process, pure copper results, together with its qualities of luster, color, and so forth. The copper has not been changed and its qualities not newly created—the impurities have simply been removed.

The creation of samsara

Tāranātha now starts to get into more detail and describes how ultimate reality, the radiant nature of mind, base awareness, indestructible drop, etc., exists as the essence of the four drops and eight qualities, and that from these arise the incidental defilements which appear to be merged with it and which are the essence of base consciousness, which is sometimes referred to as the "great primary misperception."

Specifically, there are the dispositions and so forth of the four states. The presence of these gives rise to all the appearances and thoughts of the four states and the eight qualities of gloom, passion, and goodness, together with sounds, sensations, tastes, forms, and smells. From these arise the aggregates, elements, senses, actions, and so forth.

That base awareness is said to have as its mount the so-called awareness-wind, which is essentially identical with it. The mount of the primary misperception is the subtle winds.

From this root misperception arise two things that have the characteristic of wind: the joyous wind which generates the fourth state, and the connate wind which creates the states of waking, dream, and deep sleep.

It is not the case that from this misperception physical winds are created, but rather that these "winds" have the nature of wind in that they create the thought (structures) of the four states. From these arise the ten winds described earlier; from these the winds of the twelve ascendants; these create the senses apprehending the five objects. Following on from this are mental consciousness and the self-centered emotional mind, and from these two aspects of mind grows all the limitless range of thoughts.

Furthermore, this awareness is the essence of the three: white element, red element, and wind. For this reason, the primary misperception exists in the manner of defilements of these three, and so exists as the subtle nature of the white, red, and wind and gives rise to more coarse potentials.

As the dispositions of the four states associated with the four drops are only awareness, they do not exist in particular parts of the body. However, from the activity of the channels, winds, and drops of the forehead, the dispositions of the waking state are activated and give rise to all appearances, perceptions, and thoughts when awake.

Similarly, dream comes from those of the throat, deep sleep from the heart, and from the navel are activated the dispositions of the fourth state, to give rise to the appearances, perceptions, and thought of sexual desire. In this way the four centers, the four vajras, and the four states are associated together.

As we have seen, the primary consciousness exists like a drop, as the dispositions of the white, red, and winds. From this point of view, the power of the winds (gloom, from the three qualities) causes thoughts, which have the nature of delusion. The red element, the disposition of passion, causes the characteristics of desire, and goodness, the disposition of the white element, causes the characteristics of the bliss that is associated with sexual loosening and emission.

This primary misperception causes the movements of the winds and the creation of thoughts, and it has the power to create the sixteen joys of the bliss of emission and the coarse twelve links. As potential, these coarse states do not exist, but the subtle characteristics of winds, thoughts, joys, and links do exist.

From the association of this primary misperception and the coarse body there specifically arises the experience of samsara of the desire realm. Apart from a difference of degree of grossness with the form realm and formless realm, it is basically the same for them.

Furthermore, the activation of the power of winds arising from the dispositions of the white, red, and wind causes the movements of the winds of the twelve changes (the changes of the twelve ascendants, associated with changes within the body). This activity stirs the red aspect and causes it to blaze; this causes the white aspect to melt completely.

The movements of the winds, the blazing of the red aspect, and the melting of the white aspect in general cause the creation of all the variety of thoughts, and, propelled by previous actions, other potentials are activated. As a result there arise all the appearances of self and others of the animate and inanimate worlds, and the various emotional defilements that drive actions are created.

Then again, with the increase of these emotions together with the winds, one accumulates the actions that in the future propel one to rebirth. These actions are of two kinds: the first is a normal (neutral) action, which mainly creates the world in which other births will occur, and the second type creates each being's individual body, possessions, and so forth. The animate and inanimate worlds that are created in this way are included within the aggregates, elements, and senses.

At this point Tāranātha gives a brief description of the manner in which samsara is created that could, like many of these descriptions, be read as something of a timeline, but that is not the intention here. These are not descriptions of some kind of initial process that happened in the distant past that creates our current condition but an ongoing process, one that is always happening. In the previous section mention was made of just such a process: the interaction between the red and white elements, driven by the winds. This process is contemplated in a pure form during tummo and associated practices as a means of controlling and purifying the processes that create samsara. The following description is closely related to this.

The source of samsara is taken here to be (attachment to) the bliss of emission; one could possibly say attachment to life itself. In this way, misperception is the beginningless disposition of desire. Once that desire is activated, there is then change regarding the object of that desire, and this change leads to separation from the original object of desire, and from that develops anger. The nature of anger is mindlessness, and mindlessness is delusion. In this way misperception has the nature of the three main emotional defilements of desire, anger, and delusion.

Tāranātha summarises the manner of the development of samsara in the following way:

> From the mind of the disposition of the bliss of emission arise semen, drop, and wind. From these three arise this present body, speech, and mind. And from the appearance of the channels, winds, and drops of this body, speech, and mind arise all the various appearances of the outer physical world.

From the combination of the basic cause of the power of the inner dispositions manifesting semen, drop, and wind, together with the objects of the external physical world and one's own body, emotions are generated and one accumulates actions that propel one toward other births. The initial emotional dispositions are energized and create in the future a variety of emotions. In this way all those wandering round in circles (samsara) create from emotions arising in their own minds the experience of samsara entailing all kinds of suffering.

Nobody else creates the sufferings of samsara; it is like a silkworm bound up in its own cocoon.

The reversibility of samsara

The point should be clear that the creation of samsara is reversible because the error that creates it is not inherently existent. The wandering of beings in samsara is real enough, but is not truly established and is simply an error concerning that which is not real. This error is just a thought-construct, and that thought is created by the power of the dispositions and the movements of the action-winds.

It is necessary to apply an antidote to all this, and that is nonconceptual awareness which will suppress the action-winds. Then, through this nonconceptual awareness perceiving reality directly, one eliminates the disposition of changing bliss. With the action-winds stopped, the white and red aspects subside and the processes of the sixteen blisses of emission and the twelve links come to a stop.

This brings to an end the stream of previous activity, emotions, and sufferings; and having overcome thought-constructs, these will not arise again, and the origination of existence through actions and emotions is exhausted.

Just the mere collapse of this cycle of apparent but not truly existent error is liberation.

At this point Tāranātha quotes the Kālachakra commentary, the *Vimalaprabhā*: "For this reason, that which is called Māra is the stain of dispositions of the samsaric mind of beings; that which is called Buddha is mind free from the dispositions of the samsaric mind." This expresses the fact that conventional individual beings are merely the stream of consciousness and the infinite elements of samsara, as in them eternally exists ultimate enlightened awareness.

The yogas as antidote

Before going into more detail with regard to the individual yogas, Tāranātha discusses the nature of the path of the yogas as a whole, the profound path of vajra yoga.

As the nature of the reality of the ground is of union, so the nature of the awareness of the result is also of union. For this reason the method or path that should bring about the realization of that result should be one of union, because it is in the normal nature of things that the result is compatible with the cause. For this reason this profound path of vajra yoga is the path of union.

But what is referred to here by union? It is the union of the awareness of unchanging great bliss and the body of emptiness possessed of all positive characteristics. This is the same as the union of great compassion and emptiness, or the union of illusory body and clear light.

In this context, great compassion, clear light, and unchanging bliss mean the same, normally understood as method (Tib. *thabs*, Skt. *upāya*) and explained as conventional reality. Emptiness, illusory body, and body of all positive characteristics also mean the same and are normally understood as wisdom (Tib. *shes rab*, Skt. *prajñā*) and explained as ultimate reality.

As this great bliss is able to overcome the suffering of self and others, it is called great compassion, because that which completely protects from suffering has the characteristic of compassion. But this is not just a mat-ter of applying the name "compassion," as this great bliss does in fact create an attitude of love toward all beings.

Another term that is used in this context is nonconceptual compassion. This refers to the eradication of the appearances of subject and object and of its not going beyond the seal of nonelaboration.

Also, regarding the body of all positive characteristics, this is an awareness free from all elaborations of subject and object. But, having stopped all appearances of subject and object, this does not mean that there will be no appearances at all. Free from elaboration, the retinue of the mandala and so forth and all the positive characteristics of samsara and nirvana will appear, but are not called conventional appearances or erroneous appearances; they are awareness appearance, appearance of reality, and so forth.

But why is great bliss referred to here as conventional reality? It is not actually conventional reality, but referred to as such here because its development depends on methods that utilise the conventional loosening-bliss.

The word "union" is also applied to the union of cause and result, and with regard to this, Tāranātha quotes the *Sekoddesha*: "From emptiness flow images, from unchanging comes the result of bliss; the cause is sealed by the result, and the result sealed by the cause." Seal carries here the meaning of nondual, or union.

The point is that the two are essentially the same. However, as far as the nature of reality is concerned, there is no actual cause and result by way of anything that creates anything or is itself created.

However, the nature of all causes is empty-form, and the nature of all results is unchanging bliss. Because from the emptiness of one's own essence there arises bliss, the cause and result are similar, and although they are essentially indistinguishable, in order to realize them, the first five yogas are concerned with the development of the perception of emptiness, while the last, samādhi, is concerned with great bliss.

As it combines these two aspects of bliss and emptiness, the path of vajra yoga is called the path of great union.

The six yogas are classified in several ways, and Tāranātha in fact gives a list of twelve classifications. Four of these are worth mentioning here.

The four drops: pratyāhāra and dhyāna remove obscurations from the body-drop, prāṇāyāma and dhāraṇā from the speech-drop, anusmṛti from the mind-drop, and samādhi from the awareness-drop.

The four states: pratyāhāra and dhyāna purify the waking state, prāṇāyāma and dhāraṇā the dream state, anusmṛti the state of deep sleep, and samādhi the fourth state.

Concerning the appearance of empty forms purifying the waking state, the purification is by means of similarity to the clear appearance of various images (as in the waking state).

Regarding the purification of dream by stopping the winds, as the obscurations of subtle appearances such as those of dreams, the intermediate state, and so forth are caused by the agitation of the winds, the purification is by means of stopping the movements of the winds.

The purification of deep sleep by the orgasmic melting bliss in anusmṛti occurs through similarity with the nonconceptual dissolving of the winds.

Samādhi purifies the fourth state by overcoming the drop (potential) that brings about change.

Four aspects of approach-accomplishment (Tib. *bsnyen sgrub*, Skt. *sevāsādhana*): the processes of pratyāhāra and dhyāna are approach because they lay the foundation for the body of awareness. The processes of prāṇāyāma and dhāraṇā are close approach because they lay the foundation for the path of the speech vajra. The process of anusmṛti is accomplishment because it lays the foundation for the path of the mind vajra, being the special method for the immediate development of unchanging bliss. The process of samādhi is great accomplishment because it develops in particular the awareness vajra but in general achieves the realizations of all four vajras.

Tāranātha gives a simple analogy to illustrate the meaning of these four aspects of approach-accomplishment: To come close to the ultimate realization is approach, such as, for example, considering a journey to a town. Close approach means coming closer to realization, like making preparations for the journey. Accomplishment refers to the beginning of the development of the causes that bring about the special result, like actually setting out on the journey. Great accomplishment has the meaning of developing the result without obstacle, like entering the gate of the town.

The four yogas: pratyāhāra and dhyāna are the yoga of form, as they generate images; prāṇāyāma and dhāraṇā are the yoga of mantra, as they purify the winds; anusmṛti is the yoga of dharma, as it develops bliss through focusing on all characteristics (emptiness); as from this develops the realization of ultimate nonconceptual emptiness, samādhi is the yoga of purity. Also, the four yogas can have the names of the four kāyas as they develop the realization of the kāyas.

Functioning of the yogas

Going into more detail regarding the six yogas, Tāranātha explains how they each have two aspects. With pratyāhāra, the night yoga binds the rasanā chan-nel and the day yoga binds the lalanā channel. With dhyāna, the practice of eliminating the perception of the empty-forms as objects purifies the lalanā channel

and the practice of eliminating elaborating conceptual clinging to the empty-forms purifies the rasanā channel. Of these two yogas, pratyāhāra is mainly concerned with mind, as here the solar elements are purifying the lunar elements. In dhyāna, as the lunar elements are purifying the solar, the emphasis is mainly with body. With pratyāhāra, the bliss of focusing the attention in space which is the lunar element is in union with the solar element, the empty-forms. In dhāraṇā, the lunar and solar elements are the uncontrived attitude of mind and the arising of empty-forms.

With prāṇāyāma there are six upper and lower channels (right, left, and center, above and below the navel). Suppressing the right and left upper winds and combining them with the lower central wind in the shankinī (*dung can ma*) purifies the rasanā channel, the path of the sun; stopping the right and left lower winds and combining them with the upper central wind in the avadhūtī (central channel) purifies the lalanā channel, the path of the moon. The order in which these occur is not specified, but in general the upper winds are stopped first, and after all ten winds have been halted they become combined into one entity. The lunar and solar elements are the mastering, respectively, of the prāṇa-winds and apāna-winds.

With dhāraṇā there are also two stages. Contemplating in a regressive direction from the navel to the crown mainly arrests the solar elements, and contemplating in a progressive direction from the crown to the navel purifies the lunar elements. With these two yogas, prāṇāyāma is mainly concerned with mind and dhāraṇā with body. The lunar element is the dissolution of the winds into the drops and the solar element the blazing of tummo.

The two stages of anusmṛti depend on one's ability. When one is unable to induce the full four joys with the mahāmudrā of empty-form, then practising mainly with the blazing of tummo purifies the lunar elements. Then, once the ability to induce the full four joys has been developed, practising mainly with the bodhichitta, the basis for unchanging melting bliss, one purifies the solar elements.

With samādhi, arresting the five elements at the five centers from the genitals to the forehead (upward) purifies the solar elements, and arresting the five aggregates at the five centers from the crown center (downward) purifies the lunar elements. The five elements are classified as wisdom and the five aggregates as method. Of these two yogas, anusmṛti is mainly associated with mind and samādhi with body. The lunar element is the body of empty-form and the solar element the unchanging melting bliss.

This twofold classification concerns the order in which the particular qualities are developed in the individual performing the practice. The way in which the practice is performed should be in the manner of the union of method and wisdom. The lunar and solar elements are, respectively, the cessation of the movements (activities) of the white and red elements.

Pratyāhāra is free from mental activity, but it is not simply a state in which thoughts have been stopped. Without any artificiality, by engaging with that reality which is the pure awareness that is naturally free from mental activity, incidental thoughts are reduced and one spontaneously comes to rests in pure awareness.

Both day and night yoga are important as it is necessary to purify the defilements associated with both the method and wisdom aspects, in particular to purify the dispositions regarding birth and death. Also, the night yoga makes it particularly easy to develop empty-forms, and by having practised that, one then develops with the day yoga a more rounded skill in the practice.

The experience of empty-forms is stabilized with the practice of dhyāna, and this stability in the practice means that the empty-forms cannot be stopped.

There are five aspects to the development of dhyāna: with the aspect of understanding the forms are simply observed, with perception they are recognised, with analysis they are understood for what they are, with joy one develops attachment to the forms, and with unwavering bliss one identifies the forms with mind.

Prāṇāyāma is a method for reverting the two types of impure awareness-winds, with the characteristics of sun and moon, into awareness winds. These awareness-winds are in essence the same as empty-form mahāmudrā, but the practitioner has not previously perceived the empty-forms as being the essence of the winds.

By focusing on these empty-forms one applies the methods of vase breathing and so forth gradually to

restrict the movements of the solar and lunar winds. These solar and lunar winds are the obstacles that prevent the perception of the true nature of the winds, and as these are gradually reduced and dissolved, one develops a real experience of the nature of empty-form.

In dhāraṇā, the "ultimate drop" exists as the empty-form mahāmudrā and has the nature of great bliss. From the nature of this blissful reality arises the process of all incidental appearances, which exists as the essence of the physical drop in the navel center of the conventional channels and centers. This is the basis for all the subtle and coarse winds, and they originated from there. From wherever they originated, so there will they be returned.

So dhāraṇā is the method for coercing these subtle and coarse winds back into the physical drops, so that which originally created the structure of life appears as the drop of great bliss.

When the meditation is done properly and the prāṇa- and apāna-winds have been combined into one entity, then this enables the "cheating of death." This is because one gains the ability to fill all the six centers and even the centers in the fingers and toes of the hands and feet with the prāṇa-wind. Through the power of the ten winds dissolving into the drop, the sufferings of old age and illness are removed, and through perceiving the nature of the emotional defilements, one is not enslaved by those defilements.

Anusmṛti represents something of a culmination of the processes of the previous four yogas. With pratyāhāra, the rasanā and lalanā are partially bound and one starts to experience empty-forms for the first time. With dhyāna, this is developed further; the right and left channels are bound more strongly; and the appearance of empty-forms increases by an order of magnitude. Whereas in pratyāhāra there was nothing more than a subtle feeling of bliss, the multiplication of the empty-forms causes experiences of joy and bliss to take hold.

Through prāṇāyāma the movements of the winds in the right and left channels are gradually brought to a halt, the appearance of empty-forms multiplies a hundredfold, and the experience of bliss increases with the merging of the prāṇa- and apāna-winds. With dhāraṇā the winds dissolve into the six drops and tummo blazes, beginning the experience of melting bliss. The empty-forms now increase a hundredfold or a thousandfold.

With anusmṛti these empty-forms are increasingly stabilized and now appear together with, or combined with, melting bliss. It is this process of cumulative development on the path that gives this yoga its name of consummation. The word "anusmṛti" would normally translate as "recollection," but in this context that does not seem to have sufficient strength. Consummation also usefully carries something of the sense of working with the sexual dispositions, the disposition of the melting bliss.

The focus of attention in anusmṛti and samādhi is essentially the same, and so an explanation of anusmṛti is also an explanation of samādhi. However, the process of anusmṛti is intended to develop the unchanging drop, but in that practice that has not been achieved. In samādhi, it has been achieved, and the practice builds from there.

Association of the yogas with creation of samsara

It should now be clear how the purification process of the yogas proceeds, with the winds being calmed, returned to the central channel, and dissolved back into the drops. Then the process of interaction between the winds and drops is purified in the perspective of emptiness with the last two yogas.

Finally, I shall return to the process of the creation of samsara from a slightly different point of view and show how the purification of this aligns with the characteristics of the yogas.[28]

The starting point of the creation of samsara is the clear light, base awareness. Of the winds of the six ele-

28. One source for this is the commentary by Jamgön Kongtrul (Zabnang) to the *Profound Inner Meaning* (*zab mo nang gi don*) by the Third Karmapa, Rangjung Dorje; this is a text that is largely based on Kālachakra theory. Another source is the tantra commentary, the *Vimalaprabhā* (Vimala),

ments, this is the awareness-wind, and of the six aggregates, the aggregate of awareness.

From this the first split into subject and object occurs, giving a sense of separation and space. This is the space-wind, and base consciousness, the aggregate of consciousness. This is the root of the emotional defilement of aversion.

Mind becomes fascinated by this apparent existence of external objects and reacts to their appearance. This is the wind-wind, the aggregate of reaction and the root of the emotional defilement of desire.

The process deepens, and mind becomes immersed in the increasing mass of apparent external objects. This is the fire-wind, the aggregate of sensation, the root of the emotional defilement of delusion.

Mind now tries to make sense of the situation that has developed by means of conceptual thought, by applying characteristics to objects, and so forth, and thereby developing a false sanity. This is the water-wind, the aggregate of recognition.

Finally, all of this becomes fixed, with rigid views and responses. This is the earth-wind, the aggregate of form. Individuals then act on the basis of these fixed wrong views that have developed, and the wheel of samsara relentlessly turns.

The order given here of the development of the winds and aggregates is as follows, with the buddhas, which are the purified forms of the aggregates, also given:

Wind	Aggregate	Buddha
Awareness	Awareness	Vajrasattva
Space	Consciousness	Akṣhobhya
Wind	Reaction	Amoghasiddhi
Fire	Sensation	Ratnasambhava
Water	Recognition	Amitābha
Earth	Form	Vairochana

The function of the six yogas is to purify this process:

1. Pratyāhāra develops the appearance of signs, empty-forms. This purifies the awareness aggregate, the result being the realization of the buddha Vajrasattva.

2. In dhyāna the appearance of those signs is stabilized, and they are perceived correctly. This purifies the aggregate of consciousness, the result being the buddha Akṣhobhya.

3. In prāṇāyāma one brings the right and left action-winds together. This purifies the aggregate of reaction, resulting in the buddha Amoghasiddhi.

4. In dhāraṇā one retains the prāṇa-wind, dissolving it into the drops. This purifies the aggregate of sensation, resulting in the buddha Ratnasambhava.

5. In anusmṛti one purifies the instances of desire in the central channel. This purifies the aggregate of recognition, resulting in the buddha Amitābha.

6. With the yoga of samādhi, one brings to a stop the activity of all the winds. This purifies the aggregate of form, resulting in the buddha Vairochana.

A similar description could be made with the elements and their purified forms, the goddesses that are the consorts of the buddhas.

and I am also leaning heavily on the discussion of the creation of samsara by Herbert Guenther (Guenther 1972), also based on the *Profound Inner Meaning*. (This text along with Kongtrul's commentary in English translation has been published by Snow Lion/Shambhala Publications, but its purchase is restricted to qualified practitioners.)

THE SECOND CHAPTER of this book describes in detail how the various measurements of the Kālachakra mandala are determined. This appendix offers a brief overview of those measurements relative to one another. Certain measurements and terms are unique to this tantric system, as the second chapter specifies.

As the author explains, there is some ambiguity over the precise length of smaller measurements, especially in the actual practice of constructing the mandala, and the symbol ≈ used below represents that slight uncertainty.

Units of measurement:

1. **Door Unit** (DU) = **Major Unit** (MU)
 a. **mind-DU** (the measurement of the door unit of the mind palace)
 b. **speech-DU** (the measurement of the door unit of the speech palace)
 c. **body-DU** (the measurement of the door unit of the body palace)
2. **Minor Unit** (mu) ≈ **fractional unit**
3. Other terms of reference:
 a. **Yojana**
 b. **Cubit**
 c. **Finger-width**
 d. **Half-finger**(-width)

As the body palace is the largest of the three within the triple mandala, that palace serves as the basic unit of measurement, the door unit (DU). Hence, here DU = body-DU = MU.

The other two, the speech and mind palaces, are respectively one-half and one-quarter the size of the body palace. Therefore, 1 body-DU = 2 speech-DU and 4 mind-DU.

The DU measures approximately (see below) 12 finger-widths, the same as ½ of a cubit, hence 9 inches approximately. Based on that measurement, a speech-DU = 4.5 inches approximately, and in turn a mind-DU = 2.25 inches approximately.

Because door units are relative values, the actual size of the mandala that the ritual specialist creates can be scaled up or down.

A Major Unit (MU), identical in length to the DU, is a term used in all mandala systems but with less frequency here in Kālachakra.

A minor unit (mu) = ⅛th of a mind-DU = ½ of a finger-width = 1 half-finger(-width) ≈ ⅜th of an inch.

A yojana, well known from Indian Buddhist literature, measures approximately 9 miles, or 576,000 inches, or 32,000 cubits, according to the Kālachakra literature (and quite different from the Abhidharma literature).

A cubit measures approximately 18 inches = 24 finger-widths = 2 DU (i.e., body-DU). For reference, the inner

width of the body palace, from one wall to the opposite wall, measures 4 cubits or 8 DU.

A finger-width = $\frac{1}{24}$th cubit ≈ $\frac{3}{4}$th of an inch. In practice, importantly, the finger-width is the measurement of the width of the thumb of the vajra master overseeing the empowerment—thus, it is an approximate figure.

A half-finger(-width) = $\frac{1}{48}$th of a cubit ≈ $\frac{3}{8}$th of an inch, approximately $\frac{1}{1,536,000}$th of a yojana.

Glossary

Tibetan	Sanskrit	English
ka ba	stambha	Pillar
klu	nāga	One of the ten winds
dkyil 'khor	mandala	Mandala; also group, as in groups of winds
dkyil 'khor rgyal mchog	mandalarājāgrī	Mastery of the Mandala
bka' 'gyur		Kanjur. Collection of the Tibetan translations from Sanskrit of the original teachings of the Buddha
rkang pa brgyad pa'i seng ge	śarabha	Eight-legged lion
rkyang ma	lalanā	The main channel in the body on the left
skam thig		Construction line
skye mched	āyatana	Sense fields; the senses
bskyed rim	utpattikrama	Creation process
khor yug	valaya	Perimeter
khyab byed	vyāna	One of the ten winds
khru	hasta	Cubit; unit of measurement
mkha' lding	garuḍa	A mythical bird
'khor lo	cakra	Space enclosed by the baselines of a palace
gyen rgyu	udāna	One of the ten winds
gyen thig		Vertical line
rgyang grags	krośa	Earshot; unit of measurement
sgo	dvāra	Door
sgo khang	dvārakoṣṭhaka	Porch structure
sgo khyud	niryūha	Porch projection
sgo glegs	kapāṭa	Door leaf

TIBETAN	SANSKRIT	ENGLISH
sgo 'gram	kapola	Porch extension
sgo phug		Porch alcove
sgo tshad	dvāramāna	Door Unit; unit of measurement
sgo logs	pakṣaka	Porchside
sgrub thabs	sādhana	Meditation practice for the creation process of a deity
sgrub pa	sādhana	Accomplishment; one of the four aspects of approach-accomplishment
sgrub pa chen po	mahāsādhana	Great accomplishment; one of the four aspects of approach-accomplishment
mngon shes	abhijñā	Superknowledges (five)
mngon par byang chub pa	abhibodhi	True awakening (five)
rnga yab	camara	Chowry
cod pan	mukuṭa	Crown; diadem
cod pan gyi dbang	mukuṭābhiṣeka	Crown empowerment; the second of the Seven Empowerments Raising the Child
gcus thig		Curved line
cha chen	mahābhaga	Major unit; unit of measurement
cha chung	mātrā, kṛśa	Minor unit; unit of measurement
cha phran		Fractional unit
chu gri	kṛpāṇī	Small curved knife
chu tshod	nāḍī	A period of time; sixty nāḍī equals one solar day
chu srang	pala	A period of time; sixty pala equals one nāḍī (*chu tshod*)
chu srin	makara	Crocodile-like sea monster
chu'i dbang	toyābhiṣeka	Water empowerment; the first of the Seven Empowerments Raising the Child
chos kyi 'khor lo	dharmacakra	A name for the heart center
chos kyi gaṇḍī	dharmagaṇḍī	Dharma-semantron
chos kyi dung	dharmaśaṁkha	Dharma-conch
chos dbyings ye shes	dharmadhātujñāna	Reality awareness; one of the five awarenesses
mchod pa'i cho ga	pūjāvidhi	Offering ritual
mchod pa'i sa gzhi	pūjābhūmi	Offering ground
'chi bdag gi bdud	mṛtyupatimāra	The māra of the lord of death
rjes dran	anusmṛti	Consummation; one of the six yogas

TIBETAN	SANSKRIT	ENGLISH
rjes su gnang ba'i dbang	anujñābhiṣeka	Permission empowerment; the seventh of the Seven Empowerments Raising the Child
nyag mtshams		Indent
nyam chung	Bhṛṅgī	One of the perimeter beings
nye bar sgrub pa'i yan lag	upasādhana	Near accomplishment; one of the four aspects of approach-accomplishment
nyon mongs pa	kleśa	Emotional defilement
nyon mongs pa'i bdud	kleśamāra	The māra of emotionality
mnyam nyid ye shes	samatājñāna	Equality awareness; one of the five awarenesses
mnyam gnas	samāna	One of the ten winds
mnyam pa'i stabs	samapada	Even stance
snying rje'i dbang bskur	karuṇābhiṣeka	Empowerment of Compassion
snying stobs	sattva	Goodness; one of the three qualities/principles
bsnyen pa	sevā	Approach; one of the four aspects of approach-accomplishment
bsnyen sgrub	sevāsādhana	Approach-accomplishment; this has four branches/aspects
ting nge 'dzin	samādhi	Absorption (five); also one of the six yogas
gtum mo	caṇḍālī	Tummo; literally "fierce woman"; a fire imagined blazing from drops in the central channel
rta gdong gi me	vāḍavāgni	"Fire from the mare's mouth"; a fire underneath the ocean
rta babs	toraṇa	Toran; decorative structure over a doorway; porch
rten 'brel	pratītyasamutpāda	Link of dependent origination (twelve)
lte ba	karṇikā	Of a lotus; the receptacle
stegs bu	vedika	Plinth
stong pa chen po yi ge lnga	pañcākṣaramahāśūnya	Five letters of great emptiness
stobs	bala	Power (five)
bstan 'gyur		Tenjur. Collection of the Tibetan translations from Sanskrit of the commentaries; liturgies and so forth related to the materials preserved in the Kanjur
thig skud	(vajra)sūtra	Cord used in measuring out surfaces; chalked string
thig le	bindu	Drop/drop-potential
thig le stong pa yi ge drug	binduśūnyaṣaḍakṣara	Six letters of empty potential
thig le'i rnal 'byor	binduyoga	Yoga of the Drop
thig rtsa		Grid of lines for drawing a mandala; image

Tibetan	Sanskrit	English
thun	prahara	Session/watch; a division of time, eight of which equals one solar day
thur sel	apāna	One of the ten winds
mtho	vitasti	Span; a unit of measurement
dag pa dran pa		Contemplation of purity
dar dpyangs kyi dbang	paṭṭābhiṣeka	Silk Scarf empowerment; the third of the Seven Empowerments Raising the Child
dung can ma	śaṅkhinī	"Conch"; "mother-of-pearl"; the name of the central channel below the navel
dur khrod kyi 'khor lo	śmaśānacakra	Charnel-ground wheel; the term used in the *Vajrāvalī* for weapon wheel (*mtshon cha'i 'khor lo*)
dus sbyor	lagna	Rising sign; ascendant (twelve)
de nyid	tattva	Principle; the twenty-four principles of the phenomenal world are from Sāṁkhya philosophy
de bzhin gshegs pa'i 'phar ma	tathāgatapuṭa	Tathāgata-extension; the covered area around the lotus of Kālachakra
do shal	hāra	Garland
do shal phyed pa	hārārdha	Drop (short garland hanging down from one end)
dwangs ma	mastu	Vitality; essence
dra phyed		Drop; same as '*do shal phyed pa*'
dra ba		Garland; same as '*do shal*'
dran pa nye bar gzhag pa	smṛityupasthana	Object of close attention (four)
bdud rtsi'i 'bras bu	amṛitaphala	Amla; Indian gooseberry
bdud bzhi	caturmāra	The four māras
bde ba chen po'i 'khor lo	mahāsukhacakra	A name for the forehead center in the head
bden pa gnyis	satyadvaya	The two realities
bden pa bzhi	catuḥsatya	The four truths
mda' thig	kramaśīrṣasūtra	Parapet line
mda' yab	kramaśīrṣa	Parapet
'dod pa'i gnas skabs	kāmāvasthā	Stage of passion (ten)
'dod ma	icchā	Desire goddess
rdul	rajas	Passion; one of the three qualities/principles
rdul tshon gyi dkyil 'khor	rajomaṇḍala	Powder mandala
rdul rdzas		Seed material; female equivalent of bindu

Tibetan	Sanskrit	English
rdo rje brtul zhugs kyi dbang	vajravratābhiṣeka	Vajra Conduct empowerment; the fifth of the Seven Empowerments Raising the Child
rdo rje dril bu'i dbang	vajraghaṇṭābhiṣeka	Vajra and Bell empowerment; the fourth of the Seven Empowerments Raising the Child
rdo rje 'phreng ba	vajrāvalī	Vajra-garland
rdo rje'i 'dug stangs	vajrāsana	Vajra-posture
rdo rje'i sa gzhi	vajrabhūmi	Vajra-ground; also known as the offering ground
bsdu ba'i dngos po	saṃgrahavastu	Method of influence (four)
nas	yava	Barley-corn; unit of measurment
nor las rgyal	dhanañjaya	One of the ten winds
rnam bcu dbang ldan	daśākārovaśī	The "ten-powered" Kālachakra monogram
rnam thar sgo	vimokṣamukha	Door of liberation (four)
rnam thar	vimokṣā	Liberation (eight)
rnam pa thams cad kyi mchog dang ldan pa'i stong pa nyid	sarvākāravaropetā śūnyatā	Emptiness possessing the totality of possibilities
rnal 'byor ma	yoginī	A female yogin; also a type of goddess
snam bu	paṭṭikā; paṭṭa	ledge; band
padma'i 'dug stangs	padmāsana	Lotus posture
dpag tshad	yojana	Unit of measurement (about nine miles)
dpag bsam gyi shing	kalpavṛkṣa	Wish-granting tree
spang chung		Narrow gap
spyi blugs	kamaṇḍalu	Water pot carried by monks or ascetics
sprul pa'i 'khor lo	nirmāṇacakra	A name for the navel center
pha gu	paṭṭī	(Jeweled) frieze
pha rol tu phyin pa	pāramitā	Transcendent virtue (10)
phung po'i bdud	skandhamāra	The aggregate māra
phyam		Joist; rafter
phyi tshe (byi tshe)		Cornice
phyir 'dod ma	pratīcchā	Counterdesire goddess
phyogs	pakṣa	Fortnight; half of a lunar month
phyogs skyong	dikpāla	Protector of the directions
phra mo'i rnal 'byor	sūkṣmayoga	Subtle Yoga

Tibetan	Sanskrit	English
'phred thig		Horizontal line
bag chags	vāsanā	Disposition
bum pa	kalaśa	Vase; pot
bya ba grub pa'i ye shes	kṛtyānuṣṭhānajñāna	Accomplishing awareness; one of the five awarenesses
bya ba'i 'khor lo	kriyācakra	Name of the sixty small centers in the joints of the fingers and toes
byang chub kyi phyogs kyi chos	bodhipakṣa dharma	Factors oriented toward enlightenment (37)
byang chub kyi yan lag	bodhyaṅga	Component of enlightenment (seven)
byis pa 'jug pa'i dbang bdun		The Seven Empowerments Raising the Child; the main empowerments for the Kālachakra creation process
dbang po	indriya	Ability (five); also the sense organs (six)
dbu ma	avadhūtī	The main central channel
ma 'dres pa'i chos	āveṇikā dharmā	Unique attribute of a tathāgatha (18)
ma mo	mātṛkā	"Mother"; a type of goddess
mi 'dod ma	pratīcchā	Counterdesire goddess
mig sngon	nīlākṣa	A type of blue bird
ming gi dbang	nāmābhiṣeka	Name empowerment; the sixth of the Seven Empowerments Raising the Child
mi'am ci	kinnara	Humanoid; human-like being
mun pa	tamas	Gloom; one of the three qualities/principles
me ri		Fire-mountain; also called garland of light (*'od zer gyi phreng ba*)
me long lta bu'i ye shes	ādarśajñāna	Mirror-like awareness; one of the five awarenesses
myos pa srung ba	mattavāraṇa	Guardrail; lit. "drunk-protection"
dmar ser	piṅgalā	"Red-yellow"; the continuation of the rasanā channel below the navel
rtsa thig	mūlasūtra	Baseline
rtsangs pa	kṛkara	One of the ten winds
tshangs bug	brahmarandhra	Small orifice at the crown of the head
rtsig pa	bhitti	Wall
rtseg ma	pura	Stage; level; part of the structure of a toran
tshangs thig	brahmasūtra	Central line
tshad med pa	catvāpramānāni	Immeasurable (four)

TIBETAN	SANSKRIT	ENGLISH
tshon sa	raṅgabhūmi	Colored ground
mtshon cha'i 'khor lo		Weapon wheel
'dzin pa	dhāraṇā	Retention; one of the six yogas
rdzu 'phrul gyi rkang pa	ṛddhipāda	Base of transformation (four)
rdzogs rim	utpannakrama	Perfection process
zhags pa	pāśa	Bond; fetter; binding
zhing skyong	kṣetrapāla	Protector of the land/field
zhu bde		Melting bliss
gzhal yas khang	vimāna	Palace
gzhu	dhanu	Bow; unit of measurement
bzhon pa	vāhana	Mount
zag med kyi phung po		Untainted collection (five)
zur thig	koṇasūtra	Diagonal line
zlum po'i stabs	maṇḍalapada	Circular stance
gzungs	dhāraṇī	Recited verse or formula (four)
gzungs ma	dhāriṇī	Offering goddess; "bearer of gifts"
'od zer gyi phreng ba	raśmijvāla	Garland of light; the outer perimeter of the mandala
yang dag par spong ba	samyakprahāṇa	Discipline (four)
yi dags	preta	Corpse; ghost
yid bzhin gyi nor bu	cintāmaṇi	Wish-fulfilling jewel
yongs 'du'i me tog	pārijāta [flower]	Pārijāta flower
yon tan gsum	triguṇa	Three qualities/principles; known from Sāṃkhya philosophy
ra ba	prākāra	Wall
rab gtum ma	prachaṇḍā	Fury; type of wrathful goddess
rig ma	vidyā	Female consort
rin chen snam bu	ratnapaṭṭikā	Jeweled frieze
rus sbal	kūrma	One of the ten winds
ro ma	rasanā	The main channel in the body; on the right
rol pa'i stabs	lalitapadam	Lalita (relaxed, playful) posture
rlon thig		Final line
rwa	śṛṅga	Peak; summit; pinnacle

TIBETAN	SANSKRIT	ENGLISH
las kyi 'khor lo	karmacakra	Name of the centers in the twelve joints
las kyi dbang po	karmendriya	Action organs (six)
las kyi dbang po'i yul	karmendriyaviṣaya	Activities of the action organs
las rgyal mchog	karmarājāgrī	Mastery of Activity
las rlung	karmavāyu	Action-wind
lug	iḍā	"Sheep"; the continuation of the lalanā channel below the navel
lus zungs	dhātu	Bodily constituent (six or seven)
logs thig	tiryak sūtra	Side line
longs spyod rdzogs pa'i 'khor lo	saṁbhogacakra	A name for the throat center
shar bu	bakulī	Pipes; fascia
shin tu yid bzang ma	avadhūtī, suṣumnā	a name for the central channel
sa ga'i stabs	vaiśākhapadam	Vaiśākha posture
sems 'grel skor gsum		The Bodhisattva Trilogy; three tantra commentaries written from a Kālachakra perspective
sems ma	cittā	Female bodhisattva
so sor rtogs pa'i ye shes	pratyavekṣājñāna	Distinctness awareness; one of the five awarenesses
so sor sdud pa	pratyāhāra	Withdrawal; one of the six yogas
sor	aṅgula	Finger-width; unit of measurement
sor phyed	aṅgulārdha	Half-finger; unit of measurement
srog rtsol	prāṇāyāma	Wind control; one of the six yogas
srog 'dzin	prāṇa	One of the ten winds
gsung rab kyi yan lag	pravacana	Aspect of the teachings (nine)
bsam gtan	dhyāna	Mental focus; one of the six yogas
har mi	harmi	Covering; canopy
lha snam	devatāpaṭṭikā	Deity-podium
lha'i bu'i bdud	devaputramāra	The māra of the divine child
lhan skyes 'khor lo	sahajacakra	A name for the forehead center in the head
lhas byin	devadatta	One of the ten winds

Bibliography

The author used multiple abbreviations (e.g., Bglha9) to refer to Tibetan texts. While we were able to identify many of these and cite their full references in this bibliography, we were unable to identify several abbreviations as we were not able to consult the author during the final editing process. Some of the abbreviations refer to texts that appear easily identifiable, yet specific editions used by the author were not identified and thus remain uncertain. The abbreviations, given alphabetically, that remain unidentified are: 6ykrab, Acvrjed, Bg6yspyi, Bubangre, Bukhory, Bukthig, Cgsadle, Dpkthig, Dpyega, Kacoin, Kagcho, Kaldri, KalT, Kapjon, Kasain, Katodo, Kayega, Kayolt, Kazuju, Kdkthig, Kgkdzhal, Kzabhis, Mdphend, Mtkmand, Phmangom, Phviman, Takhist, Tgpets, Tndemnag, Tnkutsd, Tsluido, Ttgyam.

Abhayākaragupta. *Niṣpannayogāvalī(-nama)* (*rdzogs pa'i rnam 'byor gyi phreng ba shes bya ba*). (Niṣpann). Tōhoku 3141.

———. *Vajrāvalī(-nāma-maṇḍalasādhana)* (*dkyil 'khor gyi cho gar do rje phren ba shes bya ba*). (Vvali). Tōhoku 3140.

Anupamarakṣita. *Ṣaḍaṅgayoga-nāma* (*sbyor ba yan lag drug pa shes bya ba*). Tōhoku 1367. (English translation in Sferra).

Banda Gelek (Banda Thubten Gelek Gyamtso). (Bgkuzi). 2019. *The Chariot That Transports to the Kingdom of the Four Kāyas.* Trans. Adele Tomlin. Dharamasala: Library of Tibetan Works and Archives.

———. (Bgdubum). *Excellent Vase of Nectar, Accomplishing the System of Cultivation of the Extensive Creation Stage of Kālacakra with Particular Connection to the Ground, Path and Fruit* (*dpal dus kyi 'khor lo'i bskyed rim rgyas pa gzhi lam 'bras bu khyad par can sbyar nas sgom tshul dngos grub bdud rtsi'i bum bzang*).

———. (Bgkuzi). 2019. *The Chariot That Transports to the Kingdom of the Four Kāyas.* trans. Adele Tomlin. Dharamasala: Library of Tibetan Works and Archives.

———. (Bggthig). *Illuminating Sun-Rays, the Lines and Colors of the Ocean of Mandala Rites Composed by the Protector of the Master* (*rje sgrol ba'i mgon pas mdzad pa'i dkyil chog rgya mtsho'i thig tshon gsal byed nyi ma'i 'od zer*).

———. (Bgslos). *Jeweled Garland, An Explanation of the Lines and Colors of the Ocean of Mandalas of the Ancient Tantras* (*gsang sngags rnying ma'i dkyil 'khor rgya mtsho'i tshig tshon gyi rnam bshad mu tig phreng ba*).

———. (Bg6yspyi). *Ocean of Nectar, Eloquent Vajra like Explanation of the General Meaning of the Six-Branched Application of the Kālachakra Perfection Stage* (*dpal dus kyi 'khor lo'i rdzogs rim sbyor ba yan lag drug gi spyi don legs bar bshad pa rdo rje bdud rtsi'i chu gter*).

———. (Bglha9) *Stages of the Path to Vajradhara, Instruction for Visualization of the Nine-Deity Kālachakra Sādhana* (*dpal dus kyi 'khor lo lha dgu'i sgrub thabs kyi dmigs khrid rdo rje 'chang*).

———. (Bgcmrir). *White Crystal Mirror, the Lines and Colors of the All-Knowing Sakya Tradition* (*kun rig sa lugs kyi tshig tshon rab gsal shel dkar me long*).

Dehejia, Vidya. 1979. *Early Stone Temples of Orissa.* (Orisrev). Durham, NC: Carolina Academic Press.

———. 1986. *Yogini Cult and Temples: A Tantric Tradition.* (Yoginct). New Delhi: The National Museum.

Detri Rinpoche, Jamyang Thubten Nyima (sde khri 'jam dbyangs thub bstan nyi ma). (Kajazhal). *dpal dus kyi 'khor lo'i thugs dkyil gyi 'don bsgrigs bdud rtsi'i bum bzang*, in *gSung 'bum 'jam dbyangs thub bstan nyi ma*, vol. 3 [Bla Brang Bkra Shis 'khyil], 1999, pp. 167–204. Buddhist Digital Resource Center MW22204.

Gerke, Barbara. 2011. *Long Lives and Untimely Deaths.* Leiden: Brill.

Gos Lotsawa. 1949. *Blue Annals.* (BlueAn) trans. George Roerich. Calcutta, Royal Asiatic Society of Bengal.

Grönbold, Günther. 1996. *The Yoga of Six Limbs: An Introduction to the History of Ṣaḍaṅgayoga*. New Mexico: Spirit of the Sun Publications.

Guenther, Herbert V. 1972. *The Tantric View of Life*. Boulder, CO: Shambhala Publications.

Kapstein, Matthew. 2001 (1995). "From Kun-mkhyen Dolpo-pa to 'Ba'-mda' Dge-legs: Three Jo-nang-pa Masters on the Interpretation of the Prajñāpāramitā," (Mkdoleg) in *Tibetan Studies, Volume 1: Proceedings of the 7th Seminar of the International Association for Tibetan Studies*, Graz: Verlag der Österreichischen Akademie der Wissenschaften. Reprinted in *Reason's Traces: Identity and Interpretation in Indian and Tibetan Buddhist Thought*. Somerville, MA: Wisdom Publications.

Kongtrul, Jamgön. 1996. *Creation and Completion: Essential Points of Tantric Meditation*. Sarah Harding, trans. Boston: Wisdom Publications.

Larson, Gerald. 1969. *Classical Sāṃkhya: An Interpretation of its History and Meaning*. Delhi: Motilal Barnasidass.

Mori, Masahide. 2009. *Vajrāvalī of Abhayākaragupta, edition of Sanskrit and Tibetan versions* (2 volumes). Buddhica Britannica Series Continua, 11. Tring: Institute of Buddhist Studies.

Nāropa. (Dbangdor). *Sekoddeśaṭīkā*.

Newman, John. 1987. "The Outer Wheel of Time: Vajrayana Buddhist Cosmology in the Kalacakra Tantra." Ph.D. dissertation, University of Wisconsin.

O'Flaherty, Wendy Doniger. 1975. *Hindu Myths: A Sourcebook Translated from the Sanskrit*. (HinduM). New York: Penguin Books.

Rangjung Dorje, Third Karmapa. 2014. *The Profound Inner Principles with Jamgön Kongtrul Lodrö Taye's Commentary Illuminating "The Profound Inner Principles."* (Kyedzok) & (Zabnang). Elizabeth M. Callahan, trans. Boston: Snow Lion Publications.

Sādhuputra. *Śrī-Kālacakrasādhana(-nama)* (*dpal dus kyi 'khor lo'i sgrub pa'i thabs shes bya ba*). Tōhoku 1358.

Sferra, Francesco. 2000. *The Ṣaḍaṅgayoga by Anupamarakṣita with Raviśrījñāna's Guṇabharaṇīnāmaṣaḍaṅgayogaṭippaṇī*. Serie Orientale Roma LXXXV. Roma: Instituto Italiano per L'Africa E L'Oriente.

Sharkey, Gregory. 2006. *Buddhist Daily Ritual*. (Gsardit) Bangkok: Orchid Press.

Tsuda, Shinichi. 1974. *The Saṃvarodaya Tantra: Selected Chapters*. Tokyo: Hokuseido Press.

Vibhūticandra. *Antarmañjarī* (*nang gi snye ma*). (Nangnye). Tōhoku 1377.

Wallace, Vesna. 2001. *The Inner Kālacakratantra: A Buddhist Tantric View of the Individual*. New York: Oxford University Press.

———. 2004. *The Kālacakratantra: The Chapter on the Individual together with the Vimalaprabhā*. New York: American Institute of Buddhist Studies, co-published with Columbia University's Center for Buddhist Studies and Tibet House US.

———. 2010. *The Kālacakra Tantra: The Chapter on Sādhanā Together with the Vimalaprabhā Commentary*. New York: American Institute of Buddhist Studies, co-published with Columbia University's Center for Buddhist Studies and Tibet House US.

INDEXES

Index of Canonical Authors Cited

INDIAN AUTHORS

Abhayākaragupta, 7, 8, 27, 28, 37, 54, 59, 65, 72, 118, 132, 142, 148

Anupamarakṣhita, 8, 125, 205, 206, 208

Kālachakrapāda, 76, 143

Kālachakrapāda the Elder (Chilupa), 5–7, 8, 205–6

Kālachakrapāda the Younger (Avadhūtipa), 6, 7, 205–6

Nālandāpa, 6–7

Nāropa, 6, 7, 199, 205

Puṇḍarīka, 5, 8

Sādhuputra, 6, 8, 28, 59, 75, 76, 80, 118, 143

Somanātha, ix, 5, 7, 8, 206

Suchandra, 5, 28, 107

Vibhūtichandra, 8, 185, 205–6

Vinayākaramati, 6, 7–8

TIBETAN AUTHORS

Atisha, 205, 206

Banda Gelek, xiii, xiv, 9, 10, 11, 27, 29, 30, 31, 32–35, 37, 39, 40, 43, 45, 46, 48, 51, 52, 53, 54, 55, 59, 61–62, 63, 72, 75, 76, 77, 81, 83, 84, 86, 87, 89, 90, 91, 92, 93, 94, 95, 96, 99, 101, 102, 104, 106, 107, 110, 111, 112, 118, 120, 121, 122, 125, 128, 132, 134, 142, 143, 145, 146, 150, 161, 162, 163, 164, 166, 167, 169, 171, 174, 175, 177, 178, 179, 181, 184, 187, 188, 195, 196, 199, 201, 204, 205, 206, 207

Buton Rinchen Drup, 8–9, 29, 35, 74, 80, 118, 153

Chowang Drakpa, 121

Dalai Lama, Kalzang Gyatso (seventh), 72

Dalai Lama, Tenzin Gyatso (fourteenth), ix, 9

Detri Rinpoche, Jamyang Thubten Nyima, 9, 117, 134, 161, 163, 165

Dolpopa Sherab Gyaltsen, ix, 8–9, 27, 29, 37, 46, 55, 69, 83, 126, 132, 134

Drakpa Gyaltsen, 4, 12, 203–4

Drukpa Pema Karpo, 20

Gos Lotsawa. *See* Zhonnu Pal

Jonang Chokle Namgyal, 9, 59, 74, 87, 94, 118, 174, 175

Kalzang Gyatso, 126, 132, 161

Karmapa, Mikyö Dorje (eighth), 9, 75

Karmapa, Rangjung Dorje (third), 9

Karmapa, Thekchog Dorje (fourteenth), 9, 28

Khedrubje, 9, 28, 204

Kunpang Thukje Tsondru, ix, 206–7

Lozang Chophel Gyatso, 58, 59, 61

Maitripa, 76

Mipham, 16, 17, 18, 33, 162, 171

Shabari, 205

Sherab Gyatso, 28, 55

Tāranātha, ix, xiii–xiv, 5, 9, 24, 27, 28, 37–55, 65, 66, 72, 73, 74, 75, 76, 77, 79, 80, 87, 89, 90, 93, 106, 112, 118, 119, 120, 121, 126, 127, 129, 131–32, 134, 137–38, 139, 142, 143, 145, 146, 150, 173, 177, 199, 201, 202, 205, 206, 207, 209, 211, 212, 214, 215, 216

Tenga Rinpoche, 60

Thekchog Dorje, 60, 75

Tsoknyi Gyatso, 27, 54, 55, 58

Tsongkhapa, 9, 46, 48, 50, 118

Vasubandhu, 28

Zhonnu Pal (Gos Lotsawa), 121

Index of Canonical Texts Cited

Abhidharmakosha (Vasubandhu), 28

Antarmañjarī (Vibhūtichandra), 185

Blue Annals, The (Gos Lotsawa Zhonnu Pal), 8

Chariot that Transports to the Kingdom of the Four Kāyas, The (Banda Gelek), 86

8,000-verse *Prajñāpāramitā*, 208

Excellent Vase of Realization Nectar (Banda Gelek), 188

General Meaning of the Six Yogas, The (Banda Gelek), 179, 181, 184

Guhyasamājatantra, 211

Illuminating Sun-rays, The (Banda Gelek), 27, 46, 51, 52, 55, 64, 81, 112

Jeweled Garland, The (Banda Gelek), 91

Kālachakra Tantra, ix, 4, 8, 10, 16, 27, 28, 31, 59, 89, 90, 161, 168, 169, 179, 181, 189, 206, 207, 212

Kālacakrasādhana (Sādhuputra), 75, 118

Kālachakra Laghutantra, 5, 6, 7, 32

Kālachakra Mūlatantra, 7, 27, 28, 32, 35–37, 163

Kālachakra Tantrottara, 6

Kaulajñānaniyama, 136

Kulārṇava Tantra, 136

Melody of the Queen of Spring, The (Tsoknyi Gyatso), 27, 57, 58, 64, 81, 142, 149

Niṣpannayogāvalī (Abhayākaragupta), 28, 65, 72, 118, 146

Ocean of Nectar (Tāranātha), 65

Saṁvarodaya Tantra, 47

Sekoddesha, 6, 7, 215

Sekoddeshaṭīkā (Nāropa), 199

Vairochanābhisambodhi, 4

Vajrāvalī (Abhayākaragupta), 27, 28, 37, 46, 54, 55, 57, 59, 62, 65, 66, 69, 72, 73, 74, 75, 79, 80, 142

Vimalaprabhā (*Stainless Light*, Pundarika), 4, 5, 6, 9, 10, 14, 15, 17, 18, 27, 28, 30, 32, 33, 35, 36, 42, 59, 65, 66, 68, 69, 70, 72, 73, 74, 76, 77, 79, 80, 91, 102, 112, 117, 118, 126, 132, 134, 139, 140, 147, 150, 161, 162, 163–64, 166, 171, 175, 184, 215

White Crystal Mirror, The (Banda Gelek), 27, 37, 55

General Index

Page numbers in italics refer to illustrations.

A

accomplishing awareness, awakening to, 191

Achala, 150, *156*

action organs, 15, 17, 22

 development of, 182

 purification of, 128, 173

aggregates

 development of, 167, 175–76, 182, 184, 193

 empowerment and, 21

 mandala symbolism and, 14, 16, 17

 māra of, 119

 purification of, 168, 172–74, 191, 195–96, 202, 217

 winds and, 219

Agni, 147

Ahibandhanecchā, 144

Ākṛṣṭīcchā, 143

Akṣhobhya, 68, 121, 123, 130, 168, 173, 193, 219

Amitābha, 21, 123, 130, 172, 191, 199, 219

Amoghasiddhi, 22, 66, 123, 130, *133*, 168, 172, 173, 191, 199, 219

Amṛtaphalā, 134

Ananta, 152

Aṅgemlecchā, 143

animal seats and mounts, 59–61, 110, 134, 138, 146–47

anusmṛti (consummation), 188, 203

 practice of, 208, 216, 217, 218, 219

approach-accomplishment, four aspects of, 187–88, 202, 203, 216

Āsanecchā, 144

Ashukecchā, 141, 143

Atinīlā, 132, 150, 152, 153

attendant deities, 144

awareness of enlightenment

 mandala as, 4, 12–13, 203–4

 mandala symbolism and, 165, 166

awareness vajra, 120, 196

 emblem, 128

 empowerment and, 20, 23

 palace symbolism and, 163

 seal of, 202

 Subtle Yoga and, 11, 170, 187

awareness-wind, 185, 186, 198, 213, 217

B

Bahukalahecchā, 144

Bālamṛtya, *158*

Bandhanecchā, 144

beatific body (*sambhogakāya*), 166, 167, 168–69, 170, 176, 189, 196, 203

Bhagavad Gītā, 147

Bhojanecchā, 143

Bhṛkuṭī, 150, *156*

Bhūṣhaṇecchā, 144

bindu, 180, 209

 for representing deities, 62, 63, 65, 66

Bindurūpiṇī, 127

birth/rebirth, 179–87

 four bodies and, 166–67

 gestation and birth, 167, 168–69, 181–87, 192, 193, 194, 195, 196, 198, 199–200

 lineage of parents and, 179–80, 189, 190–91

 process of conception, 17, 180–81

 purification of, 17, 190–91, 193–94, 195–96, 197, 198, 199, 201, 217

 types of, 178

bliss

 and emptiness, 16, 175, 197, 215–16

 gestation and, 166, 167, 168, 175, 181, 196

 tummo and, 202–3

unchanging great, 170, 202, 203, 208, 215–16, 218
bodhisattva trilogy, 5, 6, 8, 24
bodhisattvas and consorts
 empowerment and, 22
 four bodies and, 168
 purification and, 198
 radiation of, 193–94
 representations of, 68, 77, 128–29, 131
body palace, 12, 18
 deities of, 19, 73–76, 77, 79, 137, 138, 141, 144–52, 153, 169, 171
 measurements for, 28, 29–31, 32, 35–36, 37–40, 43–44, 90–91
 radiation of deities of, 194
 seats for deities of, 52–53, 60, 108–10
 in three dimensions, 105
 walls of, 57, 162, 164
body vajra, 120
 emblem, 128
 empowerment and, 20, 21
 Mastery of the Mandala and, 11, 169, 187
 orgasmic body and, 169–70
 palace symbolism and, 161–63
 seal of, 202
Brahmā, 140, 145, 147, 148, 149
Brahmāṇī, 137, 140–41
buddha levels, 163–64
Buddhalochanā, 130, 133
buddhas and consorts
 empowerment and, 21
 purification and, 193, 198
 representations of, 66–68, 128–30

C
Chakrasaṁvara tradition, 6, 9, 24, 46, 50
channels, winds, and drops
 blazing and melting and, 196–97, 198, 199, 200, 202–3, 208
 creation of samsara and, 213–14, 218–19
 death process and, 178–79
 description of, 209–10
 four bodies and, 170, 176
 gestation and birth and, 17, 167, 168, 170, 181–86, 192, 193, 194, 195, 196, 198, 199
 mandala symbolism and, 117, 118, 119, 162
 meditations on, 191–92, 194
 offering goddesses and, 134
 purification of, 11, 22, 172, 173, 174, 196–98, 199–200
 purity of channels, 170–71
 purity of postures and, 177
 shaktis and, 127–28

six yogas and, 188, 208, 216–19
ten winds, 210
character, awakening of the, 191
Charchikā, 70, 137, 138, 146
chariots, for wrathfuls, 19, 53–54, 55, 60–61, 73, 109–10, 149–50
charnel grounds
 deities of, 80, 152, 168
 in drawn mandala, 46–50
 in mind mandala, 81, 83
 symbolism of, 164
 in three dimensions, 107
 weapon wheels of, 54, 61, 76
Chundā, 150
Circle of Great Bliss, 19
 colors for, 57, 110, 115
 in drawn mandala, 38–39, 40, 41, 43, 67
 foundation for, 96–97
 four bodies and, 168, 169
 in mind mandala, 81, 83
 symbolism of, 164
 in three dimensions, 93, 94, 94, 106
clear light
 completion dissolving into, 179
 creation of samsara and, 218–19
 of death, 188
 four drops and, 212
clouds, in charnel grounds, 46, 49
colored ground, 40, 41, 43, 57, 92, 93, 110
colors
 in drawn mandala, 55–62
 of main deities, 120, 126
 in mind mandala, 83–84
 symbolism of, 15, 162
 for three-dimensional mandala, 110–12
compassion, 163
 great bliss and, 208, 215
 mandala symbolism and, 13, 120
compassionate empowerment, 11, 195–96
consciousness
 awakening of, 167, 186, 199–200
 death process and, 179
 month of, 181
contact, month of, 182
craving, month of, 183
creation process
 form of deity and, 17
 meditations, 188–202
 overview of four sections of, 10–12, 187–88

purification, perfection, and development in, 13–14, 18, 169, 178, 187–88, 191, 204

 symbolism of, 14–18

 world-system mandala and, 86, 89

crown empowerment, 20, 21–22

D

Dārakākroshanecchā, 144

day yoga, 207, 208, 217

death process

 "cheating of death" and, 218

 description of, 178–80, 186

 meditation on, 188

 purification and, 217

deceased mind, 179, 189

deep sleep state, 176, 186, 201, 216

deities of the mandala

 of body palace, 144–52

 buddhas and consorts, 128–30

 deities of the podium, 137–41, 145–49

 description of seats for, 50–55, 59–61, 108–10, 117–18, 162

 door-protectors, 149–50

 eight shaktis, 126–28

 empowerment and, 20–21

 four ways of representing, 62

 icchā goddesses, 141–44

 Kālachakra and Vishvamātā, 117–26

 male and female bodhisattvas, 131

 of mind palace, 117–34

 nāgas, 150–52

 overview of, 19, 153

 perimeter beings, 153

 prachaṇḍā goddesses, 150–53

 purity of emblems of, 174–77

 purity of four bodies and, 168–70

 purity of postures of, 177

 radiation of mandala deities, 193–95, 198

 representations in drawn mandala, 62–80

 sources for, xv

 of speech palace, 134–44

 speech vajra and, 163

 symbolism of, 166–78

deity podiums

 colors of, 57, 59

 deities of body, 145–49

 deities of speech, 137–41

 in drawn mandala, 40, 41, 43, 51

 measurements for, 97

deity practices

 of different traditions, 9

 symbolism and meaning and, 12–14

Dhanada, 146, 149. *See also* Kubera

dharāṇā (retention), 188, 197, 198, 199, 200, 201, 202

 practice of, 208, 216, 217, 218, 219

dharmachakras, 54, 165, 171

Dharmadhātu mandala, 6

Dharmadhātuvajrā, 199

dharmodaya, 16, 86

Dhāvanecchā, 143

Dhūmā, 22, 66, 127, 128, 172

Dhūpā, 69

dhyāna (mental focus), 188, 190, 191–92, 193, 194, 195, 196, 203

 practice of, 208, 216–17, 219

direction-protectors, 46, 49–50, 80, 83, 107

distinctness awareness, awakening to, 191

divine-palace mandala, 3–4, 12

door-protectors, 53, 109–10, 128, 131–32, 144, 149–50

 purification and, 198

 radiation of, 194

dream state, 176, 186, 216

Dro tradition, 8, 206

Drop Yoga, 10, 178

 as accomplishment, 187

 four bodies and, 170

 meditations, 11, 202–3

 six yogas and, 188

drop-potentials

 completion of factors of, 202

 conception and, 17, 180

 four bodies and, 212

 mental body and, 179

 purification of, 190, 196

drops, 209, 210–11. *See also* channels, winds, and drops; four drops

drunk protectors, 99

E

earth perimeter, 31, 58, 77, 84, 107

eight liberations, of body, speech, and mind, 164

eightfold path, 164

elemental disks

 measurements for, 90–91

 nāgas and, 54–55, 60, 74–75, 110, 150

 purification and, 189

 world-system mandala and, *85*, 86, 87–88, 89

elements

 breath and, 167

classification of, 17–18
development of, 181, 182, 184, 193
dissolution of, 178–79, 188, 207
four bodies and, 175–76
mandala symbolism and, 14
palace symbolism and, 162, 164
as perimeter, 31, 107
purification of, 168, 172–74, 191, 195–96, 217
emanation body (*nirmāṇakāya*), 166, 167, 168, 169, 170, 176, 203
emblems
four, 128, 165, 168, 171, 172
purity of deity's, 174–77
for representing deities, 62, 64–80
emotional defilements, 118–19
purification of, 172
empowerment
of the deities, 201–2
mind palace and, 23
structure of, 20–23
Empowerment of Compassion, 11, 195–96
emptiness
awakening to, 178, 188
and bliss, 16, 175, 197, 215–16
dissolution of elements into, 188
five letters of great, 14–18, 212
six letters of empty potential, 14–18
of six senses, 163
sixteen, 164
empty-forms
experience of, 217–18
mahāmudrā of, 208, 217, 218
nature of all causes as, 216
ten signs and, 207, 219
equality awareness, awakening to, 190–91

F
field-protectors, 80, 83
fire perimeter, 46, 54, 58, 80
fireflies, signs of, 179
fire-mountain, 59, 84, 111
five awakenings, 178
five buddhas. *See* buddhas and consorts
five powers, 164, 173
five seals, 202
five superknowledges, 165
five untainted collections, 164
flower arrows, 119
formation of the body, awakening of, 191, 195
four absorptions, 164

four bodies (*kāyas*), 166n16
four emblems and, 175
four states and, 176–77
process of life and, 166–67, 168–69, 175–77
purity of, 168–70, 175–76
realization of, 203
symbolism of deities and, 166
four dhāraṇīs, 164
four disciplines, 165
four drops
four bodies and, 212
four states and, 213
purification and, 216
four immeasurables, 163
four inner seals, 175
four joys, 202–3, 208, 217
four māras, 118–19
purification of, 172, 202
four objects of close attention, 163
four states
four bodies and, 176–77
purification of, 202, 216
samsara and, 213
four truths, 165

G
Gaṇapati, 138, 140, 147, 148, *155*
Gandhā, *139*
Gandhecchā, 144
garland of light, 31, 58, 59, 107
garuḍa, 60, 61n4, 109–10, 149
Garuḍāsyā, 150, 152
Gaurī, 148
Gelug tradition, 9, 28, 48, 54, 59, 153
Gītā, 69, 134
Glorious Lunar Mansions, 5, 6
Golden Ground, 86, 87
grasping, month of, 184
Gṛdhrāsyā, 152
ground, path, and goal, 13, 211–12
Guhyasamāja tradition, 7, 9, 205, 206

H
Hevajra tradition, 6, 9, 205, 206

I
icchā goddesses, 136–37, 141–44, 174, 195
Indra, 138, 146, 147, 148, *159*
Indrī, 137, 140

integration, awakening of, 191
intermediate state
 mental body of, 179, 180, 189
 rebirth mind and, 180, 191
involvement, month of, 184

J
Jambhakī, *136*
Jambudvīpa, 87–89
Jambukāsyā, 150, 152
Jaya, 152, 153
Jonang tradition, ix, xiv, 9–10, 27, 59, 62, 80, 107, 118, 205, 207

K
Kālachakra, *118, 119, 123*
 four bodies and, 168–70, 176
 four faces of, 17, 120–21
 four inner seals and, 175
 seed of, 65
 "ten-powered" monogram of, 10, 190
Kālachakra and Vishvamātā, 19, *125*
 anusmṛti and, 208
 awakening to reality awareness and, 191–92
 detailed description of, 117–26
 empowerment and, 22
 purity of time and, 172
 representations of, 62, 63–65
 seat for, 117–18
 union of, 10, 169, 175, 193, 198
Kālachakra mandala, 4
 empowerment and, 21
 as enlightened mind, 163
 other mandalas, 23–25
 overview of, 18–19
 sources for, xiii–xiv
 See also mandala; mandala, drawing of; mandala in three
 dimensions; mandala of 100 yoginis; mandala symbolism
Kālachakra tradition
 Buddha's teaching on, 5
 meditation practices in, 10–12
 origins of literature of, 5–8
 in Tibet, 8–10
Kākāsyā, 152
Kālāgni, 59, 117
Kāmā, 69, 134
Kāmadeva, 118, 119, 120, 138, 172
Kaṇḍūyanecchā, 143
Kangyur, 4
Kārkoṭaka, 150, 152

Karma Kagyu tradition, xiii, 9–10, 80
Kauberī, 146, 149
Kaula tradition, 136
Kaumārī, 137, 138, 140, 147, 148, *155*
Khadyotā, 127
Kīlanecchā, 144
kinnaras, kinnarīs, 61–62, 106
Krodhanīladaṇḍa, 150
Kṛṣhṇadīptā, 126–27, *129*, 168
Kṛṣhṇapāda tradition, 46
Kṣhitigarbha, *135*, 173
Kulika, 152
Kumāra Ṣhaṇmukha, 137, 146, 149

L
Lakṣhmī, 137, 141, *142*, 146, 147, *154*
lamp-like signs, 179
land-protectors, 46, 49, 50, 107
life process
 description of, 178–87
 four bodies and, 166–67, 168–69, 170, 175–77
 four states and, 176–77
 purification and, 187, 188, 202
 See also birth/rebirth; death process
lion, eight-legged, 61, 61n4, 110, 149
Lochanā, 173, 197, 199
"lord of the class" seal, 202
lotuses
 animal mounts and, 59–60
 in body palace, 72–73
 colors of, 57, 59
 description of central, 36, 40, 108, 117, 126
 in mind mandala, 83, 84
 as seats for deities, 50–53, 108–9
 in speech palace, 70–71
 on top of Mt. Meru, 89
Lūipa tradition, 46
lunar day deities, 162, 194, 198, 199

M
Mahābala, 150
Mahābhārata, 147
Mahāpadma, 152
Mahāsaṃvara Kālachakra mandala, xiv, 25
Mahāshrī, 147
mahāsiddhas, in charnel grounds, 46, 48
Maithunecchā, 144
Majjanecchā, 144
Mālā, 69

Māmakī, 62–63, 130, 173, 197, 199
mandala
 defined, 3–4
 as enlightened awareness, 4, 12–13, 203–4
mandala, drawing of, 19, *56, 78*
 beings of perimeter, 80
 charnel grounds, 46–50
 colors and designs for, 55–62
 description from *Mūlatantra*, 35–37
 description from Tāranātha, 37–55
 descriptions from Abhayākaragupta and Dolpopa, 37
 descriptions of the three palaces, 37–46
 general dimensions for, 29–31
 mind mandala and, 81–84
 original description of, 31–35
 ornaments of the mandala, 61–62, 83
 overview of methods for, 27–28
 representations of deities in, 62–80
 seats for deities, 50–55, 59–61
 units for, 28–29
mandala in three dimensions, *116*
 body palace, 105
 colors for, 110–12
 main structure of the palace, 89–96
 mind palace, 96–99
 ornaments of the mandala, 105–6
 perimeters, 106–7
 seats for deities, 108–10
 speech palace, 105
 toran structure, 99–105
 world-system mandala and, 85–89
mandala of 100 yoginis, xiv, 24, 77, 136, 137
mandala symbolism
 basics of, 14–18
 of deities, 166–78
 dynamic symbolism, 161, 178–87
 empowerment and, 20
 four bodies and, 166–67
 Kālachakra and, 118–24
 overview of, 12–14
 of palace, 161–66
 purity of body vajra and, 161–63
 recollection of purity and, 167–78
 static symbolism, 161
mantra recitation, 11, 20, 169, 195, 204
Mārīchī, 127, 150
Mastery of Activity, 10, 121, 178
 four bodies and, 170
 meditations, 11, 196–202

 as near accomplishment, 187
 purification by, 184–87
 six yogas and, 188
Mastery of the Mandala, 178, 191
 as approach, 187
 four bodies and, 169–70
 Kālachakra and, 121, 126
 meditations, 10–11, 188–96
 purification by, 184
 six yogas and, 188
mātṛkās, 134–35, 137, 138, 169
measurements, units of, xiv, 28–29, 30, 37
meditation practices
 Drop Yoga, 202–3
 Mastery of Activity, 196–202
 Mastery of the Mandala, 188–96
 overview of, 10–12, 187–88
 Subtle Yoga, 203
method and wisdom, 16, 18, 169, 208, 215, 217
mind mandala, 81–84, *82,* 173
mind palace, 12
 deities of, 14, 19, 62–69, 77, 117–34, 153, 168–69, 171
 importance of, 23, 81
 measurements for, 30, 31, 32, 35–36, 37–44, 90, 93
 in mind mandala, 81–84
 seats for deities of, 51–52, 108, 109
 in three dimensions, 96–99
 torans for, 99–105
 walls of, 57, 97, 162, 164
mind vajra, 120
 Drop Yoga and, 11, 170, 187
 emblem, 128
 empowerment and, 20
 mandala of, 65
 palace symbolism and, 163
 seal of, 202
mirage-like signs, 179, 207
mirror-like awareness, awakening to, 190
misperception
 great primary, 213
 month of, 181
moon, awakening of, 190
moon disk, 117
mountains, in charnel grounds, 46, 47
Mṛduvachanecchā, 144
Mt. Meru, 4, 31
 lotus on top of, 89
 measurements for, 90
 purification and, 189

world-system mandala and, 3, 10, *85*, 86–87, *88*
Mūtraviṭsrāvaṇecchā, 143

N
nāgas
 in body palace, 19, 144, 150–52
 in charnel grounds, 46, 48
 element seats for, 54–55, 60, 74–75, 110, 150
 four bodies and, 168, 169
 purification and, 174, 198
 radiation of, 195
 seeds and emblems for, 74–76
Nairṛti, 140
name and form, month of, 182
name empowerment, 20, 22–23
nature of reality
 as cause and result, 212
 Kālachakra and, 119, 120, 124
 sign of, 207
Navedyā, 134
night yoga, 207, 217
nirvana
 extreme of, 118, 125
 nature of mind and, 212
nonconceptual awareness, 125, 197, 207, 215
Nṛtyā, 69, 134
Nṛtyecchā, 143

O
offering goddesses, 62, 106, 112, 128, 171
 radiation of, 194
 representations of, 68–69, 77, 84, 132–34
offering ground, 31, 89, 106–7
offering mandala, 3, 89
offering ritual, 11–12, 24
orgasmic/innate body (*sahajakāya*), 166, 167, 168, 169–70, 175–76, 203
ornaments of the mandala, 61–62, 83, 105–6, 165

P
Padma, 150, 152
Padmāntaka, *136*, 173, 200, 201
Pāṇḍarā, 130, 173, 197, 199
Paramakalā, 127
Paranirmitavasavartin, 169
parents, lineage of
 purification of, 189, 190–91
 tenfold power and, 179–80

perfection process, 10, 13, 187–88, 205–19. *See also* six yogas of Kālachakra
perimeters, *113, 116*
 colors of, 58–59
 deities of, 80, 144, 153, 195
 in drawn mandala, 31, 45–46
 in mind mandala, 83, 84
 in three dimensions, 106–7
permission empowerment, 20, 23
Pītadīptā, 127
Plāvanecchā, 144
porch structure
 in drawn mandala, 42–43
 symbolism of, 164
 in three dimensions, 92, 96–97, 102
postures, purity of, 177
powder mandala, 3–4, 62, 84, *160*
 measurements for, 28, 57
 powdered bone for, 162
Prachaṇḍā, 146, 147
prachaṇḍā goddesses, *77*, 81, 107, 137, 141, 144
 on charnel wheels, 152–53
 four bodies and, 168, 169
 nāgas and, 150–52
 purification and, 174, 198
 radiation of, 195
 seats for, 46, 54, 110
 seeds and emblems for, 76
Pradīpā, 127
Prajñāntaka, 173, 200, 201
Prajñāpāramitā, 127, 130, 173, 199
prāṇāyāma (wind control), 188, 196–97
 practice of, 208, 216, 217–18, 219
pratīcchās, 19, 141, 144, 174, 195
pratyāhāra (withdrawal), 188–89, 190, 192
 practice of, 207–8, 216, 217, 218, 219
protector deities, 12
pure body (*śuddhakāya*), 166, 167
purification, in creation process, 13–14, 86, 169, 187–88, 204
purity, recollection of, 167–78
 additional purification, 177–78
 purity of aggregates and elements, 172–74
 purity of channels, 170–71
 purity of deity's emblems, 174–77
 purity of four bodies, 168–70
 purity of postures, 177
 purity of time, 172

R

Rāhu disk, 59, 62, 117, 118

Rajyecchā, 144

Rākṣha, 146, 147, 168

Rākṣhasī, 146, 147

Raktadīptā, 127

Rasavajrā, 168, 173

Ratnasambhava, 21, 62–63, 68, 123, 130, 172, 173, 191, 199, 219

Raudrākṣhī, 150, 199

Raudrī, 137, 138, 141, 146, 149

reaction, month of, 181

reality awareness, awakening to, 191, 195

reality body (*svābhāvikakāya*), 166n16

rebirth mind, 180

rivers, in charnel grounds, 46, 48

roof structure, *96, 101, 103, 104*
 colors for, 110
 in three dimensions, 93–96, 98–99, 101, 102, 104

Rudra, 118, 120, 138, 140, 147, 148, 172

Rūpavajrā, *135*, 173

Rwa (Ra) tradition, 8, 206

S

samādhi (absorption), 188, 203
 practice of, 208, 216, 217, 218, 219

Saṃgrāmecchā, 143

Sāṃkhya philosophy, 174–75

samsara
 conventional mind and, 212
 creation of, 213–14
 description of cycle of, 178–87
 reversibility of, 211, 214–15

Saṃtāpecchā, 143

Samudra, 147

Sarvāṅgakṣhodanecchā, 143

Sattvānāṃvañchanecchā, 144

seed character, for representing deities, 62, 64–80, 141, 177–78

sensation, month of, 183

senses, month of, 182

senses and objects, 17
 development of, 167, 176
 emptiness of, 163
 mandala symbolism and, 14–15
 purity of, 168–69, 173
 representations of purified, 68

Seven Empowerments Raising the Child, 14, 18, 20–23, 195, 201

sexual activity, 176, 193, 202

shaktis, 19, 168
 description of, 126–28

empowerment and, 22
 meditations on, 192
 purification and, 172

shālabañjika, 62, *64*, 106

Shaṅkhapāla, 151, 152, *157*

Ṣhaṇmukha, 141, 146, 147, *154*

Shoṣanapratīcchā, *151*

Shoṣhanecchā, 143

Shrī, 149

Shūkarāsyā, 152

Shvānāsyā, 152

Shvetadīptā, 127

silk scarf empowerment, 20, 22

six dharmas of Nāropa, 197

six perfections, 121–22

six yogas of Kālachakra, 9, 13, 89, 187–88, 205–19
 as antidote, 215–16
 brief history of, 205–7
 classifications of, 216
 creation of samsara and, 213–14, 218–19
 functioning of, 216–18
 practices of, 207–9
 reversibility of samsara and, 214–15
 ten signs and, 127–28, 207, 219
 terminology of, 209–11
 theory of, 211–13

smoke-like signs, 178, 207

space perimeter, 46, 58, 59, 84, 91, 107

space-wind, 185

Sparshanecchā, 143

speech palace, 12, 18–19
 deities of, 19, 24, 70–72, 77, 80, 134–44, 145, 153, 168, 169, 171
 measurements for, 30, 31, 32, 35–36, 37–40, 42–44, 90, 92–93
 seats for deities of, 52, 60, 108, 109
 in three dimensions, 105
 walls of, 57, 162, 164

speech vajra, 120
 emblem, 128
 empowerment and, 20, 22
 Mastery of Activity and, 11, 170, 187
 palace symbolism and, 163
 seal of, 202
 wisdom truth body and, 170

Stambhonecchā, 144

Stobhanecchā, 143

stūpas, 30
 in charnel grounds, 46, 47, 47n2

Subtle Yoga, 10, 178
 four bodies and, 170
 as great accomplishment, 187
 meditations, 11, 203
 six yogas and, 188
Sumbharāja, 150
sun, awakening of, 190–91
sun disk, 117
symbolism. *See* mandala symbolism

T
Ṭakkirāja, 150
Takṣhaka, 152
tantra, 4, 5, 211–12
Tārā, 66, 130, 141, 168, 173, 197, 199
tathāgata, unique attributes of, 165
tathāgata-extension, 40, 51, 57, 62, 77, 93, 108
tathāgatagarbha, 207, 210, 212
ten vases, 127, 130, 168, 193
ten virtues, 165
Tengyur, 4
thirty-seven factors oriented toward enlightenment, 163–65
time, purity of, 172, 173–74
toran structure, *63, 108, 109*
 colors of, 58, 61
 in drawn mandala, 43–46
 in mind mandala, 81
 in three dimensions, 99–105
torma offerings, 11, 65–66, 136
transformation, four bases of, 165
trees, in charnel grounds, 46, 47, 49
triple mandala, 12, 23
Tsami tradition, 9, 28, 80, 206
tummo, 196–97, 198, 199, 200, 202–3, 208, 218
twelve links
 awareness of ultimate, 122–23
 purity of cessation of, 163
 stages of gestation and, 181–84
 ultimate reality and, 212
 zodiac signs and, 181
twenty-four tattvas, purification of, 174–75
two accumulations, 10

U
Ucchāṭanecchā, 143
Ucchiṣhṭabhaktecchā, 143
ultimate reality, 16, 210, 212
Ulūkāsyā, 151, 153, *158*
union, path of, 215–16

Upaniṣhads, 134, 205
Uṣhṇīṣha, 132, 168, 173
Uṣhṇīṣhachakrin, 150

V
Vadanagatakaphotsarjanecchā, 143
Vādyā, 69, 134
Vādyecchā, 144
Vahni, 147
Vairochana, 23, 123, 129–30, 173, 190, 199, 219
Vaiṣhṇavī, 137, 139–40, *145*, 147
vajra, symbolism of, 16
vajra and bell empowerment, 20, 22
vajra body, 209
vajra conduct empowerment, 20, 22
vajra garland, 46, 57–58, 59, 165
vajra ground, 89–90, 91, 106
vajra repetition meditations, 208
vajra yoga, 215–16
Vajradhātvīshvarī, 127, 130, 173, 197
Vajrākṣhī, 152, 153
Vajrapāṇi, 24, 173, 199
Vajrasattva, 16, 68, 128, 130, 199, 219
 central deities and, 121, 126, 191
 empowerment and, 23
Vajrashṛṅkhalā, 150
Vajravega, 11, 25, 199–200, 201
Vārāhī, 137, 140, 147
Varuṇa, 147
Varuṇī, 147
Vāsavī, 147, 148
vase breathing, 208, 217–18
Vāsuki, 151, 153
Vāyu, *77*, 146, 147
Vidveṣhapratīcchā, 77
Vidveṣhecchā, 77, 141, 143, *148*
Vidyut, 147, 148
Vighnāntaka, 173, 200–201
Vijaya, 152, 153
Viṣhṇu, 147, 149
Vishvamātā, 127, 128, 163
 description of, 124–26
 radiation of retinue deities and, 193, 198
 See also Kālachakra and Vishvamātā
vowels and consonants, 14–18
 representations of deities and, 72–73, 177–78
Vyāghrāsyā, 151, 152, *157*

W

waking state, 176, 186, 216

water empowerment, 20, 21

water perimeter, 58, 88, 91

weapon wheels, 46, 54, 61, 110

white and red elements (semen and ovum), conception
 and, 17, 180–81

wind perimeter, 46, 49, 54, 58, 80, 107, 144, 162

winds. *See* channels, winds, and drops; prāṇāyāma

wisdom truth body (*dharmakāya*), 166, 167, 168, 170, 176, 188

womb-born beings, 175, 178, 179. *See also* birth/rebirth

world-system mandala, 3, 4, 10, 28, 85–89, 90–91, 189–90

wrathfuls and consorts

 in body palace, 73–74, 144, 149–50

 chariot seats for, 19, 53–54, 55, 60–61, 109–10

 in mind palace, 68, 77, 168

purification and, 173, 199–200

radiation of, 193

representations of, 128, 131–32

Y

Yakṣhiṇī, 147

Yama, 141, 146, 147, 149

Yamāntaka, 173, 200, 201

Yaminī, 147

yoginīs, of speech palace, 19, 153

 four bodies and, 168, 169

 as goddesses of time, 137

 purification and, 171, 173, 198

 radiation of, 194

 representations of, 70–72, 134–44, 145

 seats for, 162